PHOTOGRAPHS

AT ST. LAWRENCE UNIVERSITY

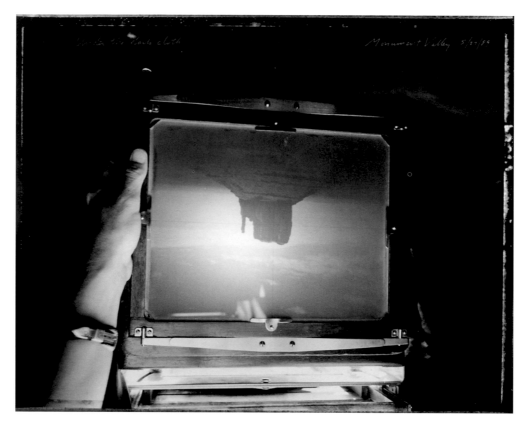

MARK C. KLETT, *Under the Dark Cloth, Monument Valley*

PHOTOGRAPHS

AT ST. LAWRENCE UNIVERSITY

A Critical Survey and
Catalogue of the Permanent Collection of
the Richard F. Brush Art Gallery

*with Selected Photographs from Special Collections and
University Archives of the Owen D. Young Library*

CATHERINE TEDFORD

GARY D. SAMPSON

EDITORS

ESSAYS BY

BILL GASKINS

ESTHER PARADA

GARY D. SAMPSON

Additional contributions by
Eloy J. Hernández, Michael E. Hoffman,
Mark C. Klett, Dorothy Limouze, Carole Mathey,
Mark C. McMurray, and Thomas W. Southall

ST. LAWRENCE UNIVERSITY
CANTON · NEW YORK
2000

PHOTOGRAPHS

AT ST. LAWRENCE UNIVERSITY

✺

was published in conjunction with
the exhibitions at the Richard F. Brush Art Gallery and the
Frank & Anne Piskor Special Collections Reading Room
23 October–15 December 2000

Photographs at St. Lawrence University was made possible by
generous gifts from Richard F. Brush '52 and Cheryl L. Grandfield '73,
and with funds from the Hap and Betty Barnes Endowment established by
the parents of Lynne Barnes Leahy '72, Joan Barnes Flynn '77, and Fuller Barnes '80.

Cover: NATHAN FARB, *Orebed Brook* (detail), n.d.
Silver-dye bleach print
Purchased with funds from the Eben Griffiths '07 Endowment and a
matching gift from the artist 97.22

ISBN 0-933607-02-4 (cloth)
ISBN 0-933607-03-2 (paper)

Contents

Foreword by the President

IN THE MID-1960s, two St. Lawrence alumni—Michael E. Hoffman '64 and Doris Offermann '34—started something here at the University, each in his or her own way, that has evolved in directions they could both imagine, I suspect, and not imagine. Both helped St. Lawrence learn to use photography to add richness, depth, and dimension to teaching and learning in a liberal arts college. Michael has shared with us extraordinary photographs by some of the world's most significant artists. Doris facilitated the donation of a diverse group of mid-century photographs that focused on the technical aspects of the medium. The works now provide a distinct window on subjects under study in critical new ways. The efforts of these two alumni allowed us to strike off on our own to develop an outstanding collection, frequently used as a resource in connection with many different courses. I think all of this is what they imagined and hoped for.

What they could not imagine, perhaps, is how well the University became a duck that took to this particular water. At some colleges, the arts are part of the genetic base, wired in from the start to be equal in the curriculum with the sciences, social sciences, and humanities. At St. Lawrence, I believe, including the arts has not always been instinctual, yet our multi-dimensional strengths are the result of the work of courageous and determined faculty assisted by University leadership. President Emeritus Frank P. Piskor's commitment to create fine new spaces for the arts comes to mind, as does the late President Eugene Bewkes' support of Michael Hoffman's initiative to bring Minor White to campus when Michael was a student.

That we took to the water so well is due to the ingenuity, creativity, and determination of Catherine Tedford, Director of the Richard F. Brush Art Gallery, and to Dick Brush himself, whose philanthropic and artistic stamp is everywhere at St. Lawrence. Cathy's goal to increase dramatically the educational use of the Permanent Collection, by highlighting its photographs in this volume and through the essays of accomplished artists and teachers, will help us envision how such a collection can enrich teaching and learning. A year does not go by at St. Lawrence without at least one significant photography exhibition in the gallery. As I write this, photographs by Vietnamese-American artists An-My Lê and Hien Duc Tran, from the exhibition *Reconsidering Vietnam*, part of this year's Festival of the Arts, are extending the vision of Hoffman and Offermann and enriching greatly the education of our students and the people of this community. I'm very proud of this volume and of the underlying work and philosophy it represents. We are deeply grateful to Dick Brush '52 and Cheryl Grandfield '73 for making its publication possible.

DANIEL F. SULLIVAN

Foreword by the Vice-President and
Dean of Academic Affairs

PHOTOGRAPHY IS A VIRTUAL UPSTART in the liberal arts tradition. That is, of course, necessarily the case, given the relatively recent and ongoing development of its technology. But the same could be said for other subjects that have now firmly established themselves within the academy. Economics, sociology, and psychology were nowhere to be seen a century ago, reminding us that the tradition of liberal learning is always dynamic, always contested, always a dialectical balancing of old ways of knowing and new.

In seeking to probe the distinctive contribution of photography to liberal learning, I am reminded of a Japanese Zen master's words to his German disciple of several years, when the latter was about to return to Europe. They had worked hard together, as the disciple, a philosopher by training, sought to master the daunting art of archery, a process that transformed his entire being. The master's parting words included the admonition: "Do not ever write to me about it [this "spiritual archery"], but send me photographs from time to time so that I can see how you draw the bow. Then I shall know everything I need to know."[1] This is reminiscent of Chuang Tzu's ancient, pithy indictment of the verbal preoccupation of "men of old": "All that was worth handing on, died with them; the rest, they put into their books."[2] What we put into our photographs, however, is another story.

Small wonder, then, that as we strive to articulate a vision of the liberal arts that does new justice to the global horizons of liberal learning, we find ourselves repeatedly brought up short by the limitations of our past ways of knowing, by the unwitting ways in which unexamined assumptions intrude upon our understanding. That is the challenge and the frustration and the joy of living with these broader horizons. From where I sit, no medium, and no subject matter, has as much potential today as photography for liberating us from these shortcomings and for living a more fully self- and other-aware life.

The technology and the subject matter of photography are entrancing in their own right. But what is at stake finally is potentially far more transformative, far closer to the heart of liberal learning. It is surely no accident that the splendid and distinctively American hymn "Amazing Grace" includes the lines, "I once was blind, but now I see. . . ." The photographs in the Permanent Collection of the Richard F. Brush Art Gallery, as represented in this volume and in the accompanying exhibition, provide countless "teachable moments," where we find ourselves becoming more than we were and striving to understand both before and after the fact how these visual artifacts work their magic on us. With these photographs now dramatically more accessible to us, we will never be quite the same again.

THOMAS B. COBURN

1. Eugen Herrigel, *Zen in the Art of Archery*, trans. R. F. C. Hull (New York: Pantheon Books, 1953) 92.
2. Arthur Waley, *Three Ways of Thought in Ancient China* (London: George Allen and Unwin, 1939) 33.

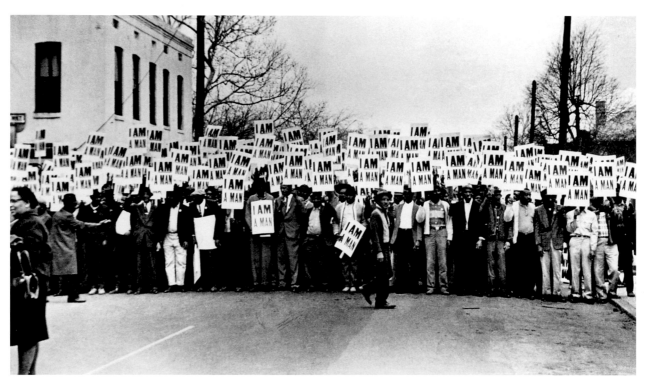

Fig. 1. ERNEST C. WITHERS, *I Am a Man*
© Ernest C. Withers, courtesy Panopticon Gallery, Boston, Massachusetts

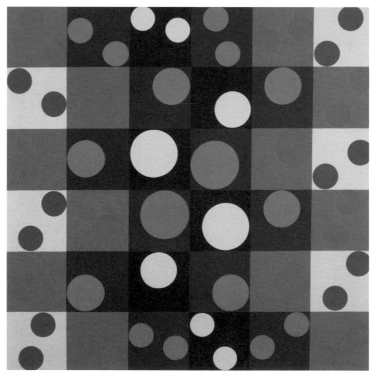

Fig. 2. HERBERT BAYER, *Birthday Picture I*, n.d.
Screen print
Gift of Jerome Singer through the Martin S. Ackerman Foundation
79.176

Director's Introduction:
The Poetry and Politics of Juxtaposition

FROM THE BEGINNING of this publication project, I have been surprised to find that many of the dynamics inherent in the context of directing a university gallery were similar to those found in creating a catalogue of photographs. Organizing exhibition programs for educational purposes and developing a teaching collection are activities that raise many of the same questions that I faced working on this publication: Whose work will be represented? Which photographs should be exhibited/illustrated and how does the sequencing of images affect their meanings? To what extent are interpretive essays useful when examining works of art? How can exhibitions and publications effectively enhance teaching and learning in real and tangible ways? In this essay, I discuss some of the often-competing perspectives surrounding these issues, and I focus on the concept of juxtaposition, for it was with this strategy in mind that *Photographs at St. Lawrence University* was created. I also describe the history of the photography collection and my work to integrate gallery activities into the undergraduate liberal arts curriculum at St. Lawrence.

One of the more intriguing projects at the Richard F. Brush Art Gallery in recent years juxtaposed the traveling exhibition *Let Us March On! Selected Civil Rights Photographs of Ernest C. Withers 1955–1968* with an untitled exhibition of American and British Op and Pop prints that I selected from the University's Permanent Collection. The first exhibition announcement featured Withers' powerful photograph of sanitation workers assembling before their 1968 strike in Memphis, Tennessee (fig. 1). In the photograph, each of the men carries a large placard with the simple and graphic message I AM A MAN. According to the exhibition catalogue, the event was Dr. Martin Luther King, Jr.'s last march.

The untitled exhibition from the Permanent Collection included prints by Allan D'Arcangelo, Gordon House, and Nicholas Monro, among others, and a reproduction of Herbert Bayer's *Birthday Picture I* was used on the exhibition announcement (fig. 2). His screen print of multi-colored circles floating on a grid of yellow, orange, and red squares is one of my favorite images in the collection. Photographs by Withers in the interior galleries of the Emmett Till murder trial, the "Little Rock Nine" (Checklist), and notable Civil Rights figures James Meredith, Rev. Ralph Abernathy, Medgar Evers, and Dr. King were juxtaposed with whimsical and colorful prints in the hallway gallery featuring titles like *Mauve, Orange, Yellow, Turquoise on Pale Blue, Mitred Matrix, Night Suite A, (B, C, D, etc.), Watertower A (B, C, D, etc.)*, and *Green Figures*, an artist's Pop version of space aliens. Hundreds of Pop and abstract prints like the ones we showed were donated to St. Lawrence University through various sources, often as tax write-offs that were available in the United States in the 1980s. Though the individual prints are more or less effective as teaching tools today, I find them most useful in discussing aspects of connoisseurship in the last few decades.

Viewed together, the concurrent exhibitions questioned the creation and promotion of certain works of art during one of the most turbulent eras in recent American social history and explored

the nature and meaning of acquisitions in institutional and academic contexts. I wanted to investigate what St. Lawrence University had acquired in the 1960s and '70s for the Permanent Collection and to invite gallery visitors to compare and contrast two very different bodies of work that were created during the same period. Ultimately, I questioned who benefited from collection development and whose creative voices had been left out. I was concerned, as always, that the gallery might be perpetuating certain practices in terms of acquisitions and exhibitions, and I wondered if and how a frank assessment of the collection would affect future programs.

I chose this example to discuss the poetry and politics of juxtaposition. No one in the community ever responded concerning the subtext of the concurrent exhibitions, yet the encounter between the two was unnerving to me, as each body of work was seen in light of the other. Although I appreciated for different reasons the two images that were represented on the exhibition announcements, their juxtaposition made me queasy. I learned a valuable lesson, however, about reading and interpreting art beyond what I see right in front of me. As gallery director, I often lean toward such scenarios, and I hope that others are as engaged by what is revealed through subtle or not-so-subtle juxtapositions. *Photographs at St. Lawrence University* therefore brings together voices from a variety of perspectives to comment on the functions of photography in the contexts of higher education, the nature and meaning of photographs and academic photography collections, and the abundant conflicts inherent in this enterprise.

PHOTOGRAPHS AT ST. LAWRENCE UNIVERSITY

The Permanent Collection at St. Lawrence University is comprised of over 7,000 art objects and artifacts, with strengths in mid- to late-twentieth-century American and British works on paper: prints, photographs, portfolios, and artists' books. Dating to the early 1900s, the collection began as "an idiosyncratic and eclectic assortment of portraits and gifts donated by alumni, reflecting the University's historical heritage and religious associations through pieces such as Hiram Powers' marble bust of Silas C. Herring, drawings by North Country native Frederic Remington, and a sixteenth-century Spanish altarpiece of St. Lawrence."[1] Several St. Lawrence faculty and administrators formally established the Permanent Collection and oversaw its continued growth. From 1961 to 1991, Dr. Harlan H. Holladay taught art history and art studio courses at St. Lawrence, and in the mid-1960s, for the first time on record, he conducted a complete inventory of the collection. With the support of President Foster Brown, a University-wide acquisitions committee was newly formed, including as chair "the most influential person on campus, Dr. Al Romer [from the Physics department]."[2] The committee—also comprised of Dr. George McFarland and Dr. Rutherford Delmage of the English department, Dr. Clayton V. Fowler of Fine Arts, and Marguerite Holmes of Theater Arts—created important new standards for gifts and purchases. Subsequent gallery directors continued to develop the Permanent Collection through careful acquisitions and proper stewardship: Dr. Paul Schweizer (1977–80), now director of the Munson-Williams-Proctor Institute in Utica, New York; Joseph Jacobs (1980–81); Dr. Betsy Cogger Rezelman (1981–82); and Geo Raica (1982–89). In addition, curators of the collection, Dr. Sarah Boehme (1973–77), now curator of the Whitney Gallery of Western Art at the Buffalo Bill Historical Center in Cody, Wyoming, and Rachael Sadinsky (1986–87), both raised standards for

1. Rachael Sadinsky, "The Gallery and Collection at St. Lawrence," St. Lawrence University, 1986–87.
2. Harlan H. Holladay, telephone conversation with author, 21 June 2000.

the care, handling, utilization, and long-term management of an evergrowing number of art objects in the University's collection.

Dr. Frank P. Piskor and his wife, Anne, provided unwavering support of the University's gallery during his tenure as President of St. Lawrence from 1969 to 1981. In the gallery's 1980–1981 Annual Report, just as Dr. Piskor was about to retire, Joseph Jacobs illustrates their active role in the gallery's mission:

> . . . ultimately, credit for the extraordinary quantity and quality of growth that has occurred in the past twelve years and culminated in the last three years must be extended to President and Mrs. Frank P. Piskor. The Piskors had been ardent collectors and supporters of the arts for many years, and, upon coming to St. Lawrence in 1969, they transferred their experience, resources, and enthusiasm to developing the University's collection. Virtually every major work and certainly the look of the entire collection is the result, either direct or indirect, of the Piskors' efforts. In the short span of twelve years and with extremely limited funds, the President and his wife assembled one of the better university art collections in America and one of the finest collections for an institution the size of St. Lawrence. As expressed by a connoisseur and friend of the gallery, "President and Mrs. Piskor have pulled off a minor miracle at St. Lawrence University."[3]

Since its inception thirty-five years ago, the photography collection has grown to include nearly 1,000 photographs: some 600 individual photographs and 28 portfolios, series, and artists' books consisting of over 325 photographs. Selected photogravures—photographic prints from mechanically engraved metal plates—were also included in this project. Two alumni were instrumental in the founding of the photography collection. In the mid-1960s, within months of one another, Michael E. Hoffman '64 and Doris M. Offermann '34 contacted University faculty and administrators to pursue the idea of acquiring photographs that could be used for teaching and research purposes. Each shared an enthusiasm for photography that led them in two very different directions.

As a student, Michael Hoffman organized two successful artists' workshops on campus with Minor White and Paul Caponigro, and initiated the Photo Service, a student-run darkroom and studio facility. A year after his graduation, Hoffman became the Executive Director of Aperture Foundation. His remarkable vision and foresight as a young man led to the acquisition in the mid- to late-1960s of many of the University's first and finest photographs by Ansel Adams, Paul Caponigro, Henri Cartier-Bresson, Alfred Stieglitz, and Paul Strand (fig. 3). In a recent interview that Gary Sampson and I conducted with Hoffman, he spoke about collection development and photography at St. Lawrence:

> Given St. Lawrence's location and the fact that you have to be quite self-contained and have meaningful resources (if you just have one or two prints of photography, it doesn't mean very much), I would pursue the photographers themselves—living photographers. Try to get them interested in the University and try to find a way to acquire representative bodies of their photographs based on which ones are going to have lasting value. I think that becomes a very meaningful part of the University environment where you bring in people with real dynamic—that's especially meaningful when you can exhibit them in your galleries. Where you can have them give seminars and symposia, and where they hopefully can leave their work behind for a much more modest sum than if you had to go to a dealer or somebody else. Where they would become interested in St. Lawrence as a place that's meaningful for them. That's basically how we pulled it off in that period. Minor White, Paul Caponigro, and others

3. Joseph Jacobs, "Annual Report 1980–1981 Richard F. Brush Art Gallery," St. Lawrence University, July 1981.

26 Oct 1965

HARLAN H. HOLLABAY
Department of Fine Arts
St. Lawrence University
Canton, New York

Dear Dick:

OK--will get to work on acquisitions as soon as possible.

Will write to the following;

ANSEL ADAMS, MINOR WHITE, PAUL CAPONIGRO
BEAUMONT NEWHALL, PAUL STRAND, GEORGIA O'KEEFE,
JOSEPH BREITENBACH,HARRY CALLAHAN, AARON SISSKIND,
AND OTHERS AS THEY COME TO MIND.

Will get the most mileage out of $250.00 as is possible.
Just don't know what these people will think or do.
Hard to know how many people approach them for same
kind of situation.

Of course I am not figuring the cost of framing in this
$250.00. A small, inexpensive, white (sometimes rounded)
frame is always splendid with fine photographs. So no big
deal here.

Trip to Canton much enjoyed. Thank heavens, the
bloom is on SLU with a fine excitement. One is willing
to work for such a situation without question and gladly.

Just haven't had time to get to Graduate problems.
Will!

Best,

Fig. 3. Letter from Michael Hoffman, 26 October 1965

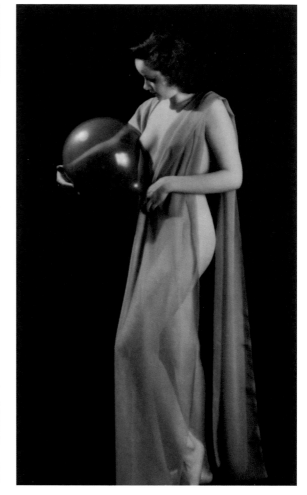

Fig. 4. W. G. POLLAK, *Balloon Dancer*

developed a very positive feeling, and they'd never heard of St. Lawrence before. But they started to feel this was a place that would support them and support their ideas.[4]

Since graduation, Hoffman has donated several photographs and photographic portfolios by Paul Strand to St. Lawrence University. So much has been written about Strand and his work that I am hesitant to try to offer a new perspective. Yet for me, these photographs are like living, breathing beings, not objects at all; the surface of the print is more like skin than paper, and the photograph functions like a meditation in which I slip into a more focused present. In these works, I am drawn to the form of the objects; I am less critical of the photographs as socio-political documents, though I'm not sure why. The Strand collection is an excellent example of why I encourage faculty to teach with original works of art, not from Xeroxes or images projected on a slide screen or computer monitor.

In the mid-1960s, Doris Offermann, who pursued photography as a hobby for many years after her graduation in 1934, was also encouraged by University faculty to acquire examples of photog-

4. Michael E. Hoffman, interview by author and Gary Sampson, tape recording, New York, N.Y., 1 June 1998.

raphy for teaching and exhibition purposes. Offermann was a member of the Photographic Society of America, "an international organization of people interested in photography, amateurs for the most part, but also professionals, camera clubs, and camera club councils."[5] As such, she was well connected to dozens of enthusiasts across the country who experimented with various complex photographic techniques, many of which are no longer in use. Her love of the photographic process itself led to the acquisition of 135 prints created from the 1930s–'60s by professional photographers such as Yousuf Karsh, as well as by other P.S.A. and camera club artists such as Arthur S. Mawhinney, Barbara Green, and Francis Wu.

Technique was emphasized over subject matter in much of the Offermann collection, according to detailed notes for each photograph. Yet a diverse range of images appears, from stereotypical Indians in full ceremonial dress and "Chinese maidens" to championship dogs. These photographs continue to be quite useful for teaching purposes, though undoubtedly for different reasons than originally intended. One of the more startling images in the Offermann collection is *Balloon Dancer*, W. G. Pollak's erotic portrayal of his young daughter (fig. 4). The photograph, while reminiscent in some ways of the contemporary work of Sally Mann, is markedly different in the father's use of the nude female model.

TOOLS FOR TEACHING AND LEARNING

Photographs, more than any other works in the collection, are used to enhance teaching and learning in the wide variety of departments and programs that characterize an undergraduate liberal arts environment. With its typically inherent accessibility and emphasis on subject matter, photography can be integrated into courses in Modern Languages, the First-Year Program, Fine Arts, History, English, and Gender Studies, among others. In the last decade, the gallery has focused particularly on photography in terms of educational outreach and collection development. The wide range of works that were acquired in the 1960s is still reflected in St. Lawrence's photography collection to this day. Several photographs and photographic portfolios were recently acquired as gifts. These include a series of 58 Farm Security Administration dye transfer prints donated in 1992 by Rick Jeffrey (parent of Richard Jeffrey, Jr. '85), and 16 gelatin silver and dye transfer prints by Harold Edgerton donated in 1996 by the Harold and Esther Edgerton Family Foundation. In 1992, after an exhibition about the war in Vietnam, veteran Richard Amerault donated a series of 63 photographs by American soldiers and nurses at home and abroad.

The Helena Walsh Kane Endowment and the Helen Jeanne Gilbert Endowment established by Richard F. Brush '52, the Eben Griffiths '07 Endowment, and the Frederic S. Remington Endowment established by Elaine Manley '14, G. Atwood Manley '16, and Alice R. Manley '17, have provided funds for recent photography acquisitions. Through these four endowments, photographs by Nathan Farb, Carole Gallagher, Bill Gaskins, Nan Goldin, Martina Lopez, Adrienne Salinger, Ernest C. Withers, and David Wojnarowicz were acquired in the last decade in order to make the collection more current and more diverse. Earlier this spring, we purchased Andres Serrano's *Istanbul (Sisters)*, and as I write, plans are underway to purchase a photographic work by Esther Parada.

As I've worked with Parada in the past few months, however, I've realized how much more globally I need to be thinking about the photography collection, especially if the gallery hopes to con-

5. Doris Offermann, letter to Harlan H. Holladay, 27 August 1964.

tinue to integrate its programs and the Permanent Collection into the curriculum at St. Lawrence. The University's new Global Studies department and new majors and minors in Environmental Studies and Outdoor Studies, among others, require us to conduct regular, ongoing re-assessments of the collection. During the last decade, the gallery has made some important strides in acquisitions, but we still have a long way to go. The collection, for example, contains no contemporary photography by artists outside of the United States—a glaring omission that is strikingly obvious now. *ZoneZero* and other Web sites provide access to images by international artists that were otherwise impossible for us to consider ten years ago from rural northern New York, and I look forward to working with Parada to identify works by Latin American photographers, for example, for future acquisitions.

While many faculty and students are accustomed to utilizing photographic works of art in the classroom or for individual research projects, the interpretive essays included in this publication envision some of the ways photographs have in the past or can in the future enhance teaching and learning. Gary Sampson, photography historian and curator of the exhibition that is presented with this publication, writes about the significance of the photographs in St. Lawrence University's Permanent Collection and places the works in historical and theoretical contexts. He and I invited two nationally recognized photographers, Bill Gaskins and Esther Parada, to contribute feature essays. Both artists address the politics of representation. Gaskins comments on the significance of race and photography in the academy, and Parada's photo/text essay presents a critical response to Paul Strand's and Manuel Alvarez Bravo's work in Mexico. From the project's inception, I have been delighted to meet several SLU alumni active in the field of photography. Eloy J. Hernandez '93, Michael E. Hoffman '64, Mark C. Klett '74, and Thomas W. Southall '73 offer personal and professional perspectives as cultural critic, publisher, photographer/teacher, and museum curator, respectively. At St. Lawrence University, the gallery's collections manager, Carole Mathey, discusses her role integrating photographs from the collection into the curriculum at St. Lawrence. Art historian Dorothy Limouze writes about the challenges of teaching with photographic images and the need to reunite creative photography with art history, and Mark C. McMurray describes selected photographs from the Libraries' Special Collections and University Archives.

In the history of the institution, *Photographs at St. Lawrence University* is the first of its kind to document any aspect of the Permanent Collection. One of the most important goals for the gallery is to increase visibility and access to the collection, especially with regard to its potential as a tool for teaching and learning, and this publication represents an important step toward realizing this goal. For the first time, students, faculty, scholars, and the broader community will be able to gain access to the photographic objects in the Permanent Collection via a complete checklist, selected reproductions, and several interpretive essays. It is to these individuals that this publication is dedicated.

<div align="right">CATHERINE TEDFORD</div>

Photographs from the
Permanent Collection: Selected Plates

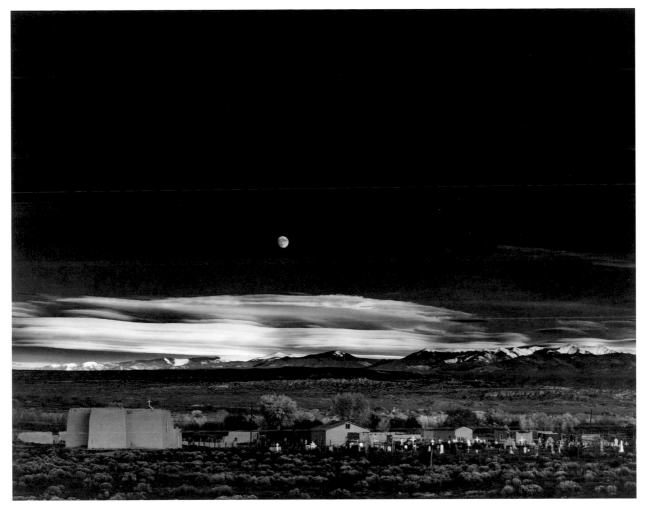

Plate I. ANSEL EASTON ADAMS, *Moonrise, Hernandez, New Mexico*

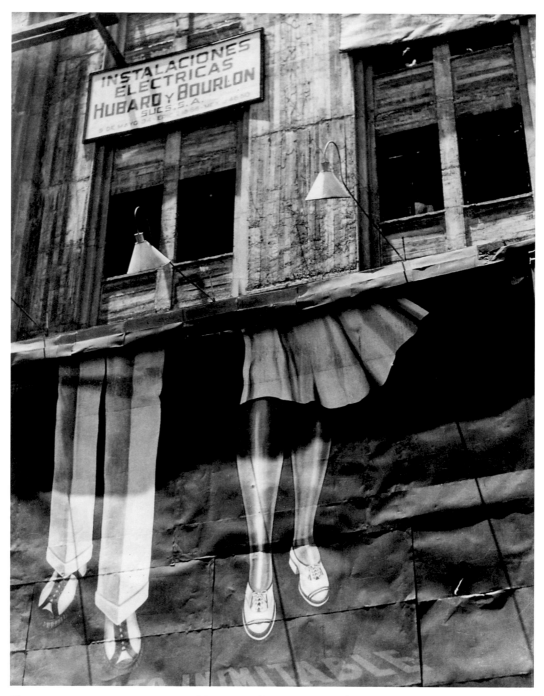

Plate 2. MANUEL ALVAREZ BRAVO, *Two Pairs of Legs* (*Dos pares de piernas*)

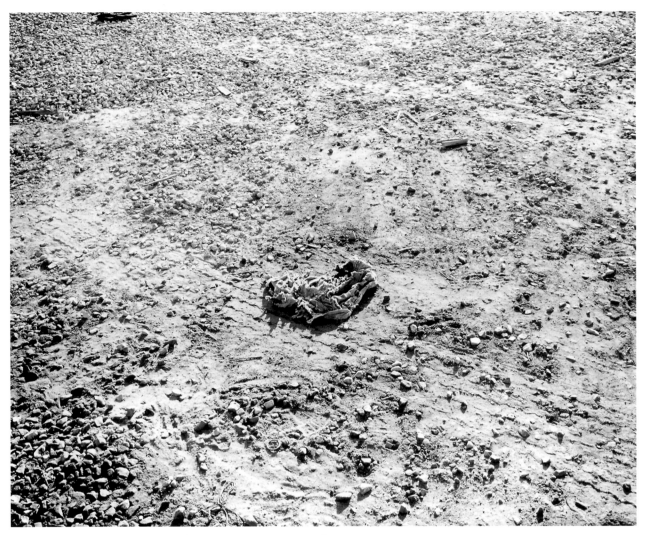

Plate 3. LEWIS BALTZ, Untitled element #20 (Rag on Gravel)

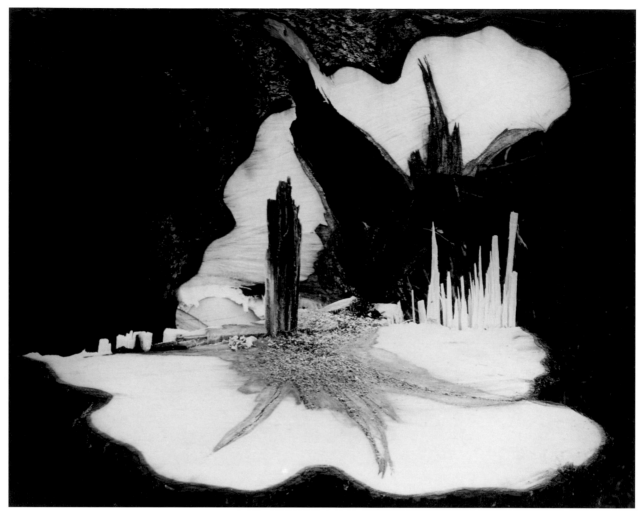

Plate 4. PAUL CAPONIGRO, *Stump, Vicinity of Rochester, New York*

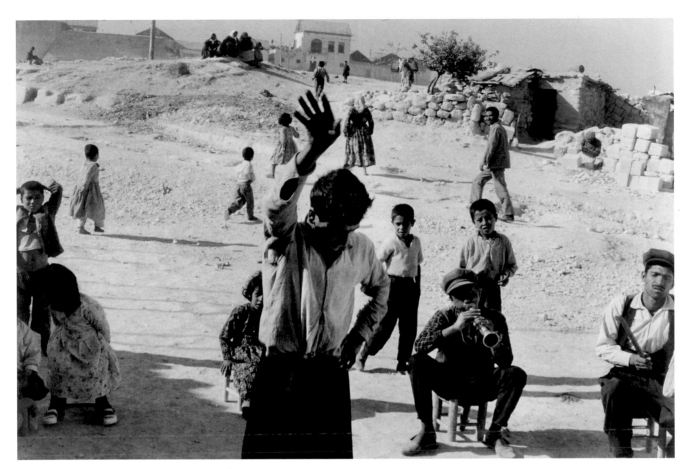

Plate 5. HENRI CARTIER-BRESSON, *Turkey*

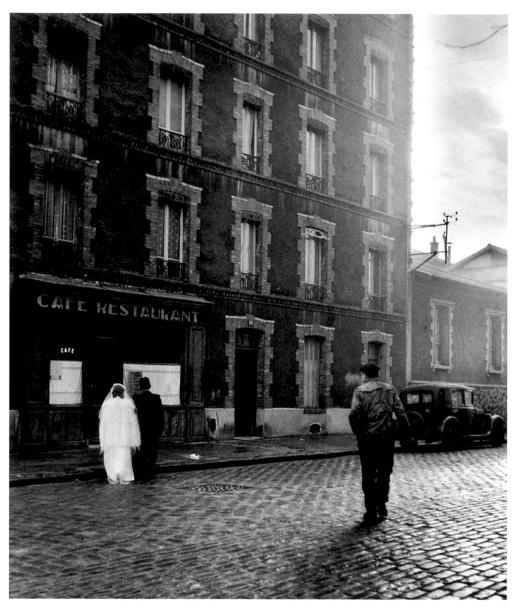

Plate 6. ROBERT DOISNEAU, *La Stricte Intimité*

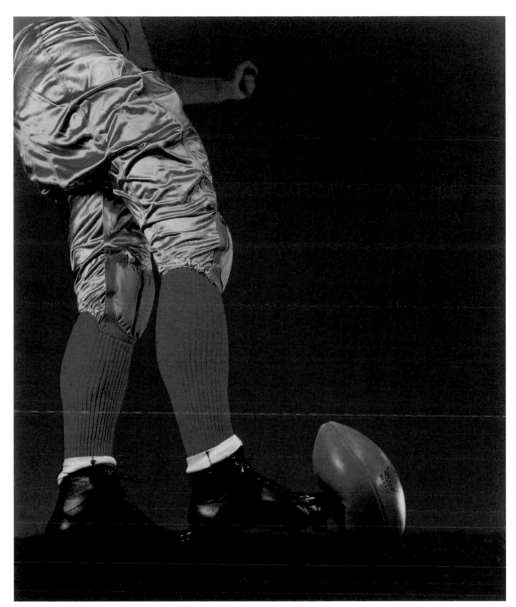

Plate 7. HAROLD EDGERTON, *Football Kick*

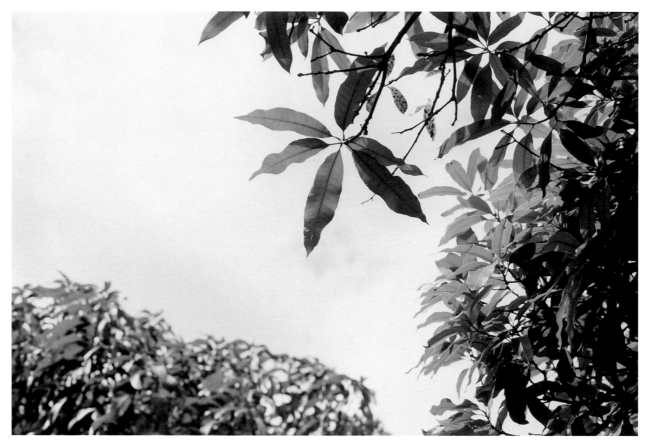

Plate 8. WILLIAM EGGLESTON, Untitled (Branches and Leaves against Sky)

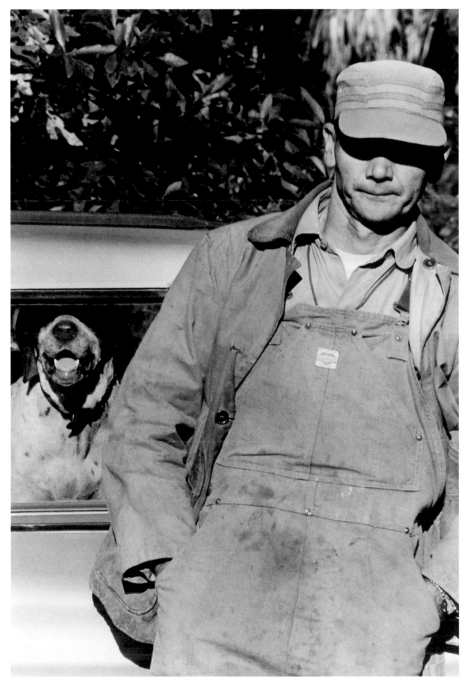

Plate 9. ELLIOT ERWITT, *Man and Dog, South California*

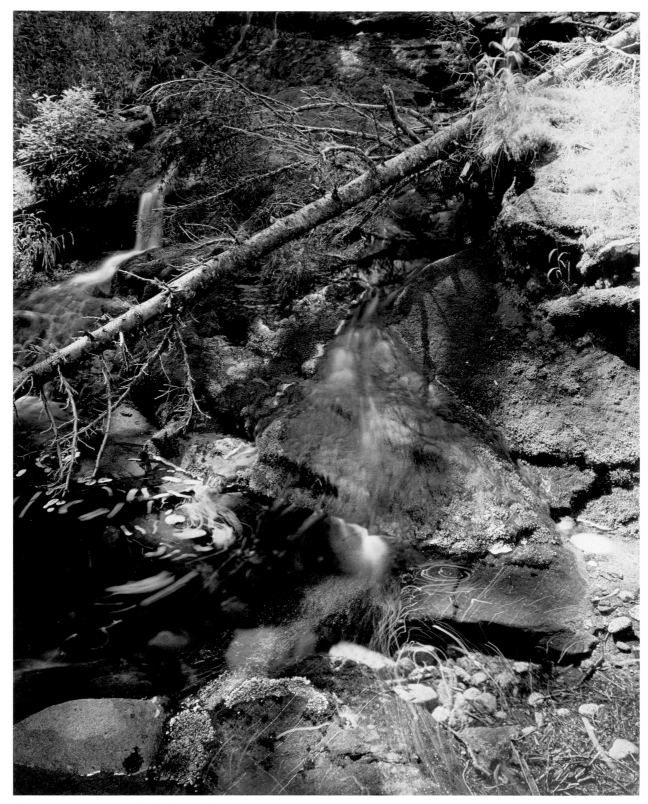

Plate 10. NATHAN FARB, *Orebed Brook*

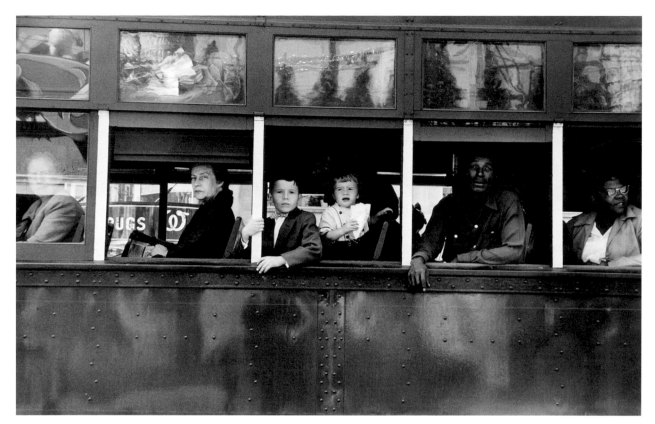

Plate 11. ROBERT FRANK, *Trolley, New Orleans*

Interview with Robert Carter by Carole Gallagher

HE WAS A BLUE-EYED 17-year-old from a small town in Utah, shy, a loner, and so scared that he threw up twice into a tin can ashtray during his pre-A bomb orientation in Operation Plumbbob at Camp Desert Rock, the Nevada Test Site. Thirty-one years later, a depressed and angry man stood before my camera, holding a photograph of his squad of Air Force buddies crouching in the desert sand in the dark, hands over their eyes, waiting for the bomb to explode. Bob Carter was the only youth whose eyes looked out toward ground zero, unshielded, and he was biting his lip. It was July 5, 1957, and he was about to witness shot Hood. The device was suspended 1,500 feet above the desert floor from a lit striped balloon, and at 74 kilotons it was by far the largest atmospheric nuclear detonation conducted within the borders of the United States.

I was happy, full of life before I saw that bomb, but then I understood evil and was never the same. I was sick inside and it stayed with me for a year after. I seen how the world can end. This world is a really thin sheet of ice between death and this happiness I had known all my life. There's a thin line between total destruction and peace and quiet and happiness. I'm just a little skinny guy in there, 140 pounds. [Carter pointed to himself in the photograph seated among forty other strobe-lit men near the press area, News Knob, just before dawn, before the bomb exploded. They would soon be marched much closer to ground zero, where they were not even protected by trenches but stood out in the open, more vulnerable than they had ever been in their lives.] *When the countdown came close I was scared to death. I thought, "Well, I'm going to die or maybe I'll be lucky and won't." The explosion went off, and I remember feeling the confusion that just blew me, it just blew me forty feet into the mountainside and all these men with me. I felt elbows, I felt knees, I felt heads banging, I felt my head hit the ground. I felt dirt in my ears, my nose, it went down my throat, I had a bloody nose. I felt all these terrible things that you don't want to go through in your whole life. I remember the ground so hot that I couldn't stand on it, and I was just burning alive. I felt like I was being cooked. After the shot my coveralls were cracked and burned, there was so much heat.*

The stunned soldiers then participated in a field exercise, a march toward ground zero where they would simulate battlefield maneuvers devised to calculate their physical and psychological responses after witnessing the blast. Little did they know how intensely radioactive their activities would be. Ground zero was radiating 500 to 1,000 roentgens an hour, more than enough to kill a man. And, contrary to a gentleman's agreement among the weapons scientists, the government, and the military never to explode a thermonuclear device on American soil, shot Hood, "the dirtiest atomic explosion in the United States,"[1] was a hydrogen bomb.[2]

I had a huge sunburn, and I remember being in a lot of pain going back to the base on the bus. The doctor told me that he thought I had radiation illness because I was nauseated, dizzy, disoriented. They didn't know what to do. They don't do anything for radiation illness, they just watch you die.

After the test, some men in the platoon had more reason for shock and dismay. While sweeping the area during their maneuver some of them had seen cages and fenced enclosures. Some contained animals burned almost beyond recognition. Carter told me the others held humans in handcuffs chained to the fences. Over the next three years I came across this story again from men who participated in shot Hood. The account of Marine Sergeant Israel Torres, published in the *Washington Law Review* in a legal brief by attorney William A. Fletcher, was identical to Carter's. In fact, when soldiers spoke of seeing the burned and shackled remains of humans on the nuclear battleground, they were submitted to the same psychiatric "deprogramming":

> [I saw] something else horrible . . . out there in the desert after we'd been decontaminated and were in our trucks. We'd only gone a short way when one of my men said, "Jesus Christ, look at that!" I looked where he was pointing, and what I saw horrified me. There were people in a stockade—a chain-link fence with barbed wire on top of it. Their hair was falling out and their skin seemed to be peeling off. They were wearing blue denim trousers but no shirts. . . . Good God, it was scary. While I was in the hospital I told my nurse what I'd seen. The next day when [the doctor] looked in on

1. Richard L. Miller, *Under the Cloud: The Decades of Nuclear Testing* (New York: The Free Press, 1986) 266. Statement of Frank Putnam of the National Academy of Sciences on January 24, 1978, under interrogation by Congressman Tim Lee Carter at a meeting of the Subcommittee on Health and Environment.

2. Thomas H. Saffer and Orville E. Kelly, *Countdown Zero*

(New York: G. P. Putnam's Sons, 1982) 47. In a letter to atomic veteran Thomas Saffer dated July 7, 1980, Col. William J. McGee of the Defense Nuclear Agency revealed, "It was a thermonuclear device and a prototype of some thermonuclear weapons currently in the national stockpile."

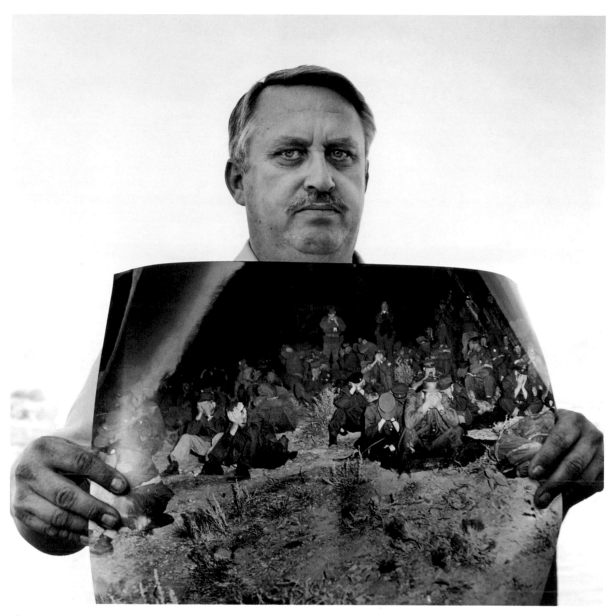

Plate 12. CAROLE GALLAGHER, *Robert Carter, Atomic Veteran*
Robert Carter holds a photograph of his platoon of soldiers taken moments before shot Hood was detonated on July 5, 1957, at 74 kilotons the biggest atmospheric shot ever in Nevada.

me, he said, "The nurse told me a most unusual story. What about those people you say you saw at the test site in Nevada?" [Torres was questioned on two occasions during the next two days. He thought that one of the questioners was a psychiatrist.] . . . They took me to the Balboa Naval Hospital in San Diego [where four men questioned him at length]. I told the story of the people behind the chain-link fence. They told me I imagined I saw those people. One of them called me a liar and forced a large pill down my throat. I must have been kept drugged for days, because I woke up back at Camp Pendleton in the hospital. The day I left to return to my unit a doctor told me not to repeat the "bizarre" story about the people I'd seen. He said if I did, he'd see to it that I was thrown out of the Corps.[3]

That cloud was like a big wall of fire with black smoke and some red inside, big, monstrous, something almost sickening. Something that would scare you. It left me really sad, real apprehensive about my life. My dad said I left home loving life and I came back, and I had no love for life any longer. How would you feel if you sent your kid, 17 years old, to watch a 74-kiloton explosion? It's destroying the human species. That's what it's done to me. That explosion told me I was part of the most evil thing I have ever seen in my life. How can anybody use it as a deterrent to a war? I'd rather go fight the war. Wouldn't you rather go fight in the war than destroy the world?

3. Saffer and Kelly, 248–250.

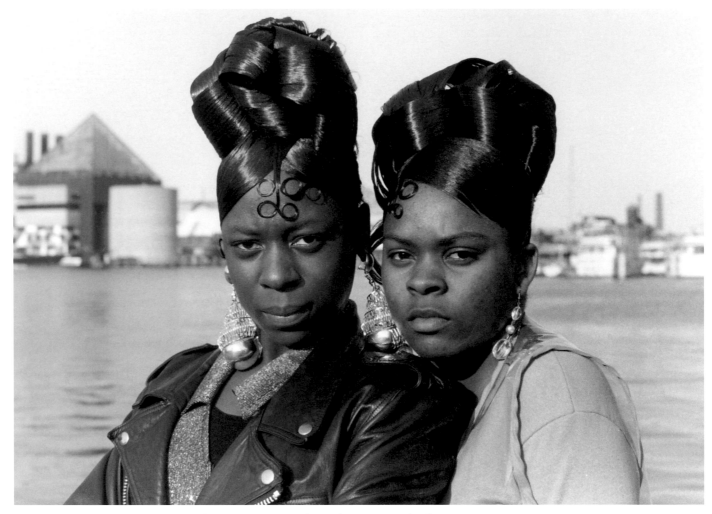

Plate 13. BILL GASKINS, *Tamara and Tireka, Easter Sunday, Baltimore, Maryland*

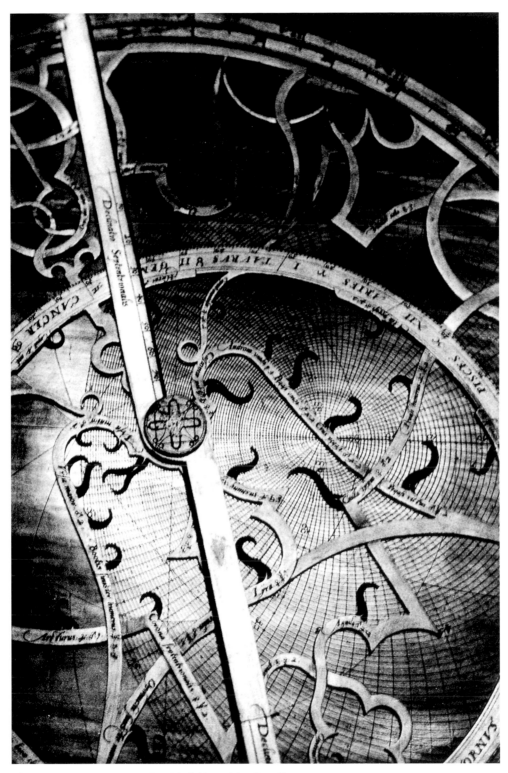

Plate 14. RALPH GIBSON, Untitled (Astrolabe Detail)

Plate 15. PHILIPPE HALSMAN, *Peter Ustinov*

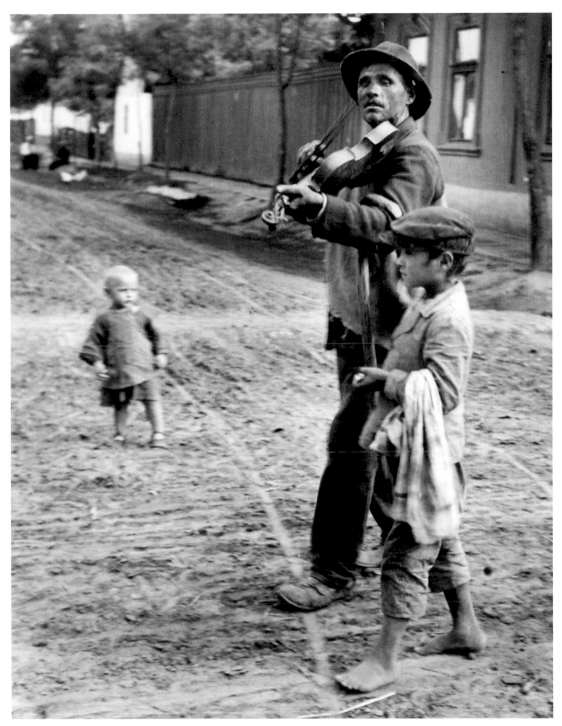

Plate 16. ANDRÉ KERTÉSZ, *Wandering Violinist*

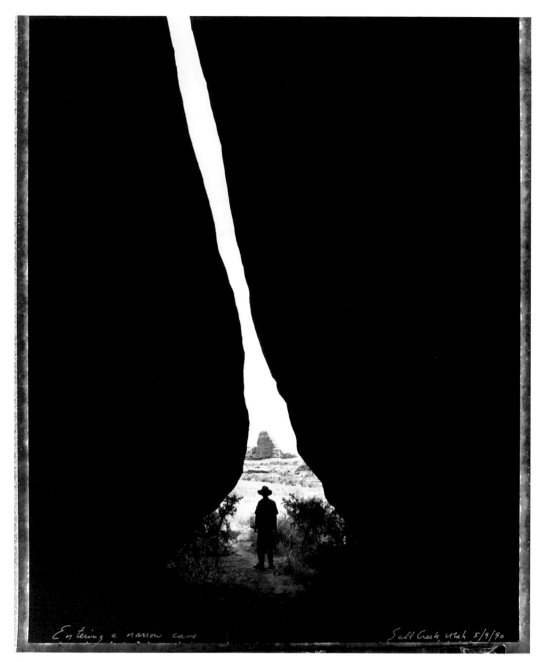

Plate 17. MARK C. KLETT, *Entering a Narrow Cave, Salt Creek, Utah*

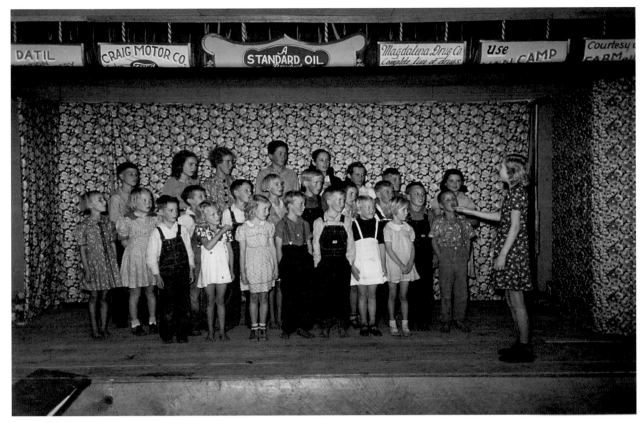

Plate 18. RUSSELL LEE, *School Children Singing, Pie Town, New Mexico*

Plate 19. MARTINA LOPEZ, *Heirs Come to Pass, 2*

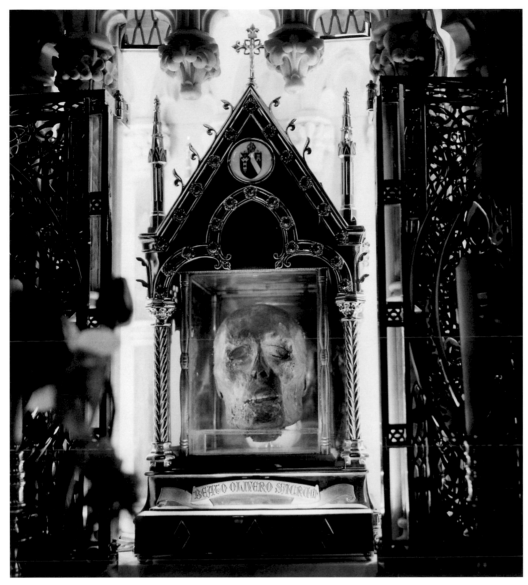

Plate 20. ALEN MACWEENEY, *The Head of Blessed Oliver Plunkett, Ireland*

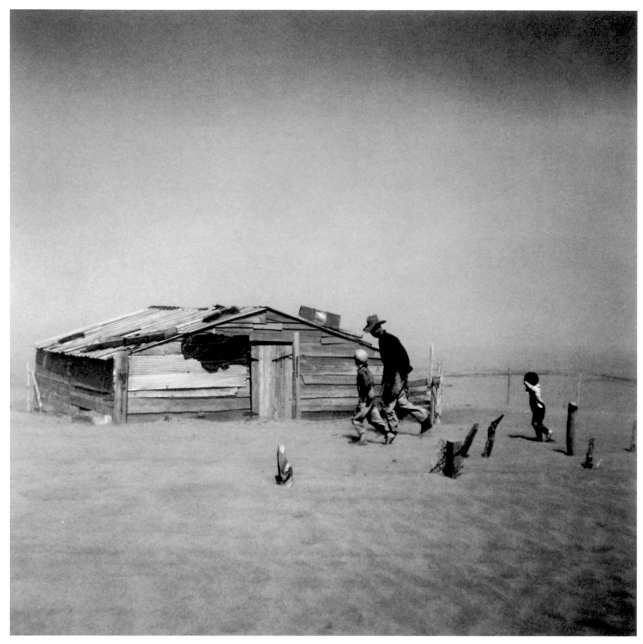

Plate 21. ARTHUR ROTHSTEIN, *Dust Storm, Cimarron County, Oklahoma*

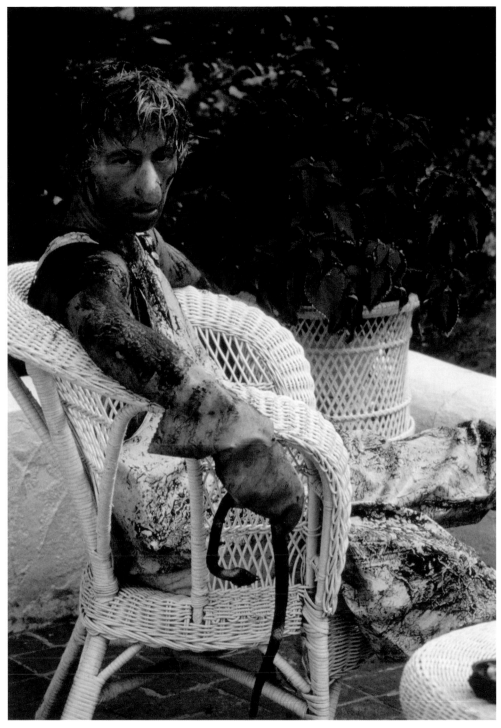

Plate 22. CINDY SHERMAN, Untitled (Self-Portrait)

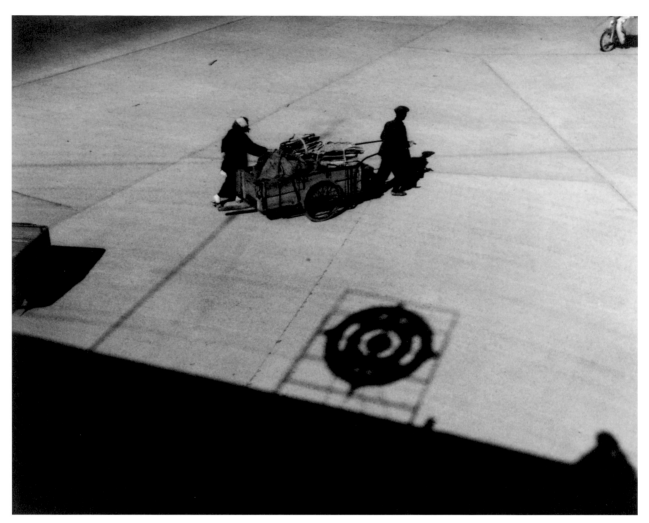

Plate 23. W. EUGENE SMITH, *Pulling Crate*

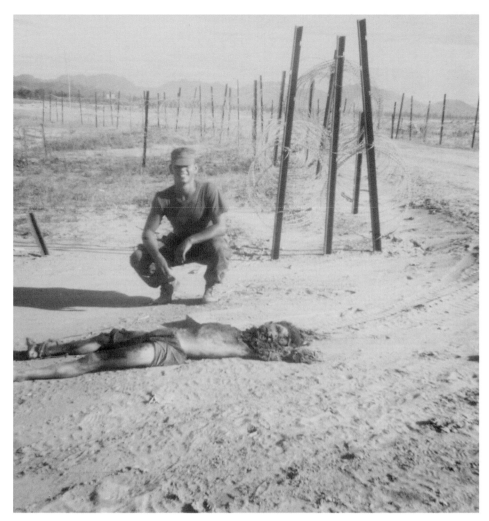

Plate 24. PATRICK STEARNS, *Quang Tri*

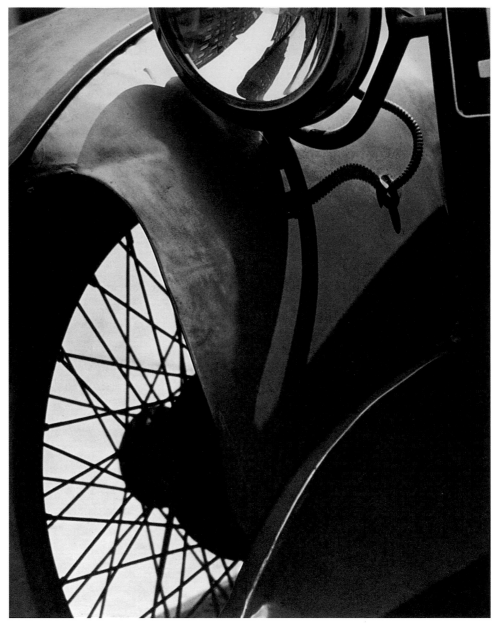

Plate 25. PAUL STRAND, *Wire Wheel, New York*

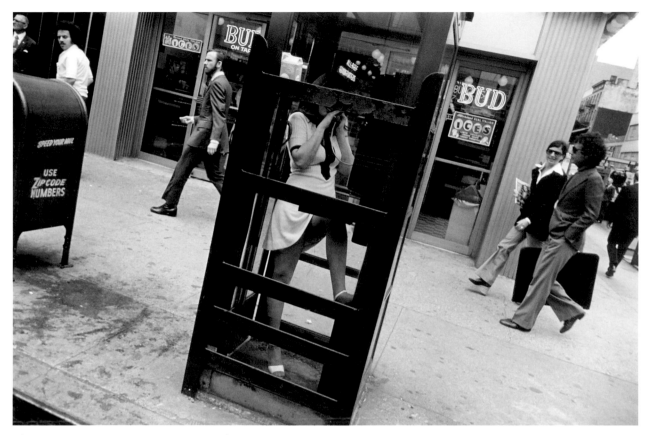

Plate 26. GARRY WINOGRAND, *New York City*

Plate 27. DAVID WOJNAROWICZ, *Sub-species Helms Senatorius*

Plate 28. FRANCIS WU, *Vanity*

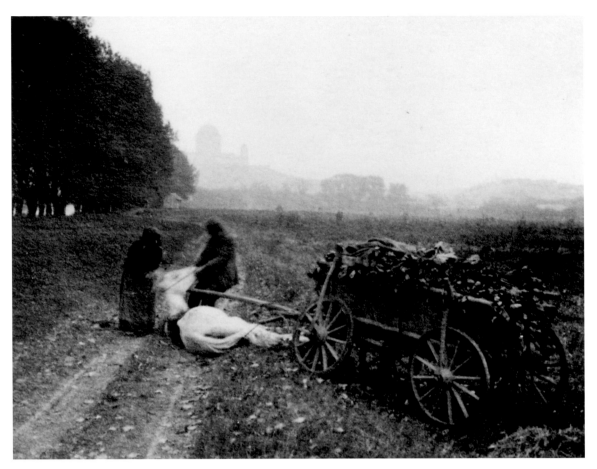

Fig. 5. ANDRÉ KERTÉSZ, *Country Accident*

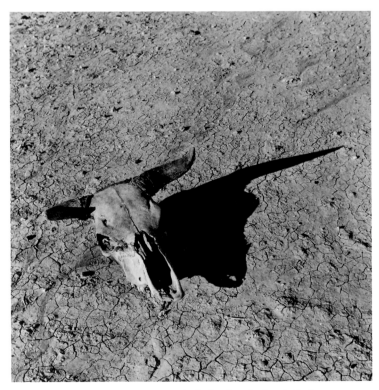

Fig. 6. ARTHUR ROTHSTEIN, *Skull, Badlands, South Dakota*

=== HOLDINGS UPDATE ===

Author : DYNIX #: 625671
Title : Photographs at St. Lawrence University : a critic # copies: 2
 # holds : 0

#	BARCODE	CALL #	TYPE STATUS	USE	LIB
1.	32815008448527	OVR TR6.N7 C36 2000	BK IN		DML
2.	-1076117	VSW TR6.N7 C36 2000	VSW Being shel	0/	DML

#, New, Back, Up, Delete(#-#), Replace Barcode, STatus(#),
SPinc label, Status Reserve(#), Collapse Holdings(#-#)

FirstSearch

SUNY COLLEGE AT BROCKPORT

WorldCat Detailed Record

* Click on a checkbox to mark a record to be e-mailed or printed in Marked Records.

Home Databases Searching Staff View | My Account | Options | Comments | **Exit** | Hide tips

List of Records Detailed Record Marked Records Saved Records Go to page

Subjects Libraries E-mail Print Export Help WorldCat results for: ti: "and" and ti: sea and ti: never and ti: rests. Record 1 of 1. WorldCat

Prev 1 Next **Mark:** ☐

And the sea never rests :
a story on the life cycle of water /

Hans **Strand**; Rolf Edberg

1995
English ◆ Book 115 p. : chiefly col. ill. ; 30 cm.
Stockholm : Journal, ; ISBN: 9197239526

GET THIS ITEM

Availability: **Check the catalogs in your library.**
* Libraries worldwide that own item: 1
* 🖥 Search the catalog at your library

External Resources:
* 🔗 Get Text!
* 🌐 Find this item at Alibris (Bookseller)

FIND RELATED

More Like This: Search for versions with same title and author | Advanced options

Find Items About: Edberg, Rolf. (max: 4)

Title: **And the sea never rests :**
a story on the life cycle of water /

Author(s): Strand, Hans, 1955- ; Edberg, Rolf, 1912-

Publication: Stockholm : Journal,

Year: 1995

Description: 115 p. : chiefly col. ill. ; 30 cm.

Language: English

Standard No: **ISBN:** 9197239526

SUBJECT(S)

Descriptor: Photography of water
Nature photography -- Scandinavia.

Class Descriptors: **Dewey:** 779.3092

Responsibility: photographs by Hans Strand ; text by Rolf Edberg.

Document Type: Book

Entry: 20050708

Update: 20050708

Accession No: **OCLC:** 60828964

Database: WorldCat

Subjects Libraries E-mail Print Export Help WorldCat results for: ti: "and" and ti: sea and ti: never and ti: rests. Record 1 of 1. WorldCat

"A Certain but
Fugitive Testimony"

INTRODUCTION

THE TITLE OF THIS ESSAY is drawn from the last compilation of reflections, *Camera Lucida*, by the French social theorist Roland Barthes.[1] In this slender volume, Barthes, long-time speculator on the meaning of photographic images in society, contemplates once more the nature of photography. The "Photograph is a certain but fugitive testimony": Barthes writes this paradoxical phrase in the context of a reflection on the implication of death embodied in the photograph, where the photographer may deliver the image of someone who appears alive, but perhaps unknowingly imparts to it the assumption of death as well. Photographs bear witness to individuals having lived, some event or episode having taken place, but elude being truly present, truly there. They are glimpses of subjects to which one can only respond from a position of remove to the circumstances surrounding their appearance. One is never able to derive a full disclosure of the facts from a photograph, despite its tantalizing promise of a "certain testimony." The photograph has been thought of as a sign of authenticity, but now, at the outset of the digital age, its once alleged impartiality as a witness to "reality" is suspect. I want to begin by acknowledging this fascination with photography, which Barthes describes in his text as the "that-has-been" character of the subject depicted in the photograph.[2]

The photographs in the Permanent Collection at St. Lawrence University, to one degree or another, have this tentative relationship to the contemporary viewer. One instance, taken by the Hungarian photographer André Kertész, depicts two figures attending to a fallen horse, which suggests that it may no longer be capable of pulling what appears a rickety and heavily laden wagon (fig. 5). The horse lies in the path of a dirt road, which one might conclude would take a rider through the flat countryside to the nearby town silhouetted in the distance. The details of the scene are obscure, perhaps owing to the quick preparation and exposure required to record such an incident. As a bearer of information, it isn't particularly good, for from the picture itself one cannot reach a position of certainty regarding the circumstances of the mishap, nor precisely where we are, nor even a time period, despite the inference that these may be peasants having a difficult time. But as a vignette of life that puts us in touch with a past encounter, one that was of sufficient human intrigue to Kertész in 1916 that he felt inclined to record it, it has an irresistible narrative appeal. Would it make a difference to know where he was, and from his own words, why he made it? Would we begin to understand his technical and personal approach to his subject by relating the image to his other photographs? The answer to these questions must be yes, presuming that one wishes to know more about Kertész as a recognized artist of twentieth-century pho-

1. Roland Barthes, *Camera Lucida: Reflections on Photography*, trans. Richard Howard (New York: Hill and Wang, 1981), 93.
2. Barthes, 76–89.

tography.[3] This would also perhaps tell us something about why his work resides in many museum and gallery collections, including St. Lawrence's, rather than, for instance, exclusively in historical repositories of eastern European artifacts or library archives of Hungarian culture.

THE COLLECTION AND THE CANON

In an excellent critical introduction to photography, Liz Wells and Derrick Price consider Douglas Crimp's book, *On the Museum's Ruins*. Wells and Price succinctly state Crimp's argument "that the entry of photographs into the privileged space of the museum stripped them of the multiple potential meanings with which they are invested. They were removed from the many realms within which they made sense, in order to stress their status as separate objects—as *photographs*."[4] This assertion introduces the problem of the potential suppression of meanings, probably unintentional, when diverse photographs are assimilated into museum collections—and specifically collections that were initially formed around objects of art. Crimp, cultural historian and critic, challenges us to consider how photographs yield different meanings depending on the cultural assumptions under which they are recovered from the past, then reassigned a new position of importance and display space. Despite the uncertainty of the photograph's testimony and the impossibility of reconstructing the faded spectacle of the past, historians, curators, educators, and critics are called to take responsibility for recuperating something of the subtlety of historical and cultural associations and the broader discursive realms in which photographs function in contemporary society. In this essay, I reflect further on the contingencies of photographic meaning. While pursuing this difficult objective, my wish is that the reader will gain knowledge of St. Lawrence University's rich photographic resources, with specific attention to the possibilities for understanding their uses.

Numerous histories of photography have been written to date, so I will refrain from revisiting both the traditional and the recent interpretations that survey the medium's past. Such histories invariably seek to account for the "origins" of the rather magical process that enabled the transfer of light to a chemically sensitized base, thereby rendering the visible world with an astounding direct correspondence to its particulars, even that which had previously escaped or was inaccessible to the human eye. Writers of these surveys have often found it logical and methodologically sound to place photographs into categories and narratives of technical developments and aesthetics.[5] Until recently, pictures that were either significant because of their association with innovations in the medium or specifically identifiable *stylistic* qualities as photographs, especially *documentary* and *artistic*, tended to dominate publications and exhibitions. The selection of photographs reproduced in books has frequently followed the western art world's pronouncements on objects that constitute the highest examples of the craft. The Museum of Modern Art in New York is undoubtedly the best-known arbiter in this regard, though one could point to other institutions prior to the 1960s that contributed to the elevation of photography's prominence as a mode of image-making worthy of attention. For many years, the first three directors of MOMA's Department of Photography, Beaumont Newhall, Edward Steichen, and John Szarkowski, helped

3. See André Kertész, *Hungarian Memories* (New York: New York Graphic Society Books, 1982), 129, 193; and Pierre Borhan, *André Kertész: His Life and Work* (Boston: Bulfinch Press, 1994), 8–12.

4. Liz Wells, ed., *Photography: A Critical Introduction*, 2d. ed. (New York: Routledge, 2000), 58–9; see Douglas Crimp, "The Museum's Old/The Library's New Subject," in *On the Museum's Ruins* (Cambridge: MIT Press, 1993), 66–83.

5. For a critical overview of important surveys of photography, see Wells, 45–55.

to shape the way in which certain photographers and their images came to be valorized by the culture of the modern art museum.

Douglas Crimp sees Szarkowski and Ansel Adams, surely one of the best-known "masters" of the camera, as affirming an approach to photography that privileges photographers whose work conforms to a modernist criteria of form and craft. "In so doing, they [Adams and Szarkowski] ignore the plurality of discourses in which photography has participated. Everything that has determined its multiple practice is set aside in favor of *photography itself.* Thus reorganized, photography is readied to be funneled through a new market, ultimately to be housed in the museum."[6] If one extends Crimp's argument to a university collection like St. Lawrence's, then the diverse images that comprise the collection require a reconnection with the multiple roles that an aesthetically unsophisticated library nomenclature once would have assigned to a broad range of classifications. Collections that consist largely of photographs that have a name value—for example, Ansel Adams, Paul Strand, or a more recent addition to the canon of celebrity photographers, Cindy Sherman[7]—while not inherently wrong, puts the curator/educator in a delicate position of needing to rethink the collection as fashioned in accordance with the primacy of modern aesthetics and the current worth of the artist's cachet in the marketplace and museum profession. Of course, the photographers themselves were each bound to suppositions about their craft, which might later determine their future reception into the canon or their self-conscious participation in the actual shaping of photography's reception into the modernist mainstream. The latter, as will be seen, is particularly true of Adams and Strand.

REALITY AND THE DOCUMENTARY ETHOS

The questions that are raised by both Barthes' and Crimp's observations relate to the position of authenticity that was historically accorded the photograph where other modes of representation were, by contrast, often thought to be embroideries on the truth of actual appearances. William Henry Jackson, for instance, provided the first acceptable proof in photographic form that previous accounts of Yellowstone were not merely the fantasies of trappers and explorers who had traversed the region (Checklist: *Upper Fire Hole, from "Old Faithful"*).[8] To be sure, certain revelations brought about by experiments with the camera, such as Eadweard Muybridge's photographs from the 1870s of the horse in action were at first difficult to accept in the face of artistic convention. But the continued strides in stop-action photography rendered irrefutable the evidence of incremental animal and human movement; Muybridge marketed his *Animal Locomotion* series in the mid-1880s, knowing that artists, scientists, and others would benefit from the discoveries made possible by the camera. Examples of Muybridge's work in St. Lawrence's collection include *Man Pulling Lawn Roller* and *Woman Doing Washing in a Tub* (Checklist). With its precise *indexical* and *iconic* relationships to the subject—in semiotic terms, the subject's image determined by light, and the forms comprising the image resembling the subject—the photograph was easy to accept as objective fact in the nineteenth century, which for educated society in Europe and the United

6. Crimp, 72–73.

7. See profile of the artist by Calvin Tomkins, "Profiles: Her Secret Identities," *The New Yorker*, 15 May 2000, 74–84. Tomkins earlier helped to elevate Paul Strand in the same magazine. See "Profiles: Look to the Things around You," *The New Yorker*, 16 September 1974, 44–94.

8. See Peter B. Hales, *William Henry Jackson and the Transformation of the American Landscape* (Philadelphia: Temple University Press, 1988), 95–96.

States was dominated by the philosophical suppositions of positivism (i.e., the senses are the only reliable sources of knowing).[9] Thus, a documentary ethos emerged that placed realism at the center of photography's nature.

Photographs were from the start, however, subject to tampering or falsification of actual circumstances. This practice has received much attention of late,[10] as if it were any surprise that the relationship of reality to what one sees, or rather imagines in a photograph could be more complicated than one's willingness to embrace the image as a faithful transcription of the subject. The more questions one asks about the photograph, the more problematic and important the issue of interpretation becomes. In order to discern the rhetoric adhering to the alleged neutral record, the reconstruction of various contexts in which the photograph was received, to the extent that this is possible, is of utmost importance. Furthermore, each new context of reception repositions the photograph for a different reading, which in turn is contingent on the reader's ideological perspective and the conditions of display in exhibition, portfolio, printed media, and now on the World Wide Web.[11]

One of the more notorious examples of this is related to the representation of the severe economic and environmental conditions in America of the mid-1930s. In 1935, a program was launched under the auspices of Franklin Delano Roosevelt's New Deal to photograph the visible evidence of the Depression and the devastating impact of drought and dust storms on rural society. Roy Stryker headed the historical section of the Resettlement Administration, and then in 1937 the Farm Security Administration. The story of the F.S.A. photographers and the nuances of their representation in support of F.D.R.'s policies have been examined in painstaking detail. At various times between 1935 and 1942, Stryker employed Arthur Rothstein, Theodor Jung, Ben Shahn, Walker Evans, Dorothea Lange, Carl Mydans, Russell Lee, Marion Post Wolcott, Jack Delano, John Vachon, and John Collier. Initially, the goal was to demonstrate that the country was in dire straits and hence in grave need of government intervention. But these ostensibly worthwhile intentions could backfire. F. Jack Hurley, who has written extensively on documentary photography in the thirties, recounts an incident concerning *The Skull*, which Rothstein photographed in North Dakota in April 1936 (fig. 6). Rothstein felt that the old steer skull would add an emphatic touch to his pictures of parched earth, which, as Hurley notes, "seemed to symbolize drought conditions."[12] The photographer produced five variant exposures that he sent to Washington, where they were well received and soon published in the press. But in August 1936, Republicans in North Dakota found out that Rothstein had moved the skull for effect and had taken his pictures before the severe drought had occurred. Midwestern newspapers began to assault F.D.R.'s New Deal policies. "It's a Fake," noted one headline. Soon the integrity of other Resettlement Administration photographs was called into question. Most dramatically, *The Dispatch-Herald* of Erie, Pennsylvania charged, "The whole resettlement program is a ghastly fake, based on fake ideas, and what is more natural than that it should be promoted by fake methods

9. For a concise introduction to realism and semiotics in photography, see Wells, 24–35.

10. See, e.g., William J. Mitchell, *The Reconfigured Eye: Visual Truth in the Post-Photographic Era* (Cambridge: MIT Press, 1994), 3–57.

11. See Derrick Price, "The Construction of the Documentary," in Wells, 89–113.

12. F. Jack Hurley, *Portrait of a Decade: Roy Stryker and the Development of Documentary Photography in the Thirties* (New York: Da Capo Press, 1972), 86.

similar to those used by ordinary confidence men."[13] This was by no means the first such instance, but it highlights a key point that photographs do not carry meaning in themselves, but come alive as agents of persuasion by individuals and groups who aspire to an objective that is often political or ideological in motivation.[14]

The photograph has functioned in a broad sense to portray the American landscape through periods of white exploration and settlement, to the present. William Henry Jackson and Timothy H. O'Sullivan were among the pioneers of this enterprise. Both joined major western expeditions to survey expanses of the Great Basin region and the Southwest. Many of the resulting images were published as reproductions in government reports and other printed media, thus illustrating the potential of the West for development and exploitation of natural resources. Such artifacts continue to provide a wellspring of historical source material for the interrogation of the mythos and project of expansion. *Perpetual Mirage*, an exhibition mounted in 1996 by the Whitney Museum of American Art, not only reassessed the pioneering work undertaken in the nineteenth century but considered photography's ongoing relationship with the desert regions of the United States.

A renewed concern for the legacy of photographic representations of America occurred around the celebration of the Bicentennial in 1976.[15] The following year, several photographers launched the Rephotographic Survey Project, seeking the precise locations of photographs from the geological and geographical surveys of the late nineteenth century. Mark C. Klett, a St. Lawrence alumnus, was one of these intrepid souls. He and his colleagues were able to pinpoint hundreds of sites and rephotograph the scenes of their predecessors. The photographs are remarkable if for no other reason than they underline the extent to which the earlier photographers would go to secure their exposures, some of which were more interpretive and systematically produced than initially thought. Gordon Bushaw's and Klett's retake of *Green River Buttes, Green River, Wyoming* (fig. 7), after O'Sullivan's view from the early 1870s for Clarence King's Fortieth Parallel Survey (fig. 8), reveals changes in the desert wilderness that one might expect to find through the passage of time. The recent works elicit a droll humor or irony by the appearance of invasive elements of human habitation and development, where any hope of an uplifting aesthetic experience based on modernist or formalist assumptions of the pristine landscape seems dashed. The implications of the R.P.S. project are explored in the publication *Second View*.[16] In the exhibition catalogue for *Perpetual Mirage*, Thomas W. Southhall in his essay rightly asserts that neither the expeditionary pictures nor the R.P.S. venture could scarcely be called objective or neutral, as some have claimed, and that it pushes us to reconsider our ideal image of the West and how the construction of this ideal was aided by the earlier photographic record.[17] Finally, one might compare photographs from the series *San Quentin Point* by Lewis Baltz that depict the blighted fringe zones of urban

13. Hurley, 88–90.

14. John Tagg examines this problem in *The Burden of Representation: Essays on the History of Photography* (Minneapolis: University of Minnesota Press, 1993), 63–65.

15. See, e.g., Weston J. Naef, *Era of Exploration: The Rise of Landscape Photography in the American West, 1860–1885* (New York: The Metropolitan Museum of Art, 1975).

16. Mark Klett, Ellen Manchester, Jo Ann Verburg, Gordon Bushaw, and Rick Dingus, *Second View: The Rephotographic Survey Project* (Albuquerque: University of New Mexico Press, 1984).

17. Thomas W. Southall, "*Second View*: A Search for the West That Exists Only in Photographs," in May Castleberry, Martha A. Sandweiss, et al., *Perpetual Mirage: Photographic Narratives of the Desert West* (New York: Whitney Museum of American Art, 1996), 192–198.

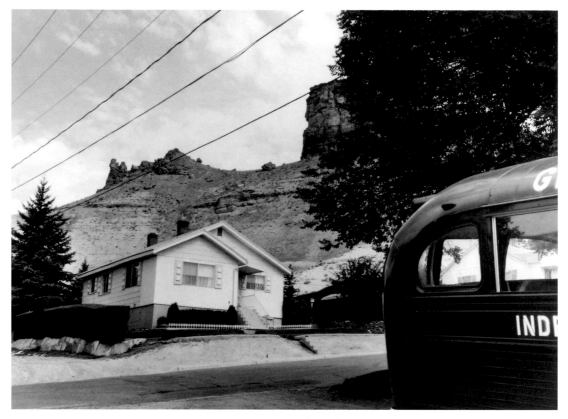

Fig. 7. MARK C. KLETT AND GORDON BUSHAW, *Castle Rock, Green River, Wyoming*

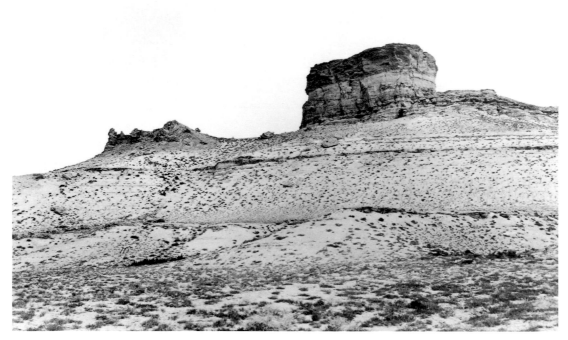

Fig. 8. TIMOTHY O'SULLIVAN, *Green River Buttes, Green River, Wyoming*

developments, signaling a most unpicturesque approach to landscape and yet redeeming it for delectation through the camera frame (Selections: Plate 3 and Checklist).[18]

PHOTOGRAPHY INTO ART

No one seemed to doubt photography's potential as a documentary medium during its pioneering years in the nineteenth century, but when calculated attempts were made to produce pictures of artistic merit, immediate outrage ensued from those who felt that the mechanics of the medium precluded its employment as an expressive vehicle. A familiar voice in the argument against photography as art was the French writer and critic Charles Baudelaire, who had called the photographic industry "the refuge of every would-be painter, every painter too ill-endowed or too lazy to complete his studies," having nothing but scorn for the pretensions of practitioners who aspired to the lofty station of painting.[19] Despite his disparaging remarks, many persisted in producing images that co-opted the look of art through varied kinds and degrees of manipulation, as well as the anecdotal and classically inspired themes of the art academy. Art photography may be said to have culminated by the turn of the century in pictorialist movements on both sides of the Atlantic, whose proponents strove to distinguish themselves from commercial operators on the one hand and amateur snap-shooters on the other. Some of these circles included the Photo-Club de Paris, the Linked Ring Brotherhood in London, and the Photo-Secession in New York, among whose members were Alfred Stieglitz, Alvin Langdon Coburn, Gertrude Kasebier, Clarence White, and Edward Steichen.[20] In 1903, Stieglitz began publication of the Photo-Secession's *Camera Work*, wherein one could find exquisite reproductions in photogravure form of Secessionist photography and of works of European modernist painters and sculptors, including Auguste Rodin, Henri Matisse, and Pablo Picasso.

The pictorialists formed something of an elite social order that collectively endeavored to elevate the medium to high art status by virtue of fine printing papers and artistic surface treatments; they often employed pigmented oil processes and regularly retouched negatives, while even relatively straightforward exposures were deliberately obscured or softened to create a romantic haze. Subjects followed established popular genres of art history and nineteenth-century developments ranging from Orientalist themes, exemplified by Eleanor Park Custis' untitled print of Arab storytelling (Checklist), sylvan landscapes reminiscent of the work of French Barbizon painters and American tonalists, to foggy scenes of the city such as Alvin Langdon Coburn's untitled photogravure (Checklist), portraits, and softly focused nudes. Pictorialism further mystified peoples whom the white European and American public preferred to envision in fanciful, exotic contexts. Arabs, black Africans, Asians, gypsies, and Native Americans were particularly the objects of these sentimentalizing attentions, at best cloying and attentive to youthful bodies, at worst demeaning by distorting the realities of racial and ethnic diversity and conflict. Even if the photographs were executed in innocence among members of photographic societies and clubs that persisted well into the twentieth century, such depictions of peoples on the margins of dominant cultures can

18. See Lewis Baltz, *Rule Without Exception* (Albuquerque: University of New Mexico Press, 1990).

19. Charles Baudelaire, "The Modern Public and Photography," reprinted from "Salon of 1859," in Charles Harrison and Paul Wood, with Jason Gaiger, eds., *Art in Theory, 1815–1900: An Anthology of Changing Ideas* (Oxford, UK: Blackwell, 1998), 667.

20. For an introduction to pictorialism, see Peter C. Bunnell, *A Photographic Vision: Pictorial Photography, 1889–1923* (Salt Lake City: Peregrine Smith, 1980).

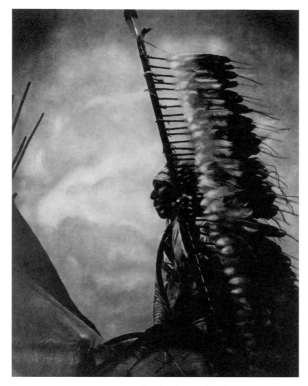

Fig. 9. MAX THOREK, *Chief White Cloud*

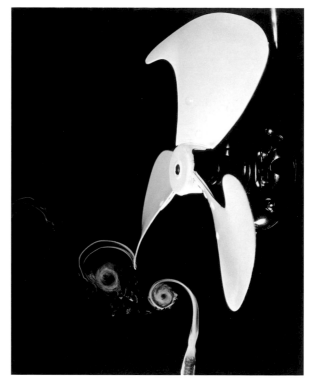

Fig. 10. HAROLD EDGERTON, *Fan and Smoke Vortices*

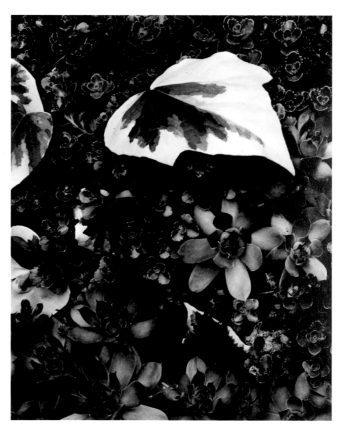

Fig. 11. PAUL STRAND, *Yellow Vine and Rock Plants, Orgeval*

nevertheless be understood as signs of complex racial biases and misconceptions. As evinced in the portrayal of Native Americans, the images may have a dubious function of underscoring the sad situation of "vanishing races" while extending the myth of the noble or primitive savage. This occurs in Edward S. Curtis' *The North American Indian*,[21] and in the lesser-known pictures of second-generation pictorialists (fig. 9). Many of the Indians represented no longer wore traditional Indian dress or performed traditional rituals yet were often induced to pose in their pre-assimilated state for the sake of posterity.

A major shift in attitude among the photographic intelligentsia is represented in Paul Strand's 1923 article, "The Art Motive in Photography." Strand, who was promoted by Stieglitz in *Camera Work* and in his first one-man exhibition at "291," the Photo-Secession gallery, argues that photography was finally acknowledged as a true medium of expression, despite the fact that "in scientific and other record making, there has been at least, perhaps of necessity, a modicum of that understanding and control of purely photographic qualities. That is why I said these other phases were nearer to truth than all the so-called pictorialism, especially the unoriginal, unexperimental pictorialism which today fills salons and year books."[22] Strand embraced modernist abstraction, delighting in the functional components of machines—the inside of a movie camera, the wire wheel of a Ford, or a machinist's lathe. In Strand's view, Stieglitz was the photographer *par excellence* of a new philosophy involving the depiction of nature, humanity, and human invention in immediate terms. A romantic at heart, all of Stieglitz's subjects, whether his famous *Steerage* (Checklist) or his intimate series of portraits of Georgia O'Keeffe, could be taken as metaphors of a love affair with photography's revelation of form. This deeply subjective point of view of the medium is reflected in Strand's statement: "From the beginning, Stieglitz has accepted the camera machine, instinctively found in it something which was part of himself, and loved it. And that is the prerequisite for any living photographic expression of anyone."[23]

As modernists, Strand, Stieglitz, and a growing number of their contemporaries, including Edward Weston, Ansel Adams, and Imogen Cunningham, honored what they considered the inherent properties of the medium: maximum resolution and depth of field and careful attention to obtaining the best possible black-and-white print from the negative. Truth to the "thing itself," to use Weston's expression, did not preclude the photograph's capacity to transform one's perspective of the world. Though the subject appearing in the "straight" photograph must necessarily conform to the world of appearances, it could also become an enigmatic sign or intimation of forces beyond external phenomena. This was understood and embodied by the European modernists as well, albeit with greater experimental ambition as exemplified by the Hungarian László Moholy-Nagy. Photography was theorized to have the potential to transform society through a variety of manifestations,[24] including the seizing of astounding increments of movement enabled by shutter speeds of thousandths of a second. Despite differences in working milieu and purpose, Moholy-Nagy, Strand, and later, Harold Edgerton shared the fundamental belief that photogra-

21. Edward S. Curtis, *The North American Indian; Being a Series of Volumes Picturing and Describing the Indians of the United States, and Alaska*, 20 vols. (Seattle: E. S. Curtis; Cambridge: The University Press, 1907–09; Norwood: Plimpton Press, 1907–30).

22. Paul Strand, "The Art Motive in Photography," reprinted in Vicki Goldberg, ed., *Photography in Print: Writings from 1816 to the Present* (New York: Simon and Schuster, 1981), 280.

23. Strand in Goldberg, 285.

24. See László Moholy-Nagy, "From Pigment to Light," in Goldberg, 339–348.

phy represented a new way of gathering information and producing knowledge, a coalescence of science and art. Edgerton's churning fan, slowed to microseconds, compels one to marvel not only at the technological feat of the illuminated dispersal of smoke, but also at the formal elegance of motorized action of otherwise utter banality (fig. 10), while an intimate close-up by Strand evokes a microcosmic glimpse of the universe in a delicate array of silvery leafage (fig. 11).

Nature held for the purist photographer a profound transcendent meaning, which Stieglitz attempted to epitomize in his notion of the "equivalent." This can be summarized as a desire for metaphysical expression through selected forms that, if exposed with an experienced eye, could become a point of departure for poetic rumination or spiritual meditation. The exemplary American photographer of the metaphorical sign in photographs of nature and certain elements of the built environment in the mid-twentieth century was Minor White, who himself had been greatly moved by Stieglitz' philosophy. Eastern mysticism played no small part in the formation of White's approach, which had a pronounced effect on his associates and students. Paul Caponigro, for instance, traveled the country with White before breaking off on his own as a skilled practitioner of black-and-white photography of breathtaking vision.[25] A split tree could trigger a sensation of stunning abstract beauty, a whole imaginary landscape (Selections: Plate 4). But for photographers like Caponigro, there must be something greater than mere delight in fixed gradations of light and dark as representative of natural beauty. In such cases, correlation with place or locale seems secondary to visual effect and contemplation.

Following World War I, and concurrent with the emergence of the modernist pursuit of significant form, was a field of practice that engaged the social dynamics of city and village life. This was stimulated by the development of small-format cameras and faster lenses (particularly 35mm cameras like the German-manufactured Leica) and an increase in photojournalistic enterprises. St. Lawrence's collection contains a number of works representative of "street photography," a term that loosely characterizes the general unfolding of human activity portrayed by Lewis Hine, André Kertész, Henri Cartier-Bresson, Robert Doisneau, and others. Cartier-Bresson is known for his notion of the "decisive moment," the English title of his 1952 book that, as Colin Westerbeck observes, does not quite capture the French original *à la sauvette*. The idea can be readily grasped through Cartier-Bresson's 1965 photograph of Turkish villagers in which men and children are situated in the foreground, some of whom face the camera, as others cross the sun-drenched open space behind (Selections: Plate 5). Two musicians play in the foreground, but the most striking element is a central figure who makes an ambiguous gesture in the face of the photographer. This confluence of movements, a chance composition that defies the viewer's ability to know precisely what is happening and what will transpire next, is central to Cartier-Bresson's mode of expression, in essence the meaning of the decisive moment.[26] Kertész depicts his world in a similar way, yet with less consistent attention to geometry and compositional balance.

Parallels exist especially between Cartier-Bresson's images of people looming large and grotesquely within the visual field and the notions of the "marvelous" and "uncanny" that helped to define surrealism for its official founder, André Breton. Cartier-Bresson, Kertész, and the

25. Paul Caponigro, *The Wise Silence: Photographs by Paul Caponigro*, with essay by Marianne Fulton (New York: New York Graphic Society Books, 1983), 176–178.

26. Colin Westerbeck and Joel Meyerowitz, *Bystander: A History of Street Photography* (Boston: Bulfinch Press, 1994), 156–157.

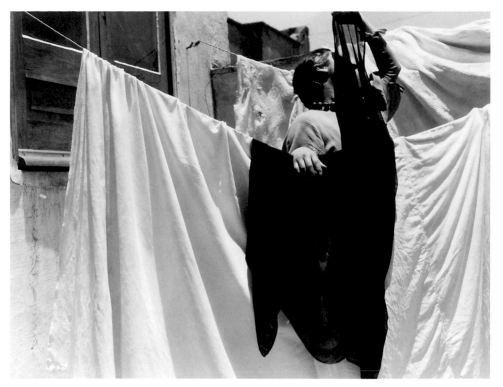

Fig. 12. MANUEL ALVAREZ BRAVO, *Invented Landscape* (*Paisaje inventado*)

Mexican photographer Manuel Alvarez Bravo were invited to participate in exhibitions of surrealist work in the 1930s and '40s.[27] Though not surrealists *per se*, they each found a way to express the unexpected and to transform the mundane into psychologically unstable figurations. Alvarez Bravo reveals his intrigue with the serendipitous and the visual allure of life and death in the public, private, and ritualized spaces of Mexico. One of a series of photographs depicts laundry hung out to dry and a woman handling a dark dress who is all but obscured by the sheets (fig. 12), a laconic play on clothing, sexuality, and identity.

POINTS OF CONTESTATION AND TRANSMUTATION

The photographers noted above honored the formal qualities of the medium and the integrity of the single print. In this respect, their photographs conform to an overarching narrative of modern art, especially in the ways art museums and the academy have enthusiastically embraced them into the fold. Yet to fully appreciate the photographs would be to examine each for their distinctive cultural associations, their correspondences to specific ways of conceiving the world, and their suggestions of alternatives to myopic viewing habits and suppositions about reality. Scholarship that contests former patterns of critical reception to the exclusion of discursive fields of meaning has been developing since the 1960s. In the United States, one can identify a subversive force among photographers who adopted a certain disregard for hallowed aesthetic and documentary traditions, perhaps best exemplified by *Life* magazine and the well-known 1955 exhibition, *The Family of Man*. Swiss émigré Robert Frank elicited unabashed disdain from the photographic

27. For Cartier-Bresson and surrealism, see Westerbeck and Meyerowitz, 157–161; and for Alvarez Bravo, see Susan Kismaric, *Manuel Alvarez Bravo* (New York: Museum of Modern Art, 1997), 32–38.

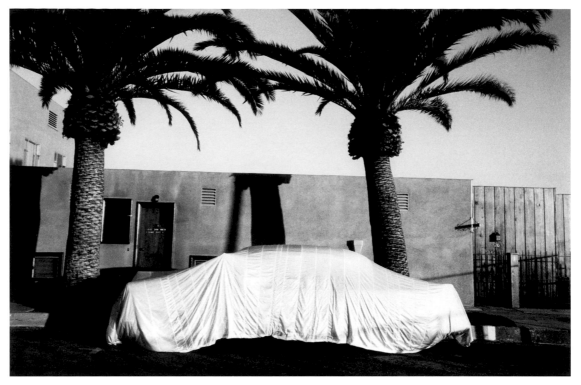

Fig. 13. ROBERT FRANK, *Covered Car, Long Beach, California*

establishment for *The Americans* (1959), a book of photographs that documented his 1955–56 car trip around the country. Frank carefully organized the images to play off of one another as the viewer turned the pages, a recognized rejoinder to Walker Evans' Depression-era volume, *American Photographs* (1938). Frank's unassuming but penetrating images of highway culture, cowboy bars, diners, gas stations, parades, and, most provocatively, the racial and cultural divide of black and white society, seemed to mock American values and met with subsequent hostility. Some of the sequences—a covered car between two palms (fig. 13), a road accident, a view down an open road—have an understated, contradictory quality of subtle vision. Frank's encounter at a Hollywood premier of an unknown and slightly out-of-focus beauty gazed upon by adoring fans contrasts with the idealization of celebrity that lies at the heart of George Hurrell's photographs of Dorothy Lamour (Checklist) and Douglas Fairbanks, Jr. (fig. 14).[28]

In the 1950s, Frank was among few photographers on the road and in the streets probing previously neglected territories of post–World War II society, but his example prompted others to operate with a similar radical edge. Certainly, there is a vast body of work that engages the unrest of the sixties and early seventies, some by professionals whose names are still scarcely known, and hundreds of amateur depictions of protest rallies, civil rights demonstrations, outdoor concerts, and most chillingly, of the war in Vietnam (Checklist: Carlile, Decker, Nicosia). Photographers like Tom Papageorge, Joel Meyerowitz, Lee Friedlander, Diane Arbus, Bruce Davidson, and Garry Winogrand seemed to have developed a sixth sense for ferreting out chaotic conditions of contemporary life and, by varying degrees of exposure, drawing attention to bizarre occurrences and appropriations of identity and self-awareness that mainstream society had overlooked. "I photo-

28. *Movie Premier—Hollywood*, reproduced in Robert Frank, *The Americans* (New York: Grove Press, 1955), 141.

Fig. 14. GEORGE HURRELL, *Douglas Fairbanks, Jr.*

graph to find out what the world looks like when photographed,"[29] is Winogrand's best-known quotation, but this peripatetic artist could in a twinkling gather the light of a "crazy" increment of crisscrossed encounters that the eye alone would have trouble picking out.[30] Not a few of these appear as subversive or light-hearted lampoons of social strata, as he catches unsuspecting individuals in ambiguous and even compromising positions from the randomness of public spectacles (fig. 15).

The camera allows the viewer to assume this uneasy position of peering into a kind of hole in time to glimpse apparitions of the remote or immediate past. One may have to make tough ethical decisions regarding the effects of the collusion between subject and object: Who is brought before the viewer's gaze and for what purpose? What are the potential consequences of accepting images as a way of knowing? How does one's perspective of the nude change, for example, when the model in W. G. Pollak's *Balloon Dancer* (fig. 4) is discovered to be the photographer's daughter? The deliberate obfuscation of her identity by an overlay of symbolic devices may remove the spectator from the immediate ramifications of the father-daughter relationship. One can find more direct but no less problematic encounters in the photographs of children taken by their mother, Sally Mann. Also difficult to negotiate are Stephanie Welsh's series of photographs of the ritual and practice of female circumcision in Kenya (fig. 16 and Checklist). The presentation calls the viewer to witness a young woman in preparation for, during, and after the experience. As in all cases of documentary approaches, the images are subject to interpretation depending on con-

29. Garry Winogrand, quoted in Jonathan Green, *American Photography: A Critical History, 1945 to the Present* (New York: Harry A. Abrams, 1984), 99.

30. Westerbeck and Meyerowitz, 376.

Fig. 15. GARRY WINOGRAND, *Metropolitan Museum of Art Centennial Ball, New York City, New York*

text. Welsh's photographs may be the cause of considerable abhorrence and moral dilemma for some, while for participants themselves, the same images may affirm a familiar cultural practice.

The presence of Welsh's work in St. Lawrence's Permanent Collection indicates that the gallery is starting to enlarge its purview for acquiring photographs, which suggests, according to past evidence of the photographs themselves, was determined by the larger context of curatorial practices of art museums and markets. The climate in the academy today has shifted to greater concern for issues that contest former categories of modern histories of art and thereby affect the focus of exhibitions and acquisitions. The increasing attention to the physical and social body and to cultural identity by revisionist efforts in the social sciences and humanities has prompted the art world to reexamine previously untapped material of popular culture, anthropology, and other sources beginning to surface in analog and digital photographic forms. Clear reverberations of these shifts are indicated in the essays in this catalogue, in the digital montage *Heirs Come to Pass, 2* by Martina Lopez (Selections: Plate 19), and most significantly, in the social vision of contemporary artists such as Nan Goldin, David Wojnarowicz, and Bill Gaskins (Selections: Plate 13 and Checklist). These artists employ photographic strategies as deeply personal responses to sexual, racial, and social codes and taboos. Goldin and Wojnarowicz were close friends at the time of his death from AIDS in 1992.[31] They each ran the risk of outrage or misunderstanding by unsympathetic audiences: Goldin for her unflinching, autobiographical reflections on her network of emotionally turbulent urban dwellers, addict acquaintances, female intimates (Selections: Plate 19),

31. See David Wojnarowicz, "Postcards from America: X-Rays from Hell," in Elisabeth Sussman, *Nan Goldin: I'll Be Your Mirror* (New York: Whitney Museum of American Art, 1996), 374–384.

Fig. 16. STEPHANIE WELSH, Untitled (Circumcision)

and abusive partners; Wojnarowicz for self-revelatory collages and photomontages that contain a personal iconography concerning his life as an artist and a gay man. These works could be scathing indictments of conservative values, as seen in *Sub-species Helms Senatorius* (Selections: Plate 27).

Despite their inclusion in St. Lawrence's collection, these photographs could hardly be expected to represent the gamut of contemporary trends. Several avenues of current practice might be investigated for future acquisitions, including work representing a larger global diversity (Asia, Oceania, Africa, and Latin America), the various diaspora of non-Europeans into the West, and generally artists who address postcolonialist conditions as a factor in their work. Some of the best photography is now coming from artists who apply digital strategies to both historical and contemporary images in order to problematize common conceptions about racial and cultural boundaries and stereotypes.[32] Analog photographs can be revitalized with radical outcomes in digitized form. Instead of assuming that the advent of computer-generated images is the death knell for photography based on negative-positive darkroom processes, one may see this change as greatly multiplying the photograph's potential for global dispersion beyond conventional publication and exhibition formats. Media theorist Roy Ascott has commented on the diverse possibilities of such strategies in an essay entitled "Photography at the Interface":

> The window onto a world of analog actualities gives way to the doorway into a world of digital potentialities. . . . But it would be false to set up the different aspects of photography, digital or analog, in complete and total opposition. . . . It's a case of both/and and either/or. All strategies are open to deploy-

32. See, e.g., *The Future Looms*, a joint venture between the British organizations Pavilion and the IRIS Women's Photography Project at Staffordshire University, England: http://adac.artec.org.uk/futurelooms/info.htm.

ment. Photography both affirms gravity and gravitates around immateriality. As for its relationship to the real, and to truth, it is as relativistic, and can be as pragmatic, as those current discourses which have replaced philosophy as the guide to artistic practice.[33]

Ascott's statement is not unrelated to my opening remarks regarding the paradoxical nature of photographs and what Barthes intriguingly reflected upon in *Camera Lucida*. The key point is that at present a remarkable base of image/meaning potentialities exists as a means of resisting complacency over the economically driven sector of Internet commerce by the sensitive dispersal of interventionist Web sites.

In current interdisciplinary discourse, one has serious cause to wrestle with the meaning of photographs in light of connoisseurship, museum politics, cultural constraints, and the fluctuating valuations attached to photographs by auction houses and art dealers. Indeed, the intriguing accumulation of images that comprises the collection at St. Lawrence University reflects the way photography has been valued and collected in the past with modernist attention to aesthetic and documentary qualities believed essential to the nature of the medium. If one is to understand the potential of the collection, the arbitrary categories that hinder one's ability to locate associative meanings below the surface of labels and names must be penetrated. St. Lawrence must work hard to maintain a vital intellectual currency in its strategic position of having a growing "permanent" collection that can be continuously tapped to augment the goals of learning.

GARY D. SAMPSON

33. Roy Ascott, "Photography at the Interface," in Timothy Druckery, ed., *Electronic Culture: Technology and Visual Representation* (New York: Aperture, 1996), 170.

Beyond the Ordinary

MY FIRST UNDERSTANDING that there were dimensions of experience which lay outside ordinary life and the apparently flat documentary plane of the photographic print was inspired by *The Flame of Recognition*, published in 1958. This issue of *Aperture* was a tribute to Edward Weston, who had died in 1957.

What appeared at first to be simple portraits or images of seemingly banal subjects like a picket fence or an outdoor toilet unexpectedly evoked at times transcendent levels of experience. Through Weston's mastery, the photographs that initially seemed evidential transformed into metaphor while never losing their essence.

When subject, photographer, and viewer come together through the interactions of intellect, emotion, intuition, and the senses, new potentials become apparent.

Many questions came to mind during the first few days as a freshman at St. Lawrence in the fall of 1960. Most of all, how would it be possible to find pathways to further these intimations of significance in what at first appeared to be an unlikely ground for such an exploration?

I had met Minor White at a photography workshop in Denver, Colorado, a few months before, and the establishment of the SLU Photo Service seemed a way that his inspired teaching might be continued. A few months of living with J. Calvin Keene, chair of the department of religion, and the classes of Donald Munson in music, Alfred Romer in physics (an impossible subject for me that he made comprehensible and connected to my own interest in the liberal arts), and Frank Curtin in English literature (I was blessed to have him as my advisor), to name a few influences, furthered and supported the opening of doors of perception so essential to this exploration.

President W. Eugene Bewkes, in his great wisdom knew, better than anyone could have hoped, the need to support such endeavors. He brought Minor White to campus, and he sent several students to Ansel Adams' workshop on the west coast to return with further benefits to the University community.

Photography became an "open sesame" and a way to test and reflect on the vital interconnections of what at first seemed disparate coursework where geology and physics became relevant to my major in English and my interest in religion and music—thus further developing and enhancing the necessary sign posts and information essential to an inner journey.

Later, the disciplines of each area of study would provide the skills necessary to develop projects and programs at Aperture that would eventually affect and reach a worldwide audience.

I believe that St. Lawrence during my four years provided qualities and opportunities that were uniquely suited to my interests. My recent visit in 1999 was a moving and affirming experience. It was clear from interactions with teachers and staff and through the inspired and deeply humane leadership of Dan Sullivan and Tom Coburn that this tradition and the opportunities and sense of potential that I experienced in the '60s continue and have been enhanced in many remarkable ways.

MICHAEL E. HOFFMAN

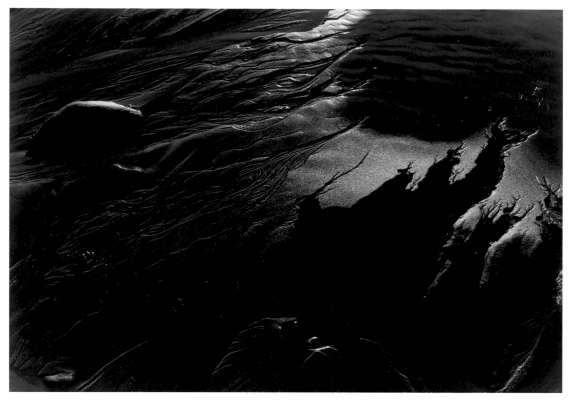

Fig. 17. PAUL CAPONIGRO, *Eroded Sand, Revere Beach, Massachusetts*

Fig. 18. MARK KLETT, *Tea Break at Teapot Rock, after O'Sullivan, Green River, Wyoming*

A Universe in a Fruit Bowl

I NEVER INTENDED to become a photographer, rather the career seemed to choose me. I was a still a freshman at St. Lawrence when I discovered how much I liked using a camera, but there were no photography classes at the University then, so I knew that cultivating my interest wouldn't rest with academia. Luckily for me, the faculty supported independent research, and beyond that there were two important resources available to students. The first was a darkroom with twenty-four-hour access, the second was the University's collection of photographs.

The photo lab was hidden in the basement of Sykes Hall and run by a group of dedicated students who called themselves the "Photo Service." These were science majors like myself, and at the time entirely men, who took pictures for the yearbook and the University's public relations department in exchange for film and paper. I wanted to learn more about printing pictures, so I joined them. We taught each other about techniques, but we needed outside help to expand our ideas. One January, we chipped in money to hire a workshop instructor, and that was the first time I saw the work of a fine art photographer. His name was Paul Caponigro, and the year was 1971.

When I saw Caponigro's prints for the first time, I realized that photographs were not just reproductions of reality, but powerful objects with a life of their own. It was a revelation that a piece of paper could contain not only the likeness of its subject but subtle layers of meaning I had only associated with poetry. This was not something I had understood looking at books; it was a discovery triggered by viewing original photographic prints.

Looking at the surface of a photograph—the details of focus and the rendition of light and tonality—was an experience more participatory than I had expected. I still remember one photograph well, a small dark close-up of an apple, translated by the print to an unexpected meaning. The surface held a shower of light spots as delicate and clear as white stars floating on an almost black background. The subject began with the deep red of the apple's skin, but the result was a celestial transformation, a universe in a fruit bowl. To experience this print was to feel the expression of the photographer as printmaker, and it was as close as I came to grasping the artist's spiritual aspirations. It changed my perspective on the medium.

I was later to see this photograph many times because, to my great joy, I learned that it was part of the University's art collection. This was my introduction to the growing University archive, and it became an important part of my visual education. Although it may seem incredible by today's standards, parts of the collection could be checked out, like library books, and I decided to hang this image in my dorm room where I could study it for an entire year.

At about the same time I borrowed Caponigro's photograph, I discovered that the collection held other wonderful works. Ansel Adams' classic *Moonrise over Hernandez* hung in Dean Eaton Hall with two more of his most famous images. The three prints were grouped near the entrance greeting visitors at a time before fine art auctions had driven the price of these photos to heights previously unheard of. I soon discovered there were other photographs from the collection hanging in unexpected places around campus. The collection included the work of photographers whose reproductions I had only seen in books, and in the North Country, far from museums and the gallery world, the collection was a focus point of great value.

Before I graduated, my perspective on the collection was to change. From a student exhibition, some of my own photographic work was purchased for inclusion in the same archive I was using as a resource. This was the first time my work had been purchased, and I felt the pride of being included in the archive that had helped educate me.

How collections are created is beyond my knowledge, but they transmit something intangible to anyone who shares the passions of their collectors. In a small university like St. Lawrence, it is to the everlasting benefit of students that an art collection is cultivated. For those who benefit from its holdings, the establishment of the collection should be considered an invaluable act of foresight. I learned the contents of a permanent collection are more than trophies in a vault; they are articles which connect generations of artists, linking the past to the present in an unbroken dialogue. The collection invites one to enter not only as viewer but as participant.

Twenty-five years after leaving St. Lawrence, my perspective on education carries the imprint of my undergraduate experience. I work today at one of the nation's largest universities, teaching to some one hundred fifty photography majors enrolled at Arizona State University. It is an environment of incredible resources. Images by the thousands are easily seen in reproduction. Books are bought by the library, slides are stored in a large teaching collection, computers access the World Wide Web, and photographic magazines are everywhere. All of this speaks to a luxury unheard of decades ago. In spite of easy access to the photographic image, the heart of photography at ASU, just as at St. Lawrence years ago, turns on the carefully handled collection of photographic prints—our archive—which students can see and touch, study and contemplate, not just as images, but as artifacts as well.

I see students studying my prints and others in the collection, responding with works of their own, and perhaps eventually finding a place in its history. This is as it should be, for a collection is not a simple pile of papers, precious though the objects may be, but evidence of a shifting conversation, a link between past and present, and a place where viewers become makers.

<div align="right">

Mark C. Klett

</div>

What Is Photography? Exploring the Question in a Liberal Arts Environment

MORE THAN THREE DECADES AGO, I was perhaps foolish to enroll at St. Lawrence, a university that offered no photography courses, even though I had already begun to realize my passion for the medium in high school. In many ways, however, I was lucky that definitions of photography—how to master the craft and interpret images—had not yet been codified and incorporated into a standard structured curriculum like other art and academic disciplines.

It might have been inconvenient for me to commute to Potsdam State ten miles away to take independent study classes from the only photography professor in the region, Steve Sumner, a very generous and encouraging teacher. It certainly was a challenge to support my increasing photography addiction by working in St. Lawrence's Photo Service to market my work to the public relations department and the yearbook. Beyond my art classes, I had difficulty convincing professors of the importance of the medium as a form of communication. I remember disagreeing with a history professor who dismissed photographs as innocuous, passive illustrations for written texts, but still he let me write a term paper on the use of photographs in *Life* magazine to mold popular opinion about World War II. Even then and especially in retrospect, I realized that photography's lack of rigidly established definitions and programs was remarkably liberating because it forced me to explore and discover for myself what photography was and how to use and understand it.

This self-motivated exploration was, of course, far from entirely independent. My education was greatly facilitated by the potential of a liberal arts university that offered significant opportunities outside the established curriculum. St. Lawrence's support of my multidisciplinary study of photography went beyond independent study classes and the Photo Service. More importantly, St. Lawrence professors provided enlightened interjections of inspiration at key points in my college experience, such as bringing in Jerry Uelsmann for an exhibition and lecture, and later Paul Caponigro for a week-long workshop one cold January. I have distinct memories of a small class of eager students hoping to impress Caponigro by getting up before dawn in sub-zero temperatures to drive out to Hermon and DeKalb to photograph the first light on picturesque rural main streets that looked just like Walker Evans' photographs from the 1930s. It was so ridiculously cold that one student, Dean Eppler, thought he was focusing, but discovered he was unscrewing the front element of his expensive frozen lens. At that point, we gave up early morning landscapes to explore the virtues of social documentary by photographing people at the local diner and laundromat—the only buildings open at that early hour.

Mark Klett's contribution to this catalogue notes the pleasure and inspiration of seeing original Ansel Adams photographs from the Permanent Collection displayed on the common room walls of the women's dorm in Dean Eaton. While the fine craft and potential of photography was a great model and inspiration, more important to my education was a huge, multicolored print of a life-sized, full-body x-ray superimposed with an astronomer's chart, a chair, and power tools—an

image that was difficult for me to interpret. Later, I learned more about the meaning of the print, *Booster*, and the significance of its maker, Robert Rauschenberg. However, the work's power for me, thirty years ago and still today, is the mystery of what I don't know or understand rather than what I do know. Most of all, in a far more challenging and perplexing way than the more predictable Ansel Adams photographs, this work seems to ask: *What is photography?*, *What are images?*, and *How do we use pictures to understand our world?*

The formulation of these questions and my initial exploration of them were greatly facilitated by St. Lawrence's diverse photography and art collections and the often unpredictable, unplanned, and even unintentional opportunities offered by the university and its broad liberal arts programs. It is exciting and appropriate that this publication underscores the multiple definitions and uses of photography by including diverse works from the library and archives rather than being limited to the University's defined fine art holdings. It is also, perhaps, an irony rather than an omission that the Rauschenberg print that had so inspired me as an undergraduate is not included in this publication, probably because established art categories (beyond the University) define this lithograph as a print rather than a photograph. This merely reminds us that categories can be useful for providing organization and focus, but they also can be blinding and misleading if followed too narrowly.

Although the St. Lawrence photography collection is more episodic than encyclopedic, this should be considered its strength rather than its weakness. It is far too predictable and obvious to develop a collection by trying to be comprehensive, covering all of the important artists, periods, and styles. The goal of filling in gaps to develop such a collection is a fool's errand, one that would result in all institutions having matching collections that tell the same history. The greater advantage of eccentric collections with different strengths, as exemplified by St. Lawrence's diverse collection, is especially important in a university setting where students can be taught the value of moving from the specific to the general, rather than the reverse.

The greatest challenge for the University in the ongoing development of its photography and other collections is to keep these diverse meanings and uses open. Art classes might concentrate on the craft and expressive content of photographs, but it is equally important that the collection be used by other disciplines in the sciences and humanities. Students can experience and study works of art in diverse ways, whether learning about the subjects depicted or what kind of information one can find in images rather than written texts.

One of the advantages of the historical neglect of photography is that in its perceived lack of "value," the medium had instead greater accessibility, both physically and intellectually, which it might not have now. Currently, the Rauschenberg and Adams prints are considered too valuable to be casually displayed in the corridors of the fine arts building and in the dormitories, but in addition, the way we treat these works as cult objects can lead to a more narrow conception of them as commodities, rather than as images and ideas.

These issues suggest more critical fundamental questions: *How do we understand others and our relationships to them?*, *How do we understand ourselves?*, and ultimately, *Who am I?* Isn't this the meaning and purpose of the Permanent Collection at St. Lawrence University? The photography collection is one of many invaluable resources of a liberal arts program that enables students and others to explore the process of learning and self-understanding.

THOMAS W. SOUTHALL

The Fictions of Collections

WHEN MY NEPHEW WAS BORN last year there were some complications. My sister's contractions were too forceful before her cervix could sufficiently dilate. The infant's forehead became severely bruised as it slammed against his mother's pelvic bones. My entire family was shocked and concerned when we first saw the baby; he had what appeared to be an enormous dark purple potato growing out of his tiny head. The hematoma had no long-term effects and soon disappeared, but its presence had a tremendous impact on our first few weeks with Matthew.

It's now common procedure for hospitals to contract with professional photographers to capture birth portraits moments after the infants are bathed and dressed. A few weeks after her recovery, my sister received the proofs from Matthew's first photo session. The photographer offered options for the new parents: return the proofs and pay for prints of the images, keep the proofs and pay a nominal fee, or return the proofs and pay nothing. I was amazed when nobody in the family wanted to buy a set, let alone keep the proofs. The images were not pleasant, I agreed, but I thought it would be important to salvage this record of what Matthew and his mother had been through and how they had survived. His parents, however, were of the opposite opinion; they seemed to want to forget the trauma and let the image fade into our imperfect memories of the past. Why, after all, would they want to be reminded of the fears they experienced that day?

The new grandfather, my father, also agreed that the images should not be saved, though for a different reason. He didn't ever want Matthew to see those pictures and think that his birth was anything but beautiful and joyous. While I could see how my Dad might want to preserve the romance of an impeccable birth for his grandson, I suspected that there were ulterior motives. My father hates clutter and has been throwing things away ever since I can remember. Regular material donations to charities, the cheapest garage sales in the neighborhood, and the most efficient weekly roundup of the artifacts of our daily lives have kept my childhood home running with a lean simplicity for decades. Of course, my father wouldn't want to save the birth images; he never, after all, liked to let anything collect.

I turned to my father's nemesis, the one who kept him from completely clearing our home of everything that had no immediate, present-day purpose. My mother, for as long as I can remember, has been an avid collector. She has archived every photograph, newspaper clipping, homemade gift, grammar school report card, Halloween costume, and letter from her kids, in addition to hundreds of other obscure objects and mementos that haven't seen the light of day in years. Surely, she would see the value in archiving these interesting images of Matthew's first hours on Earth, regardless of how he looked with his temporary deformity. My mother's collecting spirit, however, was more controlled than I thought; she agreed with the others that we shouldn't keep the unpleasant photographs.

The only other instance of restraint in my mother's urge to preserve the past, as I recall, was two years ago after her first visit back to Cuba since 1961, when she, my father, and brother had left the island. She retrieved some of the effects of her father, who had died many years earlier, and

she introduced me, through photographs, letters, and documents, to the stranger who was my grandfather. I fixated on one object, a photo ID that documented his registration as a member of Cuba's Communist party. I found the card fascinating, as I had grown up hearing how Communism was evil and disgusting and how my parents and many of their friends and family members had to flee its oppressive scourge. To see one of our own, my own flesh and blood, on the other side of such a defining issue actually brought me a sense of relief.

I thought that I was the only one in the family to question the issues that determined their assimilation into middle-class suburbia in the United States. Naturally, I wanted to share the scandal of my Communist grandfather with everyone I knew, but my mother would not take any part in this confrontation with historical fact. The ID disappeared, perhaps destroyed, and only the appropriate artifacts of our family history were publicly displayed. In the case of my family's collection of material culture, always used to define and delimit identity, my nephew's traumatic birth and my grandfather's collusion with Castro were excluded. If no proof existed, these histories could be slowly molded to conform to a family mythology of perfection and unity.

In a sense, all collecting is fundamentally similar, whether institutional, as with St. Lawrence's Permanent Collection, or personal, as in my family's collection of mementos. The human capacity to remember details is limited. Realizing this, most of us hold on to lived experiences more tightly by linking them to physical objects. Institutional art collections, like family photograph albums, use visual images to preserve the past in more tangible and often more lasting forms. The electrochemical reactions our brains use to store data and the oral traditions of passing down histories from one generation to the next are unreliable at best, and absolutely ephemeral at worst.

Fig. 19. GARRY WINOGRAND, *Cape Kennedy, Florida*

Some of us, therefore, collect, and every act of collecting involves editorial decisions, or often out-right censorship, through which we cannot help but construct idealized histories of our imperfect pasts. Every act of inclusion, by extension, has required many acts of exclusion.

St. Lawrence's educational community bears the responsibility to remain constantly self-reflective that collecting is far from objective, self-evident, or inconsequential. Not to criticize my own family, but the St. Lawrence community must be more responsible, thoughtful, and critical administrators of its Permanent Collection than my family has been of its image archives. Exclusions that define collections, often based on arbitrary notions of "quality," "positive repre-sentation," or "historical significance," are the very same exclusions that erase certain events, com-munities, and cultural expressions from history books. Whose cultural expressions will be active-ly preserved and whose will be left to decay? Which histories will be preserved, and which others will fade? How will we remind one another of the infinite diversity of human lives and historical experiences if only a minuscule fraction of its expression is honored (or dishonored, depending on how you look at it), locked away in time capsules?

My favorite television program, *Star Trek: Voyager*, is set in a far future in which these questions are obsolete. In the show, a powerful mainframe computer offers easy control of the *Voyager*'s day-to-day operation and maintains an infinitely large database that records every single cultural arti-fact of every single known humanoid species in the galaxy. Millennia of lived histories, down to the tiniest details, of Humans, Vulcans, Bajorans, Klingons, and countless other civilizations are available at the touch of a fingertip.

Of course, St. Lawrence cannot approach this technological sophistication or this breadth of inclusion in its archives and collections. If it were possible to include absolutely everything in the collection, just like the artifacts of the imaginary United Federation of Planets contained in the *Voyager*'s database, I'm not so sure that I would choose to end physical communion with tangible objects of the past. More importantly, I believe that the act of collecting, of prioritizing the arti-facts of our lives, is a vital and opportune process through which we can view the mechanics of constructing identities and negotiating differences. I saw this clearly when examining how my identity and identifications were forged by my own collecting practices and those of my family's. I hope that St. Lawrence will build and use the Permanent Collection in ways that will remind us that for every story told, there are countless others unspoken.

ELOY J. HERNÁNDEZ

Art Historians and Their Photographs

EVERY DAY OF THEIR working lives, art historians make use of photographs—not those that stem from purely creative activity, as represented by the St. Lawrence University Permanent Collection—but those that are intended as reproductions of artworks. Research photographs, slides, and digitized imagery are indispensable to teaching and scholarship. Nonetheless, the ambivalence art historians often express toward photographic media is striking. A common remark is that art history "is still being taught with the same old photographs," because strained resources, the high costs of reproduction rights, and the unfinished business of museum/ monument photography often limit teachers and students to old and inadequate images. Indeed, it is painful to expose students to artworks through certain slides—the red Caravaggio paintings; the 1920s slide of the Ziggurat at Ur, as gray and grainy as if it had gone through a sandstorm; and the heavily-colored, characterless picture that has taken its place in art survey texts. Can one then complain when students distinguish Gothic cathedrals by memorizing the parked cars in each slide? Is it because such peripheral details are often more interesting than the actual monuments in the way they were recorded on film? Finally, there is the inconvenience of classroom slide projection, a technology that despite its history carries many design flaws to this day. Unfortunately, technical barriers add another level of frustration to the complex preparations involved in teaching art history. In the end, those who should most appreciate photography become jaded and fail to tap its possibilities to the extent that they could.

All of this is ironic in light of photography's centrality to the art historian's enterprise. One scholar writes, "art history is the child of photography," reflecting the fact that the art history of the last century could not have been written without photographic reproductions.[1] In fact, photography came at the end of a series of reproductive print media that were used to document contemporary artistic activity, from works by painters, sculptors, and architects, to those by artisans and ornament designers. The relationship between reproductive engraving and the emerging field of art history goes back to the sixteenth century. By disseminating a wide variety of reproductions, early engravers made possible the comparative study of artworks without journeys to distant places and collections.[2] Thus, from the very beginning, the reproduction was an essential intermediary, linking and at the same time standing between the art historian and the original.

To be sure, art historians' experiences with photography vary according to the media they study. Those who study three-dimensional media have far more choices. Sculpture is a case in point. The legacy of the photo-documentation of sculpture reveals many named and unnamed photographers who shaped contemporary knowledge about the medium, recasting their subjects through the artful manipulation of lighting and lenses and through the selection of backgrounds and contextual information. Indeed, a new field of historiography and photo-criticism has developed regarding the history of sculptural photography. Recent studies have shed light on the interpretive roles of nineteenth- and twentieth-century museum and site photographers, the dominating control of

1. Donald Preziosi, *Rethinking Art History: Meditations on a Coy Science* (New Haven: Yale University Press, 1989), 72.
2. On reproductive printmaking and the developing fields of art history and art theory, see Dorothy Limouze, *Aegidius Sadeler (c. 1570–1629): Drawings, Prints and Art Theory* (Ph.D. diss., Princeton University, 1990).

artists like Rodin and Brancusi over the photography of their work, and political agendas behind the documentation of Roman sculptures and ruins sponsored by Pope Pius IX. More than one study has revisited André Malraux's "Musée Imaginaire," a mid-twentieth-century utopian concept, whereby a collection of art reproductions would become a universally accessible museum. Recent contributions to the history of architectural photography offer parallel examples.[3]

Scholars of prints and drawings, to which group I belong, have other primary concerns connected with the technical limitations of photo-reproduction. The graphic arts might be expected to reproduce well as two-dimensional works on paper (in this regard, closer to photographs than other artistic media). However, the originals lose most of their integrity in translation to black-and-white photographic images, the most common idiom used by museums and collectors. A photograph of a print usually erases subtle surface tones, as well as visual clues regarding paper color, texture, and the presence of watermarks. It can be difficult to determine if the impression were made during an artist's lifetime or from a plate in use for generations afterward. A reproduction also omits valuable information about the drawing's paper support and character of the drawn marks that are key to learning about the creative process and to discerning the artist's identity. Drawings cannot be studied through photographs alone; yet I know of no drawings expert who has not been sent facsimiles or Xeroxes of photographs of drawings, only to be asked to authenticate and attribute the originals with large sums of money hanging on his or her decisions.

As a teacher of art history, and at the same time not a photo-historian, I have found just a few opportunities to use the works of creative photographers in my classes. These have included showing photographs of Spanish religious processions and pilgrims by Cristina García Rodero to my Baroque art class,[4] and working with seminar students as they wrote essays on selected photographic-based media from St. Lawrence University's Permanent Collection for an exhibition examining the representation of the body. In the latter project, works by artists including George Hurrell, Malcom Morley, Peter Philips, Philippe Halsman, and Francis Wu inspired essays that were as much cultural critiques as analyses of images.[5]

In her well-known collection of essays, *On Photography*, Susan Sontag respectively links both the broader possibilities of photography and the naturalistic treatment of the medium with two of its primary inventors, William Henry Fox Talbot and Louis-Jacques-Mandé Daguerre.[6] I would argue that present-day photography of monuments and art objects has stretched the mimetic aspect of the medium to its limit, producing meticulous reproductions, and at the same time cold and anonymous images. While this may be intrinsic to the genre, something is sacrificed: the photographer's aesthetic responses to the subject matter, the very qualities that capture a viewer's imagination. Thus, such reproductions can seem less than photographs because they abandon the del-

3. For example, John Szarkowski, "Photographing Architecture," in Thomas F. Barrow et al., eds., *Reading into Photography* (Albuquerque: University of New Mexico Press, 1982), 13–18; and Julia Ballerini, "The In Visibility of Hadji-Ishmael: Maxime Du Camp's 1850 Photographs of Egypt," in Kathleen Adler and Marcia Pointon, eds., *The Body Imaged. The Human Form and Visual Culture Since the Renaissance* (Cambridge: Cambridge University Press, 1993), 147–160.

4. Cristina García Rodero, *España Oculta: Public Celebrations in Spain, 1974–1989* (Washington, D.C.: Smithsonian Institute Press, 1995).

5. See essays by Martha Feyrer, Eloy J. Hernández, Tricia Martin, Cindy Ondrick, Megan Smith, Bethany Taylor, and Inger Wardour in *According to the Flesh: Images of the Body from the Permanent Collection,* exhib. cat., Richard F. Brush Art Gallery, 5 May–7 June 1993 (Canton, N.Y.: St. Lawrence University, 1993).

6. Susan Sontag, "The Heroism of Vision," in *On Photography*, 6th ed. (New York: Farrar, Straus and Giroux, 1978), 85–112.

icate fusion of "truth-telling" and "beautification," to use Sontag's terms, that is fundamental to the medium.

But teachers are in the business of making converts, and for the purposes of teaching, if not research, there is a tangible need to reunite creative photography and art historical documentation. Liberties have to be taken, and the anecdotal and momentary need to be blended with the monument, in order to present the elusive quality known as "atmosphere" and the vibrant worlds that surround otherwise static monuments. I seek out mid-twentieth-century French post cards of monuments for this very reason, whose photographers so visibly registered their feelings about the subjects. The contexts and uses of monuments should also be revealed.[7] This is at least possible in the photography of nineteenth- and twentieth-century art. Alongside the stark, vacant views of it recognized from survey texts, a Le Corbusier villa should be shown with its original inhabitants and their possessions. At times, the peripheral must be foregrounded in order to convey not just the monument itself, but vital information *about* the monument, a shift that can only help to reflect upon the layered meanings of works of art.

<div align="right">DOROTHY LIMOUZE</div>

7. See Szarkowski, 16.

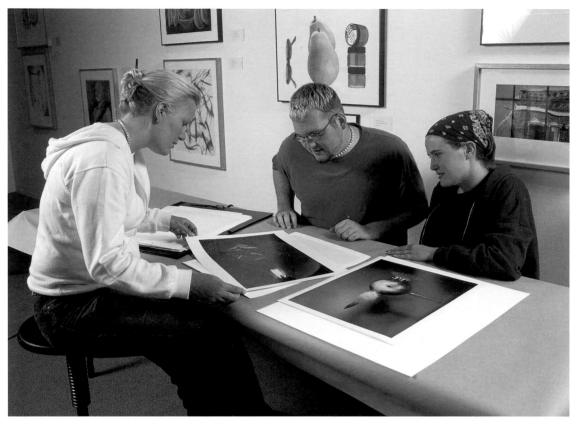

Fig. 20. Linnea Hedman '00, Todd Matte '01, and Kirsha Frye '00 examine photographs by Harold Edgerton.

Photographs in the Curriculum

O N A COOL EVENING this past spring, a dozen students sat in the gallery listening intently to a fellow student's presentation on the contemporary practice of female circumcision in Kenya. The students, from *Cross-Cultural Perspectives of Healing*, a Cultural Encounters class at St. Lawrence, were examining *A Rite of Passage*, a series of fourteen color photographs by Stephanie Welsh. The photographs depict a young woman's ambivalence regarding her impending ceremony. Over the past few semesters, several SLU students have used the photographs in final term papers and oral presentations, giving classes an opportunity to examine the morality and ethics of female circumcision and often leading to a discussion of how appropriate it is to judge the practices of other cultures. The powerful images spark intense debate, according to professors Catherine Shrady and David Hornung. Students often question whether the photographs should be available for viewing and whether the University should own the series. Many students remark that while those depicted certainly gave Welsh permission to be photographed, they could not have foreseen that they would be the focus of discussion at a small liberal arts college in northern New York. Ideally, every class interaction with the collection would be similar, with engaged students making connections between their studies and the artwork on view.

As illustrated above, this essay describes some of the educational uses of the Permanent Collection at St. Lawrence, focusing on photographs in particular. Included are examples in which faculty and students have utilized original photographs, enriching their teaching and learning experiences in tangible ways. There are also challenges in making use of the Permanent Collection, especially concerning access, and I offer an indication of future plans regarding educational outreach efforts. With the director of the gallery, I serve as a link between the University community and the Permanent Collection. In my position as collections manager, my responsibilities include making works from the collection available, either in the classroom or in the gallery, to students and professors, as well supervising the registrarial activities associated with the management, exhibition, and loan of works of art.

The collection has the capacity to be a meaningful component of teaching and learning. In one noteworthy example, students in Faye Serio's advanced photography class were asked to choose several works from the collection to emulate for an exhibition. The results were displayed with the emulated works and ranged from the stop-action photography of Harold Edgerton, though simplified, to surreal imagery created using the manipulated negative techniques of Jerry Uelsmann. The exercise required students to look at photographs in new ways, from analytical, technical, and aesthetic standpoints. In her environmental literature class, English professor Natalia Singer regularly uses Carole Gallagher's portrait, *Robert Carter, Atomic Veteran* (Selections: Plate 12). The photograph is presented with Gallagher's interview of Carter that describes the confusion and fear he felt as a result of government nuclear testing in the late 1950s and its ongoing effects on his emotional and physical well-being. The portrait and accompanying text provide, according to Singer, "moving visual testimony" to Terry Tempest Williams' memoir, *Refuge*, that is assigned for the course.

Presenting works of art to some classes can present challenges. As part of their study of Francophone culture, French-language students examined recently the typically French images of Robert Doisneau and photographs of Morocco by Paul Strand. The Doisneau photographs presented no difficulties for the students, who found them easily accessible, but the Strand images were not so readily grasped. The students viewed his North African landscapes and market scenes and seemed unable to respond to the works' complexity, aesthetically, politically, or in any way. Perhaps they could not see what they did not expect to see. To be sure, something of an aura surrounds the rituals and conventions of presenting artwork in a museum context, one that may leave the viewer speechless because he or she may not know how to "perform." Entering the "vault," the usual lowered voices, and the use of white gloves to handle artwork can create an atmosphere that some may find intimidating at first. When such instances occur, it is important to de-ritualize the viewing experience for students and make sure the artwork is conceptually and contextually integrated into their studies.

In the best-case scenario, digital images from the University's Permanent Collection, readily available on the World Wide Web, will provide access to information about the collection and encourage the study of original works of art. Although we have not yet posted images from the photography collection to the gallery's Web site, smaller projects have made an impact on the curriculum. In 1998, an internal teaching-with-technology grant funded a project to post 58 World War I propaganda posters to the Web in conjunction with a gender studies course. Fifty students selected posters, conducted research, and prepared educational text panels for related exhibitions in the gallery and on-line.[1] The students first viewed original posters in the gallery and could then access digital reproductions from any variety of locations to assist their research. For other courses at St. Lawrence, various works of art from the collection have been posted on our Web site, and we hope to provide electronic access to the photography collection that is described in this catalogue. This fall, we will begin discussions to collaborate with the University Libraries to integrate the gallery's database into their Odysseus on-line catalogue, a step that will establish public access to information about the collection for the first time.

The interaction we have with students often goes beyond presenting works of art in a classroom setting. I have helped students with digital media projects: downloading interesting fonts from the Web and digitizing and editing images for their home pages. Many students ask for guidance in terms of presenting their own artwork using museum standards. Sarah Lott '00, who took an independent study in book arts this year, created a final portfolio of her photographs. Together, we looked at various examples in the collection, noting how the images were presented. Of particular interest were details that can only be gathered by looking at original works—the construction of a portfolio box, the presentation of images in mats, and the wording and layout of a title page, artist's statement, and colophon.

One of the delightful parts of my job is being able to show original works of art to students on an informal, casual basis, often just to share. Sometimes it boils down to, "Hey, look at this," and these unrecorded moments are potentially life-changing, as witnessed in some of the other essays in this publication. I have spent many Friday afternoons with Todd Matte '01 who manages to learn from and find joy in each and every object in the collection. He created a "splash page" for

1. See *From Litho Stone to Pentium Chip: Interpreting Gender in U.S. World War I Posters* at http://www.stlawu.edu/gallery: http/gs103.htm.

the gallery's Web site, and the gallery purchased his artist's book of digital inkjet prints, *Nine Ethafoam Portraits*, for the Permanent Collection. This past spring, I showed Paul Strand prints to Matt Bogosian '03, one of our new student employees who is an ambitious photographer and graphic artist. There was no specific course-related goal to showing him the work other than he had never before seen original photographs by Strand. And Collections Assistant, Denise LaVine '00 spent countless hours on this publication project assisting with the cataloguing of the entire photography collection and digital scanning of over 200 works, and learning valuable professional experience in a museum/gallery context.

Though not insignificant in the larger scale of education, these interactions that are so rewarding define an institution like St. Lawrence. Because of the University's small size and close-knit community, it is possible for gallery visitors to view readily photographs by major photographers of the twentieth century, among other works. Few know to take advantage of the collection, and this publication was created specifically to reach out to students, professors, and independent scholars. We look forward to working with them to develop new and creative ways to utilize the Permanent Collection in the academic mission of St. Lawrence University.

<div align="right">CAROLE MATHEY</div>

The Contest of Privilege

I have come to see white privilege as an invisible package of unearned assets that I can count on cashing in each day, but about which I was "meant" to remain oblivious. White privilege is like an invisible weightless knapsack of special provisions, assurances, tools, maps, guides, codebooks, passports, visas, clothes, compass, emergency gear, and blank checks.[1]

THE CONTEST OF MEANING: Critical Histories of Photography is a seminal text for anyone considering serious contemporary writing on American photography. In his introduction, editor Richard Bolton includes a thoughtful note to his assessment of the collected essays:

> This collection is intended to be provocative rather than exhaustive, and issues and writers that have not been represented will no doubt occur to the reader. There are, for example, no essays on the representation of race. This should be an important part of the argument developed here, but this issue has yet to receive sufficient attention within photography's critical community.[2]

As Bolton's critique in *The Contest of Meaning* and the decade of photographic criticism that followed indicate, the majority of photographic critics, scholars, curators, and artists frequently evades the subject of race and photography in ways that can only be described as *negrophobic*. To date, *Picturing Us: African American Identity in Photography* (1994), a collection of essays edited by Deborah Willis, is the single critical text on photography and race that approaches the subject with intelligence, depth, and theoretical diversity.

My experiences have shown that despite the essential role of race in the United States, the majority of artists, critics, historians, and professors of photography deny, ignore, or underestimate the reality and complexity of race in American life in general and in visual culture specifically. Too often, their positions on race have been based on philosophy and personal opinion, as opposed to serious research that includes scholarship produced by a broad range of African-American perspectives across lines of discipline. While photography is essentially interdisciplinary in practice, theory, and effect, the history of photography and art, queer theory, feminism, formalism, modernism, postmodernism, structuralism, literary criticism, post-structuralism, media studies, science, and technology remain the primary legitimated frameworks for contemporary photographic criticism and production within most cultures of photographic education.

In the decade following the publication of *The Contest of Meaning* in 1989, there was a surge of conservative public policy figures such as Dinesh D'Souza (*The End of Racism*, 1996) proclaiming the insignificance of race in American life at one extreme, and social scientists on the other such as Richard J. Herrnstein and Charles Murray, authors of *The Bell Curve: Intelligence and Class Structure in American Life* (1996), rekindling yet another period of pseudo-science claiming the essential intellectual inferiority of African Americans. In many ways, the tone and quality of

1. Peggy McIntosh, "On the Invisibility of Privilege," *Peacework* (February 1991), 10.
2. Richard Bolton, ed., *The Contest of Meaning: Critical Histories of Photography* (Cambridge: MIT Press, 1989), xvii.

American racial discourse during this time were flavored by these extreme theoretical and public policy positions, many of which were developed in the academy. In this essay, I attribute the scarcity of race in photographic criticism beyond *The Contest of Meaning* to the culture of photographic education specifically and to the academy in general.

In 1990, as a graduate student in photography, I was a member of a captive audience to discussions and analysis of contemporary photography and photographic history that considered the work and ideas of artists, historians, and critics. Many of the artists we discussed were women, gay, transgendered, Latin American, Eastern and Western European, and Japanese. The dominant discussion, however, focused upon artists who were white, American, and male. Beyond a few names mentioned over the course of two years of graduate study, there was no serious consideration of how African-American artists, historians, cultural critics, or the average Black man, woman, or child regarded the photograph—or the politics of race and the photograph in general. I was often the only voice introducing the component of race to the discussion of photography in seminar discussions and studio critiques, often in the company of uninterested, if not hostile white colleagues. After repeatedly exposing this imbalance to my classmates and instructors, I was offered an unexpected and sobering challenge by two of my professors. I was charged to appreciate the fact that I had the opportunity and the responsibility to fill the intellectual void that I identified in the academy and in contemporary photographic discourse. This was, in their view, because my white colleagues could not and would not do it.

The average African-American graduate student in photography is not usually granted this response when confronting the unconscious intellectual racism of the academy. The usual response to the critique of racism by Black students in M.F.A. programs is usually more traumatizing. Commonly, these students are forced, through either outright attacks and/or abandonment by faculty and students, to forsake their critique and the scholarship and common sense that support it. In the face of such intimidation, many Black students, in order to survive the politics of a graduate program and graduate with a degree, become an imitation of their fellow students and professors in their work, speech, personal appearance, and aesthetic values. Why is it so difficult for photography's predominantly white critical community to address the issue of race? The answer first requires a broader examination of American racial discourse.

Social anthropologist Ruth Frankenburg, author of *White Women, Race Matters: The Social Construction of Whiteness*, contends that contemporary discourse concerning race on the part of white Americans and privileged minorities is dominated by "the language of color and power evasion," a discourse based on color-blindness and the myth of meritocracy.[3] Frankenburg identifies a critical part of the equation. The analysis of race in American society generally avoids the role that the absence of dark skin color plays in the structural advantages granted to the majority of white Americans or to many minorities privileged by lighter skin—whether they want those privileges or not.

With the notable exception of African-American athletes and entertainers, few identifiably "Black" Americans, regardless of their class position or economic advantage, attain the invisible status of honorary whiteness. These are the Black people who can not hail taxis, purchase luxury items or real estate, shop retail, drive their cars, or receive a college education without harassment.

3. Ruth Frankenburg, *White Women, Race Matters: The Social Construction of Whiteness* (Minneapolis: University of Minnesota Press, 1993), 15.

Whether unemployed and homeless or armed with advanced degrees and unlimited lines of credit, these sons and daughters of Ham are unable to "pass" and disguise the constructed curse of Blackness under the cover of class status, acceptable ethnicity, or income. As the shooting of African immigrant Amadou Diallo by members of the New York City Police and their subsequent acquittal by a jury trial illustrates, Black people remain the primary and most public targets of discrimination in this country. While the bias is not expressed violently, the culture industry is not immune to this.

The appearance of African Americans in photographs, produced and distributed for public consumption in this country and exported globally, has played a major role in fostering a false sense of knowledge of the African in America, and very often a sense of fear of them as well. Consequently, most Americans, regardless of their region, race, class, gender, or ethnicity, have sadly limited ideas of who African Americans are and what we can be. The daily parade of images presenting African Americans as alternately entertaining, athletic, criminal, sexual, sinful, or saintly has rarely been challenged in either the national or global imagination, least of all by professors, historians, and critics of photography in the academy. When Black artists, working out of African-American aesthetic traditions, experience, and philosophy, use photography to "picture us" and complicate Black identities in ways that challenge and disrupt so-called negative and positive stereotypes of Blackness, the work is often marginalized and critically regarded as exercises in "identity politics" without artistic merit. The racial bias of such appraisals is often expressed in oblique, genteel terms wrapped in the prosaic yet authoritative language of the art historian. In *American Visions: The Epic History of Art in America*, critic Robert Hughes presents readers with an example of this intellectual gatekeeping:

> Identity is one main channel of American cultural anxiety today. (The other is a sense of mediocrity, which "anti-elitist" postures will not alleviate.) . . . Identity says nothing about deep esthetic ordering; such ordering is conscious and existential, and identity is an accident. The multicultural society is certainly an end in itself, in terms of ethical tolerance for others. However, multiculti guarantees absolutely nothing about the merits—the quality, to use a much-disparaged word—of the writing, painting, music, and architecture made in it.[4]

In another recent survey text, *American Photography: A Century of Images*, co-author and *New York Times* photography critic Vicki Goldberg, in discussing what she terms "the new ethnic (self) representation," writes a cautionary note to African-American and Latino photographers who choose to "limit" themselves to Black and Latino subjects. She writes, "Minority photographers can find themselves in photographic ghettos when they are asked to specialize in photographing their own group whether that is their primary interest or not."[5]

The general assumption is that most contemporary white artists are never negotiating identity or race in their work, only art. At the same time, when Black Americans are the subjects of white artists, something else happens. Through a combination of oftentimes unqualified access to the gatekeepers of art, exhibitions, publishing, publicity media, and the imprimatur of white privilege, the work is anointed as culturally vital, and the artists and the work are often exclusively recognized by critics, collectors, and journalists as the preeminent visual interpreters of African-

4. Robert Hughes, *American Visions: The Epic History of Art in America* (New York: Alfred A. Knopf, 1997), 617–618.

5. Vicki Goldberg and Robert Silberman, *American Photography: A Century of Images* (San Francisco: Chronicle Books, 1999), 210.

American culture. The critical attention given to the work of white photographers such as Brian Lanker (*I Dream a World*, 1989), Keith Carter (*Mojo*, 1992), Eugene Richards (*Cocaine True, Cocaine Blue*, 1994), and David Levinthal (*Blackface*, 1999) are prominent examples of this evaluative double standard. At the same time, because the body of whiteness functions as an invisible racial category representing humanity, white artists escape being professionally "ghettoized" for working "exclusively" with "white" subject matter.

In the privileged space of the academy, the evaluation of images across race and class, in the name of personal expression, corporate communication, and/or information, is generally devoid of complexity and a comprehension of racial signifiers and tropes when read by most white artists, historians, and critics of photography. Part of the problem is that most white Americans do not identify themselves or the United States as "raced" and frequently proclaim their colorblindness when looking at non-white people. American photographic criticism, with few exceptions, has been generally consistent in its blindness to the scholarship of African Americans, and others in African-American studies specifically, whose work fundamentally influences the evaluation of American society and more particularly images produced by and about African Americans.

Works by Black scholars, such as legal scholar Patricia J. Williams, cultural critic bell hooks, social historians Robin D.G. Kelley and Noliwe M. Rooks, and American art historians Richard J. Powell and Sharon F. Patton, have no less validity in affecting the way we read images than have, for example, gender studies and French literary criticism over the last ten years. The introduction of whiteness studies by Ruth Frankenburg, Andrew Hacker, and David Roediger has also had little to no impact upon the way that race and whiteness in American photography are discussed by the majority of students, scholars, critics, and curators in American photography since *The Contest of Meaning*. The absence of this scholarship in most contemporary photographic discourse is evidence of what I describe as a contest of privilege within photographic education.

A compelling illustration of this contest occurred over the course of a campus interview I had as a finalist for a tenure-track position at a major American art school. At that point in my career, I had established myself on regional and national levels as an emerging artist, writer, and educator. My visual work attracted critical attention through solo and group exhibitions, publication of my work in exhibition catalogues and anthologies, as well as my first monograph. As a cultural critic, my published reviews and essays concentrated on photography, film, and video produced by and/or about African Americans. Most of my writing was an ongoing critique of the representation of race in American art and media. I presumed that my work had garnered the respect and positive attention of the search committee. I looked forward to meeting them, along with the students and members of the faculty and administration.

The evening before my presentation to students, faculty, and administrators, I was invited to have dinner with a few members of the search committee and a faculty member in the photography department. In this school, there were only two full-time African-American professors of art. I would eventually learn that the search was specifically directed at racially diversifying the faculty and was told by the search committee chair, "We really don't need another faculty member in the department. We do need someone to shake the place up." I was the first of the campus interviews and one of three finalists who amounted to a smorgasbord of "difference." One candidate was Asian, another Native American, and I was the representative Black candidate. The dinner progressed through the normal cycle of exchanging information until one of the committee members suddenly shifted the flow of conversation by commenting, "I think that to be fair to Mr.

Gaskins, as well as to the other candidates, we should discuss the events of the past two weeks here. I, for one, would be interested in his response."

The events she referred to involved a group of senior painting students who, without understanding the implications of their choice, selected an image of a Black "mammy" to announce a reception for their year-end exhibition. The committee member who raised the issue at dinner was an African-American woman. She also happened to be the lone full-time Black faculty member in the painting department, one of three African Americans teaching in the entire school. Subsequent to her bringing the racist implications of the announcement to the attention of the department chair, the department of student life withdrew its customary offering of wine and cheese, which led to the postponement of the opening reception pending an investigation. On the recommendation of this faculty member, the students were required to view a screening of Marlon Riggs' *Ethnic Notions* (1990), a film on the relationship between racial stereotyping and visual images in America, followed by a discussion. The chairperson agreed, and the screening took place.

The students, agitated because of the decision to postpone the opening reception, felt that being made to watch the film amounted to declaring them racists. Without addressing the issues raised in the film, the students asserted that their First Amendment right to free expression was being violated. In their view, this was the issue, *not* racism. Thus, in subtle ways, the female Black professor was regarded as the problem in this situation. It was decided that a closing reception for the exhibition by the painting students would take place. Another flyer for the reception was made with the usual perfunctory information about time, date, place, and nature of the event. But this time, another racially charged statement was added as a trailer: *"Fried chicken and watermelon will be served. Racists don't get to have their wine and cheese."*

I was then asked to respond to the story. Momentarily stunned by the details, I collected myself and began by telling them that I did not think that the students involved were necessarily a group of card-carrying racists. I felt that a major part of the problem was the fundamental contradiction of teaching students to become responsible makers of images without teaching them to be responsible *viewers* of images. There were no required courses in the photography department on photography and race. There were no required courses in African-American studies. "Given what you've just told me, the absence of a required course in race and representation in this school cannot continue," I said. This, I felt, was not only a requirement for addressing the problem that these students exposed, but a requirement for the liberal arts education of all students being trained in art and photography in this country regardless of their race. I also shared with the committee the opinion that the school needed to consult with experts in the areas of race and resistance to institutional change. No one would think of planning a technology initiative without consulting experts. If the institution were truly interested in solving the problem, it would have to acknowledge its lack of experience and skills and make the same commitment to seeking appropriate expertise. I offered names of people who had the tools and experience that the school needed.

The following day, I gave my talk. With the exception of the two Black search committee members and a few Latino students in the room, I was looking at the usual sea of white faces one finds in an art school. A question-and-answer period followed. It did not take long for the actions of the painting students to come up, and the students wanted to know my opinion. I explained the fundamental problem of being in a school where training in art did not include critical discussions of class, gender, *and* race through required classes in the humanities. I offered my credentials and experience in writing and teaching in this area and made it clear that I would want to

teach a course exploring these issues and their impact on the production and viewing of images. Other questions ranged from art to my teaching. Then one of the Latino students unsettled the room by stating, "I believe that you could bring a lot to us if you came here. But I want you to address many of the students in this room who feel that hiring you would be a form of reverse discrimination."

Apparently, I was not the only one in the school besides the committee and administration who knew that the search was nakedly a "diversity" hire and that the search and the candidates were a topic of discussion among the student body. I addressed the comment in a manner that expanded the question of affirmative action beyond the search and the school. "We live in a society that has no problem paying Black men millions of dollars per year to play basketball. At the same time, I don't hear anyone privately or publicly complain that there are too many Black basketball players. At the same time, there are propositions, protests, and debates over paying a relative handful of qualified Black men and women fifty or sixty thousand dollars to be professors of art, history, or science. What's wrong with this picture?" Continuing, I said, "I see a contradiction in this tension over Blacks in the academy which says to me that too many people in this country are more comfortable with Black people who entertain and more uncomfortable with Black people who enlighten and challenge minds. Much of this opposition is coming from colleges and universities where there is an overwhelming white majority proclaiming the declining significance of race. It's the inconsistency of this contradiction that is the real issue in my view."

When the question-and-answer period ended, more than a few students approached me. Most thanked me for my clarity, sincerity, and candor in answering their questions. One student, shaking my hand, told me that he looked forward to seeing me in the fall. I was not so certain. In my meetings with the president and the dean and in my interview with the search committee, I was consistent and insistent in my appeal to realize the need to challenge students and faculty through required coursework in the area of race and visual representation. During the final interview with the committee, the Dean of Faculty asked me an unusual question, "What do you fear most about coming to our school?" My fear, I answered, was that the school would only contain the problems exposed by the painting students as opposed to solving them. My other fear was that the administration would not be sensitive to the potential of separate and unequal experiences I would have with students, faculty, and staff, and to the invisible load I would bear as a Black assistant professor hired under the stigma of a so-called "diversity" hire. There were adjunct faculty members in the department who more than likely would have a problem with a full-time, tenure-track position being offered to an exclusive pool of non-white applicants. During dinner that night, one of the two Black committee members asked me the most important question I heard that day, "Are you sure you want to come here?"

Three months later, I received a letter that one of the other finalists—someone I knew, in fact—was chosen for the position. Consistent with the politics of continuity that govern most diversity initiatives of this kind, "diversity" in this case meant difference in physical appearance, not in thinking. As I recall, the countenance, politics, and point-of-view of the chosen finalist clearly made that person the preferred junior member in the view of the faculty. I remember the person as someone who would not disrupt the social dynamics of the department or ever be charged with disturbing the peace through a discourse on race or a critique of whiteness. Given my experience of the school and its culture, I had to agree.

This story illustrates the contest of privilege taking place daily among the various cultures of

photographic education, history, and criticism in America. I see a contest over, among other things, the unalienable right to censor and omit what many regard as an alien and unwelcome African-American presence. This contest may be invisible to most readers of this essay. It is, however, fortified by decades of equally invisible cultural and intellectual bias, too often disguised as knowledge, aesthetics, taste, professional opinion, academic freedom, and the standards of an unregulated industry called culture. At work here is a sophisticated brand of discrimination obscured by personal and elastic standards of quality that manages, by extension, an invisible quota system. This system, I would thus contend, privileges a small group of African-American artists at the highest levels of American art photography—and no more than that.

The biographical sketches at the end of *The Contest of Meaning* cite the professional affiliations of each contributor. Most are associated with art schools or university departments of art and art history. For the most part, these schools maintain their historical identities as exclusive, privileged, predominantly white, socially conservative, private and public institutions. From my vantage points as a past student and a present professor, I view the art school as a socially predetermined cocoon, segregated by race and class and particularly resistant to efforts to change its intellectual complexion. Through their coursework and faculty, the programs and departments of photography within most American colleges, universities, and schools of art maintain the neglect of race in American photographic criticism that Richard Bolton incisively identified in 1989. Since its entrance into the academy, photographic education has failed in its resistance to examine and critique, as a required component of the curriculum, what historian George M. Fredrickson has called the "Black image in the white mind." In the matter of race and visual representation, it is important to understand that the white mind, in this instance, is not restricted to white *people*.

An examination of current course offerings from departments of photography in major American schools of art, such as the School of the Art Institute of Chicago; California Institute of the Arts; Rhode Island School of Design; Maryland Institute, College of Art; and Yale University, shows no required courses in race and representation. For example, the Master of Fine Arts program at New York's School of Visual Arts, considered one of the leading graduate programs in photography, has a required reading list for applicants. While the list covers a range of disciplines within and beyond photography, not one title listed is authored by an African American.

> I can choose to ignore developments in minority writing and minority activist programs, or disparage them, or learn from them, but in any case, I can find ways to be more or less protected from negative consequences of any of these choices.[6]

We are both spectators and producers in an age of photographs. Images are not innocent documents marked, as they have always been, consciously and unconsciously by racial codes. Consequently, teaching students in and out of photography to read the tropes and signifiers of race can, I believe, provide them with the agency to challenge the limited concepts of whiteness and Blackness that reside in the global imagination and in everyday life. Ideally, this group of students will develop into the next generation of professors, curators, historians, and critics and consequently dismantle the racially biased enterprise of American photography. This transformation will depend upon bold curricular initiatives that include required coursework in race and visual representation and the emergence of leaders within photographic education who have the courage to correct what Martin Luther King, Jr. described as a "moral astigmatism" managing their blind-

6. McIntosh, 10.

ness to the structure of white privilege in general and the ways that privilege is exercised in contemporary American photography and photographic criticism.

> Having described this, what will each of us do to lessen this imbalance of power and privilege? Will we choose to use any of our arbitrarily awarded power to try and reconstruct power systems?[7]

The issue here is not simply expanding the job opportunities of Black artists or the book sales of African-American artists and scholars. The overwhelming majority of white students are negatively affected by race- and class-based homogeneity in the academy. In fact, my mandate as a professor came from the predominately white students I taught as a graduate student in photography at Ohio State University. These were young adults who came into my classrooms for two years from farm towns named Reynoldsburg, Gahanna, and Lima. For many of them, I was the first and perhaps the only Black professor they had at Ohio State. In pursuing a Master of Arts degree, I had no plans to teach beyond graduate school. It was those students who told me both indirectly and directly, "You are a teacher." It was those students who insisted that I consider staying in the academy as a professor. It was those students and their unexpected appeal to me to remain an artist in the academy that would change my mind, and consequently the path of my life.

While the culture of photography commits largely unconscious acts of white privilege that omit and censor a diverse and complex African-American presence, among others, there are also conscious expressions of that privilege by individuals who recognize their possession of it and seek to correct the imbalances such privilege creates. These are the individuals and institutions that perform abolitionist acts in the course of their professional, personal, and political lives. There are a number of people who have acted in such a manner with distinction, presenting alternative models for the production, evaluation, and advancement of contemporary photography, photographic education, and education through photography within the American academy.

In 1972, a group of students and alumni of Syracuse University turned an abandoned campus space into a darkroom facility without departmental affiliation. The Community Darkrooms, as they were called, provided space to anyone in the university community and beyond for the purpose of printing black-and-white and color photographs and slowly grew to include an exhibitions gallery. One year later, Phil Block and Tom Bryan founded and incorporated Light Work. Seven years afterwards, Jeffrey Hoone assumed the position of director that he currently holds. One of Light Work's central components is its collection of over 1700 images donated by artists who have participated in its residency program. The curatorial vision of the collection has managed to avoid an exclusionary, elitist, market-driven connoisseurship. Hoone writes, "I kept this in mind when reviewing proposals for our Artist-In-Residence program, so the handwritten résumés listing cab driver as an occupation made a bigger impression than the neatly composed vitae of tenured professors. When an artist was doing something I didn't understand, it offered up a better reason to check them out than to turn them away."[8]

Representing one of the most progressive centers of photography in the world, the goal of Hoone, his staff, and predecessors at Light Work has been to provide a space for producers and viewers to experience the ways that art can enrich their lives. Light Work has been most successful at the enterprise. This one program has provided countless numbers of artists—from the emerging to the eminent to the obscure—support, insight, challenges, affirmation, inspiration, and most of all a place for their vision.

7. McIntosh, 11.
8. Jeffrey Hoone, "Many Hands: Light Work's First 25 Years," *Contact Sheet* (1997): 13.

In 1990, Cheryl Younger established the American Photography Institute's National Graduate Seminar. For the past ten years, this unprecedented academic and social experiment has been supported by New York University's Tisch School of the Arts. Each year, twenty graduate students in photography from different regions of the United States are invited to spend three weeks in intensive seminars driven by thematic topics presented by a diverse group of artists, scholars, curators, critics, and others in and out of the culture of American photography. The API Seminar is one of the most daring efforts in American photographic education, and each year, its participants are charged by Younger to accept responsibility for the future of photography and education in America.

In 1989, Catherine Tedford began her tenure as Director of the Richard F. Brush Art Gallery at St. Lawrence University. In the curatorial mission that she implements with Collections Manager Carole Mathey, photographs at St. Lawrence University have been identified not only as objects worthy of a serious collection, but as active teaching tools used in an interdisciplinary relationship with other instructors in a number of courses at their rural New York campus. Their efforts over the past decade will have an impact as lasting as this publication.

The photograph is the most democratic means of visual expression and representation in the world. Few academic and cultural institutions have been as committed as they to democratizing the production, evaluation, exhibition, and collection of contemporary photography, and for their uncommonly keen, conscious, and heterogeneous, spiritual, moral, and intellectual agendas. More importantly, they also offer academic cultures of photography challenging strategies for ending the contest of privilege within American photographic education, history, and criticism.

BILL GASKINS

SELECTED WRITINGS BY THE AUTHOR

Good and Bad Hair: Photographs by Bill Gaskins. New Brunswick, N.J.: Rutgers University Press, 1997.

"Gaming at the Whitney," *New Art Examiner* 22, no. 8 (April 1995): 28–31.

"Picturing Us: African-American Identity in Photography," *New Art Examiner* 23, no. 3 (November 1995): 49.

"Photography and the Myopia of Privilege," *Afterimage* 22, no. 2 (September 1992): 15–16.

"Vertical Hold: Racial Politics and Network Television," *Afterimage* 21, no. 6 (January 1995): 11–13.

"What's Wrong with This Picture? Reviewing *Basquiat*," *New Art Examiner* 24, no. 3 (October 1996): 18–21.

ADDITIONAL READINGS

Abramson, Jeffrey. "A Story the Jury Never Heard." *New York Times*, 26 February 2000.

Fredrickson, George M. *The Black Image in the White Mind: The Debate on Afro-American Character and Destiny, 1817–1914.* Hanover, N.H.: Wesleyan University Press, 1971.

hooks, bell. *Black Looks: Race and Representation.* Boston: South End Press, 1992.

Kelley, Robin D.G. *Race Rebels: Culture, Politics, and the Black Working Class.* New York: The Free Press, 1994.

Patton, Sharon F. *African-American Art.* New York: Oxford University Press, 1998.

Powell, Richard J. *Black Art and Culture in the 20th Century.* London: Thames and Hudson, 1997.

Rooks, Noliwe M. *Hair Raising: Beauty, Culture, and African American Women.* New Brunswick, N.J.: Rutgers University Press, 1996.

Williams, Patricia J. *The Rooster's Egg: On the Persistence of Prejudice.* Cambridge: Harvard University Press, 1995.

Willis, Deborah. *Picturing Us: African American Identity in Photography.* New York: The New Press, 1994.

Jewels, Native Fruits, and Ragged Merchandise: Imaging Latin America *by Esther Parada*

Jewels,

Church, Coapiaxtla, 1933
Virgin, San Felipe, Oaxaca, 1933
Women of Santa Ana, Michoacan, 1933
photogravures from *The Mexican Portfolio by* Paul Strand

Paul Strand's *Mexican Portfolio* has been described as "the spiritual jewel of his life's work,"[1] and is indeed a jewel in the St. Lawrence collection. When I visited the Art Institute of Chicago's photography collection to examine their copy of the Strand portfolio, my awareness of its precious status was vividly reinforced: handling the exquisite photogravures included washing my hands, donning white cotton gloves, and divesting myself of ink pens as I prepared to take notes.

There is considerable irony in this ritual approach to the portfolio, since Strand's intent in issuing a selection of his 1930s Mexican images as photogravures (a first edition of 250 in 1940, a second edition of 1000 in 1967) was, at least in part, to make these high quality prints more widely available to the public. But Strand's work is fraught with such contradictions.[2] My initial response to the portfolio was to see it as a quintessential example of the idealized, exoticized Third World "other" — all too familiar in the history of European/North American photography. For example, the distinctness of different regions of the country — Saltillo, Oaxaca, Michoacan, Tenancingo — is subsumed under the rubric of a timeless "Mexico"; the stoic (stern? bitter? dignified?) faces and figures are frontal but anonymous, communicating neither with each other nor the viewer.[3] The settings — cracked adobe walls and wooden doors — give "no trace of the modern era, even so much as a telephone wire, light bulb, or tin can."[4]

Yet Strand as a North American outsider was hardly a disengaged tourist in Mexico. His trip was facilitated by his connection with Carlos Chávez, Chief of the Department of Fine Arts in the Secretariat of Education, and he travelled throughout the country with Chávez's nephew, art teacher Augustine Velásquez Chávez. Strand was subsequently hired by the Mexican Department of Fine Arts to head a film series concerning the country's Indian population. While only one film was completed (*Redes*, released in English as *The Wave*, which focussed on the exploitation and resistance of Veracruz fishermen), it was a significant influence on his structuring of the portfolio. In particular, this was evident in his sensitive sequencing of images, such as the three shown on this page, where the carved Oaxacan Madonna resonates both formally and psychologically with the church portal at Coapiaxtla and the women of Santa Ana. As Katherine Ware, in her perceptive essay *Photographs of Mexico, 1940* underlines, Strand made a lifelong commitment to photographing people "who have strength and dignity in their faces, whatever life has done to them." She cites the heightened sense of redemptive suffering Strand achieved in the portfolio through juxtaposing a Christ pierced by thorns with the furrowed face of a peasant of Tenancingo.[5]

I've chosen to focus on the *Mexican Portfolio* and the complex history of Paul Strand's relationship to Mexico as a way of thinking about the strengths and limitations of the St. Lawrence photography collection vis-à-vis Mexico and Latin America. The other two reproductions on this page show images both *of* and *by* contemporary Mexican women. An obvious gap in the St. Lawrence collection is work by *any* living Mexican photographer, with the significant exception of two portfolios by the acknowledged dean of Mexican photographers, Manuel Alvarez Bravo. Indeed, Graciela Iturbide, whose *Angel Woman* is shown at left below, studied with Alvarez Bravo. But what I would most like to emphasize in the work of Iturbide and Maya Goded on the right is their attention to *hybridity*. In contrast to Strand's women, both women represented in these photographs are part of a particular cultural group.[6] Both are in motion, taking action. And both display an edge of incongruity, because they have chosen to integrate elements (the boombox, the wedding outfit, and cigarette) commonly associated with the modern world, presumably from a different era or class, into their lives.

Angel Woman, 1979, gelatin silver print by Graciela Iturbide

"I always wanted to get married; today after living for twenty years with the father of my children, I will get married." Untitled c. 1992, gelatin silver print from *Black Earth* by Maya Goded [7]

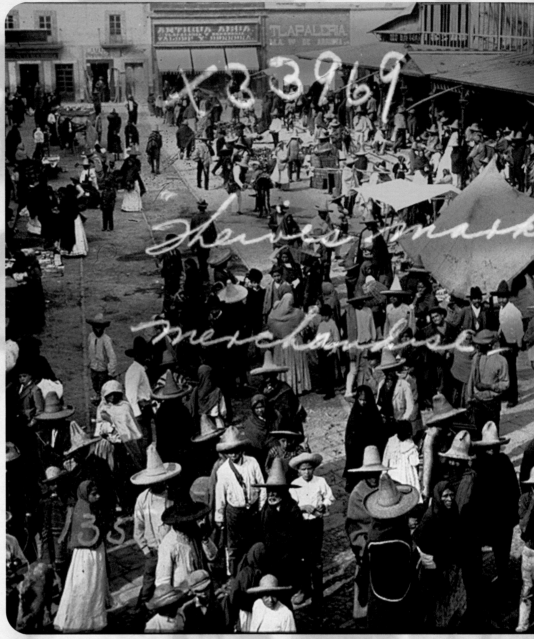

Tarabuco, Bolivia, 1965, gelatin silver print by
Esther Parada

While in no way do I mean to suggest that my stature as a photographer approaches Strand's,
I identify substantially — and was undoubtedly influenced by — his attraction to faces of pathos and
mythic dignity. During my two-year experience as a Peace Corps art teacher in Sucre, Bolivia in
the mid-1960s, it never occurred to me to photograph the mestizo population with whom I lived
and worked. Rather, I was intrigued by the Quechua-speaking indigenous peoples with whom
I could not communicate a word.

Strand and I were but two of a long lineage of North Americans and Europeans who have been
drawn to Mexico and Latin America in a spirit of curiosity, idealism, and spiritual quest.[8] However,
there is a dark side to that connection, manifest in various aspects of U.S. popular culture such
as the 1920s stereograph card seen on this page. This image formed part of the Keystone
Company's educational packages marketed to North Americans as "authoritative and complete,"
whereas in fact they were frequently superficial, Eurocentric, and even outright racist. These
stereographs echoed or reinforced the images often seen in early twentieth-century political
cartoons which depicted Third World natives as infantile, indolent, and irresponsible, or
docile and passive creatures of the "natural" world.[9]

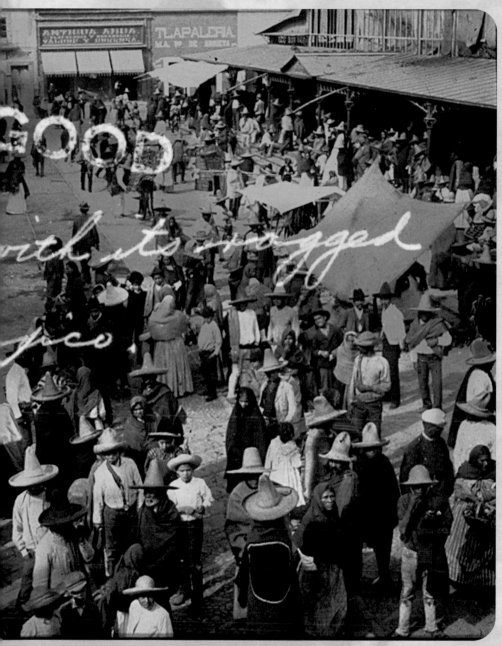

...rchandise, 1996, digital photomontage by Esther Parada[10]

"It was not til the last quarter of the 18th century th

the mortification of failure in the proud reflection th

was that the New World opened wide its golden gate

discovery Italy had lent the patient explorer and Spa

"While lying at anchor in LaCruz (Cuba), Columbus was visited by many natives who manifest

"...who never surrenders, surrendered to her own, thus losing ... could produce the race that could conquer her....Then it ... hemisphereand presently to the continent for whose succor, England brought her contingent of a sturdy race...."

friendly disposition as those whom he first met...and generously supplied the expedition with fruits...."

Native Fruits, 1992/2000,
digital photomontage by Esther Parada[11]

Cuban journalist Gisela Arandia interviews Mexican photographer Manuel Alvarez Bravo during the Third Latin American Photography Colloquium, Havana, Cuba, 1984 (photo by Esther Parada)

Forbidden Fruit, 1976, is one of Alvarez Bravo's best-known images

All of the component images of the digital photomontage *Native Fruits* on the previous page (with the exception of the engraving) were photographed by me in Havana, Cuba, where I attended the First Cuban Photography Colloquium and Exhibition in 1982 and the Third Latin American Photography Colloquium and Exhibition in 1984. Both of these events were momentous steps toward heightened visibility and cultural autonomy in Latin American photographic practice.[12] Although the 1984 Colloquium paid tribute to three venerable "masters" of twentieth-century photography, Alexander Rodchenko of the Soviet Union, Manuel Alvarez Bravo of Mexico, and Martín Chambi of Peru, it also offered a forum for burgeoning talent throughout the hemisphere.

Unfortunately, I have no way of knowing the conversation that took place between Gisela Arandia and Alvarez Bravo that day in 1984 (shown above). Chances are she did not challenge the authority of his work. Nor would I quarrel with the whimsy, magical light, and seductive beauty of his images.[13] But her presence as an interrogating subject is an important element in *Native Fruits*; and her active role at the Colloquium symbolizes for me the challenge faced by anyone — particularly a North American artist or curator — who strives to represent contemporary practices in Latin America.

This essay only begins to assume the important task of identifying work by contemporary Latin American photographers. As a point of departure, I have presented some of my own work which employs digital layering to highlight the constructed nature of historical truths; and I include images by Sharon Lockhart whose documentary strategies honor the complexity of cross-cultural representation. On the opposite page I offer a platform for a variety of voices: scholars, critics, curators, and artists, who challenge boundaries from both North and South. I believe their deep commitment to the nurturing and circulation of multiple visions creates a rich and ongoing dialogical montage.

Woman Combing Her Hair (Retrato de lo eterno), 1932-33, gelatin silver prints by Manuel Alvarez Bravo

Threshold (Umbral), 1947

Ruth Behar: anthropologist; Professor, University of Michigan; MacArthur Fellow

It was in 1983, during the Day of the Dead, that I first came face to face with Esperanza in the town cemetery while I was busy taking photographs. I kept snapping away at the sight of the tombstones people were lavishly decorating with the yellow and orange marigolds known as *zempazúchiles*....She held a bulging bouquet of calla lilies and seemed to me like something out of one of Diego Rivera's epic Indian women canvasses. As I drew closer, I asked if I might take her picture. She looked at me haughtily and asked me, with a brusqueness that I had not encountered before among local women, *why* I wanted to photograph her....I think that many of the contradictions of my work with Esperanza were dramatized in that first encounter. I jumped on her as an alluring image of Mexican womanhood, ready to create my own exotic portrait of her, but the image turned around and spoke back to me, questioning my project and daring me to carry it out.[14]

Pedro Meyer: Mexican photographer; publisher of the electronic journal of photography *ZoneZero*

Corrections [to the limitations of museum and gallery collections] are of much less consequence...than at any time in the past because new technologies have opened up new ways for dealing with past transgressions. To our good fortune we've not had to wait to get some patronizing nod from the "center" in order for our work (at the periphery) to be accepted, seen, distributed, or recognized. We are taking care of that, to a large degree, ourselves. The numbers speak for themselves: for example, at *ZoneZero* we have a daily audience of visitors that rivals attendance at the most important museums in the world and our presentations are always bilingual (English/Spanish). Beyond that, we can bring forth new work and share it with the rest of the world at a speed unparalleled by what the "establishment" presently offers. I might add that, as the technology improves from day to day, our shows are increasingly rich and exciting, offering the viewers expanded multimedia ways of looking and creating relationships with the work at hand. I do not state this in a competitive or arrogant manner, but only because I want to point out specific realities rather than abstract speculations.[15]

Dominic Molon: associate curator, Museum of Contemporary Art, Chicago

The assimilation of postcolonial sensibilities into art theory and practice in the 1990s has resulted in a greater awareness and sensitivity in cross-cultural representation. For example, Sharon Lockhart's recent sequence, *Maria da Conceição Pereira de Souza with the Fruits of the Island of Apeú-Salvador, Pará, Brazil*, resulted from a collaboration between artist and subject, with Lockhart initiating the concept and Maria choosing her own pose and framing the image, reversing the usual dynamic of observer and observed in classic anthropological representation....Physical aspects of her own sexuality underscore the fruitful abundance that Maria displays with each successive fruit, yet the confident directness of her gaze diffuses any erotic objectification of her by the viewer.[16]

Mari Carmen Ramirez: critic; curator, Jack S. Blanton Museum of Art, University of Texas at Austin

The traditional survey model that has dominated the idea of representation of Latin American art since the nineteenth century and, most particularly, since the post-World War II period...is not only naive, but absolutely ineffective to encompass the broad heterogeneity of artistic manifestations originating in a complex region such as Latin America—a region that includes over twenty countries with a wide array of ethnicities, languages, and cultures inside their own borders, where artistic manifestations do not follow a sequential or homogeneous pattern and, for the most part, thrive in relative isolation from each other....To the gap [created by exile and repression] must be added the complicit role played by Latin American elites in the promotion of facile constructions of Latin American identity through art (i.e., the cult of Frida Kahlo) intended for short-term market consumption.[17]

Gerardo Mosquera: Cuban art critic; historian; adjunct curator, New Museum of Contemporary Art, New York

Paradoxically, new critics are questioning old notions of identity just when the issue has become relevant to the West as a result of multiculturalism. From this debate they take and develop a dynamic, relational, multiple, and polymorphic view of identity, making a plausible break with more or less deep-rooted essentialisms that had affected previous discourses to a certain degree. The increase in migratory movement, along with the consolidation of Latin American communities in the United States and of Latin Americans from one country in another, have all contributed to this "liberation of identity." Latin America is a continent of internal and external displacement. This situation has sharpened multiple identities and emphasized frontier cultures. Many artists have centred their work on this. There is widespread enthusiasm for "hybridization," a category that critics have underlined as one of the paradigms with which to interpret contemporary culture in the continent in several directions. The previous concept of *mestizaje*, which was based on ethnocultural identity and for some writers was tainted by an ontological aftertaste, has been replaced by a more dynamic, encompassing, and polymorphic notion that nonetheless also runs the risk of becoming another all-encompassing term with which to blur differences, power relationships, and conflicts of interest.[18]

Maria da Conceição Pereira de Souza with the Fruits of the Island of Apeú-Salvador, Pará, Brazil, 1999, from a sequence of ten chromogenic prints by Sharon Lockhart[19]

 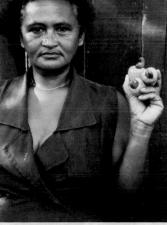 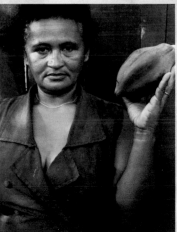

Ajirú *Murici* *Cajú* *Mamão*

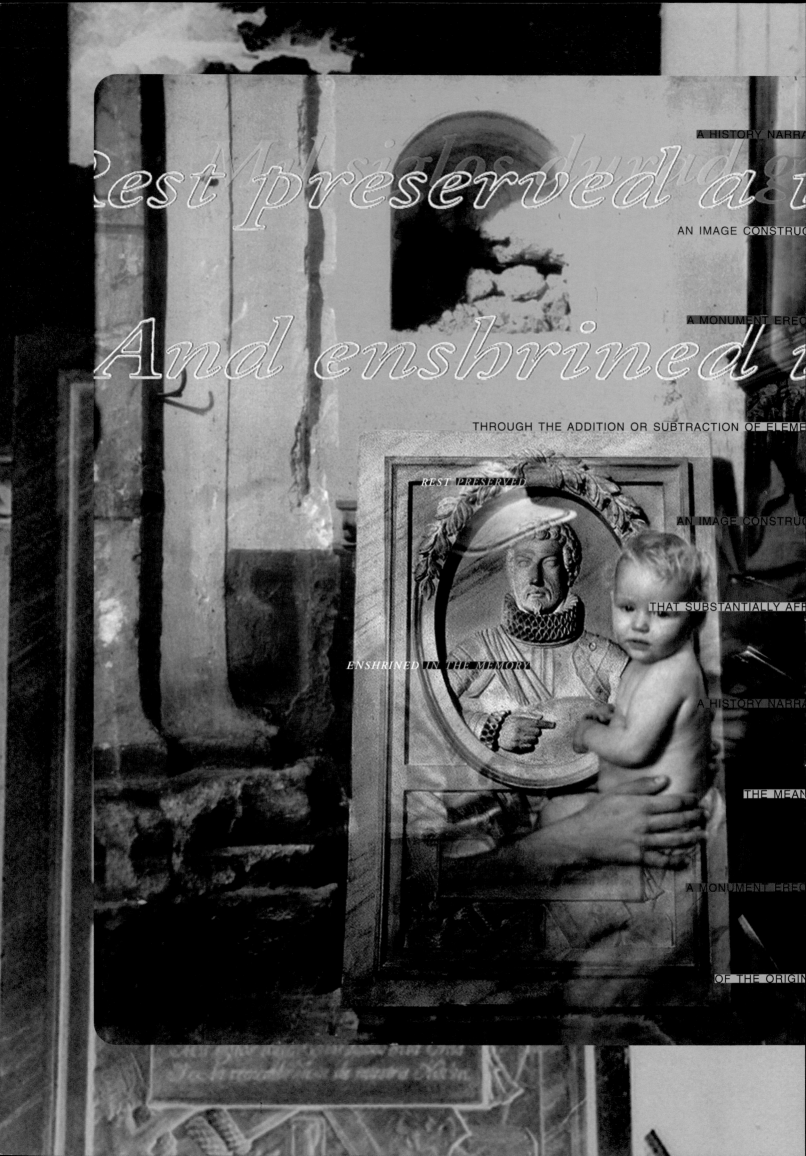

Rest preserved at

And enshrined i

Rest preserved

Enshrined in the memory

A HISTORY NARRA

AN IMAGE CONSTRUC

A MONUMENT EREC

THROUGH THE ADDITION OR SUBTRACTION OF ELEME

AN IMAGE CONSTRUC

THAT SUBSTANTIALLY AFF

A HISTORY NARRA

THE MEAN

A MONUMENT EREC

OF THE ORIGIN

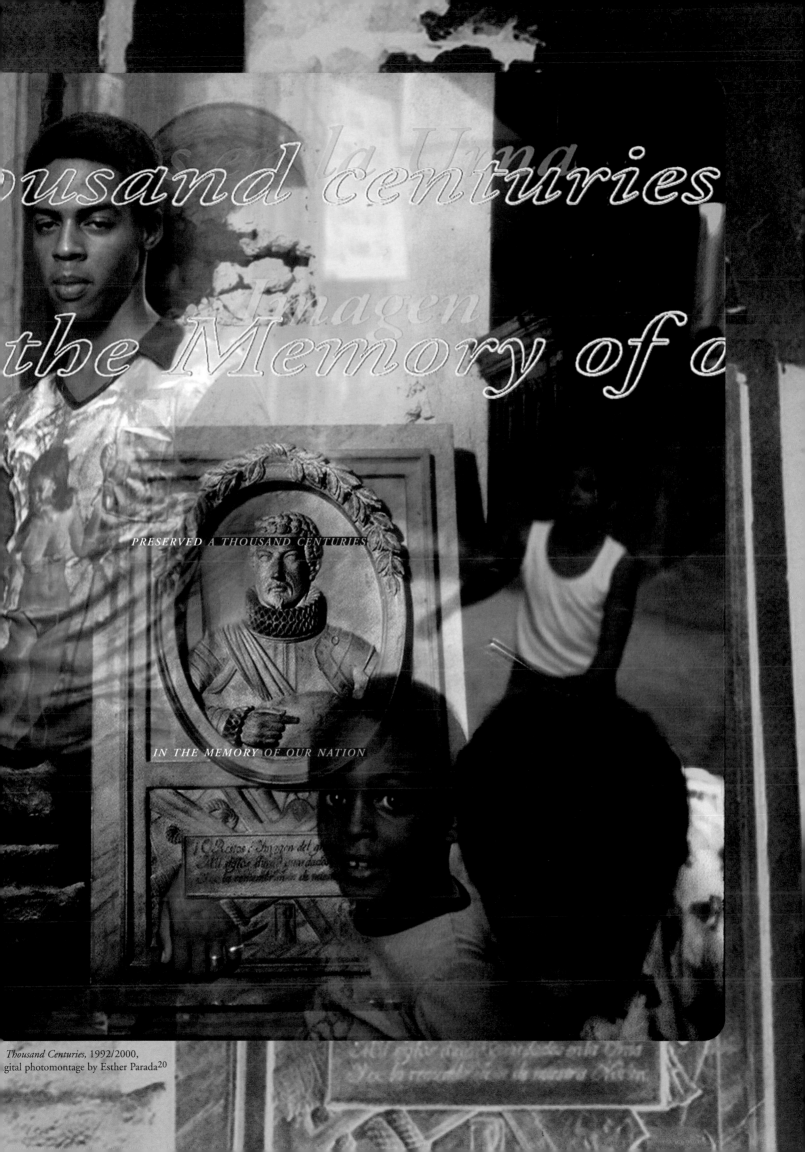

Thousand Centuries, 1992/2000,
digital photomontage by Esther Parada[20]

NOTES

1. Carole Naggar and Fred Ritchin, foreword, *Mexico Through Foreign Eyes, 1850-1990*, (New York: W.W. Norton and Co, 1993) 7.

2. These contradictions are eloquently articulated by Alan Trachtenberg in his introduction to *Paul Strand: Essays on His Life and Work,* edited by Maren Stange (New York: Aperture, 1990) 1-17.

3. Strand used a mechanical subterfuge (a right angle prism) to capture his human subjects unaware. According to Katherine Ware's essay in *Paul Strand: Essays on His Life and Work,* "this may have been the only way to photograph the Tarascans, who were averse to having their picture taken, especially by a foreigner." 119.

4. According to James Oles, quoted in Naggar's essay "The Fascination for the Other," in *Mexico Through Foreign Eyes, 1850-1990*, 47.

5. See Ware's essay "Photographs of Mexico, 1940" in *Paul Strand: Essays on His Life and Work,* 118.

6. Although this image was included in a 1998 exhibition at the Philadelphia Museum of Art called *Images of the Spirit: The Evocative Vision of Graciela Iturbide*, I first saw Iturbide's *Angel Woman* in 1981 as the final image of a book called *Los que Viven en la Arena* (*Those Who Live in the Sand*) about the Seri Indians of northern Mexico, published by INI (Instituto Nacional Indigenista) in Mexico City as part of an ethnographic archive.

7. This image was discovered and downloaded from Goded's *ZoneZero* portfolio (www.zonezero.com). In spite of extensive research, we were not able to obtain a high resolution version of the image.

8. The list of almost fifty European and North American photographers represented in *Mexico: Through Foreign Eyes* includes Marilyn Bridges, Harry Callahan, Henri Cartier-Bresson, Linda Connor, Helen Levitt, Ken Light, Richard Misrach, Tina Modotti, Eadward Muybridge, Paul Outerbridge, Eliot Porter, Aaron Siskind, Rosalind Solomon, Edward Steichen, Arthur Tress, Alex Webb, and Edward Weston.

9. This cartoon, originally published in the *Chicago Tribune* in 1916, is reproduced from *Latin America in Caricature* by John J. Johnson (Austin: University of Texas Press, 1993).

10. "Theives (sic) market with its ragged merchandise" was the handwritten text on the back of this c.1926 stereograph, which I found in the Keystone-Mast Collection at the UCR/California Museum of Photography, University of California, Riverside. For a more detailed analysis of the bias in this archive, see *To Make All Mankind Acquaintances* by Esther Parada, part of *Three Works*, a CD-ROM published by the UCR/California Museum of Photography in 1996.

11. This photomontage combines photographs taken by Esther Parada in Havana, Cuba in 1982 and 1984. The historical engraving and texts are from *Columbus and Columbia: A Pictorial History of the Man and the Nation*, published in 1892 on the occasion of the World's Fair Columbian Exposition in Chicago. The text in white is from James G. Blaine's essay, "Progress and Development of the Western World," on page 48; the text in yellow accompanies the engraving on page 198.

12. See "Eye Opening Debuts in Latin America," in *Time-Life Photography Year 1979*, 74-83; and "Notes on Latin American Photography" by Esther Parada in *Afterimage* (November 1981): 10-16.

13. The two photographs reproduced at the bottom of the page are from the 1977 portfolio *Photographs by Manuel Alvarez Bravo* in St. Lawrence University's Permanent Collection.

14. From Ruth Behar's book *Translated Woman: Crossing the Border with Esperanza's Story* (Boston: Beacon Press, 1993) 4.

15. *ZoneZero* (http://www.zonezero.com) is an internet site dedicated to photography and its journey from the analog to digital world. See also Pedro Meyer's editorial #17 "Do Not Touch" at *ZoneZero* regarding tactility and the digital image.

16. From catalogue notes on Sharon Lockhart's exhibition curated by Dominic Molon at the Museum of Contemporary Art, Chicago, 24 February 2001 through 20 May 2001.

17. From "Constellations: Toward a Radical Questioning of Dominant Curatorial Models," in *Art Journal* 59, no. 1 (spring 2000): 14-16.

18. From the introduction to *Beyond the Fantastic: Contemporary Art Criticism in Latin America*, edited by Gerardo Mosquera (London: Institute of International Visual Arts; Cambridge: MIT Press, 1996) 13-14.

19. The full title for this 10-part sequence by Sharon Lockhart is *Maria da Conceição Pereira de Souza with the Fruits of the Island of Apeú-Salvador, Pará, Brazil: coco, ajirú, murici, cajú, mamão, tucumã, taperebá, goiaba, tamarino, graviola.* The chromogenic prints were created in 1999 in an edition of 6 and measure 17.5 x 203 inches overall (framed).

20. This photomontage combines a photograph taken by Esther Parada in Havana, Cuba, 1984, with an historical stereograph from the Keystone-Mast Collection. These are interwoven with two radically different texts: the definition of photo-composite as "an image constructed through the addition or subtraction of elements that substantially affect the meaning of the original," from "Proposed Standards for Photographic Reproduction in the Press," developed by the NYU/ITP Program on Copyright & the New Technologies Committee in 1992; and the inscription from Columbus's Havana tomb depicted in the stereograph, "O Remains and Countenance of Great Columbus/Rest preserved a thousand centuries in this Urn/And enshrined in the Memory of our Nation."

Photographs from the Permanent Collection
An Illustrated Checklist

Photographs from St. Lawrence University's Permanent Collection are listed alphabetically by artist's surname and then chronologically. Dated photographs precede photographs whose dates are unknown, and photographic portfolios follow individual works. Dimensions are listed in inches, height by width, and both image sizes and paper sizes are noted. A symbol (§) after an accession number indicates that the photograph is reproduced in the catalogue.

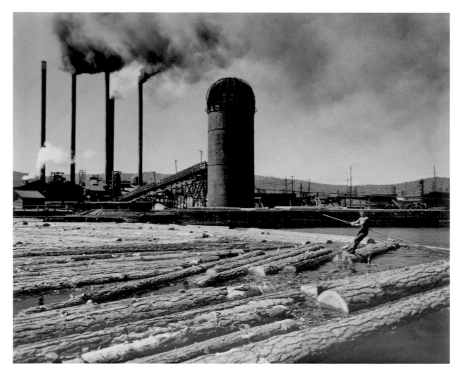

BERENICE ABBOTT, *Westwood, California*

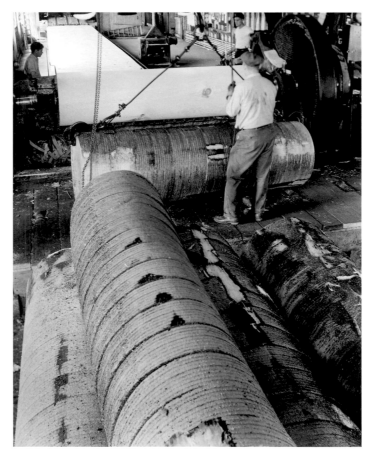

BERENICE ABBOTT, Untitled (Man Rolling Paper)

BERENICE ABBOTT
Landscape at Sea, n.d.
Gelatin silver print
Image: 13⅞ x 16½
Paper: 13⅞ x 16⅞
Gift of Albert Vaiser, M.D. through the
Martin S. Ackerman Foundation
85.87

BERENICE ABBOTT
Westwood, California, n.d.
Gelatin silver print
Image/Paper: 13⁷⁄₁₆ x 16¹¹⁄₁₆
Gift of Albert Vaiser, M.D. through the
Martin S. Ackerman Foundation
85.88 §

BERENICE ABBOTT
Untitled (Log Train), n.d.
Gelatin silver print
Image: 15¹³⁄₁₆ x 17⁵⁄₁₆
Paper: 15¹³⁄₁₆ x 18⅛
Gift of Albert Vaiser, M.D. through the
Martin S. Ackerman Foundation
85.89

BERENICE ABBOTT
Grass Roots, n.d.
Gelatin silver print
Image/Paper: 19¼ x 15⅛
Gift of Albert Vaiser, M.D. through the
Martin S. Ackerman Foundation
85.90

BERENICE ABBOTT
Untitled (Man Rolling Paper), n.d.
Gelatin silver print
Image: 19⅜ x 15⅝
Paper: 19⅞ x 15⅞
Gift of Albert Vaiser, M.D. through the
Martin S. Ackerman Foundation
85.91 §

ANSEL EASTON ADAMS
Moonrise, Hernandez, New Mexico,
1941
Gelatin silver print
Image/Paper: 15³⁄₁₆ x 19¼
University purchase through Michael E.
Hoffman '64
66.33 § *(Plate 1)*

ANSEL EASTON ADAMS
*Mount Williamson, Sierra Nevada,
California*, 1944
Gelatin silver print
Image/Paper: 15⅛ x 18³⁄₁₆
Gift of the artist through Michael E.
Hoffman '64
66.34 §

ADRIANNE ALLGEIER '75
Untitled (Light through Window), n.d.

Gelatin silver print
Image: 5½ x 4⁵⁄₁₆
Paper: 10 x 8
University purchase
75.23.8

MANUEL ALVAREZ BRAVO
*15 Photographs by Manuel Alvarez
Bravo* (New York: The Double
Elephant Press, 1974)
Portfolio of 13 out of 15 gelatin silver prints,
ed. 28/75
Gift of Donald T. Johnson '61
79.465

Optical Parable (*Parábolá óptica*), 1931
Image/Paper: 9⅜ x 7⅛
79.465.1 §

The Sympathetic Nervous System (*El
sistema nervioso del gran simpático*),
1929
Image/Paper: 9½ x 7⁹⁄₁₆
79.465.2

The Eclipse (*El Eclipse*), n.d.
Image/Paper: 11¹⁵⁄₁₆ x 14⁵⁄₁₆
79.465.3

The Daydream (*El ensueño*), 1931
Image/Paper: 9¼ x 7¹⁄₁₆
79.465.4

Somewhat Gay and Useful (*Un poco
alegre y graciosa*), 1942
Image/Paper: 6¹³⁄₁₆ x 9
79.465.5

The Kiln (*La quema*), n.d.
Image/Paper: 6⁷⁄₁₆ x 9⅜
79.465.6

She of the Fine Arts (*La de las Bellas
Artes*), 1933
Image/Paper: 7⅜ x 9½
79.465.7

Set Trap (*Trampa puesta*), 1930s
Image/Paper: 6¾ x 9½
79.465.8

The Crouched Ones (*Los agachados*),
1934
Image/Paper: 7¼ x 9½
79.465.9 §

The Bard of the Pantheon (*Barda de
Panteon*), n.d.
Image/Paper: 9½ x 7³⁄₁₆
79.465.10

Striking Worker, Assassinated (*Obrero
en huelga, asesinado*), 1934
Image/Paper: 7⅜ x 9⅝
79.465.11 §

Recent Grave (*Tumba reciente*), 1933
Image/Paper: 6¾ x 9¹¹⁄₁₆
79.465.12

Invented Landscape (*Paisaje inventado*),
n.d.
Image/Paper: 7⁵⁄₁₆ x 9⁷⁄₁₆
79.465.13 § *(Fig. 12)*

MANUEL ALVAREZ BRAVO
Photographs by Manuel Alvarez Bravo
(Geneva, Switzerland: Acorn Editions
Limited, 1977)
Portfolio of 15 gelatin silver prints, ed.
42/100
Gift of Mr. and Mrs. John H. Gornell '62
80.58/82.9

Sand and Small Pines (*Arena y pinitos*),
1920s
Image: 6⅝ x 9⁷⁄₁₆
Paper: 8 x 10
80.58.1

Growing Landscape (*Paisaje de
siembras*), 1972–74
Image: 7⅛ x 9½
Paper: 7¹⁵⁄₁₆ x 10
80.58.2

Votive Offering (*Votos*), 1969
Image: 7³⁄₁₆ x 9⁹⁄₁₆
Paper: 7¹⁵⁄₁₆ x 9⁹⁄₁₆
80.58.3

Lengthened Light (*Luz restirada*), 1944
Image: 6¹³⁄₁₆ x 9½
Paper: 7¹⁵⁄₁₆ x 10
80.58.4

*Two Women, a Large Blind, and
Shadows* (*Dos mujeres y la gran cortina
con sombras*), 1977
Image: 7¼ x 9½
Paper: 7¹⁵⁄₁₆ x 10
80.58.5

First Act (*Acto primero*), 1975
Image: 7¹⁄₁₆ x 9⁷⁄₁₆
Paper: 7¹⁵⁄₁₆ x 10
80.58.6

Box of Visions (*Caja de visiones*), 1930s
Image: 7½ x 9¼
Paper: 8 x 10
80.58.7

The Man from Papantla (*Señor de
Papantla*), 1934–35
Image: 9⁵⁄₁₆ x 7¼
Paper: 10 x 7¹⁵⁄₁₆
80.58.8 §

Sleeping Dogs Bark (*Los perros dur-
miendo ladran*), 1966
Image: 9 x 7½

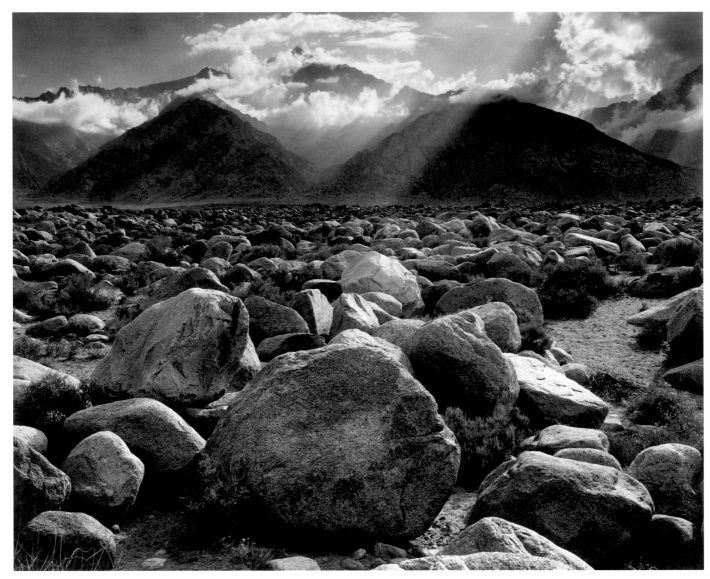

ANSEL EASTON ADAMS, *Mount Williamson, Sierra Nevada, California*

MANUEL ALVAREZ BRAVO, *The Crouched Ones* (*Los agachados*)

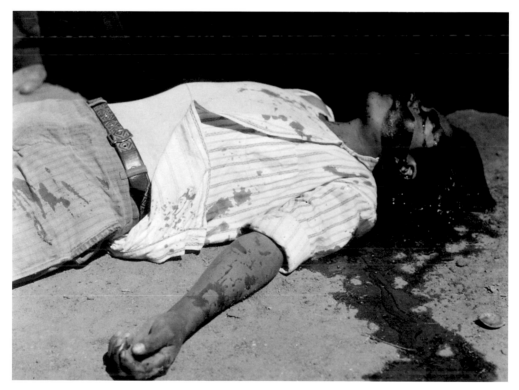

MANUEL ALVAREZ BRAVO, *Striking Worker, Assassinated* (*Obrero en huelga, asesinado*)

MANUEL ALVAREZ BRAVO, *Optical Parable* (*Parábolá óptica*)

MANUEL ALVAREZ BRAVO, *The Man from Papantla* (*Señor de Papantla*)

MANUEL ALVAREZ BRAVO, *Sleeping Dogs Bark* (*Los perros durmiendo ladran*)

MANUEL ALVAREZ BRAVO, *". . . A Fish Called Saw"* (*". . . Un pez que llaman Sierra"*)

Paper: 9^{15}/$_{16}$ x 7^{15}/$_{16}$
82.9.1 §

Two Pairs of Legs (*Dos pares de piernas*), 1928–29
Image: 9^{3}/$_{16}$ x 7^{3}/$_{16}$
Paper: 10 x 7^{15}/$_{16}$
82.9.2 § (*Plate 2*)

"… A Fish Called Saw" ("*… Un pez que llaman Sierra*"), 1942
Image: 9^{7}/$_{16}$ x 6^{7}/$_{8}$
Paper: 9^{15}/$_{16}$ x 7^{15}/$_{16}$
82.9.3 §

Almost (*Ya mero*), 1968
Image: 7^{3}/$_{8}$ x 9^{3}/$_{8}$
Paper: 7^{15}/$_{16}$ x 10
82.9.4

Skylight (*Gorrión, claro*), 1938–40
Image: 7^{3}/$_{16}$ x 9^{7}/$_{16}$
Paper: 7^{15}/$_{16}$ x 10
82.9.5

Threshold (*Umbral*), 1947
Image: 9^{1}/$_{2}$ x 7^{5}/$_{8}$
Paper: 9^{15}/$_{16}$ x 7^{15}/$_{16}$
82.9.6

Woman Combing Her Hair (*Retrato de lo eterno*), 1932–33
Image: 9^{3}/$_{8}$ x 7^{7}/$_{16}$
Paper: 10 x 7^{15}/$_{16}$
82.9.7

LESLIE ARAKELIAN '74
One Path, n.d.
Gelatin silver print
Image/Paper: 6^{1}/$_{8}$ x 8^{9}/$_{16}$
University purchase
74.48.7

LORETTA AYEROFF
Camp Pendleton, 1975
Gelatin silver print
Image: 5^{7}/$_{8}$ x 8^{3}/$_{4}$
Paper: 10^{5}/$_{8}$ x 13^{7}/$_{8}$
Gift of Richard Amerault
92.22.3

JOHN BALDESSARI
Black Dice (New York: Peter Blum Edition, November 1982)
Portfolio of 1 photograph and 9 color etchings, ed. 13/35
University purchase
83.16 §

Black Dice
Gelatin silver print
Image: 6^{15}/$_{16}$ x 8^{7}/$_{16}$
Paper: 8^{1}/$_{16}$ x 9^{3}/$_{16}$
83.16.1 §

LEWIS BALTZ
San Quentin Point: Selections (New York: Hyperion Press, 1985)
Portfolio of 25 untitled gelatin silver prints, ed. 5/35
Gift of Donald T. Johnson '61
85.289/86.13

Untitled element #1 (Deserted Lot), 1982–83
Image: 7^{3}/$_{8}$ x 9
Paper: 7^{15}/$_{16}$ x 9^{15}/$_{16}$
85.289.1

Untitled element #2 (Bulldozed Debris and Brush Pile), 1982–83
Image: 7^{3}/$_{8}$ x 9
Paper: 7^{15}/$_{16}$ x 9^{15}/$_{16}$
85.289.2

Untitled element #3 (Debris and Brush near Water), 1982–83
Image: 7^{3}/$_{8}$ x 9
Paper: 7^{15}/$_{16}$ x 9^{15}/$_{16}$
85.289.3 §

Untitled element #4 (Concrete Debris and Weeds at Water's Edge), 1982–83
Image: 7^{3}/$_{8}$ x 9
Paper: 7^{15}/$_{16}$ x 9^{15}/$_{16}$
85.289.4

Untitled element #5 (Wire Mass in Weeds), 1982–83
Image: 7^{3}/$_{8}$ x 9
Paper: 7^{15}/$_{16}$ x 9^{15}/$_{16}$
85.289.5

Untitled element #6 (Structure Overgrown with Moss), 1982–83
Image: 7^{3}/$_{8}$ x 9
Paper: 7^{15}/$_{16}$ x 9^{15}/$_{16}$
85.289.6 §

Untitled element #7 (Construction Debris in Weeds), 1982–83
Image: 7^{3}/$_{8}$ x 9
Paper: 7^{15}/$_{16}$ x 9^{15}/$_{16}$
85.289.7

Untitled element #8 (Rocks), 1982–83
Image: 7^{3}/$_{8}$ x 9
Paper: 7^{15}/$_{16}$ x 9^{15}/$_{16}$
85.289.8

Untitled element #9 (Debris against Rock Wall), 1982–83
Image: 7^{3}/$_{8}$ x 9
Paper: 7^{15}/$_{16}$ x 9^{15}/$_{16}$
85.289.9 §

Untitled element #10 (Broken Glass on Rock), 1982–83
Image: 7^{3}/$_{8}$ x 9

Paper: 7^{15}/$_{16}$ x 9^{15}/$_{16}$
85.289.10

Untitled element #11 (Rags on Dirt Path), 1982–83
Image: 7^{3}/$_{8}$ x 9
Paper: 7^{15}/$_{16}$ x 9^{15}/$_{16}$
85.289.11

Untitled element #12 (Animal Tracks and Rocks in Mud), 1982–83
Image: 7^{3}/$_{8}$ x 9
Paper: 7^{15}/$_{16}$ x 9^{15}/$_{16}$
85.289.12

Untitled element #13 (Animal and Human Tracks in Mud), 1982–83
Image: 7^{3}/$_{8}$ x 9
Paper: 7^{15}/$_{16}$ x 9^{15}/$_{16}$
85.289.13

Untitled element #14 (Cracked Mud, Heaved Earth), 1982–83
Image: 7^{3}/$_{8}$ x 9
Paper: 7^{15}/$_{16}$ x 9^{15}/$_{16}$
85.289.14

Untitled element #15 (Paper Bag and Debris), 1982–83
Image: 7^{3}/$_{8}$ x 9
Paper: 7^{15}/$_{16}$ x 9^{15}/$_{16}$
86.13.1

Untitled element #16 (Dried Stalks in Mud Flat), 1982–83
Image: 7^{3}/$_{8}$ x 9
Paper: 7^{15}/$_{16}$ x 9^{15}/$_{16}$
86.13.2

Untitled element #17 (Industrial Waste), 1982–83
Image: 7^{3}/$_{8}$ x 9
Paper: 7^{15}/$_{16}$ x 9^{15}/$_{16}$
86.13.3

Untitled element #18 (Concrete Pipe Fragments and Wire), 1982–83
Image: 7^{3}/$_{8}$ x 9
Paper: 7^{15}/$_{16}$ x 9^{15}/$_{16}$
86.13.4

Untitled element #19 (Dried Stalk), 1982–83
Image: 7^{3}/$_{8}$ x 9
Paper: 7^{15}/$_{16}$ x 9^{15}/$_{16}$
86.13.5

Untitled element #20 (Rag on Gravel), 1982–83
Image: 7^{3}/$_{8}$ x 9
Paper: 7^{15}/$_{16}$ x 9^{15}/$_{16}$
86.13.6 § (*Plate 3*)

Untitled element #21 (Flooring Scraps on Mud Flat), 1982–83
Image: 7^{3}/$_{8}$ x 9
Paper: 7^{15}/$_{16}$ x 9^{15}/$_{16}$
86.13.7 §

BLACK DICE formerly No Orchids For Miss Blandish starring Jack La Rue, Linden Travers and Hugh McDermott.

52/472

JOHN BALDESSARI, *Black Dice*

Untitled element #22 (Deserted Industrial Site by Road), 1982–83
Image: 7⅜ x 9
Paper: 7¹⁵⁄₁₆ x 9¹⁵⁄₁₆
86.13.8

Untitled element #23 (Muddy Vegetation), 1982–83
Image: 7⅜ x 9
Paper: 7¹⁵⁄₁₆ x 9¹⁵⁄₁₆
86.13.9

Untitled element #24 (Nail Cluster in Branches), 1982–83
Image: 7⅜ x 9
Paper: 7¹⁵⁄₁₆ x 9¹⁵⁄₁₆
86.13.10 §

Untitled element #25 (Shredded Carpet and Wire), 1982–83

Image: 7⅜ x 9
Paper: 7¹⁵⁄₁₆ x 9¹⁵⁄₁₆
86.13.11

HENRY W. BARKER
January Dusk, n.d.
Chlorobromide print
Image/Paper: 13¹⁵⁄₁₆ x 10⁹⁄₁₆
Gift of Arthur S. and Katherine Holt Mawhinney through Doris M. Offermann '34
65.1.54

HENRY W. BARKER
Rural Rhythm, n.d.
Gelatin silver print
Image/Paper: 16¹⁵⁄₁₆ x 13⁷⁄₁₆
Gift of Arthur S. and Katherine Holt Mawhinney through Doris M.

Offermann '34
65.1.54a §

ANTOINE F. BAUMANN
Untitled (Child in Folkloric Dress), c. 1938
Three-color carbro process print
Image/Paper: 8 x 6
Gift of Arthur S. and Katherine Holt Mawhinney through Doris M. Offermann '34
65.1.94

ANTOINE F. BAUMANN
Untitled (Mountain Landscape with Pines), c. 1938
Three-color carbro process print
Image/Paper: 4¾ x 6½
Gift of Arthur S. and Katherine Holt

JOHN BALDESSARI, *Black Dice*

Mawhinney through Doris M.
Offermann '34
65.1.95

JOHN BELZ
San Francisco Peace Rally, 1971
Gelatin silver print (diptych)
Image: 6¼ x 18⅝
Paper: 8 x 19⁵⁄₁₆
Gift of Richard Amerault
92.22.4

GEORGE C. BERTICEVICH
View of Mt. Kailas, Tibet, 1992–1993

Hand-colored gelatin silver print
Image: 6½ diameter
Paper: 10⅞ x 13⅞
Purchased with funds from the Eben
Griffiths '07 Endowment
94.14 §

A. A. BIEBER
St. Paul's, Eastchester, n.d.
Gelatin silver print
Image/Paper: 19 x 15³⁄₁₆
Gift of Arthur S. and Katherine Holt
Mawhinney through Doris M.
Offermann '34
65.1.55

A. A. BIEBER
Giant Lotus, n.d.
Gelatin silver print
Image/Paper: 14⅞ x 18⅝
Gift of Arthur S. and Katherine Holt
Mawhinney through Doris M.
Offermann '34
65.1.56

MICHAEL BISHOP
Untitled (Fenced Area), 1974, from
Tones, 1972–75
Sepia-toned gelatin silver print
Image: 11¾ x 17¹⁵⁄₁₆

LEWIS BALTZ, Untitled element #3 (Debris and Brush near Water)

LEWIS BALTZ, Untitled element #6 (Structure Overgrown with Moss)

LEWIS BALTZ, Untitled element #9 (Debris against Rock Wall)

LEWIS BALTZ, Untitled element #21 (Flooring Scraps on Mud Flat)

LEWIS BALTZ, Untitled element #24 (Nail Cluster in Branches)

Paper: 15⅞ x 19¹⁵⁄₁₆
University purchase
77.110

DIANA BISNETT '97
Tangled Tears, October 1996
Gelatin silver print
Image/Paper: 9½ x 7½
Purchased with funds from the Jeanne
Scribner Cashin Endowment for Fine Arts
established by Thomas H. Cashin '46
97.37

A. AUBREY BODINE
Three Kittens, 1943
Chlorobromide print
Image/Paper: 19¹⁄₁₆ x 15²⁄₁₆
Gift of Doris M. Offermann '34
65.1.74

ROBERT BORSIG
Storm Swept, n.d.
Chlorobromide print from paper negative
Image/Paper: 9¾ x 12⅛
Gift of Arthur S. and Katherine Holt
Mawhinney through Doris M.
Offermann '34
65.1.89

ROBERT BORSIG
Snow, Slush, and Sleet, n.d.
Chlorobromide print
Image/Paper: 16¾ x 13⅞

Gift of Arthur S. and Katherine Holt
Mawhinney through Doris M.
Offermann '34
65.1.113

MARK BOYLE with HANS LOCHER
Journey to the Surface of the Earth
(Stuttgart: Edition Hansjörg Mayer,
1978)
Artists' book with photograph
Gift of Herman Friedman
79.424

Untitled (Microscopic Image), n.d.
Gelatin silver print
Image: 7½ x 8
Paper: 9¼ x 8
79.424.2 §

JOHN BRAILEY
Soap Lesson, RVN, 1970
Chromogenic process color print
Image: 7¾ x 7⁷⁄₁₆
Paper: 9⅞ x 8
Gift of Richard Amerault
92.22.5

PETER W. BRAMLEY '68
Untitled (Arched Windows and
Textured Wall), 1968
Gelatin silver print
Image/Paper: 7⅛ x 7¾
Purchased with funds from the David B.

Steinman Festival of the Arts Endowment
68.3.1

PETER W. BRAMLEY '68
Untitled (Church Door), 1968
Gelatin silver print
Image/Paper: 8¹⁵⁄₁₆ x 7½
Purchased with funds from the David B.
Steinman Festival of the Arts Endowment
68.3.2

ERNESTO BURCIAGA
Colored Only–By Choice of Owner,
1966
Chromogenic process color print
Image: 8¼ x 12⅜
Paper: 10¹⁵⁄₁₆ x 13⅞
Gift of Richard Amerault
92.22.6

ERNESTO BURCIAGA
New York Peace March, 1966
Chromogenic process color print
Image: 8⁵⁄₁₆ x 12½
Paper: 10¹⁵⁄₁₆ x 13¹⁵⁄₁₆
Gift of Richard Amerault
92.22.7 §

REID E. CALLANAN '75
Untitled (Boot Prints in Mud),
c. 1975
Gelatin silver print

HENRY W. BARKER, *Rural Rhythm*

GEORGE C. BERTICEVICH, *View of Mt. Kailas, Tibet*

MARK BOYLE WITH HANS LOCHER, Untitled (Microscopic Image)

Image: 5¾ x 4¹⁄₁₆
Paper: 8⅞ x 7¹⁄₁₆
University purchase
75.23.4

REID E. CALLANAN '75
Untitled (Statues and Building with Cross), c. 1975
Gelatin silver print
Image: 5⁷⁄₁₆ x 7½
Paper: 7¹⁵⁄₁₆ x 9¹⁵⁄₁₆
University purchase
75.23.9

PAUL CAPONIGRO
Stump, Vicinity of Rochester, New York, 1957
Gelatin silver print
Image/Paper: 7⅝ x 9⁹⁄₁₆
University purchase through Michael E. Hoffman '64
67.74§ *(Plate 4)*

PAUL CAPONIGRO
Mushroom–Fungus, c. 1958
Gelatin silver print
Image/Paper: 13½ x 10⅝
University purchase through Michael E. Hoffman '64
67.68

PAUL CAPONIGRO
Eroded Sand, Revere Beach, Massachusetts, 1958

Gelatin silver print
Image/Paper: 13½ x 19¼
University purchase through Michael E. Hoffman '64
67.89 § *(Fig. 17)*

CECIL O. CARLILE
Door Gunner, RVN, 1966

Chromogenic process color print
Image: 7¹⁄₁₆ x 9⁷⁄₁₆
Paper: 7¹⁵⁄₁₆ x 9⅞
Gift of Richard Amerault
92.22.9

CECIL O. CARLILE
1st Infantry Division, Phu Loi, 1966
Chromogenic process color print
Image: 6⅜ x 9⅜
Paper: 7¹⁵⁄₁₆ x 9⅞
Gift of Richard Amerault
92.22.10 §

CECIL O. CARLILE
Kids, RVN, 1966
Chromogenic process color print
Image: 7¹³⁄₁₆ x 11½
Paper: 10⅞ x 13⅞
Gift of Richard Amerault
92.22.11

CECIL O. CARLILE
Troops, RVN, 1966
Chromogenic process color print
Image: 7⅞ x 11¼
Paper: 10⅞ x 13⅞
Gift of Richard Amerault
92.22.12

CECIL O. CARLILE
Result of a V.C. Night Attack, 1967
Chromogenic process color print
Image: 8¹³⁄₁₆ x 12⅞
Paper: 10⅞ x 13⅞
Gift of Richard Amerault
92.22.8 §

ERNESTO BURCIAGA, *New York Peace March*

CECIL O. CARLILE, *1st Infantry Division, Phu Loi*

CECIL O. CARLILE, *Result of a V.C. Night Attack*

WILLARD H. CARR
Ocean Bather #1, 1958
Chlorobromide print
Image/Paper: 16¼ x 10½
Gift of the artist through Doris M.
Offermann '34
65.1.6

WILLARD H. CARR
Ocean Bather Evolution, c. 1958
Chlorobromide print
Image/Paper: 16¹¹⁄₁₆ x 11
Gift of the artist through Doris M.
Offermann '34
65.1.7

WILLARD H. CARR
Arcade, c. 1958
Chlorobromide print
Image: 16¼ x 13⁷⁄₁₆
Paper: 16⅜ x 13⁹⁄₁₆
Gift of the artist through Doris M.
Offermann '34
65.1.8

WILLARD H. CARR
Quiet Waters, c. 1958
Chlorobromide print
Image/Paper: 13½ x 16⅜
Gift of the artist through Doris M.
Offermann '34
65.1.32

WILLARD H. CARR
Slugger, c. 1954
Chlorobromide print
Image/Paper: 19¾ x 15⅜
Gift of the artist through Doris M.
Offermann '34
65.1.85

WILLARD H. CARR
Landing the Mail, c. 1958
Chlorobromide print
Image/Paper: 13³⁄₁₆ x 16³⁄₁₆
Gift of the artist through Doris M.
Offermann '34
65.1.125

HENRI CARTIER-BRESSON
Barcelona, 1933
Gelatin silver print
Image: 7⅝ x 11⅜
Paper: 7¾ x 11⁹⁄₁₆
Gift of Michael E. Hoffman '64
82.6 §

HENRI CARTIER-BRESSON
Untitled (Fields and Olive Trees),
1953
Gelatin silver print
Image: 11½ x 7¾
Paper: 11⅝ x 7⅞
Gift of Michael E. Hoffman '64
82.5

HENRI CARTIER-BRESSON
Untitled (Man Resting in the Shade
of a Tree), 1963
Gelatin silver print
Image: 11½ x 7¹¹⁄₁₆
Paper: 11¹¹⁄₁₆ x 7¹⁵⁄₁₆
Gift of Michael E. Hoffman '64
82.7

HENRI CARTIER-BRESSON
Turkey, 1965
Gelatin silver print
Image: 7¹³⁄₁₆ x 11¹¹⁄₁₆
Paper: 7¹⁵⁄₁₆ x 11¾

Gift of Michael E. Hoffman '64
82.8 § *(Plate 5)*

PETER CHARTRAND
Bag Lady, New York City, 1968
Gelatin silver print
Image: 14⁷⁄₁₆ x 9½
Paper: 14 x 18⅞
Gift of Richard Amerault
92.22.13

PETER CHARTRAND
Columbia University, New York City,
1968
Gelatin silver print
Image: 9½ x 14⁵⁄₁₆
Paper: 13¹⁄₁₆ x 17¹¹⁄₁₆
Gift of Richard Amerault
92.22.14

PETER CHARTRAND
United Nations, New York City, 1968
Gelatin silver print
Image: 9½ x 14⁵⁄₁₆
Paper: 14⅝ x 17½
Gift of Richard Amerault
92.22.15 §

MICHAEL CHIKIRIS
Reflection Pool, Washington, DC,
May 1970
Chromogenic process color print
Image: 9⅜ x 6¹⁵⁄₁₆
Paper: 9⅞ x 7¹⁵⁄₁₆
Gift of Richard Amerault
92.22.16

MICHAEL CHIKIRIS
Smash the War Machine, 1970
Chromogenic process color print
Image: 6½ x 9½

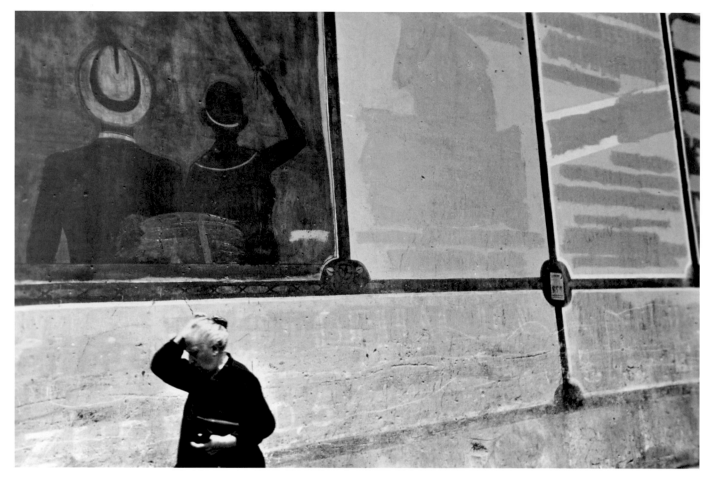

HENRI CARTIER-BRESSON, *Barcelona*

PETER CHARTRAND, *United Nations, New York City*

MICHAEL CHIKIRIS, *Washington, DC*

Paper: 7¹⁵⁄₁₆ x 9⅞
Gift of Richard Amerault
92.22.17

MICHAEL CHIKIRIS
Washington, DC, 1970
Chromogenic process color print
Image: 6½ x 9½
Paper: 7¹⁵⁄₁₆ x 9⅞
Gift of Richard Amerault
92.22.18

MICHAEL CHIKIRIS
Washington, DC, 1970
Chromogenic process color print
Image: 6⁹⁄₁₆ x 9½
Paper: 7¹⁵⁄₁₆ x 9⅞
Gift of Richard Amerault
92.22.19

MICHAEL CHIKIRIS
Washington, DC, 1970
Chromogenic process color print
Image: 9½ x 6⁷⁄₁₆
Paper: 9⅞ x 7¹⁵⁄₁₆
Gift of Richard Amerault
92.22.20 §

EDWARD CHRISTIANA
William Palmer, 1942

Chlorobromide print
Image/Paper: 16¾ x 13⅛
Gift of William Palmer in honor of Dr.
Frank P. and Anne C. Piskor
81.125

W. JOSEPH CHRISTIANSEN
Rose at the Wall, n.d.
Hand-colored gelatin silver print
Image/Paper: 8 x 9¹⁵⁄₁₆
Gift of Richard Amerault
92.22.21

ALVIN LANGDON COBURN
Untitled (Landscape with
Bridge), c. 1909
Photogravure
Image: 5⅛ x 6¹⁵⁄₁₆
Paper: 5¹³⁄₁₆ x 7⁵⁄₁₆
University purchase
75.15 §

JOE COSTA
Untitled (Speedboats and Wake),
n.d.
Chlorobromide print
Image/Paper: 13 x 10¼
Gift of Arthur S. and Katherine Holt
Mawhinney through Doris M.
Offermann '34
65.1.133

VINCENT P. CRONIN
The Patriarch, 1945
Chlorobromide print
Image/Paper: 17⅞ x 13¹³⁄₁₆
Gift of Arthur S. and Katherine Holt
Mawhinney through Doris M.
Offermann '34
65.1.40

ELEANOR PARKE CUSTIS
Untitled (Men Sitting by Street), n.d.
Chlorobromide print
Image/Paper: 16⅞ x 13⅞
Gift of Barbara Green through Doris M.
Offermann '34
65.1.22 §

DAVE DECKER
Rainbow and Tank, RVN, 1967
Chromogenic process color print
Image: 7⁹⁄₁₆ x 5⁷⁄₁₆
Paper: 7¹⁵⁄₁₆ x 9⅞
Gift of Richard Amerault
92.22.24

DAVE DECKER
Cobra, RVN, 1968
Chromogenic process color print
Image: 7½ x 9⅜

· 117 ·

ALVIN LANGDON COBURN, Untitled (Landscape with Bridge)

ELEANOR PARKE CUSTIS, Untitled (Men Sitting by Street)

DAVE DECKER, *Decker, RVN*

Paper: 7¹⁵⁄₁₆ x 9⅞
Gift of Richard Amerault
92.22.22 §

DAVE DECKER
Rockets, RVN, 1968
Chromogenic process color print
Image: 6¹⁵⁄₁₆ x 9⅜
Paper: 7¹⁵⁄₁₆ x 9⅞
Gift of Richard Amerault
92.22.25

DAVE DECKER
Decker, RVN, c. 1960s
Chromogenic process color print
Image: 7⁹⁄₁₆ x 5⅝
Paper: 9⅞ x 7¹⁵⁄₁₆
Gift of Richard Amerault
92.22.23 §

DAVE DECKER
The Admiral Made It, RVN, c. 1960s
Chromogenic process color print

Image: 9¹⁄₁₆ x 6¼
Paper: 9⅞ x 7¹⁵⁄₁₆
Gift of Richard Amerault
92.22.26

JACK DELANO
A Starch Factory along the Aroostook River, Caribou, Aroostook County, Maine, October 1940, printed 1986
Dye transfer print
Image: 7 x 10
Paper: 10 x 13
Gift of Rick Jeffrey (parent of Richard Jeffrey, Jr. '85)
92.11.36

JACK DELANO
A Man Painting a View of the Shenandoah Valley from the Skyline Drive, near an Entrance to the Appalachian Trail, Virginia, November 1940, printed 1984
Dye transfer print
Image: 7 x 10
Paper: 10 x 13¹⁄₁₆
Gift of Rick Jeffrey (parent of Richard Jeffrey, Jr. '85)
92.11.35

JACK DELANO
A Square with Old Houses in an Old Fishing Village, Stonington, Connecticut, November 1940, printed 1985
Dye transfer print

DAVE DECKER, *Cobra, RVN*

Image: 7 x 10
Paper: 10 x 13
Gift of Rick Jeffrey (parent of
Richard Jeffrey, Jr. '85)
92.11.51

JACK DELANO
*A View of the Old Sea Town,
Stonington, Connecticut,*
November 1940, printed 1982
Dye transfer print
Image: 7¼ x 10½
Paper: 10¹⁄₁₆ x 13⁷⁄₁₆
Gift of Rick Jeffrey (parent of
Richard Jeffrey, Jr. '85)
92.11.52

JACK DELANO
*Connecticut Town, Probably
Stonington, on the Sea,* November
1940, printed 1985
Dye transfer print
Image: 10¼ x 6⅞
Paper: 13 x 9¹³⁄₁₆
Gift of Rick Jeffrey (parent of Richard
Jeffrey, Jr. '85)
92.11.53

JACK DELANO
Brockton, Massachusetts, December
1940, printed 1986
Dye transfer print
Image: 7 x 10
Paper: 10 x 13¹⁄₁₆
Gift of Rick Jeffrey (parent of Richard
Jeffrey, Jr. '85)
92.11.57

JACK DELANO
*Street in Industrial Town in
Massachusetts,* December
1940–January 1941, printed 1986
Dye transfer print
Image: 6¹⁵⁄₁₆ x 10
Paper: 10¹⁄₁₆ x 13¹⁄₁₆
Gift of Rick Jeffrey (parent of Richard
Jeffrey, Jr. '85)
92.11.56

JACK DELANO
*Street Corner, Brockton,
Massachusetts,* January 1941,
printed 1985
Dye transfer print
Image: 10 x 6¹⁵⁄₁₆
Paper: 13¹⁄₁₆ x 10
Gift of Rick Jeffrey (parent of Richard
Jeffrey, Jr. '85)
92.11.54

JACK DELANO
Near the Waterfront, New Bedford,

JACK DELANO, *Steel Mills, Midland, Pennsylvania*

Massachusetts, January 1941, printed
1986
Dye transfer print
Image: 6¹⁵⁄₁₆ x 10
Paper: 10 x 13⅛
Gift of Rick Jeffrey (parent of Richard
Jeffrey, Jr. '85)
92.11.55

JACK DELANO
*Commuters, Who Have Just Come off
the Train, Waiting for the Bus to Go
Home, Lowell, Massachusetts,* January
1941, printed 1985
Dye transfer print
Image: 6¹⁵⁄₁₆ x 10
Paper: 10 x 13¹⁄₁₆
Gift of Rick Jeffrey (parent of Richard
Jeffrey, Jr. '85)
92.11.58

JACK DELANO
Steel Mills, Midland, Pennsylvania,
February 1941, printed 1985
Dye transfer print
Image: 6½ x 9¹⁵⁄₁₆
Paper: 9⁹⁄₁₆ x 13¼
Gift of Rick Jeffrey (parent of Richard
Jeffrey, Jr. '85)
92.11.5 §

JACK DELANO
*The Greensboro Lumber Company,
Greensboro, Georgia,* June 1941,
printed 1985
Dye transfer print
Image: 7⁵⁄₁₆ x 9¹¹⁄₁₆
Paper: 10 x 13¹⁄₁₆
Gift of Rick Jeffrey (parent of Richard

Jeffrey, Jr. '85)
92.11.1

JACK DELANO
*Sawmill at the Greensboro Lumber
Company, Greensboro, Georgia,*
June 1941, printed 1986
Dye transfer print
Image: 7 x 10
Paper: 10 x 13¹⁄₁₆
Gift of Rick Jeffrey (parent of Richard
Jeffrey, Jr. '85)
92.11.21

JACK DELANO
At the Vermont State Fair, Rutland,
September 1941, printed 1985
Dye transfer print
Image: 7 x 10
Paper: 10¹⁄₁₆ x 13¹⁄₁₆
Gift of Rick Jeffrey (parent of Richard
Jeffrey, Jr. '85)
92.11.37

JACK DELANO
At the Vermont State Fair, Rutland,
September 1941, printed 1984
Dye transfer print
Image: 7 x 10
Paper: 10 x 13¹⁄₁₆
Gift of Rick Jeffrey (parent of Richard
Jeffrey, Jr. '85)
92.11.38

JACK DELANO
At the Vermont State Fair, Rutland,
September 1941, printed 1984
Dye transfer print
Image: 6¹⁵⁄₁₆ x 10

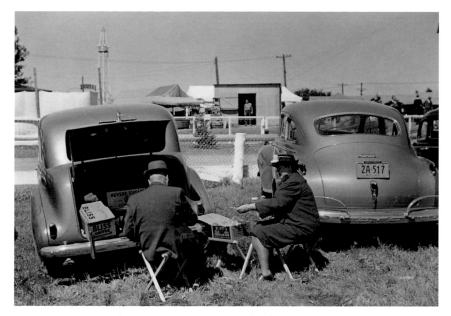

JACK DELANO, *At the Vermont State Fair, Rutland*

Paper: 10 x 13
Gift of Rick Jeffrey (parent of Richard
Jeffrey, Jr. '85)
92.11.49 §

JACK DELANO
At the Vermont State Fair, Rutland,
September 1941, printed 1985
Dye transfer print
Image: 7 x 10
Paper: 10 x 13
Gift of Rick Jeffrey (parent of Richard
Jeffrey, Jr. '85)
92.11.50

JACK DELANO
*Tobacco Country, Vicinity of
Barranquitas, Puerto Rico,* December
1941, printed 1985
Dye transfer print
Image: 7 x 10
Paper: 10 x 13¹⁄₁₆
Gift of Rick Jeffrey (parent of Richard
Jeffrey, Jr. '85)
92.11.2

JACK DELANO
*Farm Security Administration
Borrower, Vicinity of Frederiksted, St.
Croix, Virgin Islands,* December 1941,
printed 1985
Dye transfer print
Image: 6¹¹⁄₁₆ x 9¾
Paper: 10⅛ x 12¹⁵⁄₁₆
Gift of Rick Jeffrey (parent of Richard
Jeffrey, Jr. '85)
92.11.7

JACK DELANO
Street Scene, Christiansted, St. Croix,

Virgin Islands, December 1941,
printed 1985
Dye transfer print
Image: 6¹¹⁄₁₆ x 9¾
Paper: 10 x 12⅞
Gift of Rick Jeffrey (parent of Richard
Jeffrey, Jr. '85)
92.11.8

JACK DELANO
Untitled (Gas Pump with
Clothesline, Barn, and Horse-drawn
Wagon in Background), 1941–1942,
printed 1985
Dye transfer print
Image: 6¹³⁄₁₆ x 9⁹⁄₁₆
Paper: 9¹⁵⁄₁₆ x 12¹³⁄₁₆
Gift of Rick Jeffrey (parent of Richard
Jeffrey, Jr. '85)
92.11.4

JACK DELANO
*Federal Housing Project on the
Outskirts of the Town of Yuaco [i.e.,
Yauco] . . . , Puerto Rico,* January
1942, printed 1984
Dye transfer print
Image: 6¹⁵⁄₁₆ x 10
Paper: 10 x 13⅛
Gift of Rick Jeffrey (parent of Richard
Jeffrey, Jr. '85)
92.11.6

FRED A. DEMAREST
Spring Showers, n.d.
Three-color carbro process print
Image/Paper: 8¾ x 6⅜
Gift of Anne C. Piskor
78.225

WILLIAM DENNIN
Late Local, n.d.
Chlorobromide print
Image: 16½ x 13½
Paper: 16⅝ x 13¹¹⁄₁₆
Gift of Arthur S. and Katherine Holt
Mawhinney through Doris M.
Offermann '34
65.1.99

ROBERT DESMÉ
Untitled (Still Life), n.d.
Chlorobromide print
Image: 13⅞ x 10¾
Paper: 13⅞ x 10¹⁵⁄₁₆
Gift of Arthur S. and Katherine Holt
Mawhinney through Doris M.
Offermann '34
65.1.88

ANTHONY J. P. DITOMASSO '75
Untitled (Street Scene from Above),
c. 1974
Gelatin silver print
Image/Paper: 6½ x 9⁵⁄₁₆
University purchase
74.48.10

ROBERT DOISNEAU
Robert Doisneau (New York:
Hyperion Press Limited, 1979)
Portfolio of 11 out of 15 gelatin silver prints,
ed. 18/100
Gift of Donald T. Johnson '61
82.38

Le Baiser du Trottoir, 1950
Image: 9⁹⁄₁₆ x 12
Paper: 11⅞ x 15⅞
82.38.1

La Stricte Intimité, 1945
Image: 11⅛ x 9⁹⁄₁₆
Paper: 15⅞ x 11¹⁵⁄₁₆
82.38.2 § *(Plate 6)*

Le Jeune Homme et Rita, 1954
Image: 9⁵⁄₁₆ x 13½
Paper: 11¹⁵⁄₁₆ x 15⅞
82.38.3

La Poule au Gibier, 1945
Image: 9⁹⁄₁₆ x 12
Paper: 11¹⁵⁄₁₆ x 15¹³⁄₁₆
82.38.4

Pain et Rideau de Fer, 1953
Image: 11⁵⁄₁₆ x 9⅜
Paper: 15⅞ x 11⅞
82.38.5

Les Concierges Rue du Dragon, 1946
Image: 9⁹⁄₁₆ x 11⁹⁄₁₆
Paper: 11¹⁵⁄₁₆ x 15⅞
82.38.7

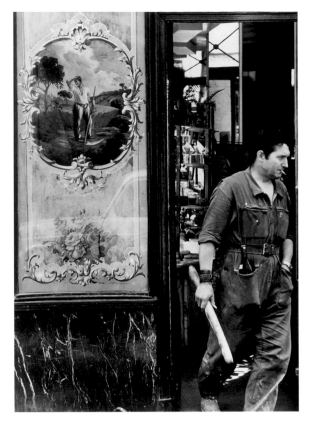

ROBERT DOISNEAU, *Boulangerie Rue de Poitou*

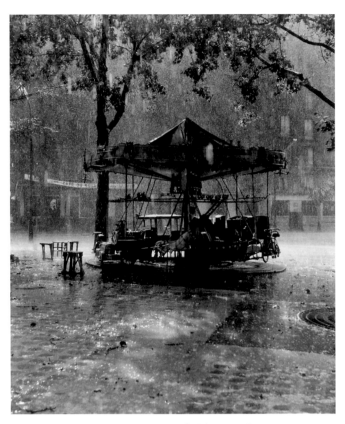

ROBERT DOISNEAU, *Le Manège de Monsieur Barré*

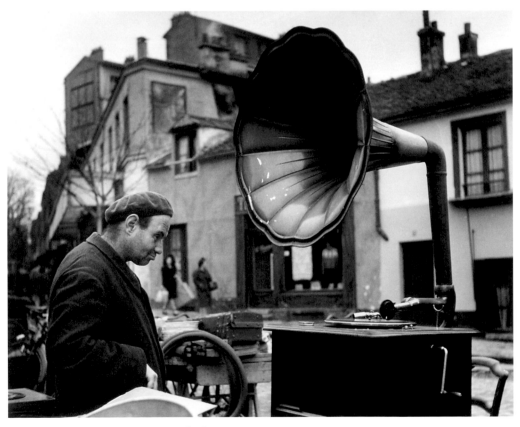

ROBERT DOISNEAU, *La Musique des Puces*

BENJAMIN M. EATON, *Brain Cell Countdown*

Boulangerie Rue de Poitou, 1971
Image: 13⁵⁄₁₆ x 9⁹⁄₁₆
Paper: 15⅞ x 11⅞
82.38.8 §

Les Hélicoptères, 1972
Image: 13½ x 8¹³⁄₁₆
Paper: 15⅞ x 11⅞
82.38.9

La Musique des Puces, 1944
Image: 9⁵⁄₁₆ x 11½
Paper: 11¹⁵⁄₁₆ x 15⅞
82.38.10 §

Le Manège de Monsieur Barré, 1955
Image: 11¹³⁄₁₆ x 9⁹⁄₁₆

Paper: 15¹⁵⁄₁₆ x 11⅞
82.38.11 §

Le Muguet du Métro, 1953
Image: 12⁹⁄₁₆ x 9⅝
Paper: 15⅞ x 11¹⁵⁄₁₆
82.38.12

JOE DO PADRE
Ap-Cha-Do-Tay Ninh, 1966
Chromogenic process color print
Image: 6⅝ x 9⅞
Paper: 7¹⁵⁄₁₆ x 9⅞
Gift of Richard Amerault
92.22.43

JOE DO PADRE
Remains of War, RVN, 1966
Chromogenic process color print
Image: 6¹¹⁄₁₆ x 9⁷⁄₁₆
Paper: 7¹⁵⁄₁₆ x 9⅞
Gift of Richard Amerault
92.22.44

JOE DO PADRE
Rice Farmers, RVN, 1966
Chromogenic process color print
Image: 7³⁄₁₆ x 9⁷⁄₁₆
Paper: 8 x 9⅞
Gift of Richard Amerault
92.22.45

JOE DO PADRE
Strack Major, Lai Khe, 1966
Chromogenic process color print
Image: 8³⁄₁₆ x 12⁷⁄₁₆
Paper: 10⅞ x 13¹⁵⁄₁₆
Gift of Richard Amerault
92.22.46

GEORGE A. DUBERG
If Winter Comes, c. 1945
Chlorobromide print
Image/Paper: 16³⁄₁₆ x 13⅛
Gift of Arthur S. and Katherine Holt
Mawhinney through Doris M.
Offermann '34
65.1.121

GEORGE A. DUBERG
Mirage, 1952
Gelatin silver Gevalux print
Image/Paper: 13⁷⁄₁₆ x 8⁷⁄₁₆
Gift of Arthur S. and Katherine Holt
Mawhinney through Doris M. Offermann
'34
65.1.117

BENJAMIN M. EATON '94
Brain Cell Countdown, c. 1993
Gelatin silver print
Image: 8 x 4¹⁵⁄₁₆
Paper: 9¹⁵⁄₁₆ x 7¹⁵⁄₁₆
Purchased with funds from the Eben
Griffiths '07 Endowment
93.19 §

BENJAMIN M. EATON '94
The Grave, 1992
Gelatin silver print
Image: 7¹³⁄₁₆ x 5¹⁵⁄₁₆
Paper: 10 x 8
Purchased with funds from the Jeanne
Scribner Cashin Endowment for Fine Arts
established by Thomas H. Cashin '46
93.21

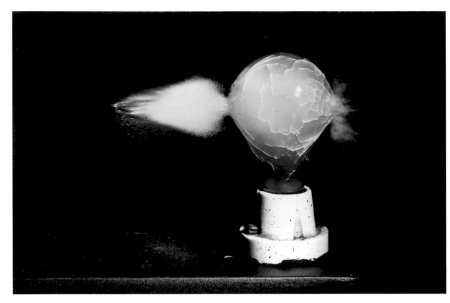

HAROLD EDGERTON, *Bullet through Bulb*

HAROLD EDGERTON, *Jackie Jumps a Bench*

HAROLD EDGERTON
Fan and Smoke Vortices, c. 1934
Gelatin silver print, ed. 93/125
Image: 18¹/₁₆ x 14⁵/₁₆
Paper: 19⅞ x 16
Gift of the Harold and Esther Edgerton
Family Foundation
96.9 § *(Fig. 10)*

HAROLD EDGERTON
Bullet through Bulb, c. 1936
Gelatin silver print, ed. 73/125
Image: 12¼ x 18⁷/₁₆
Paper: 15⅞ x 19⅞
Gift of the Harold and Esther Edgerton
Family Foundation
96.10 §

HAROLD EDGERTON
Jackie Jumps a Bench, 1938
Gelatin silver print
Image: 8¼ x 12
Paper: 11 x 13⅞
University purchase
93.47 §

HAROLD EDGERTON
Jackie Wags His Tail, 1938
Gelatin silver print
Image: 12⅝ x 9⅞
Paper: 13⅞ x 10⅞
University purchase
93.48

HAROLD EDGERTON
Tumblers, 1942
Gelatin silver print, ed. 70/125
Image: 17⁷/₁₆ x 13⅞
Paper: 19⅞ x 15¹⁵/₁₆
Gift of the Harold and Esther Edgerton
Family Foundation
96.11

HAROLD EDGERTON
Moving Skip Rope, 1952
Gelatin silver print, ed. 108/125
Image: 6³/₁₆ x 9¾
Paper: 8¹⁵/₁₆ x 10⅞
Gift of the Harold and Esther Edgerton
Family Foundation
96.6

HAROLD EDGERTON
Milk Drop Coronet, 1957
Dye transfer print
Image: 18¼ x 13¼
Paper: 19⅞ x 15⅞
Purchased with funds from the Eben
Griffiths '07 Endowment
93.49

HAROLD EDGERTON
Cutting the Card Quickly!, 1964
Dye transfer print
Image: 7½ x 10
Paper: 8¹⁵/₁₆ x 10¹⁵/₁₆
Gift of the Harold and Esther Edgerton
Family Foundation
96.7

HAROLD EDGERTON
Puncturing a Balloon, 1977
Chromogenic process color print
Image: 8⅞ x 12¹⁵/₁₆
Paper: 10⅞ x 13¹⁵/₁₆
University purchase
93.45

HAROLD EDGERTON
Marine Organisms, 1980
Photogram
Image: 12¹⁵/₁₆ x 10
Paper: 13¹⁵/₁₆ x 10¹⁵/₁₆
University purchase
93.46 §

HAROLD EDGERTON
Ouch! (Archery), n.d.
Gelatin silver print, ed. 69/125

HAROLD EDGERTON, *Marine Organisms*

Image: 14¼ x 18¹⁵⁄₁₆
Paper: 15⅞ x 19⁹⁄₁₆
Gift of the Harold and Esther Edgerton
Family Foundation
96.8

HAROLD EDGERTON
Bullet through Jack of Hearts, n.d.
Gelatin silver print, ed. 66/125
Image: 14⅜ x 18⅜
Paper: 15¹⁵⁄₁₆ x 19⅛
Gift of the Harold and Esther Edgerton
Family Foundation
96.12

HAROLD EDGERTON
*Harold Edgerton: Ten Dye Transfer
Photographs* (Littleton, MA: Palm
Press, Inc., 1985)

Portfolio of 9 out of 10 dye transfer prints,
ed. 140/150
Gift of the Harold and Esther Edgerton
Family Foundation
96.5

Football Kick, 1938
Image: 16⅝ x 14
Paper: 20 x 16
96.5.1 § *(Plate 7)*

Milk Drop Coronet, 1957
Image: 18¼ x 13¼
Paper: 19⅞ x 15⅞
96.5.2 §

Cranberry Juice into Milk, 1960
Image: 15⅞ x 13¹⁵⁄₁₆
Paper: 19⅞ x 15¾
96.5.3

Moscow Circus, 1963
Image: 14¼ x 17⅞
Paper: 15⅞ x 20¹⁄₁₆
96.5.4

Bullet through Banana, 1964
Image: 14³⁄₁₆ x 16³⁄₁₆
Paper: 16¹⁄₁₆ x 20
96.5.5

.30 Bullet Piercing an Apple, 1964
Image: 14 x 18
Paper: 15⅞ x 19⅞
96.5.6

Cutting the Card Quickly!, 1964
Image: 14⅛ x 18
Paper: 15⅞ x 19¹⁵⁄₁₆
96.5.7

Pigeon Released, 1965
Image: 14¹⁄₁₆ x 17¹⁵⁄₁₆
Paper: 16 x 20
96.5.8

Bullet through Candle Flame, 1973
(with Kim Vandiver)
Image: 18³⁄₁₆ x 12¼
Paper: 20 x 15¹⁵⁄₁₆
96.5.9

WILLIAM EGGLESTON
Jamaica Series, n.d.
Series of 33 chromogenic process color
prints, ed. 15/35
Gift of Steven Suhacki through the Martin
S. Ackerman Foundation
79.196

Untitled (Tree in Blossom)
Image: 10⁷⁄₁₆ x 15⁷⁄₁₆
Paper: 13⅞ x 16¹⁵⁄₁₆
79.196.1

Untitled (White Variegated Foliage)
Image: 10³⁄₁₆ x 15³⁄₁₆
Paper: 13⅞ x 16¹⁵⁄₁₆
79.196.2 §

Untitled (Hibiscus)
Image: 10¼ x 15¹⁄₁₆
Paper: 13⅞ x 16¹⁵⁄₁₆
79.196.3

Untitled (Palm Fronds)
Image: 10¼ x 15⅛
Paper: 13⅞ x 16¹⁵⁄₁₆
79.196.4

Untitled (Red and White Variegated
Foliage)
Image: 10³⁄₁₆ x 15³⁄₁₆
Paper: 13¹⁵⁄₁₆ x 16¹⁵⁄₁₆
79.196.5

HAROLD EDGERTON, *Milk Drop Coronet*

WILLIAM EGGLESTON, Untitled (White Variegated Foliage)

WILLIAM EGGLESTON, Untitled (Open Air Porch with Columns and Tile Floor)

WILLIAM EGGLESTON, Untitled (Yellow and Red Variegated Foliage and Flower on Vine)

WILLIAM EGGLESTON, Untitled (Yellow and Red Variegated Foliage)

Untitled (Red and Yellow Variegated Foliage and Sky)
Image: 15 x 10⅛
Paper: 16¹⁵⁄₁₆ x 13⅞
79.196.6

Untitled (Open Air Porch with Columns and Tile Floor)
Image: 10⅛ x 14¹⁵⁄₁₆

Paper: 13⅞ x 16¹⁵⁄₁₆
79.196.7 §

Untitled (Tree against Sky)
Image: 10⅛ x 15
Paper: 13⅞ x 16¹⁵⁄₁₆
79.196.8

Untitled (Yellow and Red Variegated Foliage and Flower on Vine)

Image: 10¹¹⁄₁₆ x 14¹⁵⁄₁₆
Paper: 13⅞ x 16¹⁵⁄₁₆
79.196.9 §

Untitled (Red and Yellow Variegated Foliage)
Image: 10¹⁄₁₆ x 14¹⁵⁄₁₆
Paper: 13⅞ x 16¹⁵⁄₁₆
79.196.10 §

Untitled (Tree Branches against Sky)
Image: 10⅝ x 15¾
Paper: 13⅞ x 16¹⁵⁄₁₆
79.196.11

Untitled (Branches and Leaves against Sky)
Image: 10¾ x 15¹⁵⁄₁₆
Paper: 13⅞ x 16⅞
79.196.12 § (Plate 8)

Untitled (Green Fern and Vine)
Image: 10⁷⁄₁₆ x 15⁷⁄₁₆
Paper: 13⅞ x 16¹⁵⁄₁₆
79.196.13

Untitled (Tree in Field)
Image: 10⁷⁄₁₆ x 15⁷⁄₁₆
Paper: 13¹⁵⁄₁₆ x 16¹⁵⁄₁₆
79.196.14

Untitled (Tree with Pods against Sky)
Image: 10⁷⁄₁₆ x 15⁷⁄₁₆
Paper: 13⅞ x 16¹⁵⁄₁₆
79.196.15

Untitled (Orchids against Sky)
Image: 10⁷⁄₁₆ x 15⁷⁄₁₆
Paper: 13⅞ x 16¹⁵⁄₁₆
79.196.16

Untitled (Red Variegated Foliage)
Image: 10⁵⁄₁₆ x 15⅜
Paper: 13⅞ x 16¹⁵⁄₁₆
79.196.17

Untitled (Palm Tree against Sky)
Image: 10⁷⁄₁₆ x 15⁷⁄₁₆
Paper: 13⅞ x 16¹⁵⁄₁₆
79.196.18

Untitled (Fruit Tree against Sky)
Image: 10¼ x 15³⁄₁₆
Paper: 13⅞ x 16¹⁵⁄₁₆
79.196.19

Untitled (Red Variegated Foliage With Palm Trees)
Image: 10⁵⁄₁₆ x 15⅜
Paper: 13⅞ x 16¹⁵⁄₁₆
79.196.20

Untitled (Orchids in Field)
Image: 10⁷⁄₁₆ x 15⁷⁄₁₆
Paper: 13¹⁵⁄₁₆ x 16¹⁵⁄₁₆
79.196.21

Untitled (Red Bell-Shaped Flowers in Field)
Image: 10⁷⁄16 x 15⁷⁄16
Paper: 13¹⁵⁄16 x 16¹⁵⁄16
79.196.22

Untitled (Yellow Variegated Foliage)
Image: 10¹⁄16 x 14¹⁵⁄16
Paper: 13⅞ x 16¹⁵⁄16
79.196.23

Untitled (Green Ferns)
Image: 10⁷⁄16 x 15⁷⁄16
Paper: 13⅞ x 16¹⁵⁄16
79.196.24

Untitled (Green Ferns)
Image: 10⁷⁄16 x 15⁷⁄16
Paper: 13⅞ x 16¹⁵⁄16
79.196.25

Untitled (Red Foliage and Green Vine)
Image: 10¼ x 14¹⁵⁄16
Paper: 13¹⁵⁄16 x 16¹⁵⁄16
79.196.26

Untitled (Brown Edged Foliage)
Image: 10⁷⁄16 x 15⁷⁄16
Paper: 13⅞ x 16¹⁵⁄16
79.196.27

Untitled (Yellow Variegated Foliage and Branches)
Image: 15 x 10⅛
Paper: 16¹⁵⁄16 x 13⅞
79.196.28

Untitled (Green Fern and Vines)
Image: 10⁷⁄16 x 15⅞
Paper: 13⅞ x 16¹⁵⁄16
79.196.29

Untitled (White Variegated Foliage)
Image: 10⁷⁄16 x 15⁷⁄16
Paper: 13⅞ x 16¹⁵⁄16
79.196.30

Untitled (Palm Tree Fronds)
Image: 10⁷⁄16 x 15⁷⁄16
Paper: 13⅞ x 16¹⁵⁄16
79.196.31

Untitled (Flowering Tree)
Image: 15⁷⁄16 x 10⅜
Paper: 19¹⁵⁄16 x 13⅞
79.196.32 §

Untitled (Fruit, Leaves, and Branches)
Image: 10⁷⁄16 x 15⁷⁄16
Paper: 13⅞ x 16¹⁵⁄16
79.196.33

DOROTHY MEIGS EIDLITZ
Ant Antics, n.d.

Gelatin silver print
Image/Paper: 7½ x 13¾
Gift of the artist through
Doris M. Offermann '34
65.1.75

DOROTHY MEIGS EIDLITZ
Nautical Abstract, n.d.
Gelatin silver print
Image/Paper: 15½ x 8⅞
Gift of the artist through
Doris M. Offermann '34
65.1.93

TIMOTHY E. ELLSWORTH '72
Untitled (Barbed Wire and Fence Posts in Snow), c. 1972
Gelatin silver print
Image/Paper: 3 x 8½
University purchase
72.6

JEAN ELWELL
Musetta, c. 1939
Chlorobromide print
Image/Paper: 19¹⁄16 x 15³⁄16
Gift of Barbara Green through
Doris M. Offermann '34
65.1.91

DUANE T. EPPLER '71
Untitled (Landscape), April 1968
Gelatin silver print
Image/Paper: 6⅜ x 8⁹⁄16
Purchased with funds from the
David B. Steinman Festival of
the Arts Endowment
68.4

ELLIOT ERWITT
Photographs (Geneva, Switzerland: Acorn Editions, Ltd., 1977)
Portfolio of 15 gelatin silver prints, ed. 78/100
Gift of Donald T. Johnson '61
79.455/80.38

Yale, New Haven, 1955
Image: 6⁵⁄16 x 9⁷⁄16
Paper: 8 x 9¹⁵⁄16
79.455.1

Parade Group, Paris, 1951
Image: 9½ x 6⅜
Paper: 9⅞ x 8
79.455.2

WILLIAM EGGLESTON, Untitled (Flowering Tree)

Inspecting Guards, Teheran, 1967
Image: 9⁷⁄16 x 6⁵⁄16
Paper: 9¹⁵⁄16 x 8
79.455.3

Geese, Hungary, 1964
Image: 6⁵⁄16 x 9⅜
Paper: 8 x 9¹⁵⁄16
79.455.4

Monkey Paw, St. Tropez, 1968
Image: 6½ x 9⅜
Paper: 8 x 9⅞
79.455.5

Confessional, Czestochowa, Poland, 1964
Image: 6¼ x 9⅜
Paper: 8 x 9⅞
79.455.6 §

Piano Lesson, Odessa, 1957
Image: 6¼ x 9⅜
Paper: 8 x 9⅞
79.455.7

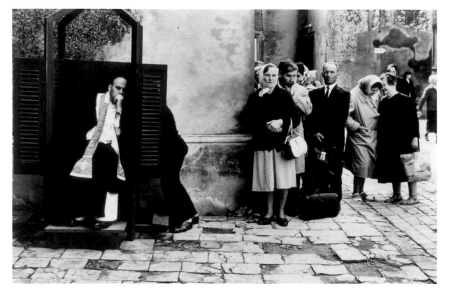

ELLIOT ERWITT, *Confessional, Czestochowa, Poland*

ELLIOT ERWITT, *Car and Poles, Rome*

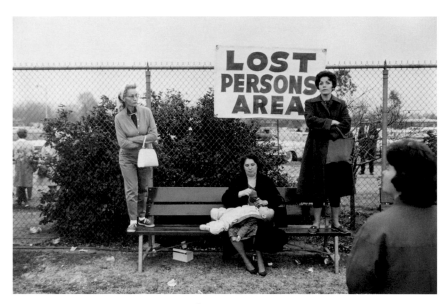

ELLIOT ERWITT, *Lost Persons, Pasadena*

Waves, Brighton, 1956
Image: 6⁵⁄₁₆ x 9⁷⁄₁₆
Paper: 8 x 9¹⁵⁄₁₆
79.455.8

Southern Charm, Alabama, 1955
Image: 6¼ x 9⁷⁄₁₆
Paper: 8 x 9¹⁵⁄₁₆
79.455.9

Diana, New York, 1949
Image: 9½ x 6⅜
Paper: 9¹⁵⁄₁₆ x 8
79.455.10

Beach Group, Sylt, West Germany, 1968

Image: 6⁵⁄₁₆ x 9⁷⁄₁₆
Paper: 8 x 9¹⁵⁄₁₆
80.38.1

Lost Persons, Pasadena, 1963
Image: 6¼ x 9⅜
Paper: 8 x 9⅞
80.38.2 §

Man and Dog, South California, 1962
Image: 9⅜ x 6⅜
Paper: 9⅞ x 8
80.38.3 § *(Plate 9)*

Soldier, New Jersey, 1951
Image: 6⅜ x 9½
Paper: 8 x 9¹⁵⁄₁₆
80.38.4

Car and Poles, Rome, 1965
Image: 9⁷⁄₁₆ x 6⅜
Paper: 9¹⁵⁄₁₆ x 8
80.38.5 §

ANDREW G. FANTAIN
Untitled (Street Scene), n.d.
Kodalith print from positive negative
Image: 9¼ x 7⅜
Film: 9¹⁵⁄₁₆ x 7¹⁵⁄₁₆
University purchase
75.23.13

NATHAN FARB
Algonquin Peaks, 1983, printed 1984
Dye transfer print

Image: 28⅛ x 35½
Paper: 30 x 40
Purchased with funds from the Frederic S.
Remington Endowment established by
Elaine Manley '14, G. Atwood Manley '16,
and Alice R. Manley '17, and a matching
gift from the artist
99.32 §

NATHAN FARB
Echo Pond, 1983, printed 1989
Silver-dye bleach print
Image: 36¼ x 29⅛
Paper: 40 x 30
Purchased with funds from the Frederic S.
Remington Endowment established by
Elaine Manley '14, G. Atwood Manley '16,
and Alice R. Manley '17, and a matching
gift from the artist
99.31

NATHAN FARB
The Goodnow Flowage, 1984, printed
1990
Silver-dye bleach print
Image: 48¾ x 62⅝
Paper: 49½ x 69
Purchased with funds from the Frederic S.
Remington Endowment established by
Elaine Manley '14, G. Atwood Manley '16,
and Alice R. Manley '17, and a matching
gift from the artist
98.57

NATHAN FARB
Little Long Pond, 1984
Silver-dye bleach print
Image: 20⅛ x 16¼
Paper: 20⅝ x 16¾
Gift of the artist
99.23

NATHAN FARB
Split Rock Falls, January 28, 1986,
printed 1994
Silver-dye bleach print
Image: 49⅜ x 63⅛
Paper: 49⅜ x 69
Purchased with funds from the Frederic S.
Remington Endowment established by
Elaine Manley '14, G. Atwood Manley '16,
and Alice R. Manley '17, and a matching
gift from the artist
99.22

NATHAN FARB
Untitled (Stupas in Nepal), 1990,
printed 1998
Silver-dye bleach print
Image: 29⅛ x 37⅛
Paper: 30 x 40
Purchased with funds from the Eben
Griffiths '07 Endowment and a matching
gift from the artist
98.58 §

NATHAN FARB, *Algonquin Peaks*

NATHAN FARB, Untitled (Stupas in Nepal)

NATHAN FARB, Untitled (Josh Crabtree '94 on Algonquin Peak)

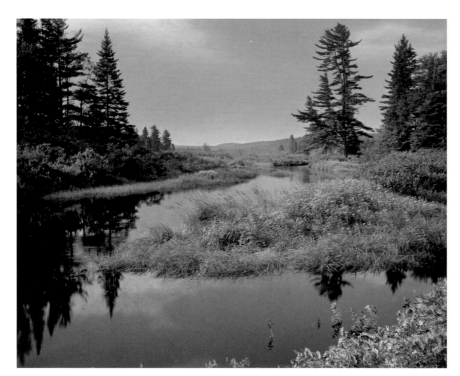

NATHAN FARB, *Oswegatchie River*

NATHAN FARB
Untitled (Winter Landscape), 1991
Silver-dye bleach print
Image: 29 x 37½
Paper: 30 x 40
University purchase
97.49

NATHAN FARB
Untitled (Josh Crabtree '94 on
Algonquin Peak), 1994
Color 8 x 10 transparency
Gift of the artist
97.24 §

NATHAN FARB
Orebed Brook, n.d.
Silver-dye bleach print
Image: 37½ x 29
Paper: 40 x 30
Purchased with funds from the Eben
Griffiths '07 Endowment and a matching
gift from the artist
97.22 § *(Plate 10)*

NATHAN FARB
Oswegatchie River, n.d.
Silver-dye bleach print
Image: 29 x 37½
Paper: 30 x 40
Purchased with funds from the Eben
Griffiths '07 Endowment and a matching
gift from the artist
97.23 §

ADOLF FASSBENDER
When Knights Were Bold, c. 1938
Chlorobromide print
Image/Paper: 16¼ x 12⅜
Gift of Arthur S. and Katherine Holt
Mawhinney through Doris M.
Offermann '34
65.1.73

SIDNEY FICHTELBERG
Old Woman, c. 1970
Gelatin silver print
Image/Paper: 17⅝ x 12¹³⁄₁₆
Gift of Doris M. Offermann '34
65.1.2

BRUCE J. FONDA '72
Untitled (Woman in Conversation),
November 1968
Gelatin silver print
Image/Paper: 9⅛ x 7¹⁵⁄₁₆
Purchased with funds from the David B.
Steinman Festival of the Arts Endowment
69.21

ROBERT FRANK
Trolley, New Orleans, from *The
Americans*, 1955–1956
Gelatin silver print
Image: 12⁵⁄₁₆ x 18¾
Paper: 15⅞ x 19¹³⁄₁₆
Gift of an anonymous donor
85.19 § *(Plate 11)*

ROBERT FRANK
Covered Car, Long Beach, California,
1956, from *The Americans*, 1955–1956
Gelatin silver print
Image: 12⁵⁄₁₆ x 18⅞
Paper: 15⅞ x 19¹⁵⁄₁₆
Gift of an anonymous donor
85.20 § *(Fig. 13)*

CAROLE GALLAGHER, *Sedan Crater, Yucca Flat, Nevada Test Site*

THOMAS FRENCH '74
The Sidewalk Leaves, n.d.
Gelatin silver print
Image/Paper: 9⁵/₁₆ x 7⁷/₁₆
University purchase
74.48.11

JACK FRIEDMAN
Enchanted, n.d.
Chlorobromide print
Image/Paper: 17½ x 13¾
Gift of Barbara Green through Doris M.
Offermann '34
65.1.14

RODERICK J. FRY
Tranquil, c. 1935
Silver bromide print
Image/Paper: 11 x 14¹¹/₁₆
Gift of Arthur S. and Katherine Holt
Mawhinney through Doris M.
Offermann '34
65.1.97

JOHN FUNARO
Beacon of the Night, 1941
Chlorobromide print
Image/Paper: 16⁷/₁₆ x 13½
Gift of Arthur S. and Katherine Holt
Mawhinney through Doris M.
Offermann '34
65.1.37

MAX J. FUTTERMAN
Three Score and Ten, n.d.
Chlorobromide print
Image/Paper: 15⁹/₁₆ x 12¹¹/₁₆

Gift of Arthur S. and Katherine Holt
Mawhinney through Doris M.
Offermann '34
65.1.52

CAROLE GALLAGHER
Robert Carter, Atomic Veteran,
October 1988, printed 1995, from
*American Ground Zero: The Secret
Nuclear War*
Gelatin silver print, ed. 2/50
Image: 14⁷/₁₆ x 14½
Paper: 28 x 16
Purchased with funds from the Eben
Griffiths '07 Endowment
95.28 § *(Plate 12)*

CAROLE GALLAGHER
*Sedan Crater, Yucca Flat, Nevada Test
Site*, 1990, printed c. 1995, from
*American Ground Zero: The Secret
Nuclear War*
Gelatin silver print
Image: 9¼ x 22¾
Paper: 20 x 24
Purchased with funds from the Eben
Griffiths '07 Endowment
95.29 §

KYLE GARDNER '98
T.N. Valley, 1997, printed 1998
Chromogenic process color print
Image/Paper: 15⁷/₈ x 23⁹/₁₆
Purchased with funds from the Helena
Walsh Kane Endowment established by
Richard F. Brush '52
98.20

RAFAELA GARRIDO, SLU 1989–90
New York City, c. 1989
Gelatin silver print
Image: 5⁹/₁₆ x 8
Paper: 6 x 8¼
Purchased with funds from the Jeanne
Scribner Cashin Endowment for Fine Arts
established by Thomas H. Cashin '46
90.04

BILL GASKINS
*Tamara and Tireka, Easter Sunday,
Baltimore, Maryland*, 1995
Gelatin silver print
Image: 9 x 12⁵/₁₆
Paper: 11 x 13⁷/₈
Purchased with funds from the Helen
Jeanne Gilbert Endowment established by
Richard F. Brush '52
97.1 § *(Plate 13)*

BILL GASKINS
Japonica, Baltimore, Maryland, 1995
Gelatin silver print
Image: 8¹⁵/₁₆ x 12½
Paper: 10³/₁₆ x 13⁷/₈
Purchased with funds from the Helen
Jeanne Gilbert Endowment established by
Richard F. Brush '52
97.2 §

RALPH GIBSON
Chiaroscuro (New York: Hyperion
Press, 1982)
Portfolio of 15 gelatin silver prints, ed.
74/100
Gift of Donald T. Johnson '61
85.1

BILL GASKINS, *Japonica, Baltimore, Maryland*

RALPH GIBSON, Untitled (Man Transporting Statue)

RALPH GIBSON, Untitled (Man in Suit)

NAN GOLDIN, *Lynette and Donna at Marion's Restaurant, New York*

Untitled (Man Transporting Statue), 1972
Image: 12⁵⁄₁₆ x 8¹⁄₁₆
Paper: 13⅞ x 10⅞
85.1.1 §

Untitled (Hands in Doorway), 1972
Image: 12⁵⁄₁₆ x 8¹⁄₁₆
Paper: 13⅞ x 10⅞
85.1.2

Untitled (Man with Mona Lisa), 1972
Image: 12⁵⁄₁₆ x 8¹⁄₁₆
Paper: 13⅞ x 10⅞
85.1.3

Untitled (Man in Suit), 1973
Image: 12⁵⁄₁₆ x 8¹⁄₁₆
Paper: 13⅞ x 10⅞
85.1.4 §

Untitled (Shadow on Statue), 1975
Image: 8¹⁄₁₆ x 12⁵⁄₁₆
Paper: 10⅞ x 13⅞
85.1.5

Untitled (Chef Smoking), 1976
Image: 12⁵⁄₁₆ x 8¹⁄₁₆
Paper: 13⅞ x 10⅞
85.1.6

Untitled (Painting Detail, Woman's Face), 1979

Image: 8¹⁄₁₆ x 12⁵⁄₁₆
Paper: 10⅞ x 13⅞
85.1.7

Untitled (Window Reflection), 1980
Image: 12⁵⁄₁₆ x 8¹⁄₁₆
Paper: 13⅞ x 10⅞
85.1.8

Untitled (Cornerstone In Shadow), 1980
Image: 12¹⁵⁄₁₆ x 8¹⁄₁₆
Paper: 13⅞ x 10⅞
85.1.9

Untitled (Woodwork Detail), 1980
Image: 12⁵⁄₁₆ x 8¹⁄₁₆
Paper: 13⅞ x 10⅞
85.1.10

Untitled (Silhouetted Profile), 1981
Image: 12⁵⁄₁₆ x 8¹⁄₁₆
Paper: 13⅞ x 10⅞
85.1.11

Untitled (Woman in Mask), 1981
Image: 8¹⁄₁₆ x 12⁵⁄₁₆
Paper: 10⅞ x 13⅞
85.1.12

Untitled (Astrolabe Detail), 1981
Image: 12⁵⁄₁₆ x 8
Paper: 13⅞ x 10⅞
85.1.13 § *(Plate 14)*

Untitled (Architectural Detail), 1981
Image: 8 x 12⁵⁄₁₆
Paper: 10⅞ x 13⅞
85.1.14

Untitled (Statue in Archway), 1981
Image: 12⁵⁄₁₆ x 8¹⁄₁₆
Paper: 13⅞ x 10⅞
85.1.15

JAMES A. GLENN '65
Señora X, n.d.
Chlorobromide print
Image: 13⅜ x 10⅞
Paper: 13⅝ x 10¹⁵⁄₁₆
Gift of Arthur S. and Katherine Holt Mawhinney through Doris M. Offermann '34
65.1.53

DAVID R. GODDARD '77
Untitled (Reflections on Water), c. 1974
Gelatin silver print
Image/Paper: 6¹³⁄₁₆ x 7⁷⁄₁₆
University purchase
74.48.3

NAN GOLDIN
Lynette and Donna at Marion's Restaurant, New York, 1991
Silver dye bleach print, ed. 79/100

BARBARA GREEN, *Don't You Dare!*

Image: 9 x 13½
Paper: 10¹⁵⁄₁₆ x 14
Purchased with funds from the Helen
Jeanne Gilbert Endowment established by
Richard F. Brush '52
97.46 §

ROBERT J. GOLDMAN
Gardner's Bench, c. 1958
Chlorobromide print
Image/Paper: 19⅜ x 15⁹⁄₁₆
Gift of Barbara Green through Doris M.
Offermann '34
65.1.23

JOHN C. GOODWIN
Marchers, 1967
Gelatin silver print
Image: 9⅜ x 9³⁄₁₆
Paper: 13⅞ x 10⅞
Gift of Richard Amerault
92.22.27

JOHN C. GOODWIN
Peace Nun, 1967
Gelatin silver print

Image: 9⅞ x 9½
Paper: 13⅞ x 12⅞
Gift of Richard Amerault
92.22.28

SAMUEL H. GOTTSCHO
Untitled (Library Interior),
c. mid-1930s
Gelatin silver print
Image/Paper: 9⅛ x 12¹⁵⁄₁₆
Gift of Barbara Green through Doris M.
Offermann '34
65.1.18

MARK R. GRECO '80
Untitled (Porch), c. 1980
Gelatin silver print
Image: 7 x 10⁷⁄₁₆
Paper: 11 x 13⅞
University purchase
80.67

BARBARA GREEN
Whence Cometh My Help, 1935
Chlorobromide print
Image/Paper: 9¹⁵⁄₁₆ x 13⁵⁄₁₆

Gift of the artist through Doris M.
Offermann '34
65.1.36

BARBARA GREEN
The Mount, 1937
Chlorobromide print
Image/Paper: 12½ x 16¼
Gift of Doris M. Offermann '34
65.1.29

BARBARA GREEN
This Other Eden, 1937
Chlorobromide print
Image/Paper: 12⅞ x 16⅜
Gift of the artist through Doris M.
Offermann '34
65.1.130

BARBARA GREEN
Everywhichway, 1937
Gelatin silver print
Image/Paper: 16³⁄₁₆ x 12¹⁄₁₆
Gift of the artist through Doris M.
Offermann '34
65.1.43

BARBARA GREEN
Between the Hedgerows, 1937
Chlorobromide print
Image/Paper: 16⁵⁄₁₆ x 13¹⁄₁₆
Gift of the artist through Doris M.
Offermann '34
65.1.45

BARBARA GREEN
Don't You Dare!, c. 1942
Chlorobromide print
Image/Paper: 16¼ x 13⅜
Gift of Arthur S. and Katherine Holt
Mawhinney through Doris M.
Offermann '34
65.1.30 §

BARBARA GREEN
Portal to the Past (Pattern of Piety),
1947
Gelatin silver print
Image/Paper: 16³⁄₁₆ x 13⁵⁄₁₆
Gift of the artist through Doris M.
Offermann '34
65.1.44

BARBARA GREEN
Alice in Mobile-Land, 1959
Gelatin silver montage
Image/Paper: 16⁵⁄₁₆ x 13½
Gift of the artist through Doris M.
Offermann '34
65.1.120

NEWELL GREEN
Golden Sweep, 1944

JOHN JAMES GRUEN, *Still Life with Whiskbroom*

Gelatin silver print
Image/Paper: 16¼ x 13³⁄₁₆
Gift of the artist through Doris M.
Offermann '34
65.1.28

GARY W. GRIFFIN '77
Untitled (Royal Typewriter), c. 1977
Gelatin silver print
Image: 5¼ x 7¹³⁄₁₆
Paper: 8 x 9⅞
University purchase
77.8

GARY W. GRIFFIN '77
Untitled (Winter Landscape with
Pine Trees), c. 1977
Gelatin silver print
Image/Paper: 6½ x 9⅝
University purchase
74.48.9

GARY W. GRIFFIN '77
Untitled (Informal Social Scene),
c. 1977
Gelatin silver print
Image: 5 x 7
Paper: 8 x 9⅞
University purchase
76.32

JOHN JAMES GRUEN
Still Lifes (New York: Symbax, 1980)
Series of 3 out of 10 gelatin silver prints
Gift of Albert Vaiser, M.D. through the
Martin S. Ackerman Foundation

Still Life with Spring and Disk, 1979,
ed. 37/60
Image: 14⁷⁄₁₆ x 18⅜
Paper: 15⅞ x 19¹¹⁄₁₆
85.81

Still Life with Whiskbroom, 1978,
ed. 31/60
Image: 14⁷⁄₁₆ x 18⁵⁄₁₆
Paper: 15½ x 19¹³⁄₁₆
85.83 §

Still Life with Spring and Disk, 1979,
ed. 29/60
Image: 14⁷⁄₁₆ x 18⁷⁄₁₆
Paper: 15⅞ x 19⅛
85.86

JOHN JAMES GRUEN
Doorbells, 1981
Gelatin silver print
Image: 13 x 17
Paper: 15¹³⁄₁₆ x 19¹³⁄₁₆
Gift of Albert Vaiser, M.D. through the
Martin S. Ackerman Foundation
85.82

JOHN JAMES GRUEN
*Still Life with Oil Can and Smudge
Pot*, 1981
Gelatin silver print
Image: 12⅛ x 15⅝
Paper: 15⁵⁄₁₆ x 19⅜
Gift of Albert Vaiser, M.D. through the
Martin S. Ackerman Foundation
85.84

CARLOS A. GUERRA
Vietnamese Interpreter, RVN, 1966
Gelatin silver print
Image: 10¼ x 15½
Paper: 12½ x 17½
Gift of Richard Amerault
92.22.29 §

PHILIPPE HALSMAN
Teresa Wright, 1944
Gelatin silver print
Image: 13½ x 10¹³⁄₁₆
Paper: 13¹⁵⁄₁₆ x 11¹⁄₁₆
Gift of Craig Nalen through the Martin S.
Ackerman Foundation
79.231

PHILIPPE HALSMAN
Alexis Smith, 1944

CARLOS A. GUERRA, *Vietnamese Interpreter, RVN*

PHILIPPE HALSMAN, *Charles Boyer* PHILIPPE HALSMAN, *Jean Simmons*

Gelatin silver print
Image: 13⁹⁄₁₆ x 10⅝
Paper: 13⅞ x 10¹⁵⁄₁₆
Gift of Craig Nalen through the Martin S.
Ackerman Foundation
79.244

PHILIPPE HALSMAN
Charles Boyer, 1944
Gelatin silver print
Image: 13¾ x 10¹¹⁄₁₆
Paper: 13⅞ x 10¹⁵⁄₁₆
Gift of Craig Nalen through the Martin S.
Ackerman Foundation
79.254 §

PHILIPPE HALSMAN
Betty Field, 1944
Gelatin silver print
Image/Paper: 10¹³⁄₁₆ x 12¾
Gift of Craig Nalen through the Martin S.
Ackerman Foundation
79.260

PHILIPPE HALSMAN
Jennifer Jones, 1944
Gelatin silver print
Image/Paper: 13⅜ x 10⅜
Gift of Craig Nalen through the Martin S.
Ackerman Foundation
79.262

PHILIPPE HALSMAN
Van Johnson, 1944
Gelatin silver print
Image: 13¾ x 10⅞
Paper: 13⅞ x 11
Gift of Craig Nalen through the Martin S.
Ackerman Foundation
79.267

PHILIPPE HALSMAN
Paul Lukas, 1944
Gelatin silver print
Image: 13⁹⁄₁₆ x 10⅝
Paper: 14 x 10⅞
Gift of Craig Nalen through the Martin S.
Ackerman Foundation
79.269

PHILIPPE HALSMAN
Mary Martin, 1945
Gelatin silver print
Image: 9¹¹⁄₁₆ x 7⅞
Paper: 10 x 8⅛
Gift of Craig Nalen through the Martin S.
Ackerman Foundation
79.240

PHILIPPE HALSMAN
Richard Koret, 1946
Gelatin silver print
Image: 13¹¹⁄₁₆ x 10¹¹⁄₁₆

Paper: 13⅞ x 11
Gift of Craig Nalen through the Martin S.
Ackerman Foundation
79.229

PHILIPPE HALSMAN
Ricki Soma, 1946
Gelatin silver print
Image: 13⅝ x 10¾
Paper: 13⅞ x 11
Gift of Craig Nalen through the Martin S.
Ackerman Foundation
79.261

PHILIPPE HALSMAN
Roy Larsen, 1948
Gelatin silver print
Image: 13½ x 10¾
Paper: 13⅞ x 10¹⁵⁄₁₆
Gift of Craig Nalen through the Martin S.
Ackerman Foundation
79.250

PHILIPPE HALSMAN
Colette Marchand, 1949
Gelatin silver print
Image/Paper: 13⁹⁄₁₆ x 10⅝
Gift of Craig Nalen through the Martin S.
Ackerman Foundation
79.241

PHILIPPE HALSMAN, *Mike Wallace's Wife*

PHILIPPE HALSMAN, *Dinah Shore*

PHILIPPE HALSMAN
Joanne Dru, 1949
Gelatin silver print
Image/Paper: 10⅝ x 13⅝
Gift of Craig Nalen through the Martin S.
Ackerman Foundation
79.265

PHILIPPE HALSMAN
Shelley Winters, 1950
Gelatin silver print
Image: 13¾ x 10¾
Paper: 13⅞ x 10¹⁵⁄₁₆
Gift of Craig Nalen through the Martin S.
Ackerman Foundation
79.232

PHILIPPE HALSMAN
Patrice Munsel, 1950
Gelatin silver print
Image: 13⁹⁄₁₆ x 10¹¹⁄₁₆
Paper: 13¹⁵⁄₁₆ x 10⅞
Gift of Craig Nalen through the Martin S.
Ackerman Foundation
79.237

PHILIPPE HALSMAN
Jean Simmons, 1950
Gelatin silver print
Image: 13⅝ x 10¾
Paper: 13⅞ x 10¹⁵⁄₁₆
Gift of Craig Nalen through the Martin S.
Ackerman Foundation
79.252 §

PHILIPPE HALSMAN
Jerry Lewis, 1951
Gelatin silver print
Image/Paper: 13⅜ x 10¹³⁄₁₆
Gift of Craig Nalen through the Martin S.
Ackerman Foundation
79.235

PHILIPPE HALSMAN
Red Skelton, 1952
Gelatin silver print
Image: 13⅝ x 10¹¹⁄₁₆
Paper: 13⅞ x 10¹⁵⁄₁₆
Gift of Craig Nalen through the Martin S.
Ackerman Foundation
79.245

PHILIPPE HALSMAN
Dinah Shore, 1952
Gelatin silver print
Image: 13¹¹⁄₁₆ x 10¹¹⁄₁₆
Paper: 13⅞ x 10⅞
Gift of Craig Nalen through the Martin S.
Ackerman Foundation
79.253 §

PHILIPPE HALSMAN
Dennis Day, 1952
Gelatin silver print
Image: 13⅝ x 10⅝
Paper: 13¹⁵⁄₁₆ x 10⅞
Gift of Craig Nalen through the Martin S.
Ackerman Foundation
79.255

PHILIPPE HALSMAN
Dawn Addams, 1952
Gelatin silver print
Image: 13¾ x 10¾
Paper: 13¹⁵⁄₁₆ x 10¹⁵⁄₁₆
Gift of Craig Nalen through the Martin S.
Ackerman Foundation
79.257

PHILIPPE HALSMAN
Vanesse Brown, 1952
Gelatin silver print
Image: 13⅝ x 10¹³⁄₁₆

Paper: 13¹⁵⁄₁₆ x 10¹⁵⁄₁₆
Gift of Craig Nalen through the Martin S.
Ackerman Foundation
79.263

PHILIPPE HALSMAN
Sandra Krasne, 1953
Gelatin silver print
Image: 13¹¹⁄₁₆ x 10⅞
Paper: 14 x 10¹⁵⁄₁₆
Gift of Craig Nalen through the Martin S.
Ackerman Foundation
79.225

PHILIPPE HALSMAN
Sandra Krasne, 1953
Gelatin silver print
Image: 13⁹⁄₁₆ x 10¹³⁄₁₆
Paper: 13¹⁵⁄₁₆ x 10¹⁵⁄₁₆
Gift of Craig Nalen through the Martin S.
Ackerman Foundation
79.226

PHILIPPE HALSMAN
Josh Logan, 1953
Gelatin silver print
Image: 13¹¹⁄₁₆ x 10¾
Paper: 14¾ x 11⁷⁄₁₆
Gift of Craig Nalen through the Martin S.
Ackerman Foundation
79.239

PHILIPPE HALSMAN
Marguerite Piazza, 1953
Gelatin silver print
Image: 13¾ x 10¾
Paper: 13¹⁵⁄₁₆ x 10¹⁵⁄₁₆
Gift of Craig Nalen through the Martin S.
Ackerman Foundation
79.248

PHILIPPE HALSMAN
Claire Booth Luce, 1953
Gelatin silver print
Image: 13 x 10³⁄₁₆
Paper: 13¹⁵⁄₁₆ x 10¹⁵⁄₁₆
Gift of Craig Nalen through the Martin S.
Ackerman Foundation
79.249

PHILIPPE HALSMAN
Mindy Carson, 1953
Gelatin silver print
Image: 13¾ x 10¹³⁄₁₆
Paper: 14 x 11
Gift of Craig Nalen through the Martin S.
Ackerman Foundation
79.268

PHILIPPE HALSMAN
Gina Lollobrigida, 1954
Gelatin silver print
Image: 12 x 10¾

Paper: 13⅞ x 10¹⁵⁄₁₆
Gift of Craig Nalen through the Martin S.
Ackerman Foundation
79.236

PHILIPPE HALSMAN
Ava Gardner, 1954
Gelatin silver print
Image: 13⅝ x 10⅞
Paper: 13⅞ x 11
Gift of Craig Nalen through the Martin S.
Ackerman Foundation
79.264

PHILIPPE HALSMAN
Mai Zetterling, 1955
Gelatin silver print
Image: 13⁹⁄₁₆ x 10⁹⁄₁₆
Paper: 13⅞ x 10¹⁵⁄₁₆
Gift of Craig Nalen through the Martin S.
Ackerman Foundation
79.246

PHILIPPE HALSMAN
Peter Ustinov, 1955
Gelatin silver print
Image: 13⅝ x 10⅝
Paper: 13⅞ x 10⅞
Gift of Craig Nalen through the Martin S.
Ackerman Foundation
79.247 § *(Plate 15)*

PHILIPPE HALSMAN
Maria Tallchief, 1956
Gelatin silver print
Image: 13¹¹⁄₁₆ x 10¾
Paper: 13¹⁵⁄₁₆ x 10¹⁵⁄₁₆
Gift of Craig Nalen through the Martin S.
Ackerman Foundation
79.234

PHILIPPE HALSMAN
Mike Wallace's Wife, 1957
Gelatin silver print
Image: 12¹¹⁄₁₆ x 10¹¹⁄₁₆
Paper: 13¹⁵⁄₁₆ x 10⅞
Gift of Craig Nalen through the Martin S.
Ackerman Foundation
79.243 §

PHILIPPE HALSMAN
Benny Goodman, 1957
Gelatin silver print
Image: 13½ x 10¹¹⁄₁₆
Paper: 13¹⁵⁄₁₆ x 10⅞
Gift of Craig Nalen through the Martin S.
Ackerman Foundation
79.266

PHILIPPE HALSMAN
Hans Koningsberger, 1959
Gelatin silver print
Image: 13⅝ x 10¾

Paper: 13⅞ x 10¹⁵⁄₁₆
Gift of Craig Nalen through the Martin S.
Ackerman Foundation
79.228

PHILIPPE HALSMAN
Paul Mayer, 1959
Gelatin silver print
Image: 13½ x 10¾
Paper: 13⅞ x 10¹⁵⁄₁₆
Gift of Craig Nalen through the Martin S.
Ackerman Foundation
79.238

PHILIPPE HALSMAN
Danny Kaye, 1960
Gelatin silver print
Image: 13⅝ x 10¹³⁄₁₆
Paper: 13¹⁵⁄₁₆ x 10¹⁵⁄₁₆
Gift of Craig Nalen through the Martin S.
Ackerman Foundation
79.251

PHILIPPE HALSMAN
Danny Kaye, 1960
Gelatin silver print
Image: 13¹¹⁄₁₆ x 10¾
Paper: 13¹⁵⁄₁₆ x 10¹⁵⁄₁₆
Gift of Craig Nalen through the Martin S.
Ackerman Foundation
79.259

PHILIPPE HALSMAN
Susannah York, 1961
Gelatin silver print
Image: 13⅝ x 10¾
Paper: 13⅞ x 11
Gift of Craig Nalen through the Martin S.
Ackerman Foundation
79.230

PHILIPPE HALSMAN
Anna Marie Alberghetti, 1961
Gelatin silver print
Image/Paper: 10⅝ x 13⅝
Gift of Craig Nalen through the Martin S.
Ackerman Foundation
79.256

PHILIPPE HALSMAN
Shirley MacLaine, 1962
Gelatin silver print
Image: 13¹¹⁄₁₆ x 10¹¹⁄₁₆
Paper: 13¹⁵⁄₁₆ x 10¹⁵⁄₁₆
Gift of Craig Nalen through the Martin S.
Ackerman Foundation
79.242

PHILIPPE HALSMAN
W. W. Kerler, 1967
Gelatin silver print
Image: 13¹¹⁄₁₆ x 10¹³⁄₁₆
Paper: 13⅞ x 10¹⁵⁄₁₆

CHUCK HENDRICKS, *Pleiku*

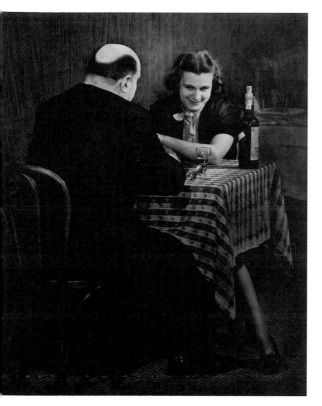

JOSEPH W. HAZELL, *It Must be Love*

Gift of Craig Nalen through the Martin S. Ackerman Foundation
79.227

PHILIPPE HALSMAN
Cary Grant and Dyan Cannon, 1968
Gelatin silver print
Image: 10⁹⁄16 x 13½
Paper: 11 x 13⅞
Gift of Craig Nalen through the Martin S. Ackerman Foundation
79.258

PHILIPPE HALSMAN
Mrs. Eugene Meyer, 1969
Gelatin silver print
Image: 9⅝ x 7¾
Paper: 9¹⁵⁄16 x 8
Gift of Craig Nalen through the Martin S. Ackerman Foundation
79.224

PHILIPPE HALSMAN
Ira Levin, 1972
Gelatin silver print
Image: 13⁹⁄16 x 10¾
Paper: 13¹⁵⁄16 x 11
Gift of Craig Nalen through the Martin S. Ackerman Foundation
79.223

PHILIPPE HALSMAN
Untitled (Street Scene), n.d.

Gelatin silver print
Image: 13½ x 10⅝
Paper: 13⅞ x 11
Gift of Craig Nalen through the Martin S. Ackerman Foundation
79.233

HOWARD HAMMIT
Jack in the Pulpit, c. 1940
Gelatin silver print
Image/Paper: 16¼ x 13³⁄16
Gift of Mr. Newell Green through Doris M. Offermann '34
65.1.19

MILDRED HATRY
Vanity Fair, 1947
Chlorobromide print
Image/Paper: 16⁷⁄16 x 13⅝
Gift of Arthur S. and Katherine Holt Mawhinney through Doris M. Offermann '34
65.1.131

AMY K. HAYES '88
Mobil, c. 1988
Gelatin silver print
Image: 4⁵⁄16 x 8⁹⁄16
Paper: 4⅜ x 8⅝
University purchase
88.5

JOSEPH W. HAZELL
Bookend, n.d.
Chlorobromide print
Image: 16⅜ x 13½
Paper: 16¾ x 13⅞
Gift of Barbara Green through Doris M. Offermann '34
65.1.17

JOSEPH W. HAZELL
It Must be Love, n.d.
Chlorobromide print
Image/Paper: 16⁵⁄16 x 13¹⁄16
Gift of Barbara Green through Doris M. Offermann '34
65.1.115 §

TIMOTHY R. HEARSUM
Untitled (Portrait of Couple with Car), 1971
Gelatin silver print
Image: 4½ x 6¹¹⁄16
Paper: 4⁹⁄16 x 6¾
University purchase
77.14

CHUCK HENDRICKS
Pleiku, 1970
Chromogenic process color print
Image: 8⁹⁄16 x 12¼
Paper: 10⅞ x 13⅞
Gift of Richard Amerault
92.22.30 §

LEWIS HINE, *Noon Hour on Skyscraper: Toasting on the Rivet Heater*

LEWIS HINE, Untitled (Two Boys on a Street Corner)

LEWIS HINE
Noon Hour on Skyscraper: Toasting on the Rivet Heater, c. 1931
Gelatin silver print
Image: 7½ x 9⁷⁄₁₆
Paper: 8 x 10
University purchase
75.18 §

LEWIS HINE
Untitled (Working Men), n.d.
Gelatin silver print
Image: 4⁹⁄₁₆ x 6⁹⁄₁₆
Paper: 4¹⁵⁄₁₆ x 6¹⁵⁄₁₆
University purchase
75.16

LEWIS HINE
Untitled (Two Boys on a Street Corner), n.d.
Gelatin silver print
Image/Paper: 4⁷⁄₁₆ x 6⁷⁄₁₆
University purchase
75.17 §

ALLAN HOESE
Fields of Fire, 1972
Chromogenic process color print
Image: 6¾ x 9¼
Paper: 7¹⁵⁄₁₆ x 10
Gift of Richard Amerault
92.22.31

JOHN R. HOGAN
A Friend in the Fog, c. 1940
Chlorobromide print
Image/Paper: 13⅜ x 10½
Gift of Arthur S. and Katherine Holt
Mawhinney through Doris M.
Offermann '34
65.1.38

JOHN R. HOGAN
In the Sedge, c. 1940
Chlorobromide print
Image/Paper: 9¼ x 7⁵⁄₁₆
Gift of Barbara Green through Doris M.
Offermann '34
65.1.92

LON HOLMBERG
Bunker and Bay, RVN, 1971
Gelatin silver print
Image: 11⅛ x 16⅝
Paper: 16 x 19⅞
Gift of Richard Amerault
92.22.32

CLAIRE HORR
Adirondack Birches, n.d.
Chromogenic process color print
Image/Paper: 9½ x 13¾
Gift of Dr. Frank P. and Anne C. Piskor
78.224

NANCY L. HUBBARD '75
Untitled (Picture Postcards), c. 1975
Gelatin silver print
Image: 4⁷⁄₁₆ x 6¾
Paper: 7⁹⁄₁₆ x 9⅞
University purchase
75.23.1

LAWRENCE N. HUPPERT '76
Untitled (Child), c. 1974
Gelatin silver print
Image: 4¹¹⁄₁₆ x 6⅝
Paper: 5 x 6¹⁵⁄₁₆
University purchase
74.48.12

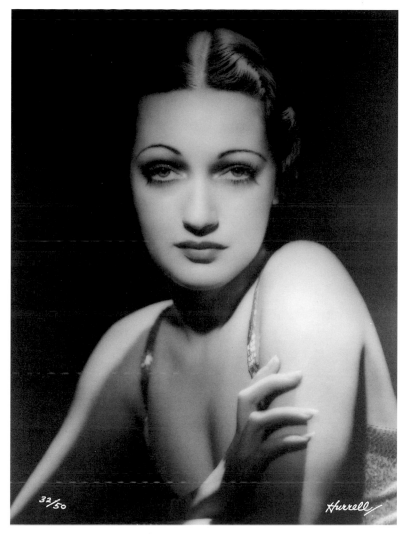

GEORGE HURRELL, *Dorothy Lamour*

LAWRENCE N. HUPPERT '76
Untitled (Face and Fabric), c. 1975
Gelatin silver print
Image: 4⅜ x 6⁹⁄₁₆
Paper: 7⁷⁄₁₆ x 10
University purchase
75.23.6

LAWRENCE N. HUPPERT '76
Untitled (Barn Scene), c. 1975
Gelatin silver print
Image: 5⅞ x 4⅞
Paper: 9¹⁵⁄₁₆ x 6⁹⁄₁₆
University purchase
75.23.11

LAWRENCE N. HUPPERT '76
Untitled (Sky, Leaves and Fence),
c. 1976
Gelatin silver print
Image: 4 x 6¼
Paper: 7¹⁵⁄₁₆ x 9⅞
University purchase
76.31

GEORGE HURRELL
Portfolio II (Los Angeles, CA: Allan
Rich, 1980)
Series of 8 gelatin silver prints
Gift of Albert Vaiser, M.D. through the
Martin S. Ackerman Foundation

Greta Garbo, 1930, ed. 22/50
Image/Paper: 47⅞ x 35¹⁵⁄₁₆
85.74

Jane Russell, 1944, ed. 31/50
Image/Paper: 36 x 47⅞
85.75.

Dorothy Lamour, ca. 1936, ed. 32/50
Image/Paper: 47⅞ x 36
85.76 §

Hedy Lamarr, 1938, ed. 24/50
Image/Paper: 47¹³⁄₁₆ x 36
85.77

Johnny Weissmuller, 1932, ed. 24/50
Image/Paper: 47¹³⁄₁₆ x 35¹⁵⁄₁₆
85.78

Douglas Fairbanks, Jr., 1933, ed. 32/50
Image/Paper: 47⅞ x 36
85.79 § *(Fig. 14)*

Ramon Navarro, 1931, ed. 1/50
Image/Paper: 47¹³⁄₁₆ x 36
85.80

Jane Russell, 1944, ed. 21/50
Image/Paper: 36 x 47⅞
85.85

DEBORAH H. HUSTON '77
Untitled (Curtain in Mirror), c. 1974
Gelatin silver print
Image/Paper: 4¾ x 6⁹⁄₁₆
University purchase
74.48.2

JOHN HUTTCHINS
Judith, c. 1937
Chlorobromide print
Image/Paper: 13⅞ x 10¹⁵⁄₁₆
Gift of Arthur S. and Katherine Holt
Mawhinney through Doris M.
Offermann '34
65.1.90

JAY IRELAND '76
Untitled (Child Smoking), c. 1975
Gelatin silver print
Image: 5 x 3⅜
Paper: 10 x 7⅞
University purchase
75.23.2

OLGA EMMA IRISH
Top Lofty, n.d.
Chlorobromide print
Image/Paper: 19⅝ x 15⁹⁄₁₆
Gift of the artist through Doris M.
Offermann '34
65.1.5

OLGA EMMA IRISH
Untitled (Windows), n.d.
Chlorobromide print
Image: 19 x 15
Paper: 19¾ x 16
Gift of Doris M. Offermann '34
65.1.46

OLGA EMMA IRISH
Set to Go, n.d.
Chlorobromide print
Image/Paper: 16½ x 13⁷⁄₁₆
Gift of the artist through Doris M.
Offermann '34
65.1.47

OLGA EMMA IRISH
Lost, n.d.
Chlorobromide print
Image: 16¹⁄₁₆ x 13¼

OLGA EMMA IRISH, *All Eyes*

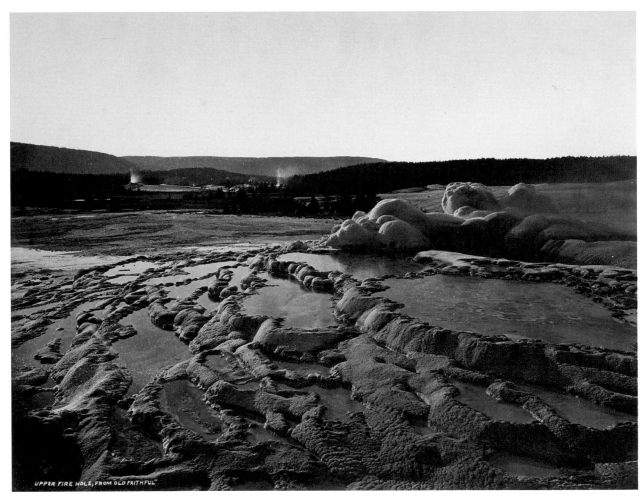

WILLIAM HENRY JACKSON, *Upper Fire Hole, from "Old Faithful"*

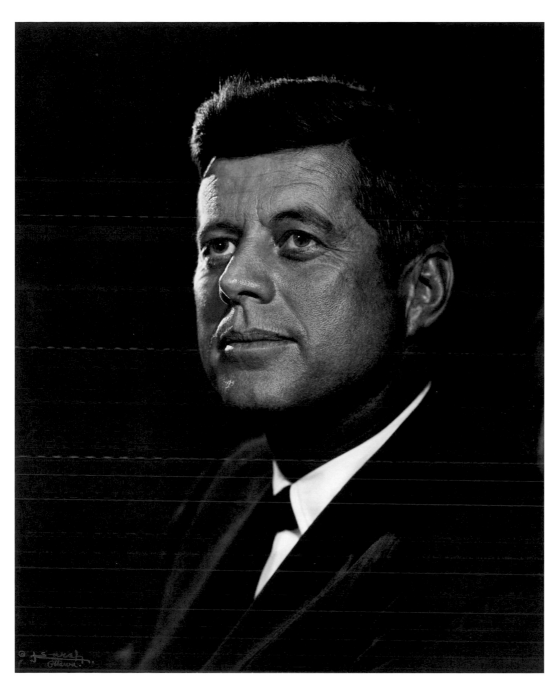

YOUSUF KARSH, *Portrait of John Fitzgerald Kennedy*

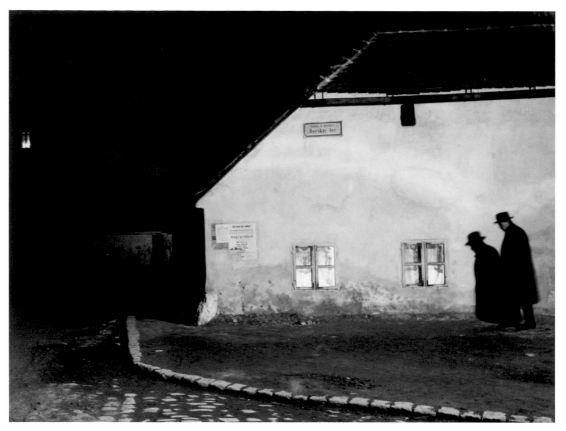

ANDRÉ KERTÉSZ, *Bockay Tér*

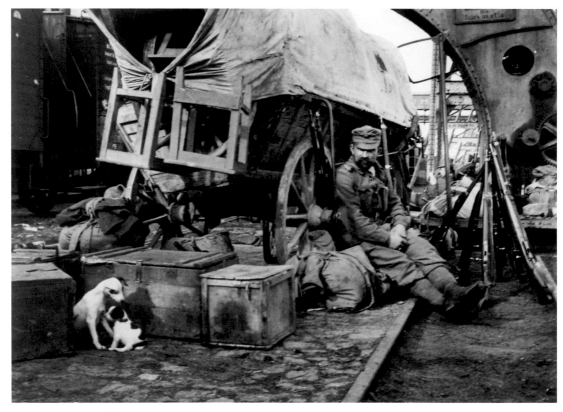

ANDRÉ KERTÉSZ, *Transport*

JOHN P. KELLY, *The Jumper: 90M Jumping Finals, 1980 Winter Olympics, Lake Placid*

Paper: 16⅜ x 13⅜
Gift of Doris M. Offermann '34
65.1.48

OLGA EMMA IRISH
New Amsterdam, n.d.
Chlorobromide print
Image/Paper: 18½ x 14½
Gift of the artist through Doris M.
Offermann '34
65.1.49

OLGA EMMA IRISH
All Eyes, n.d.
Chlorobromide print
Image/Paper: 13⅜ x 15⅝
Gift of the artist through Doris M.
Offermann '34
65.1.50 §

OLGA EMMA IRISH
Immaculata, n.d.
Chlorobromide print
Image/Paper: 18⅜ x 14½
Gift of Doris M. Offermann '34
65.1.51

OLGA EMMA IRISH
Gishlain Lootens, n.d.
Chlorobromide print
Image/Paper: 18⅜ x 14⅜
Gift of Doris M. Offermann '34
65.1.87

WILLIAM HENRY JACKSON
Upper Fire Hole, from "Old Faithful,"
c. 1880s
Albumen print
Image: 10 x 13
Paper: 15⅛ x 18¹⁵⁄₁₆
Gift of Dr. Alfred Romer
X.289 §

SIDNEY JAFFE
Merry Monk, n.d.
Gelatin silver print
Image: 13⅜ x 10⁷⁄₁₆
Paper: 13⅞ x 10¹⁵⁄₁₆
Gift of Barbara Green through Doris M.
Offermann '34
65.1.64

FLORENCE JORDY
Title Holders, Puppy Class, n.d.
Chlorobromide print
Image/Paper: 13⅞ x 16¾
Gift of Arthur S. and Katherine Holt
Mawhinney through Doris M.
Offermann '34
65.1.96

HANS KADEN
Pastural, n.d.
Chlorobromide print
Image/Paper: 16⅞ x 13⅞
Gift of Doris M. Offermann '34
65.1.20

HANS KADEN
Dusk, n.d.
Chlorobromide print
Image: 18¾ x 15³⁄₁₆
Paper: 18⅞ x 15⁵⁄₁₆
Gift of Doris M. Offermann '34
65.1.118

YOUSUF KARSH
Portrait of John Fitzgerald Kennedy,
c. 1961
Gelatin silver print
Image/Paper: 19⅝ x 15¹⁵⁄₁₆
University purchase
66.27 §

JOHN P. KELLY '69
*The Jumper: 90M Jumping Finals,
1980 Winter Olympics, Lake Placid*,
1980
Chromogenic process color print
Image/Paper: 30 x 19⅞
Gift of the artist
82.100 §

JOHN P. KELLY '69
*Jack Nicklaus: Winning Putt, 18th
Hole*, June 1980

Chromogenic process color print
Image/Paper: 19⅜ x 12⅜
Gift of the artist
82.99

JOHN P. KELLY '69
Destination, 1980
Chromogenic process color print
Image/Paper: 29 x 20
Gift of the artist
82.101

PHILIP E. KELLEY '77
Untitled (Park at Dusk), 1976
Gelatin silver print
Image: 5 x 7½
Paper: 8 x 9¹⁵⁄₁₆
University purchase
76.33

ANDRÉ KERTÉSZ
A Hungarian Memory (New York:
Hyperion Press, 1980)
Portfolio of 13 gelatin silver prints, ed.
12/100
Gift of Donald T. Johnson '61
83.141

Hungarian Landscape, Puszta, 1914
Image: 7⅜ x 9¾
Paper: 8 x 9¹⁵⁄₁₆
83.141.1

Tisza-Szalka, July 6, 1924
Image: 7¾ x 9¹¹⁄₁₆
Paper: 8 x 9¹⁵⁄₁₆
83.141.2

Bockay Tér, Budapest, 1914
Image: 7⅜ x 9¹¹⁄₁₆
Paper: 8 x 9¹⁵⁄₁₆
83.141.3 §

Sunset, Esztergom, May 15, 1917
Image: 7¹⁄₁₆ x 9¹¹⁄₁₆
Paper: 8 x 9¹⁵⁄₁₆
83.141.4

Wandering Violinist, Abony,
July 19, 1921
Image: 9¹¹⁄₁₆ x 7½
Paper: 9¹⁵⁄₁₆ x 7¹⁵⁄₁₆
83.141.5 § *(Plate 16)*

My Brothers, Budapest, 1919
Image: 7¹¹⁄₁₆ x 9¹¹⁄₁₆
Paper: 7¹⁵⁄₁₆ x 9¹⁵⁄₁₆
83.141.6

The Swing, Esztergom,
September 26, 1917
Image: 9¹¹⁄₁₆ x 7⁹⁄₁₆
Paper: 9⅞ x 8
83.141.7

Trio, Ráczkeve, May 6, 1923

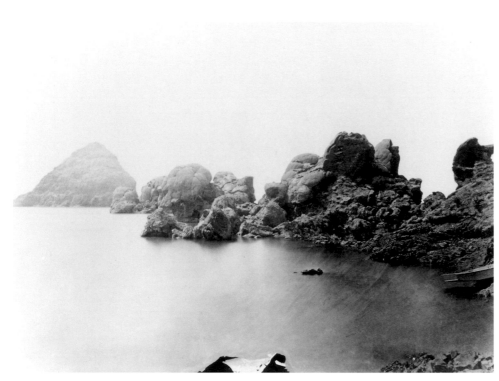

TIMOTHY O'SULLIVAN, *Pyramid Lake Nevada, Pyramid Island and Tufa Knobs, Thinolite*

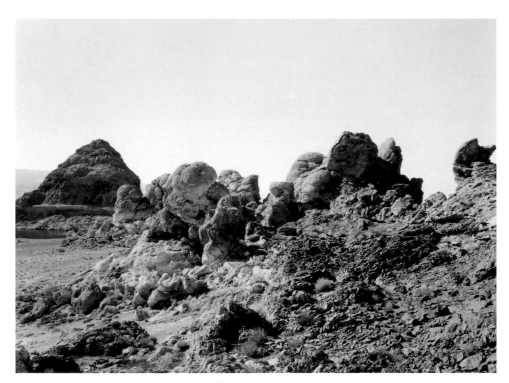

MARK C. KLETT, *Tufa Knobs, Pyramid Lake, Nevada*

Image: 7⁵/₁₆ x 9¹¹/₁₆
Paper: 7¹⁵/₁₆ x 9¹⁵/₁₆
83.141.8

Heavy Burden, Esztergom, 1916
Image: 7³/₈ x 9¾
Paper: 7¹⁵/₁₆ x 9¹⁵/₁₆
83.141.9

Country Accident, Esztergom,
September 1916
Image: 7⁵/₈ x 9¹¹/₁₆
Paper: 8 x 9¹⁵/₁₆
83.141.10 § *(Fig. 5)*

Transport, Braila, Rumania,
October 19, 1918

Image: 7³/₁₆ x 9¹¹/₁₆
Paper: 8 x 9¹⁵/₁₆
83.141.11 §

*Forced March to the Front between
Lonié and Mitulen,* Poland,
July 19, 1915
Image: 6¾ x 9¾
Paper: 8 x 9¹⁵/₁₆
83.141.12

Budafok, 1919
Image: 7 x 9¾
Paper: 8 x 9¹⁵/₁₆
83.141.13

HELMMO KINDERMANN
*Doggie Discipline/An Owner's
Manual-Levi's,* 1981
Gelatin silver print
Image: 12⁹/₁₆ x 18⁵/₈
Paper: 15¹⁵/₁₆ x 19¹³/₁₆
University purchase
81.74

MARK C. KLETT '74
Untitled (Windows and Shadow on
Textured Wall), c. 1973
Gelatin silver print
Image: 6¼ x 7⁷/₈
Paper: 10¹⁵/₁₆ x 13¹³/₁₆
University purchase
73.107.1

MARK C. KLETT '74
Untitled (View Down Staircase),
c. 1973
Gelatin silver print
Image: 5¹³/₁₆ x 8¹¹/₁₆
Paper: 10¹⁵/₁₆ x 13⁷/₈
University purchase
73.107.2

MARK C. KLETT '74
Untitled (Female Nude), c. 1973
Gelatin silver print
Image: 5¹¹/₁₆ x 7³/₈
Paper: 10¹⁵/₁₆ x 13⁷/₈
University purchase
73.107.3

MARK C. KLETT '74
Untitled (Female Nude), c. 1973
Gelatin silver print
Image: 6 x 7⁵/₈
Paper: 10¹⁵/₁₆ x 13⁷/₈
University purchase
73.107.4

MARK C. KLETT '74
*#1 Color Form Series (Silver Ball in
Hand),* c. 1973
Chromogenic process color print

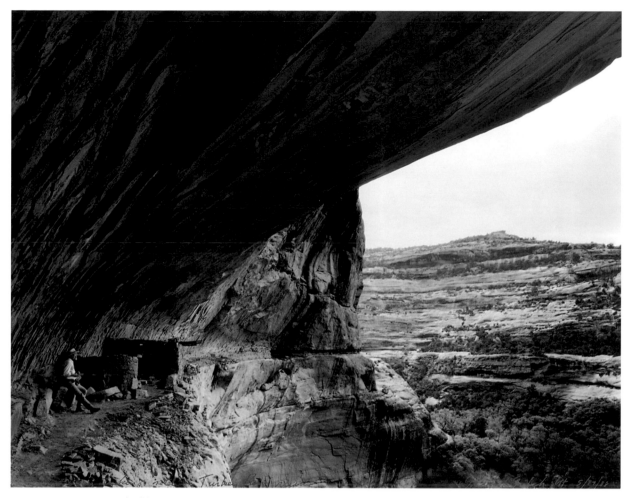

MARK C. KLETT, *Ed Abbey Taking Notes in Turkey Pen Ruins, Grand Gulch, Utah*

Image: 7¼ x 5⁵/₁₆
Paper: 8 x 10
University purchase
74.36.1

MARK C. KLETT '74
#2 Color Form Series (Red Machine),
c. 1973
Chromogenic process color print
Image: 6¹³/₁₆ x 6¹³/₁₆
Paper: 8 x 10
University purchase
74.36.2

MARK C. KLETT '74
#1 Color Series (Painted Wall), c. 1973
Chromogenic process color print
Image: 5⁹/₁₆ x 6⁹/₁₆
Paper: 8 x 10
University purchase
74.36.3

MARK C. KLETT '74
Untitled (Winding Staircase), c. 1973
Gelatin silver print

Image: 4¹⁵/₁₆ x 3⁵/₁₆
Paper: 8 x 10
University purchase
74.48.1

MARK C. KLETT '74
Untitled (Riverbend), 1975
Chromogenic process color print
Image: 4⅝ x 7¹/₁₆
Paper: 8 x 10
Gift of the artist
75.31.1

MARK C. KLETT '74
Untitled (Sidewalk with Foliage),
1975
Chromogenic process color print
Image: 4⅝ x 7¹/₁₆
Paper: 8 x 10
Gift of the artist
75.31.2

MARK C. KLETT '74
Untitled (Neon Sign), 1975
Chromogenic process color print

Image: 4⅝ x 7¹/₁₆
Paper: 8 x 10
Gift of the artist
75.31.3

MARK C. KLETT '74
Untitled (Corner of Building), 1975
Chromogenic process color print
Image: 4⅝ x 7⅛
Paper: 8 x 10
Gift of the artist
75.31.4

MARK C. KLETT '74
Untitled (Street with Billboard), 1975
Chromogenic process color print
Image: 5¹/₁₆ x 7¹¹/₁₆
Paper: 7¹⁵/₁₆ x 10
Gift of the artist
75.32.1

MARK C. KLETT '74
Untitled (Brick Smokestack), 1975
Chromogenic process color print
Image: 4⅝ x 7¹/₁₆

Paper: 7¹⁵⁄₁₆ x 10
Gift of the artist
75.32.2

MARK C. KLETT '74
Color Multiple Image #1, 1975
Chromogenic process color print
Image: 5¹⁵⁄₁₆ x 7¹¹⁄₁₆
Paper: 8 x 10
Gift of the artist
75.33

**MARK C. KLETT '74 for the
Rephotographic Survey Project**
Vermillion Creek, Colorado, 1979
Gelatin silver print
Image: 6½ x 8¾
Paper: 7¹⁵⁄₁₆ x 9¹⁵⁄₁₆
University purchase
82.196a

**MARK C. KLETT '74 for the
Rephotographic Survey Project**
Tufa Knobs, Pyramid Lake, Nevada,
1979
Gelatin silver print
Image: 6³⁄₁₆ x 8⅜
Paper: 7⅞ x 9¹⁵⁄₁₆
University purchase
82.197a §

**MARK C. KLETT '74 and Gordon
Bushaw for the Rephotographic Survey
Project**
Castle Rock, Green River, Wyoming,
1979
Gelatin silver print
Image: 6⅝ x 9
Paper: 7⅞ x 9⅞
University purchase
82.198a § *(Fig. 7)*

MARK C. KLETT '74
Kem Brown in her Garden, September
6, 1981
Gelatin silver print from Polaroid negative
Image/Paper: 15⅞ x 19¾
University purchase
82.195

MARK C. KLETT '74
Deb, Walker Lake, California, January
24, 1982
Gelatin silver print from Polaroid negative
Image/Paper: 15⅞ x 19¾
University purchase
84.25

MARK C. KLETT '74
*Checking the Road Map: Crossing into
Arizona, Monument Valley*,
June 22, 1982

· 150 ·

Gelatin silver print from Polaroid negative
Image/Paper: 15⅞ x 19¹³⁄₁₆
University purchase
84.27

MARK C. KLETT '74
*Searching for Artifacts: Unexcavated
Ruins, Chaco Canyon, New Mexico*,
September 6, 1982
Gelatin silver print from Polaroid negative
Image/Paper: 15⅞ x 19¹³⁄₁₆
University purchase
84.23

MARK C. KLETT '74
*Campsite Reached by Boat through
Watery Canyons, Lake Powell*, August
20, 1983
Gelatin silver print from Polaroid negative
Image/Paper: 15⅞ x 19⅝
University purchase
84.29

MARK C. KLETT '74
*Evening Storm Passing South, Tucson,
Arizona*, September 5, 1983
Gelatin silver print from Polaroid negative
Image/Paper: 15⅞ x 19¹³⁄₁₆
University purchase
84.26

MARK C. KLETT '74
*Truck Moving West, Echo Cliffs
from Route 89A, Arizona*,
September 14, 1983
Gelatin silver print from Polaroid negative
Image/Paper: 15⅞ x 19¾
University purchase
84.28

MARK C. KLETT '74
*View from London Bridge at Its New
Home, Lake Havasu, Arizona*,
November 13, 1983
Gelatin silver print from Polaroid negative
Image/Paper: 15⅞ x 19¾
University purchase
84.30

MARK C. KLETT '74
*Fallen Cactus, New Golf Course, near
Carefree, Arizona*, March 4, 1984
Gelatin silver print from Polaroid negative
Image/Paper: 15⅞ x 19¹³⁄₁₆
University purchase
84.24

MARK C. KLETT '74
*Under the Dark Cloth, Monument
Valley*, May 1989
Gelatin silver print from Polaroid negative

Image/Paper: 15⅞ x 19¾
Gift of the artist
99.96 § *(Frontispiece)*

MARK C. KLETT '74
*Entering a Narrow Cave, Salt Creek,
Utah*, May 1990
Gelatin silver print from Polaroid negative
Image/Paper: 19¾ x 16
Gift of the artist
99.95 § *(Plate 17)*

MARK C. KLETT '74
*Tea Break at Teapot Rock, after
O'Sullivan, Green River, Wyoming*,
August 1997
Gelatin silver print from Polaroid negative
Image/Paper: 16 x 19¾
Gift of the artist
99.97 § *(Fig. 18)*

MARK C. KLETT '74
*Ed Abbey Taking Notes in Turkey Pen
Ruins, Grand Gulch, Utah*, May 1998
Gelatin silver print from Polaroid negative
Image/Paper: 15⅞ x 19¾
Gift of the artist
99.94 §

CORBIN KOHN
Smoky Weather, c. 1939
Chlorobromide print
Image/Paper: 16⅜ x 13⅛
Gift of Newell Green through Doris M.
Offermann '34
65.1.3

JOHN KREVO
Chow Line, RVN, 1967
Chromogenic process color print
Image: 6¾ x 9³⁄₁₆
Paper: 7¹⁵⁄₁₆ x 9¹⁵⁄₁₆
Gift of Richard Amerault
92.22.33

JOOST DE LAAT '98
Tader, 1997, printed 1998
Chromogenic process color print
Image/Paper: 11⅞ x 17¾
Purchased with funds from the Jeanne
Scribner Cashin Endowment for Fine Arts
established by Thomas H. Cashin '46
98.19

LISA LAW
Haight-Ashbury, Allen Ginsberg, 1967
Gelatin silver print
Image: 13⅜ x 10½
Paper: 13¹⁵⁄₁₆ x 11¹⁄₁₆
Gift of Richard Amerault
92.22.34

WILLIAM LEAHY
Orphan Girls, RVN, 1960s
Chromogenic process color print
Image: 7¹⁵⁄₁₆ x 6⅜
Paper: 9¹⁵⁄₁₆ x 8
Gift of Richard Amerault
92.22.35

RUSSELL LEE
Orchestra during Intermission at Square Dance . . . , McIntosh County, Oklahoma, 1939 or 1940, printed 1986
Dye transfer print
Image: 6¹⁵⁄₁₆ x 10¹⁄₁₆
Paper: 10 x 13¹⁄₁₆
Gift of Rick Jeffrey (parent of Richard Jeffrey, Jr. '85)
92.11.14

RUSSELL LEE
Round Dance between Squares at Dance in McIntosh County, Oklahoma, 1939 or 1940, printed 1985
Dye transfer print
Image: 6⅞ x 10⅛
Paper: 9⅞ x 13
Gift of Rick Jeffrey (parent of Richard Jeffrey, Jr. '85)
92.11.15 §

RUSSELL LEE
Couples at Square Dance, McIntosh County, Oklahoma, 1939 or 1940, printed 1985
Dye transfer print
Image: 6⁷⁄₁₆ x 9¹³⁄₁₆
Paper: 9⁷⁄₁₆ x 13
Gift of Rick Jeffrey (parent of Richard

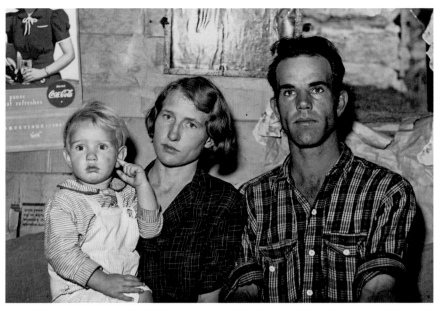

RUSSELL LEE, *Jack Whinery, Homesteader, with His Wife and the Youngest of His Five Children, Pie Town, New Mexico*

Jeffrey, Jr. '85)
92.11.16

RUSSELL LEE
Jack Whinery, Homesteader, with His Wife and the Youngest of His Five Children, Pie Town, New Mexico, September 1940, printed 1985
Dye transfer print
Image: 6¹⁵⁄₁₆ x 10
Paper: 10 x 13¹⁄₁₆
Gift of Rick Jeffrey (parent of Richard Jeffrey, Jr. '85)
92.11.3 §

RUSSELL LEE
Fruit Wagon at the Pie Town, New Mexico Fair, October 1940, printed 1986
Dye transfer print
Image: 6¹⁵⁄₁₆ x 10
Paper: 10 x 13¹⁄₁₆
Gift of Rick Jeffrey (parent of Richard Jeffrey, Jr. '85)
92.11.9

RUSSELL LEE
Bill Stagg Turning Up Pinto Beans, Pie Town, New Mexico, October 1940, printed 1985
Dye transfer print
Image: 9¹⁵⁄₁₆ x 6¾
Paper: 12¹⁵⁄₁₆ x 9⅝
Gift of Rick Jeffrey (parent of Richard Jeffrey, Jr. '85)
92.11.10

RUSSELL LEE
Jim Norris and Wife, Homesteaders, Pie Town, New Mexico, October 1940, printed 1985
Dye transfer print
Image: 6¹¹⁄₁₆ x 9¾
Paper: 9¹⁵⁄₁₆ x 12¹⁵⁄₁₆
Gift of Rick Jeffrey (parent of Richard Jeffrey, Jr. '85)
92.11.11

RUSSELL LEE
Filling Station and Garage at Pie Town, New Mexico, October 1940, printed 1985

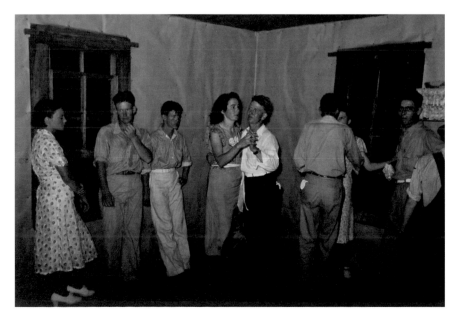

RUSSELL LEE, *Round Dance between Squares at Dance in McIntosh County, Oklahoma*

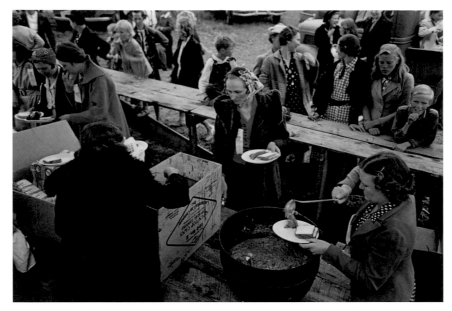

RUSSELL LEE, *Serving Pinto Beans at the Pie Town, New Mexico Fair*

Dye transfer print
Image: 6¹¹⁄₁₆ x 10
Paper: 9¾ x 13
Gift of Rick Jeffrey (parent of Richard
Jeffrey, Jr. '85)
92.11.12

RUSSELL LEE
*Mrs. Bill Stagg with State Quilt, Pie
Town, New Mexico*, October 1940,
printed March 1986
Dye transfer print
Image: 10¹⁄₁₆ x 6¹¹⁄₁₆
Paper: 13⅝ x 9⅝
Gift of Rick Jeffrey (parent of Richard
Jeffrey, Jr. '85)
92.11.13

RUSSELL LEE
*Distributing Surplus Commodities,
St. Johns, Arizona*, October 1940,
printed 1984
Dye transfer print
Image: 6½ x 9¹⁵⁄₁₆
Paper: 9¾ x 13
Gift of Rick Jeffrey (parent of Richard
Jeffrey, Jr. '85)
92.11.22

RUSSELL LEE
*Friends Meeting at the Pie Town, New
Mexico Fair*, October 1940, printed
1985
Dye transfer print
Image: 6⁹⁄₁₆ x 9⅞
Paper: 9¹⁵⁄₁₆ x 13
Gift of Rick Jeffrey (parent of Richard
Jeffrey, Jr. '85)
92.11.39

RUSSELL LEE
*School Children Singing, Pie Town,
New Mexico*, October 1940, printed
1986
Dye transfer print
Image: 6⁹⁄₁₆ x 9⅞
Paper: 9¹¹⁄₁₆ x 13
Gift of Rick Jeffrey (parent of Richard
Jeffrey, Jr. '85)
92.11.40 § *(Plate 18)*

RUSSELL LEE
Main Street, Pie Town, New Mexico,
October 1940, printed c. 1984–1986

Dye transfer print
Image: 6¹¹⁄₁₆ x 10
Paper: 10 x 13¼
Gift of Rick Jeffrey (parent of Richard
Jeffrey, Jr. '85)
92.11.41

RUSSELL LEE
*Grace Was Said before the Barbeque
Was Served at the Pie Town, New
Mexico Fair*, October 1940, printed
1985
Dye transfer print
Image: 7 x 10
Paper: 9¹⁵⁄₁₆ x 13¹⁄₁₆
Gift of Rick Jeffrey (parent of Richard
Jeffrey, Jr. '85)
92.11.42

RUSSELL LEE
*Saying Grace before the Barbeque
Dinner at the Pie Town, New Mexico
Fair*, October 1940, printed 1985
Dye transfer print
Image: 6⅝ x 9¹³⁄₁₆
Paper: 9¹¹⁄₁₆ x 12⅞
Gift of Rick Jeffrey (parent of Richard
Jeffrey, Jr. '85)
92.11.43

RUSSELL LEE
*Serving Pinto Beans at the Pie Town,
New Mexico Fair*, October 1940,
printed 1985
Dye transfer print
Image: 6¹⁵⁄₁₆ x 10
Paper: 10 x 13
Gift of Rick Jeffrey (parent of Richard
Jeffrey, Jr. '85)
92.11.44 §

RUSSELL LEE, *Grain Elevators, Caldwell, Idaho*

RUSSELL LEE, *Wheat Farm, Walla Walla, Washington*

RUSSELL LEE
Cutting the Pies and Cakes at the Barbeque Dinner, Pie Town, New Mexico Fair, October 1940, printed 1985
Dye transfer print
Image: 6⅞ x 9¹⁵⁄₁₆
Paper: 9¹⁵⁄₁₆ x 12¹⁵⁄₁₆
Gift of Rick Jeffrey (parent of Richard Jeffrey, Jr. '85)
92.11.45

RUSSELL LEE
People at the Fair, Pie Town, New Mexico, October 1940, printed 1985
Dye transfer print
Image: 6⅝ x 10¼
Paper: 9⅝ x 12¹⁵⁄₁₆
Gift of Rick Jeffrey (parent of Richard Jeffrey, Jr. '85)
92.11.46

RUSSELL LEE
Jim Norris, Homesteader, Pie Town, New Mexico, October 1940, printed 1986
Dye transfer print
Image: 6⁹⁄₁₆ x 9¹⁵⁄₁₆
Paper: 9½ x 13
Gift of Rick Jeffrey (parent of Richard Jeffrey, Jr. '85)
92.11.47

RUSSELL LEE
Group of Homesteaders in Front of the Bean House Which Was Used for Exhibit Hall at the Pie Town, New

Mexico Fair, October 1940, printed 1985
Dye transfer print
Image: 6⅝ x 10
Paper: 9¾ x 12¹⁵⁄₁₆
Gift of Rick Jeffrey (parent of Richard Jeffrey, Jr. '85)
92.11.48

RUSSELL LEE
Grain Elevators, Caldwell, Idaho, July 1941, printed 1986
Dye transfer print
Image: 7 x 10
Paper: 10¹⁄₁₆ x 13¹⁄₁₆
Gift of Rick Jeffrey (parent of Richard Jeffrey, Jr. '85)
92.11.23 §

RUSSELL LEE
On Main Street, Cascade, Idaho, July 1941, printed 1985
Dye transfer print
Image: 6¹³⁄₁₆ x 9¹⁵⁄₁₆
Paper: 9¹³⁄₁₆ x 12⅞
Gift of Rick Jeffrey (parent of Richard Jeffrey, Jr. '85)
92.11.24

RUSSELL LEE
Wheat Farm, Walla Walla, Washington, July 1941, printed 1985
Dye transfer print
Image: 6¹⁵⁄₁₆ x 9¹⁵⁄₁₆
Paper: 10 x 13
Gift of Rick Jeffrey (parent of Richard Jeffrey, Jr. '85)
92.11.25 §

WELLINGTON LEE
Umbrella Girl, n.d.
Chromogenic process color print, Ektacolor
Image/Paper: 16¾ x 13⁹⁄₁₆
Gift of the artist through Doris M. Offermann '34
65.1.10 §

WELLINGTON LEE
Steel Age, c. 1940
Chlorobromide print
Image: 19¹¹⁄₁₆ x 7⅞
Paper: 19¹³⁄₁₆ x 8
Gift of Mr. and Mrs. Ludwig Kramer through Doris M. Offermann '34
65.1.69

WELLINGTON LEE
Modernistic, n.d.
Chlorobromide print
Image/Paper: 19⅝ x 15¾
Gift of Mr. and Mrs. Ludwig Kramer through Doris M. Offermann '34
65.1.135

SARA ANNE LESSER '91
Untitled (Woman's Neck), April 1991
Gelatin silver print
Image/Paper: 9¹¹⁄₁₆ x 13⅜
Purchased with funds from the Jeanne Scribner Cashin Endowment for Fine Arts established by Thomas H. Cashin '46
91.17

FAY STURTEVANT LINCOLN
Untitled (Mont St. Michel), c. 1939
Chlorobromide print
Image/Paper: 13⅜ x 10¼
Gift of Barbara Green through Doris M. Offermann '34
65.1.21

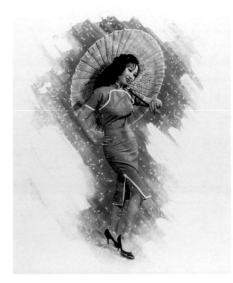

WELLINGTON LEE, *Umbrella Girl*

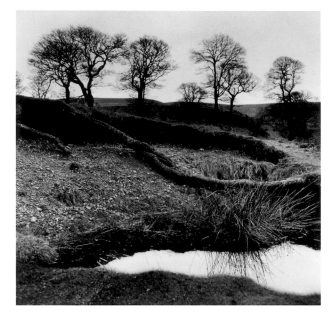

ALEN MACWEENEY, *Wicklow Trees, County Wicklow, Ireland*

ROGER MANLEY, *Reverend Ruth at Big No. 5,* 1987

OTTO LITZEL
Mighty Manhattan, n.d.
Gelatin silver print
Image/Paper: 13½ x 16⅞
Gift of Arthur S. and Katherine Holt
Mawhinney through Doris M.
Offermann '34
65.1.4

MARTINA LOPEZ
Heirs Come to Pass, 2, 1991
Silver-dye bleach print
Image: 30 x 50⅜
Paper: 41¼ x 60
Purchased with funds from the Eben
Griffiths '07 Endowment
92.29 § *(Plate 19)*

SARAH LOTT '00
Reflection, June 1999
Silver-dye bleach print
Image: 9½ x 14
Paper: 11 x 14
Purchased with funds from the Helen
Jeanne Gilbert Endowment established by
Richard F. Brush '52
2000.10

WILLIAM P. LOVEJOY, JR. '88
Untitled (Stairs and Shadows Against
Warehouse Wall), 1988
Gelatin silver print
Image/Paper: 5½ x 6⅞
University purchase
88.9

DAVID A. MACPHEE '76
Untitled (Figure in Field, Dog on
Wooded Path), c. 1975

Gelatin silver print, diptych
Image/Paper: 6⁵⁄₁₆ x 10
University purchase
75.23.3

DAVID A. MACPHEE '76
Untitled (House with Gables),
c. 1975
Gelatin silver print
Image: 4⁹⁄₁₆ x 6¹³⁄₁₆
Paper: 7⅜ x 10
University purchase
75.23.12

DAVID A. MACPHEE '76
Untitled (Porch and White Fence),
c. 1974
Gelatin silver print
Image/Paper: 5⅛ x 3⅞
University purchase
74.48.8

ALEN MACWEENEY
Alen MacWeeney (New York:
Hyperion Press Limited, 1979)
Portfolio of 11 gelatin silver prints, ed. 13/90
Gift of Donald T. Johnson '61
82.26

*Wicklow Trees, County Wicklow,
Ireland,* 1965–1966
Image: 11¾ x 11¹³⁄₁₆
Paper: 19¹³⁄₁₆ x 15⅞
82.26.1 §

Chimney Sweep and Children, Ireland,
1965–1966
Image: 11¹¹⁄₁₆ x 11⅝
Paper: 15⅞ x 19¹³⁄₁₆
86.26.2

*Flies in the Window, Castletown
House, Ireland,* 1972
Image: 10⅝ x 15⅝
Paper: 15¹⁵⁄₁₆ x 19¹³⁄₁₆
82.26.3

Horsewoman, Ireland, 1965
Image: 11¹³⁄₁₆ x 11¹¹⁄₁₆
Paper: 19¾ x 15⅞
82.26.4

*The Head of Blessed Oliver Plunkett,
Ireland,* 1965–1966
Image: 12¹⁄₁₆ x 11⅛
Paper: 19¹³⁄₁₆ x 15⅞
82.26.5 § *(Plate 20)*

Nightwalkers, Dublin, Ireland,
1965–1966
Image: 10⅝ x 15½
Paper: 15⅞ x 19¹³⁄₁₆
82.26.6

Joe and Olivene, Ireland, 1965–1966
Image: 10⅜ x 15⁹⁄₁₆
Paper: 15⅞ x 19¾
82.26.7

*John Grogan, A Patriot and His Dog,
Ireland,* 1965–1966
Image: 12⅛ x 11¹³⁄₁₆
Paper: 19¾ x 15¹³⁄₁₆
82.26.8

*Watching, A Street Scene, Dublin,
Ireland,* 1965–1966
Image: 12¾ x 11⁵⁄₁₆
Paper: 19¾ x 15⅞
82.26.9

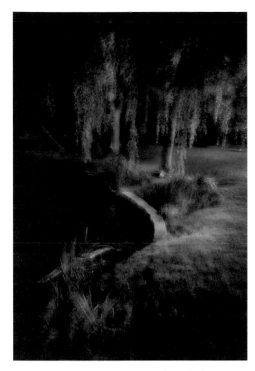

RICHARD MARGOLIS, *#140 Stratford*

Little Tinker Child, Ireland,
1965–1966
Image: 11½ x 11½
Paper: 19¾ x 15¹⁵⁄₁₆
82.26.10

The Townland, Donegal, Ireland,
1965–1966
Image: 11⅝ x 11⅝
Paper: 19¹³⁄₁₆ x 15¹⁵⁄₁₆
82.26.11

DANIEL MAINZER
Chicago Wall, 1970
Chromogenic process color print
Image: 13 x 8⅞
Paper: 13¹⁵⁄₁₆ x 10¹⁵⁄₁₆
Gift of Richard Amerault
92.22.36

DANIEL MAINZER
Denver, 1970
Gelatin silver print
Image: 13⁷⁄₁₆ x 8¹⁵⁄₁₆
Paper: 14 x 10¹⁵⁄₁₆
Gift of Richard Amerault
92.22.37

DANIEL MAINZER
Ohio University, Ohio, 1971
Chromogenic process color print
Image: 7⅞ x 11⅞
Paper: 10⅞ x 13¹⁵⁄₁₆
Gift of Richard Amerault
92.22.38

DANIEL MAINZER
Ohio University, Ohio, 1971
Chromogenic process color print
Image: 9⁷⁄₁₆ x 6⅝
Paper: 9⅞ x 7¹⁵⁄₁₆
Gift of Richard Amerault
92.22.39

WILLIAM MALLAS
Barrels, n.d.
Chromogenic process color print
Image: 7⁷⁄₁₆ x 18¹⁵⁄₁₆
Paper: 7½ x 19
Gift of Dr. William and Mary Mallas
through Doris M. Offermann '34
65.1.12

MARY MALLAS
A Helping Hand, n.d.
Chromogenic process color print
Image/Paper: 15⅝ x 12⁹⁄₁₆
Gift of Dr. William and Mary Mallas
through Doris M. Offermann '34
65.1.13

SUSAN A. MALLEN-MARCERO '68
Untitled (Sculpture Garden with
Visitors), 1967
Gelatin silver print
Image/Paper: 7⁷⁄₁₆ x 9⁷⁄₁₆
University purchase
68.5

ROGER MANLEY
Reverend Ruth at Big No. 5, 1987,
printed 1991
Gelatin silver print
Image: 14⅛ x 14⁷⁄₁₆
Paper: 19⅞ x 15¹³⁄₁₆
Purchased with funds from the Helen
Jeanne Gilbert Endowment established by
Richard F. Brush '52
91.24 §

RICHARD MARGOLIS
#140 Stratford, September 4, 1977
Gelatin silver print
Image: 18½ x 12½
Paper: 19¾ x 15¹⁵⁄₁₆
University Purchase
77.69 §

T. WILLIAM MARTIN
Manhattan Vista, n.d.
Chlorobromide print
Image/Paper: 13⁹⁄₁₆ x 16¼
Gift of Barbara Green through Doris M.
Offermann '34
65.1.41

CHARLES MARTZ
Untitled (Violinist), c. 1942
Gelatin silver print
Image: 10 x 7⅞
Paper: 11¹³⁄₁₆ x 9⁷⁄₁₆
Gift of Barbara Green through Doris M.
Offermann '34
65.1.123 §

ARTHUR S. MAWHINNEY
Cape Cod Light, c. 1940
Chlorobromide print
Image/Paper: 13¼ x 10¼
Gift of Arthur S. and Katherine Holt
Mawhinney through Doris M.
Offermann '34
65.1.31

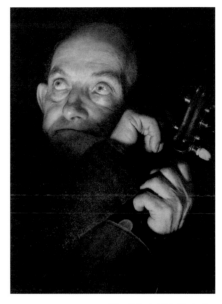

CHARLES MARTZ, Untitled (Violinist)

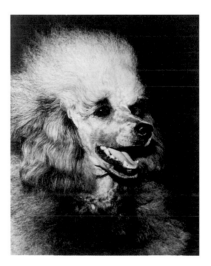

ARTHUR S. MAWHINNEY,
Ch. Cartlane Claudine

AMANDA MEANS, *Flower Number 61*

ARTHUR S. MAWHINNEY
Ch. Basquarie Gui de Noel, c. 1940
Chlorobromide print
Image/Paper: 16½ x 13
Gift of Arthur S. and Katherine Holt
Mawhinney through Doris M.
Offermann '34
65.1.80

ARTHUR S. MAWHINNEY
Ch. Rascal Red Pat, c. 1940
Chlorobromide print
Image/Paper: 16½ x 13⁷⁄₁₆
Gift of Arthur S. and Katherine Holt
Mawhinney through Doris M.
Offermann '34
65.1.82

ARTHUR S. MAWHINNEY
Ch. Astwood Qui Vive, c. 1940
Chlorobromide print
Image/Paper: 16⅛ x 13¼
Gift of Arthur S. and Katherine Holt
Mawhinney through Doris M.
Offermann '34
65.1.86

ARTHUR S. MAWHINNEY
Ch. Jimmee Boy, c. 1940
Chlorobromide print
Image/Paper: 16½ x 13½
Gift of Arthur S. and Katherine Holt
Mawhinney through Doris M.
Offermann '34
65.1.102

ARTHUR S. MAWHINNEY
Panzo, c. 1940
Chlorobromide print
Image/Paper: 11¼ x 8⅜
Gift of Arthur S. and Katherine Holt
Mawhinney through Doris M.
Offermann '34
65.1.103

ARTHUR S. MAWHINNEY
Ch. Cartlane Claudine, n.d.
Chlorobromide print
Image/Paper: 14¹³⁄₁₆ x 12¹⁄₁₆

Gift of Arthur S. and Katherine Holt
Mawhinney through Doris M.
Offermann '34
65.1.104 §

ARTHUR S. MAWHINNEY
Ch. Foxcatcher Merrymaker, c. 1940
Chlorobromide print
Image/Paper: 15¼ x 12½
Gift of Arthur S. and Katherine Holt
Mawhinney through Doris M.
Offermann '34
65.1.106

ARTHUR S. MAWHINNEY
Ch. Hersog of Evenlode, c. 1940
Chlorobromide print
Image/Paper: 14¹³⁄₁₆ x 12⅜
Gift of Arthur S. and Katherine Holt
Mawhinney through Doris M.
Offermann '34
65.1.107

ARTHUR S. MAWHINNEY
The Breaker, c. 1939
Chlorobromide print
Image/Paper: 15¹³⁄₁₆ x 12¹³⁄₁₆
Gift of Arthur S. and Katherine Holt
Mawhinney through Doris M.
Offermann '34
65.1.119

ARTHUR S. MAWHINNEY
The Crest Rolls By, c. 1939
Chlorobromide print
Image/Paper: 15⅞ x 12⅞
Gift of Arthur S. and Katherine Holt
Mawhinney through Doris M.
Offermann '34
65.1.128

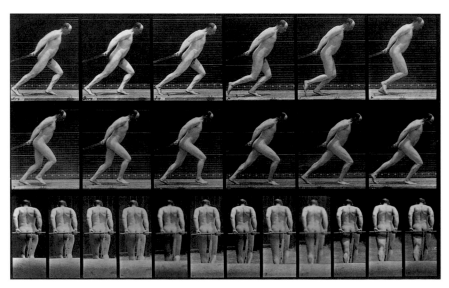

EADWEARD MUYBRIDGE, *Man Pulling Lawn Roller*

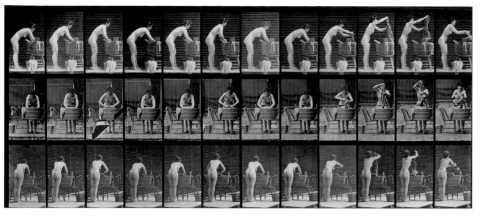

EADWEARD MUYBRIDGE, *Woman Doing Washing in a Tub*

ARTHUR S. MAWHINNEY
Persian Princess, c. 1938
Chlorobromide print
Image/Paper: 10⅜ x 13¼
Gift of Arthur S. and Katherine Holt
Mawhinney through Doris M.
Offermann '34
65.1.132

ARTHUR S. MAWHINNEY
Ch. Bessie's Courageous (Otter Hound),
c. 1940
Chlorobromide print
Image/Paper: 16¼ x 13⁵⁄₁₆
Gift of Arthur S. and Katherine Holt
Mawhinney through Doris M.
Offermann '34
65.1.134

KATHERINE HOLT MAWHINNEY
Antique Shoppe, c. 1938
Chlorobromide print
Image/Paper: 13¼ x 10
Gift of Arthur S. and Katherine Holt
Mawhinney through Doris M.
Offermann '34
65.1.67

KATHERINE HOLT MAWHINNEY
Ch. All Celia's Petit Poilu, c. 1940
Chlorobromide print
Image/Paper: 10⁷⁄₁₆ x 8¼
Gift of Arthur S. and Katherine
Holt Mawhinney through
Doris M. Offermann '34
65.1.108

KATHERINE HOLT MAWHINNEY
Ch. Little Tim's Chipper, c. 1940
Chlorobromide print
Image/Paper: 11⅜ x 9⅜
Gift of Arthur S. and Katherine Holt
Mawhinney through Doris M.

Offermann '34
65.1.110

KATHERINE HOLT MAWHINNEY
Morning Mist, n.d.
Chlorobromide print
Image/Paper: 15¾ x 12⅞
Gift of Arthur S. and Katherine Holt
Mawhinney through Doris M.
Offermann '34
65.1.71

KATHERINE HOLT MAWHINNEY
Bub V. Anwander, n.d.
Gelatin silver print
Image/Paper: 11⁵⁄₁₆ x 8¾
Gift of Arthur S. and Katherine Holt
Mawhinney through Doris M.
Offermann '34
65.1.109

WILLIAM H. MAWHINNEY
Indian Service of Supply, India,
c. 1940
Chlorobromide print
Image/Paper: 12½ x 15¼
Gift of Arthur S. and Katherine Holt
Mawhinney through Doris M.
Offermann '34
65.1.105

AMANDA MEANS
Flower Number 61, 1997
Master gelatin silver print, ed. 2/5
Image: 17¹⁵⁄₁₆ x 21⅞
Paper: 19¾ x 23⅞
Gift of Douglas Beube
99.100 §

RUSSELL MITCHELL
Elephant Grass Cuts, RVN, 1960s
Chromogenic process color print
Image: 7⅜ x 9½
Paper: 8 x 10
Gift of Richard Amerault
92.22.40

DAVID A. MURRAY
And Spring Must Follow, n.d.
Chlorobromide print
Image/Paper: 13⅜ x 16½
Gift of Barbara Green through Doris M.
Offermann '34
65.1.16

EADWEARD MUYBRIDGE
Man Pulling Lawn Roller, pl. 392,
from *Animal Locomotion*
(Philadelphia: University of
Pennsylvania, 1887)

EILEEN NICOSIA, *War Feelings*

DORIS M. OFFERMANN, *The Blizzard*

Collotype
Image: 8⁷⁄₁₆ x 13⁹⁄₁₆
Paper: 19 x 23⁹⁄₁₆
Purchased with funds from the Helena
Walsh Kane Endowment established by
Richard F. Brush '52
95.26 §

EADWEARD MUYBRIDGE
Woman Doing Washing in a Tub,
pl. 432, from *Animal Locomotion*
(Philadelphia: University of
Pennsylvania, 1887)
Collotype
Image: 7¼ x 16½
Paper: 19¹⁄₁₆ x 23¹³⁄₁₆
Purchased with funds from the Helena
Walsh Kane Endowment established by
Richard F. Brush '52
95.27 §

FRANZ C. NICOLAY '73
Untitled (French Door and
Phone), c. 1972
Gelatin silver print
Image/Paper: 9⅜ x 6½
Purchased with funds from the David B.
Steinman Festival of the Arts Endowment
72.5

EILEEN NICOSIA
War Feelings, 1960s
Chromogenic process color print
Image: 6¼ x 9⅜
Paper: 7¹⁵⁄₁₆ x 9⅞
Gift of Richard Amerault
92.22.41

EILEEN NICOSIA
War Feelings, 1960s
Chromogenic process color print
Image: 6¼ x 9⅜
Paper: 7¹⁵⁄₁₆ x 9⅞
Gift of Richard Amerault
92.22.42 §

JOHN PFAHL, *Wave, Lave, Lace, Pescadero Beach, California*

DORIS M. OFFERMANN '34
The Blizzard, c. 1949
Chlorobromide print
Image/Paper: 9⅛ x 7¼
Gift of the artist
65.1.33 §

TIMOTHY O'SULLIVAN
Vermillion Creek Looking Downstream towards Brown's Park, 1872, printed c. 1980
Gelatin silver copy print from original albumen print, U.S.G.S. collection
Image: 6½ x 8¾
Paper: 7⅞ x 9¹⁵⁄₁₆
University purchase
82.196b

TIMOTHY O'SULLIVAN
Pyramid Lake Nevada, Pyramid Island and Tufa Knobs, Thinolite, 1867, printed c. 1980
Gelatin silver copy print from original albumen print, U.S.G.S. collection
Image: 6⅛ x 8⅜
Paper: 7⅞ x 9¹⁵⁄₁₆
University purchase
82.197b §

TIMOTHY O'SULLIVAN
Green River Buttes, Green River, Wyoming, 1872, printed c. 1980
Gelatin silver copy print from original albumen print, U.S.G.S. collection
Image: 6⅝ x 9
Paper: 7⅞ x 9¹⁵⁄₁₆
University purchase
82.198h § *(Fig. 8)*

FRED PALUMBO
Untitled (Worker), c. 1942
Gelatin silver print
Image/Paper: 13¹³⁄₁₆ x 10¹⁵⁄₁₆
Gift of Arthur S. and Katherine Holt Mawhinney through Doris M. Offermann '34
65.1.79

ESTHER PARADA
Native Fruits, 2000
Digital Iris print
Image/Paper: 18 x 27
Purchased with funds from the Eben Griffiths '07 Endowment
2000.17

MICHAEL PEEL
The Camera Never Lies (Guilford, England: Circle Press, 1979)
Artist's book with photograph, ed. 223/300

Gift of Saul Steinberg through the Martin S. Ackerman Foundation
80.100

But . . .
Chromogenic process color print
Image: 6¾ x 9½
Paper: 7¹⁵⁄₁₆ x 10
80.100.2

BLAYLOCK A. PEPPARD '75
Untitled (Refrigerator Interior), c. 1974
Gelatin silver print
Image: 5¾ x 8¹⁵⁄₁₆
Paper: 8¹⁄₁₆ x 9¹⁵⁄₁₆
University purchase
74.48.4

BLAYLOCK A. PEPPARD '75
Untitled (Urban Landscape, Deserted Gas Station), c. 1975
Gelatin silver print
Image: 4¹¹⁄₁₆ x 6¹⁵⁄₁₆
Paper: 8 x 9¹⁵⁄₁₆
University purchase
75.23.5

JOHN PFAHL
Wave, Lave, Lace, Pescadero Beach, California, April 1978
Chromogenic process color print, Ektacolor
Image: 7⅜ x 9⁷⁄₁₆
Paper: 7¹⁵⁄₁₆ x 9¹⁵⁄₁₆
University purchase
78.226 §

JOE PICHLER
Light in Darkness, c. 1942
Chlorobromide print
Image/Paper: 15¹³⁄₁₆ x 13⁵⁄₁₆
Gift of Arthur S. and Katherine Holt Mawhinney through Doris M. Offermann '34
65.1.84

DAVID I. PLATZKER '87
Untitled (Two Calla Lilies), 1987
Gelatin silver print
Image: 10 x 10
Paper: 13¹³⁄₁₆ x 10¹⁵⁄₁₆
University purchase
87.40

DAVID I. PLATZKER '87
Untitled (Calla Lily), 1987
Gelatin silver print
Image: 10 x 10
Paper: 13¹³⁄₁₆ x 10¹⁵⁄₁₆
University purchase
87.41

DAVID I. PLATZKER '87
Untitled (Two Flowers), 1987
Gelatin silver print
Image: 10 x 10
Paper: 13¹⁵⁄₁₆ x 10¹⁵⁄₁₆
University purchase
87.42

DAVID I. PLATZKER '87
Untitled (Flower), 1987
Gelatin silver print
Image: 10 x 10
Paper: 13¾ x 10¹⁵⁄₁₆
University purchase
87.43

DAVID I. PLATZKER '87
Dead Duane, 1987
Gelatin silver print
Image: 9¹¹⁄₁₆ x 9¹¹⁄₁₆
Paper: 13⅞ x 10¹⁵⁄₁₆
University purchase
87.44 §

W. G. POLLAK
Balloon Dancer, n.d.
Chlorobromide print
Image/Paper: 13¼ x 7¹¹⁄₁₆
Gift of Arthur S. and Katherine Holt Mawhinney through Doris M. Offermann '34
65.1.81 § *(Fig. 4)*

C. E. QUEEN
An Khe, 1st Air Cavalry, 1968
Chromogenic process color print
Image: 7⁷⁄₁₆ x 9⁷⁄₁₆
Paper: 7¹⁵⁄₁₆ x 9⅞
Gift of Richard Amerault
92.22.47

DAVID I. PLATZKER, *Dead Duane*

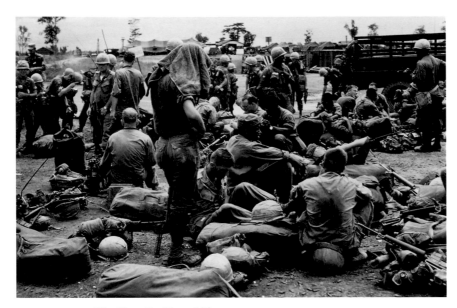

C. E. QUEEN, *War Zone D, Phuoc Vihn*

C. E. QUEEN
Fat Sergeants, RVN, 1960s
Chromogenic process color print
Image: 7 x 9½
Paper: 8 x 10
Gift of Richard Amerault
92.22.48

C. E. QUEEN
War Zone D, Phuoc Vihn, 1966
Chromogenic process color print
Image: 8⁹⁄₁₆ x 12½
Paper: 10¹⁵⁄₁₆ x 13¹⁵⁄₁₆
Gift of Richard Amerault
92.22.49 §

VERNON RANDALL
Village, RVN, 1967
Chromogenic process color print
Image: 10⅜ x 13½
Paper: 10⅞ x 14
Gift of Richard Amerault
92.22.50

TOM A. RITCHIE
The Kunming Kid, n.d.
Chlorobromide print
Image/Paper: 15⁹⁄₁₆ x 13¼
Gift of Arthur S. and Katherine Holt
Mawhinney through Doris M.
Offermann '34
65.1.111

MILTON ROGOVIN
Untitled (Wash Basins on Pole), from
Appalachia, 1970
Gelatin silver print
Image/Paper: 7¾ x 6½

University purchase
77.4

MILTON ROGOVIN
Untitled (Bride and Groom), from
Lower West Side-Buffalo, 1973
Gelatin silver print
Image/Paper: 6⅞ x 6¾
University purchase
77.5

LEROY ROSELIEVE
Untitled (Shipwrecked Boats), n.d.

Gelatin silver Gevalux print
Image/Paper: 13³⁄₁₆ x 10⁵⁄₁₆
Gift of Arthur S. and Katherine Holt
Mawhinney through Doris M.
Offermann '34
65.1.39

LEROY ROSELIEVE
Untitled (Summer Landscape), n.d.
Gelatin silver Gevalux print
Image/Paper: 10⅜ x 13⁷⁄₁₆
Gift of Arthur S. and Katherine Holt
Mawhinney through Doris M.
Offermann '34
65.1.124

LEROY ROSELIEVE
Untitled (Blimps and Palm Trees),
n.d.
Gelatin silver print
Image/Paper: 10⁷⁄₁₆ x 13½
Gift of Arthur S. and Katherine Holt
Mawhinney through Doris M.
Offermann '34
65.148

ARTHUR ROTHSTEIN
Arthur Rothstein (New York:
Hyperion Press, 1981)
Portfolio of 27 gelatin silver prints, ed.
17/50
Gift of Donald T. Johnson '61
83.142

Postmaster Brown, Old Rag, Virginia,
1935
Image: 8¾ x 11½
Paper: 10⅞ x 13¹⁵⁄₁₆
83.142.1

ARTHUR ROTHSTEIN, *Girl at Gee's Bend, Alabama*

Girl at Gee's Bend, Alabama, 1937
Image: 8⅞ x 12
Paper: 10⁷/₁₆ x 13⁷/₁₆
83.142.2 §

Migrant Family, Oklahoma, 1936
Image: 8¹/₁₆ x 12¹/₁₆
Paper: 10⅞ x 13¹⁵/₁₆
83.142.3

Dust Storm, Cimarron County, Oklahoma, 1936
Image: 9 x 8¹⁵/₁₆
Paper: 14 x 10⅞
83.142.4 § *(Plate 21)*

Skull, Badlands, South Dakota, 1936
Image: 8¹⁵/₁₆ x 8¾
Paper: 14 x 10⅞
83.142.5 § *(Fig. 6)*

Minnie Knox, Garrett County, Maryland, 1937
Image: 12¹/₁₆ x 9
Paper: 13¹⁵/₁₆ x 10⅞
83.142.6

Migrant Worker, Visalia, California, 1940
Image: 11⅞ x 9¹/₁₆
Paper: 13⅞ x 10¹⁵/₁₆
83.142.7

John Dudeck, Dalton, New York, 1937
Image: 12 x 8
Paper: 13⅞ x 10¹⁵/₁₆
83.142.8 §

Flood Victim, Missouri, 1938
Image: 12 x 9
Paper: 13¹⁵/₁₆ x 10⅞
83.142.9

Mississippi River Flood, St. Louis, Missouri, 1943
Image: 9¹/₁₆ x 12
Paper: 11 x 13¹⁵/₁₆
83.142.10

Sheepherder's Camp, Montana, 1939
Image: 8¹⁵/₁₆ x 12¹/₁₆
Paper: 10¹³/₁₆ x 13¹⁵/₁₆
83.142.11

Hotel de Paris, Exterior, Georgetown, Colorado, 1939
Image: 8⅞ x 11½
Paper: 10⅞ x 13⅞
83.142.12

Hotel de Paris, Interior, Georgetown, Colorado, 1939
Image: 12 x 8¹³/₁₆
Paper: 13¹⁵/₁₆ x 10⅞
83.142.13

Gamblers, Las Vegas, Nevada, 1947
Image: 9¹/₁₆ x 8¹³/₁₆
Paper: 13¹⁵/₁₆ x 10⅞
83.142.14

Pool Hall, Culp, Illinois, 1940
Image: 9 x 12
Paper: 11 x 13⅞
83.142.15

George Washington Carver, Tuskegee, Alabama, 1941
Image: 12 x 9
Paper: 13¹⁵/₁₆ x 11
83.142.16

Boy with Chicken, Hungjao, China, 1945
Image: 12 x 9
Paper: 13¹⁵/₁₆ x 11
83.142.17

The Burma Road, 1945
Image: 8¹⁵/₁₆ x 8¹³/₁₆
Paper: 13⅞ x 11
83.142.18

Famine Victim, Hengyang, China, 1946
Image: 12¹/₁₆ x 9
Paper: 13¹²/₁₆ x 10⅞
83.142.19

Burial of Famine Victim, Hengyang, China, 1946
Image: 12 x 9
Paper: 14 x 10¹⁵/₁₆
83.142.20

Coal Miners, Wales, 1947
Image: 12¹/₁₆ x 9
Paper: 13¹⁵/₁₆ x 10⅞
83.142.21

Young Coal Miner, Wales, 1947
Image: 11¹⁵/₁₆ x 9
Paper: 13⅞ x 11
83.142.22

Farmers in the Market, Tocco, Italy, 1947
Image: 8⅛ x 11¹⁵/₁₆
Paper: 10¹⁵/₁₆ x 13⅞
83.142.23

John Marin and His Studio, Hoboken, New Jersey, 1949
Image: 9¹/₁₆ x 12
Paper: 11 x 13⅞
83.142.24

American Soldiers in Nightclub, Vienna, Austria, 1947
Image: 12¹/₁₆ x 9
Paper: 13¹⁵/₁₆ x 10⅞
83.142.25

ARTHUR ROTHSTEIN, *John Dudeck, Dalton, New York*

At a Charity Ball, New York City, 1951
Image: 9¼ x 9
Paper: 13¹⁵/₁₆ x 10¹⁵/₁₆
83.142.26

Rockland, Maine, 1937
Image: 8¹/₁₆ x 12
Paper: 10⅞ x 13⅞
83.142.27

RONALD RUSSO
Quan Loi, Nuns, 1960s
Gelatin silver print
Image: 9³/₁₆ x 8¼
Paper: 13⅞ x 10⅞
Gift of Richard Amerault
92.22.51

DRAHOMIR JOSEPH RUZICKA
Sunlight in the Chicken House, c. 1938
Chlorobromide print
Image: 12⁵/₁₆ x 10⁹/₁₆
Paper: 12¾ x 10⁹/₁₆
Gift of Arthur S. and Katherine Holt Mawhinney through Doris M. Offermann '34
65.1.65

DRAHOMIR JOSEPH RUZICKA
The Dictator, c. 1942

ADRIENNE SALINGER, *Daryle M.*

ADRIENNE SALINGER, *Tooth #22*

Gelatin silver print developed in pyrocate-
chin
Image/Paper: 13⅜ x 10⅜
Gift of Arthur S. and Katherine Holt
Mawhinney through Doris M.
Offermann '34
65.1.116

ADRIENNE SALINGER
Daryle M., 1990, printed 1995
Chromogenic process color print, ed. 2/15
Image: 19⁵⁄₁₆ x 23⁹⁄₁₆
Paper: 19⅞ x 23⅞
Purchased with funds from the Helen
Jeanne Gilbert Endowment established by
Richard F. Brush '52
95.16 §

ADRIENNE SALINGER
Tooth #22, 1994
Chromogenic process color print, ed. 2/15
Image: 9¾ x 7¹¹⁄₁₆
Paper: 9¹⁵⁄₁₆ x 7¹⁵⁄₁₆
Purchased with funds from the Helen
Jeanne Gilbert Endowment established by
Richard F. Brush '52
95.17 §

D. H. SARAFIAN
Sand Grass in Rhythm, c. 1942
Chlorobromide print
Image/Paper: 13¾ x 15⅞
Gift of Arthur S. and Katherine Holt
Mawhinney through Doris M.
Offermann '34
65.1.100

STEPHANIE SATTER
Biker, 1971
Chromogenic process color print
Image: 8¼ x 12⅜
Paper: 10⅞ x 13⅞
Gift of Richard Amerault
92.22.52

STEPHANIE SATTER
Jodi, Buffalo Party, 1970
Chromogenic process color print
Image: 7 x 5
Paper: 9⅞ x 7¹⁵⁄₁₆
Gift of Richard Amerault
92.22.53

I. W. SCHMIDT
The Merry Heart, c. 1947
Chlorobromide print
Image/Paper: 12¹³⁄₁₆ x 10½
Gift of Doris M. Offermann '34
65.1.101

LOUIS SCHUCK
River Poesy, n.d.
Gelatin silver Gevalux print
Image/Paper: 10½ x 13⅜
Gift of Arthur S. and Katherine Holt
Mawhinney through Doris M.
Offermann '34
65.1.34

ALFRED C. SCHWARTZ
Boardwalk, n.d.
Gelatin silver print

Image/Paper: 6⅞ x 16¼
Gift of the artist through Doris M.
Offermann '34
65.1.26

ALFRED C. SCHWARTZ
Image of Industry, n.d.
Chlorobromide print
Image/Paper: 13⁷⁄₁₆ x 15¾
Gift of the artist through Doris M.
Offermann '34
65.1.27

ALFRED C. SCHWARTZ
Winterama, n.d.
Chlorobromide print
Image/Paper: 16¼ x 13¹³⁄₁₆
Gift of the artist through Doris M.
Offermann '34
65.1.76

ALFRED C. SCHWARTZ
Modern Symmetry, n.d.
Gelatin silver bromide print
Image/Paper: 13¾ x 14¾
Gift of the artist through
Doris M. Offermann '34
65.1.78

ALFRED C. SCHWARTZ
Snow and Smog, n.d.
Chlorobromide print
Image/Paper: 16¹¹⁄₁₆ x 11¹³⁄₁₆
Gift of the artist through Doris M.
Offermann '34
65.1.83

FAYE A. SERIO, *Pantheon Sky*

FAYE A. SERIO
Istanbul, Turkey, 1995
Dye transfer print
Image: 5¹³/₁₆ x 8½
Paper: 8¼ x 11⅝
Purchased with funds from the Helen
Jeanne Gilbert Endowment established by
Richard F. Brush '52
95.18

FAYE A. SERIO
Panorama, Greece, 1995
Dye transfer print
Image: 6¾ x 5¹⁵/₁₆
Paper: 11⅝ x 8¼
Purchased with funds from the Helen
Jeanne Gilbert Endowment established by
Richard F. Brush '52
95.19

FAYE A. SERIO
Two, 1997
Digital inkjet print
Image: 8¹³/₁₆ x 6
Paper: 11 x 8½

Purchased with funds from the Jeanne
Scribner Endowment for Fine Arts estab-
lished by Thomas H. Cashin '46
98.79

FAYE A. SERIO
Pantheon Sky, 1997
Digital inkjet print
Image: 8¹¹/₁₆ x 6
Paper: 11 x 8½
Purchased with funds from the Jeanne
Scribner Cashin Endowment for Fine Arts
established by Thomas H. Cashin '46
98.80 §

ANDRES SERRANO
Istanbul (Sisters), 1996
Platinum print, ed. 66/125
Image: 9¾ x 8
Paper: 11¹¹/₁₆ x 10
Purchased with funds from the Helena
Walsh Kane Endowment established by
Richard F. Brush '52
2000.1

THOMAS P. SHAVER '76
Untitled (Seashell), n.d.
Gelatin silver print
Image/Paper: 4⅝ x 7³/₁₆
University purchase
74.48.5

THOMAS O. SHEAKELL
Still Life, n.d.
Gelatin silver print
Image/Paper: 10½ x 13¼
Gift of Arthur S. and Katherine Holt
Mawhinney through Doris M.
Offermann '34
65.1.98

MALLON SHEFFIELD
'Taint, n.d.
Chlorobromide print
Image/Paper: 16½ x 13⁵/₁₆
Gift of Arthur S. and Katherine Holt
Mawhinney through Doris M.
Offermann '34
65.1.129

CINDY SHERMAN
Untitled (Self-Portrait), 1985

Chromogenic process color print, ed. 7/15
A.P.
Image: 11½ x 8
Paper: 13¹⁵/₁₆ x 10¹⁵/₁₆
Gift of Dr. Richard T. and Odile ('54) Stern
99.110 § *(Plate 22)*

LAURIE SIMMONS
Party Pictures, 1985
Chromogenic process color print, ed.
50/100
Image: 2¾ x 12¾
Paper: 10¹⁵/₁₆ x 13¹⁵/₁₆
University Purchase
86.36 §

DONALD SIMPSON
Bob Hope Show, 1968
Chromogenic process color print
Image: 8⅞ x 12⁷/₁₆
Paper: 10⅞ x 13⅞
Gift of Richard Amerault
92.22.55

DANA SLAYMAKER
Boyd, Rancho Linda Vista, 1970
Chromogenic process color print
Image: 7 x 9⁷/₁₆
Paper: 8 x 9⅞
Gift of Richard Amerault
92.22.54

W. EUGENE SMITH
Planes and Strip, from *World War II*,
1943–1945
Gelatin silver print
Image: 9⁷/₁₆ x 13⁹/₁₆
Paper: 11 x 13¹³/₁₆
Gift of Gary Fish
85.235.5 §

W. EUGENE SMITH
Soldier Drinking from Canteen, from
World War II, 1943–1945
Gelatin silver print
Image: 9⅞ x 12¹⁵/₁₆
Paper: 10¹⁵/₁₆ x 13⅞
Gift of Gary Fish
85.235.6 §

LAURIE SIMMONS, *Party Pictures*

W. EUGENE SMITH, *Planes and Strip*

W. EUGENE SMITH, *Soldier Drinking from Canteen*

W. EUGENE SMITH
Soldiers and Tank, from *World War II*,
1943–1945
Gelatin silver print
Image: 10½ x 13⁷⁄16
Paper: 10¹⁵⁄16 x 13⅞
Gift of Gary Fish
85.235.7

W. EUGENE SMITH
Water and Mountains, from *World War II*, 1943–1945
Gelatin silver print
Image: 13⅜ x 10⁹⁄16
Paper: 13⅞ x 11
Gift of Gary Fish
85.235.8

W. EUGENE SMITH
Banjo and Harp, from *Folk Singers*,
1947
Gelatin silver print
Image: 11¹¹⁄16 x 10⁷⁄16
Paper: 13⅞ x 11
Gift of Gary Fish
85.235.13

W. EUGENE SMITH
Jean in Snow, from *Theater Girl/Jean Pearson*, 1949
Gelatin silver print
Image: 10½ x 13⅜
Paper: 11 x 13¹⁵⁄16
Gift of Gary Fish
85.235.16

W. EUGENE SMITH
Stokowsky Pointing, from *Recording Artists*, 1951
Gelatin silver print
Image: 10⁷⁄16 x 12¹¹⁄16
Paper: 11 x 14
Gift of Gary Fish
85.235.19 §

W. EUGENE SMITH
Medical Workers, from *Man of Mercy-Schweitzer AFI*, 1954
Gelatin silver print
Image: 13⁹⁄16 x 8¹³⁄16
Paper: 13¹⁵⁄16 x 10⅞
Gift of Gary Fish
85.235.17

W. EUGENE SMITH
Hal Overton, Composer, from *Loft Inside*, 1954
Gelatin silver print
Image: 12½ x 8⅛
Paper: 13⅞ x 10¹⁵⁄16
Gift of Gary Fish
85.235.18

W. EUGENE SMITH
Outdoor Games, from *Pittsburgh*,
1955–1956
Gelatin silver print
Image: 8¹⁵⁄16 x 13⅜
Paper: 11 x 13⅞
Gift of Gary Fish
85.235.9

W. EUGENE SMITH
Flood Control, from *Pittsburgh*,
1955–1956
Gelatin silver print
Image: 8¾ x 13½
Paper: 10⅞ x 13¹⁵⁄16
Gift of Gary Fish
85.235.10

W. EUGENE SMITH, *Stokowsky Pointing*

W. EUGENE SMITH, *Worker Reading Newspaper*

W. EUGENE SMITH, *Pushing Large Machine*

W. EUGENE SMITH
House Construction, from *Pittsburgh*, 1955–1956
Gelatin silver print
Image: 13⅛ x 8⅞
Paper: 13¹⁵⁄₁₆ x 10⅞
Gift of Gary Fish
85.235.11

W. EUGENE SMITH
Men Planting Tree, from *Pittsburgh*, 1955–1956
Gelatin silver print
Image: 8¹¹⁄₁₆ x 13³⁄₁₆
Paper: 10⅞ x 13⅞
Gift of Gary Fish
85.235.12

W. EUGENE SMITH
Charles Lloyd (Sax), from *Jazz Musicians*, 1959–1969
Gelatin silver print
Image: 13½ x 8¾
Paper: 13⅞ x 11
Gift of Gary Fish
85.235.15

W. EUGENE SMITH
Pulling Crate, from *Hitachi*, 1961–1962
Gelatin silver print
Image: 9⅜ x 11⁹⁄₁₆
Paper: 9⅝ x 11⅞
Gift of Gary Fish
85.235.1 § *(Plate 23)*

W. EUGENE SMITH
Pushing Large Machine, from *Hitachi*, 1961–1962
Gelatin silver print
Image: 9¾ x 14⁹⁄₁₆
Paper: 10⅝ x 15
Gift of Gary Fish
85.235.2 §

W. EUGENE SMITH
Worker Reading Newspaper, from *Hitachi*, 1961–1962
Gelatin silver print
Image: 14⅞ x 9¹⁵⁄₁₆
Paper: 15⁹⁄₁₆ x 10⁹⁄₁₆

LOUIS STETTNER, *Man near Manhole, Broadway, New York City*

LOUIS STETTNER, *Black Woman, Rockefeller Center,*
New York City

LOUIS STETTNER, *Horse and Cowboy, Rockefeller Center,*
New York City

Gift of Gary Fish
85.235.3 §

W. EUGENE SMITH
Ladder Platform, Factory, from
Hitachi, 1961–1962
Gelatin silver print
Image: 12³⁄₁₆ x 7⅛
Paper: 13⅞ x 9¹³⁄₁₆
Gift of Gary Fish
85.235.4

W. EUGENE SMITH
Worker Portrait, from *International*
Nickel, n.d.
Gelatin silver print
Image: 13⁹⁄₁₆ x 16½
Paper: 13⅞ x 16¹³⁄₁₆
Gift of Gary Fish
85.235.14

W. EUGENE SMITH
Impeach the Red Mayor, from *Sixties*
Protest and Woodstock, n.d.
Gelatin silver print

Image: 13¼ x 8¹⁵⁄₁₆
Paper: 13⅞ x 11
Gift of Gary Fish
85.235.20

JOHN T. SNYDER
Untitled (Locomotive Wheels),
c. 1938
Gelatin silver print
Image: 14 x 16⅝
Paper: 14¼ x 16⅞
Gift of Arthur S. and Katherine Holt
Mawhinney through Doris M.
Offermann '34
65.1.127

THOMAS W. SOUTHALL '73
Leaves, 1973
Chromogenic process color print
Image: 8¹¹⁄₁₆ x 6½
Paper: 9¹⁵⁄₁₆ x 8¹⁄₁₆
University purchase
73.105

THOMAS W. SOUTHALL '73
Motel Wall, 1973

Chromogenic process color print
Image: 5¼ x 7¹³⁄₁₆
Paper: 8 x 9¹⁵⁄₁₆
University purchase
73.106

JOHN SPRINGTHORPE
Fishermen, South Carolina, n.d.
Chlorobromide print
Image/Paper: 16³⁄₁₆ x 13⁵⁄₁₆
Gift of Arthur S. and Katherine Holt
Mawhinney through Doris M.
Offermann '34
65.1.70

JEFFREY B. STANNARD '75
Untitled (Screen Door), c. 1975
Gelatin silver print
Image/Paper: 6⅜ x 4⅜
University purchase
74.48.6

PATRICK STEARNS
My Squad, Quang Tri, 1969
Chromogenic process color print
Image: 7¹⁵⁄₁₆ x 7½

Paper: 9⅞ x 8
Gift of Richard Amerault
92.22.56

PATRICK STEARNS
Quang Tri, 1969
Chromogenic process color print
Image: 7¹⁵⁄₁₆ x 7½
Paper: 9¹⁵⁄₁₆ x 7¹⁵⁄₁₆
Gift of Richard Amerault
92.22.57 § *(Plate 24)*

LOUIS STETTNER
Streetwork (New York: Symbax, 1981)
Portfolio of 12 gelatin silver prints, ed. 25/30
Gift of Ben Wunsch through the Martin S. Ackerman Foundation
85.102

Children, Aubervilliers, France, 1947
Image/Paper: 17¹⁄₁₆ x 13⁹⁄₁₆
85.102.1

Man near Manhole, Broadway, New York City, 1954
Image/Paper: 17¹⁵⁄₁₆ x 12
85.102.2 §

Truck, Garment District, New York City, 1979
Image/Paper: 18⅝ x 12⅜
85.102.3

People Walking, Fifth Avenue, New York City, 1976
Image: 17¹³⁄₁₆ x 11¹⁵⁄₁₆
85.102.4

Black Woman, Rockefeller Center, New York City, 1974
Image/Paper: 17¹³⁄₁₆ x 12
85.102.5 §

Parking Lot, Volendam, Holland, 1962
Image/Paper: 12 x 18
85.102.6

Car in Winter, Seventh Avenue, New York City, 1956
Image/Paper: 17¹⁵⁄₁₆ x 11⅞
85.102.7

Coal Miner, Lens, France, 1978
Image/Paper: 18 x 12⅛
85.102.8

Horse and Cowboy, Rockefeller Center, New York City, 1974
Image/Paper: 18½ x 12⅜
85.102.9 §

Windshield, Saratoga Springs, New York, 1957
Image/Paper: 12 x 18
85.102.10

Skyscraper, 45th Street, New York City, 1980
Image/Paper: 17⅞ x 11¾
85.102.11

Young Girl, Penn Station, New York City, 1953
Image/Paper: 18⅛ x 12
85.102.12

ALFRED STIEGLITZ
The Steerage, 1907
Photogravure on Imperial Japan paper
Image: 13⅛ x 10⁷⁄₁₆
Paper: 15¾ x 11
Gift of Michael E. Hoffman '64
77.105 §

HENRY F. STOKES '75
Untitled (Firefighters), 1974
Gelatin silver print
Image/Paper: 5⅛ x 7⁷⁄₁₆
University purchase
75.23.7

PAUL STRAND
Ranchos de Taos, New Mexico, 1930
Gelatin silver print
Image: 7⁵⁄₁₆ x 9⅜
Paper: 7⁹⁄₁₆ x 9⁹⁄₁₆
Gift of Michael E. Hoffman '64
97.25

PAUL STRAND
False Front, Red River, New Mexico, 1931, printed 1960s
Gelatin silver print, signed by Hazel Strand
Image: 7⁹⁄₁₆ x 9½
Paper: 8 x 9⅞
Gift of Michael E. Hoffman '64
99.93

PAUL STRAND
Road, Winter, New England, 1944
Gelatin silver print, signed by Hazel Strand
Image: 9⅝ x 7⅝
Paper: 9¹⁵⁄₁₆ x 7¹⁵⁄₁₆
Gift of Michael E. Hoffman '64
97.27 §

PAUL STRAND, *Road, Winter, New England*

PAUL STRAND, *Harnesses, Aspach-le-bas, Haut-Rhin, Alsace, France*

PAUL STRAND
Rocks and Sea, Maine, 1945
Gelatin silver print, signed by Ann
Kennedy
Image: 4⅝ x 5⅞
Paper: 5 x 6¼
Gift of Michael E. Hoffman '64
97.26

PAUL STRAND
Dead Tree, Vermont, 1945
Gelatin silver print, signed by Hazel Strand
Image: 9⅝ x 7⅝
Paper: 9⅞ x 7¹³⁄₁₆
Gift of Michael E. Hoffman '64
97.28

PAUL STRAND
Window, Brittany, France, 1950
Gelatin silver print, signed by Ann
Kennedy
Image: 9¹¹⁄₁₆ x 7⁹⁄₁₆
Paper: 9¹³⁄₁₆ x 7¾
Gift of Michael E. Hoffman '64 in honor
of Drs. J. Calvin Keene, Frank Curtin, and
Rutherford Delmage
96.14.3

PAUL STRAND
*Harnesses, Aspach-le-Bas, Haut-Rhin,
Alsace, France*, 1950
Gelatin silver print
Image/Paper: 9½ x 7½
Gift of Michael E. Hoffman '64 in honor
of Drs. J. Calvin Keene, Frank Curtin, and
Rutherford Delmage
96.14.4

PAUL STRAND
*Harnesses, Aspach-le-bas, Haut-Rhin,
Alsace, France*, 1950
Gelatin silver print
Image/Paper: 9⅝ x 7⁹⁄₁₆
Gift of Michael E. Hoffman '64
99.74 §

PAUL STRAND
Village, Road to Brittany, France, 1950
Gelatin silver print, signed by Hazel Strand
Image/Paper: 4⅝ x 5⅞
Gift of Michael E. Hoffman '64
99.72

PAUL STRAND
Farm Village, Burgundy, France, 1951
Gelatin silver print
Image/Paper: 4⅝ x 5⅞
Gift of Michael E. Hoffman '64 in honor
of Drs. J. Calvin Keene, Frank Curtin, and
Rutherford Delmage
96.14.1

PAUL STRAND
*Old Shop Front, Lagrasse, Pyrenées-
Orientales, France*, 1951
Gelatin silver print
Image/Paper: 9½ x 7½
Gift of Michael E. Hoffman '64 in honor
of Drs. J. Calvin Keene, Frank Curtin, and
Rutherford Delmage
96.14.2

PAUL STRAND
Portrait, Gondeville, Charente, France,
1951

Gelatin silver print, signed by Hazel Strand
Image: 5⅞ x 4⅝
Paper: 6⅞ x 4⅞
Gift of Michael E. Hoffman '64
99.71

PAUL STRAND
*Basque House, Pyrenées-Atlantique,
France*, 1951
Gelatin silver print
Image/Paper: 7⁹⁄₁₆ x 6¼
Gift of Michael E. Hoffman '64
99.73

PAUL STRAND
The Mayor's Mother, Luzzara, 1953
Gelatin silver print, signed by Hazel Strand
Image/Paper: 5¹³⁄₁₆ x 4⅝
Gift of Michael E. Hoffman '64 in honor
of Drs. J. Calvin Keene, Frank Curtin, and
Rutherford Delmage
96.14.6

PAUL STRAND
Portrait, Woman, Italy, 1953
Gelatin silver print
Image/Paper: 5⅞ x 4⅝
Gift of Michael E. Hoffman '64 in honor
of Drs. J. Calvin Keene, Frank Curtin, and
Rutherford Delmage
96.14.7

PAUL STRAND
The Baker, Luzzara, Italy, 1953
Gelatin silver print, signed by Hazel Strand
Image/Paper: 5⅞ x 4⅝

PAUL STRAND, *Mrs. Archie MacDonald, South Uist, Hebrides*

Gift of Michael E. Hoffman '64 in honor of Drs. J. Calvin Keene, Frank Curtin, and Rutherford Delmage
96.14.8

PAUL STRAND
Portrait, Riverman, Luzzara, Italy, 1953
Gelatin silver print

Image/Paper: 5¹³⁄₁₆ x 4⅝
Gift of Michael E. Hoffman '64 in honor of Drs. J. Calvin Keene, Frank Curtin, and Rutherford Delmage
96.14.9

PAUL STRAND
Farm, Luzzara, Italy, 1953
Gelatin silver print, signed by Hazel Strand

PAUL STRAND, *Angus Peter MacIntyre, South Uist, Outer Hebrides*

Image/Paper: 4⅝ x 5⅞
Gift of Michael E. Hoffman '64 in honor of Drs. J. Calvin Keene, Frank Curtin, and Rutherford Delmage
96.14.10

PAUL STRAND
Portrait, Luzzara, Italy, 1953
Gelatin silver print
Image/Paper: 3¹¹⁄₁₆ x 4¾
Gift of Michael E. Hoffman '64
99.75

PAUL STRAND
Mrs. Archie MacDonald, South Uist, Hebrides, 1954
Gelatin silver print, signed by Ann Kennedy
Image: 7⅝ x 9¾
Paper: 7¹⁵⁄₁₆ x 9⅞
Gift of Michael E. Hoffman '64 in honor of Drs. J. Calvin Keene, Frank Curtin, and Rutherford Delmage
96.14.11 §

PAUL STRAND
Marian MacLellan, South Uist, Outer Hebrides, 1954
Gelatin silver print, signed by Ann Kennedy
Image: 7¹¹⁄₁₆ x 9⁹⁄₁₆
Paper: 8 x 9⅞
Gift of Michael E. Hoffman '64 in honor of Drs. J. Calvin Keene, Frank Curtin, and Rutherford Delmage
96.14.12

PAUL STRAND
Angus Peter MacIntyre, South Uist, Outer Hebrides, 1954
Gelatin silver print, signed by Ann Kennedy
Image: 4⅝ x 5¹³⁄₁₆
Paper: 4¹³⁄₁₆ x 6¹⁄₁₆
Gift of Michael E. Hoffman '64 in honor of Drs. J. Calvin Keene, Frank Curtin, and Rutherford Delmage
96.14.13 §

PAUL STRAND
Landscape, South Uist, Outer Hebrides, 1954
Gelatin silver print, signed by Ann Kennedy
Image/Paper: 4⁹⁄₁₆ x 5¹³⁄₁₆
Gift of Michael E. Hoffman '64 in honor of Drs. J. Calvin Keene, Frank Curtin, and Rutherford Delmage
96.14.14

PAUL STRAND
Benbecula, Hebrides, 1954
Gelatin silver print
Image/Paper: 4⁹⁄₁₆ x 5¹³⁄₁₆

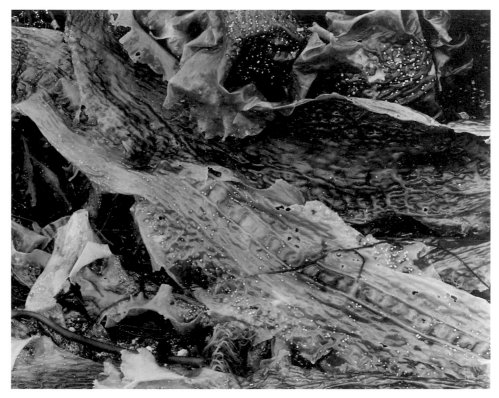

PAUL STRAND, *Seaweed, South Uist, Hebrides*

PAUL STRAND, *Petrochemical Plant, Pitest, Romania*

PAUL STRAND, *Fez, Morocco*

PAUL STRAND, *Late Travel, Caribbean, Grenada*

Gift of Michael E. Hoffman '64 in honor of Drs. J. Calvin Keene, Frank Curtin, and Rutherford Delmage
96.14.15

PAUL STRAND
Near Daliburgh, South Uist, Outer Hebrides, 1954
Gelatin silver print, signed by Ann Kennedy
Image: 7⁹⁄₁₆ x 9⁹⁄₁₆
Paper: 7¹⁵⁄₁₆ x 9⅞
Gift of Michael E. Hoffman '64 in honor of Drs. J. Calvin Keene, Frank Curtin, and Rutherford Delmage
96.14.16

PAUL STRAND
House, Benbecula, Hebrides, 1954
Gelatin silver print, signed by Hazel Strand
Image: 5⅞ x 4⅝
Paper: 6¹⁵⁄₁₆ x 5
Gift of Michael E. Hoffman '64 in honor of Drs. J. Calvin Keene, Frank Curtin, and Rutherford Delmage
96.14.17

PAUL STRAND
Seaweed, South Uist, Hebrides, 1954
Gelatin silver print
Image/Paper: 7⅝ x 9½
Gift of Michael E. Hoffman '64 in honor of Drs. J. Calvin Keene, Frank Curtin, and Rutherford Delmage
96.14.18 §

PAUL STRAND
Portrait, Katie MacPhee, South Uist, Hebrides, 1954
Gelatin silver print, signed by Ann Kennedy
Image: 9¹¹⁄₁₆ x 7¾
Paper: 9¹⁵⁄₁₆ x 7¹⁵⁄₁₆
Gift of Michael E. Hoffman '64
97.29

PAUL STRAND
Peter Maclellan, South Uist, Hebrides, 1954
Gelatin silver print, signed by Ann Kennedy
Image: 7⁹⁄₁₆ x 6⅜
Paper: 7¹¹⁄₁₆ x 6⅜
Gift of Michael E. Hoffman '64
97.30

PAUL STRAND
Marian MacLellan, South Uist, Hebrides, 1954
Gelatin silver print
Image/Paper: 3⅞ x 4⁹⁄₁₆
Gift of Michael E. Hoffman '64
99.76

PAUL STRAND
Mrs. Donald MacPhee, South Uist, Hebrides, 1954
Gelatin silver print, signed by Ann Kennedy
Image: 9¹¹⁄₁₆ x 7¾
Paper: 9⅞ x 7¹⁵⁄₁₆
Gift of Michael E. Hoffman '64
99.77

PAUL STRAND
D. J. MacLean, South Uist, Hebrides, 1954
Gelatin silver print, signed by Ann Kennedy
Image: 9¹¹⁄₁₆ x 7¾
Paper: 9¹⁵⁄₁₆ x 8
Gift of Michael E. Hoffman '64
99.78

PAUL STRAND
Mme. Chudet, Parc-De-Coeuilly, France, 1957
Gelatin silver print, signed by Hazel Strand
Image/Paper: 4⁹⁄₁₆ x 5¹³⁄₁₆
Gift of Michael E. Hoffman '64 in honor of Drs. J. Calvin Keene, Frank Curtin, and Rutherford Delmage
96.14.5

PAUL STRAND
Moldavia, Romania, 1960
Gelatin silver print, signed by Ann Kennedy
Image: 9¹⁄₁₆ x 7⅛
Paper: 9⅛ x 7³⁄₁₆
Gift of Michael E. Hoffman '64 in honor of Drs. J. Calvin Keene, Frank Curtin, and Rutherford Delmage
96.14.20

PAUL STRAND
House and Landscape, Cleja, Romania, 1960
Gelatin silver print
Image/Paper: 9⁷⁄₁₆ x 7⅜
Gift of Michael E. Hoffman '64 in honor of Drs. J. Calvin Keene, Frank Curtin, and Rutherford Delmage
96.14.21

PAUL STRAND
Houses, Moldavia, 1960
Gelatin silver print, signed by Hazel Strand
Image: 9¹⁄₁₆ x 7¹⁄₁₆
Paper: 9⁷⁄₁₆ x 7⁷⁄₁₆
Gift of Michael E. Hoffman '64
97.33

PAUL STRAND
Iordache, Ciaocota, Bicaz, Romania, 1960

PAUL STRAND
Gelatin silver print, signed by Hazel Strand
Image: 9¹⁄₁₆ x 7⅛
Paper: 9⅜ x 7⁷⁄₁₆
Gift of Michael E. Hoffman '64
99.87

PAUL STRAND
Drazodana, Romania, 1960
Gelatin silver print, signed by Ann Kennedy
Image: 7⁷⁄₁₆ x 9½
Paper: 7⁹⁄₁₆ x 9⅝
Gift of Michael E. Hoffman '64
99.89

PAUL STRAND
Market, Tahannaoute, Morocco, 1962
Gelatin silver print, signed by artist
Image/Paper: 7⁹⁄₁₆ x 9⅝
Gift of Michael E. Hoffman '64 in honor of Drs. J. Calvin Keene, Frank Curtin, and Rutherford Delmage
96.14.19

PAUL STRAND
Marabout, Morocco, 1962
Gelatin silver print, signed by Hazel Strand
Image: 7⁷⁄₁₆ x 6⅝
Paper: 7⁹⁄₁₆ x 6⅝
Gift of Michael E. Hoffman '64
97.31

PAUL STRAND
Market, Tahannaoute, Morocco, 1962
Gelatin silver print, signed by Hazel Strand
Image/Paper: 7¹¹⁄₁₆ x 9⅜
Gift of Michael E. Hoffman '64
97.32

PAUL STRAND
Cultivation, Valley of the Todra, Morocco, 1962
Gelatin silver print, signed by Hazel Strand
Image/Paper: 7⁷⁄₁₆ x 6¹⁄₁₆
Gift of Michael E. Hoffman '64
99.79

PAUL STRAND
In a Souk, Tangier, Morocco, 1962
Gelatin silver print, signed by Ann Kennedy
Image: 9½ x 7⅛
Paper: 9¹¹⁄₁₆ x 7⅛
Gift of Michael E. Hoffman '64
99.80

PAUL STRAND
Fez, Morocco, 1962
Gelatin silver print, signed by Hazel Strand
Image: 7 x 9⅝
Paper: 7¼ x 9¹³⁄₁₆
Gift of Michael E. Hoffman '64
99.81 §

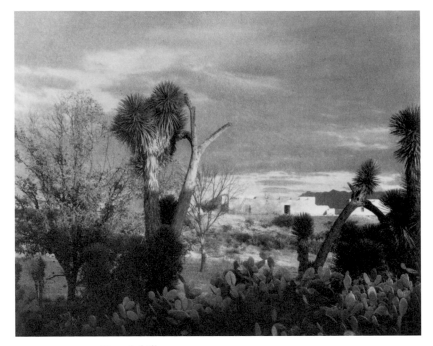

PAUL STRAND, *Near Saltillo*

PAUL STRAND, *Woman and Boy, Tenancingo*

PAUL STRAND, *Virgin, San Felipe, Oaxaca*

PAUL STRAND, *Church, Coapiaxtla*

· 174 ·

PAUL STRAND

Market Day, Tahannaoute, Morocco, 1962

Gelatin silver print, signed by Hazel Strand
Image: 7⅝ x 9⅜
Paper: 7¹⁵/₁₆ x 9¹¹/₁₆
Gift of Michael E. Hoffman '64
99.82

PAUL STRAND

Fishing Boats, Accra, Ghana, 1963
Gelatin silver print, signed by Hazel Strand
Image: 7⁷/₁₆ x 9⅝
Paper: 7⅝ x 9⅞
Gift of Michael E. Hoffman '64
99.83

PAUL STRAND

Jungle Growth, Ashanti Country, Ghana, 1963
Gelatin silver print, signed by Hazel Strand
Image/Paper: 9⅝ x 7⅝
Gift of Michael E. Hoffman '64
99.84

PAUL STRAND

Forest, Central Ahafo, Ghana, 1963
Gelatin silver print, signed by Hazel Strand
Image/Paper: 7¹/₁₆ x 9¾
Gift of Michael E. Hoffman '64
99.85

PAUL STRAND

Trunk, Village Shade Tree, Akiyiakrom, Ghana, 1963
Gelatin silver print, signed by Hazel Strand
Image/Paper: 9⅝ x 7⁷/₁₆
Gift of Michael E. Hoffman '64
99.86

PAUL STRAND

Petrochemical Plant, Brazi, Romania, 1967
Gelatin silver print
Image: 9⁹/₁₆ x 7⁷/₁₆
Paper: 9¹³/₁₆ x 7¹¹/₁₆
Gift of Michael E. Hoffman '64
97.34

PAUL STRAND

Cismigiu Gardens, Bucharest, Romania, 1967
Gelatin silver print, signed by Ann Kennedy
Image: 6¹³/₁₆ x 8⁹/₁₆
Paper: 6¹⁵/₁₆ x 8¹¹/₁₆
Gift of Michael E. Hoffman '64
99.88

PAUL STRAND

Seeder, Teaca State Farm, Romania, 1967

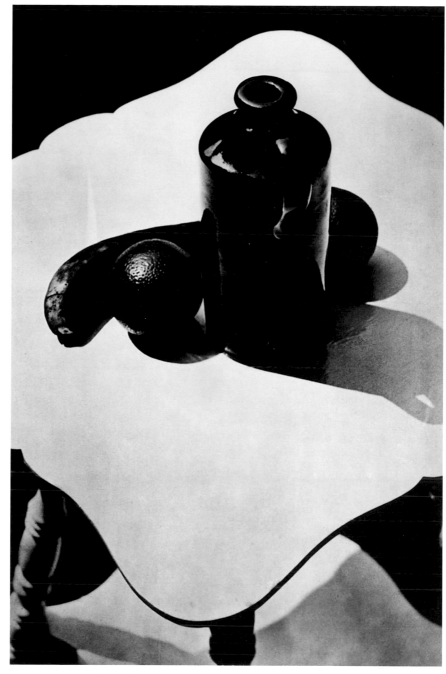

PAUL STRAND, *Jug and Fruit, Connecticut*

Gelatin silver print, signed by Hazel Strand
Image: 9⅝ x 7⅝
Paper: 9¹⁵/₁₆ x 8
Gift of Michael E. Hoffman '64
99.90

PAUL STRAND

Petrochemical Plant, Pitest, Romania, 1967
Gelatin silver print
Image/Paper: 7⁵/₁₆ x 6¹/₁₆
Gift of Michael E. Hoffman '64
99.91 §

PAUL STRAND

Late Travel, Caribbean, Grenada, 1971
Gelatin silver print, signed by Hazel Strand
Image/Paper: 8⁵/₁₆ x 7¼
Gift of Michael E. Hoffman '64
99.92 §

PAUL STRAND

The Mexican Portfolio, 2nd ed. (New York: Da Capo Press, 1967)
Portfolio of 20 photogravures
Gift of Michael E. Hoffman '64
67.44

PAUL STRAND, *The Garden, Orgeval*

PAUL STRAND, *Cobweb in Rain, Georgetown, Maine*

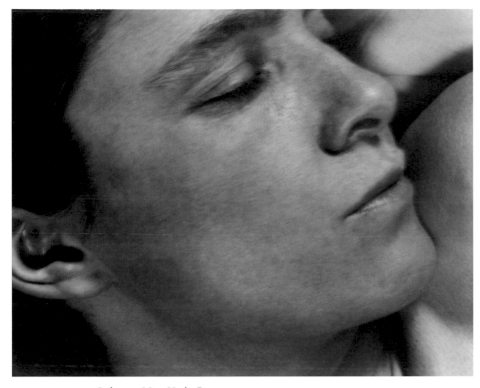

PAUL STRAND, *Rebecca, New York City*

Near Saltillo, 1932
Image: 4⅞ x 6³⁄₁₆
Paper: 12⁵⁄₁₆ x 15¹³⁄₁₆
67.44.1 §

Church, Coapiaxtla, 1933
Image: 10¹⁄₁₆ x 7⅞
Paper: 15¾ x 12⅜
67.44.2 §

Virgin, San Felipe, Oaxaca, 1933
Image: 10¼ x 7¹⁵⁄₁₆
Paper: 15¹³⁄₁₆ x 12⁵⁄₁₆
67.44.3 §

Women of Santa Ana, Michoacan, 1933
Image: 5 x 6³⁄₁₆
Paper: 15¾ x 12⁵⁄₁₆
67.44.4

Men of Santa Ana, Michoacan, 1933
Image: 6⁵⁄₁₆ x 4⅞
Paper: 15¹³⁄₁₆ x 12⁵⁄₁₆
67.44.5

Woman, Patzcuaro, 1933
Image: 6⅜ x 4¹⁵⁄₁₆
Paper: 15¾ x 12⁵⁄₁₆
67.44.6

Boy, Uruapan, 1933
Image: 10¹⁄₁₆ x 7¹⁵⁄₁₆
Paper: 15¹³⁄₁₆ x 12⁵⁄₁₆
67.44.7

Cristo, Oaxaca, 1933
Image: 10³⁄₁₆ x 7⅞
Paper: 15¹³⁄₁₆ x 12⁵⁄₁₆
67.44.8

Woman and Boy, Tenancingo, 1933
Image: 6⅜ x 5
Paper: 15¾ x 12⁵⁄₁₆
67.44.9 §

Plaza, State of Puebla, 1933
Image: 5 x 6¼
Paper: 12⁵⁄₁₆ x 15¾
67.44.10

Man with a Hoe, Los Remedios, 1933
Image: 6¼ x 4⅞
Paper: 15¾ x 12⁵⁄₁₆
67.44.11

Calvario, Patzcuaro, 1933
Image: 10¹⁄₁₆ x 7⅞
Paper: 15¹³⁄₁₆ x 12⁵⁄₁₆
67.44.12

Cristo, Tlacochoaya, Oaxaca, 1933
Image: 9⅞ x 7¾
Paper: 15¹³⁄₁₆ x 12⅜
67.44.13

Boy, Hidalgo, 1933
Image: 6⁵⁄₁₆ x 4⅞
Paper: 15¹³⁄₁₆ x 12⁵⁄₁₆
67.44.14

Woman and Baby, Hidalgo, 1933
Image: 4¹⁵⁄₁₆ x 6³⁄₁₆
Paper: 15¹³⁄₁₆ x 12⁵⁄₁₆
67.44.15

Girl and Child, Toluca, 1933
Image: 6⅜ x 5
Paper: 15¹³⁄₁₆ x 12⁵⁄₁₆
67.44.16

Cristo with Thorns, Huexotla, 1933
Image: 10³⁄₁₆ x 7⅞
Paper: 12⁵⁄₁₆ x 15¹³⁄₁₆
67.44.17

Man, Tenancingo, 1933
Image: 6⁷⁄₁₆ x 5
Paper: 15¾ x 12⁷⁄₁₆
67.44.18

Young Woman and Boy, Toluca, 1933
Image: 5 x 6⅛
Paper: 15¾ x 12⁵⁄₁₆
67.44.19

Gateway, Hidalgo, 1933
Image: 6⁵⁄₁₆ x 4⅞
Paper: 15¹³⁄₁₆ x 12⁵⁄₁₆
67.44.20

PAUL STRAND
Portfolio I: On My Doorstep
(Millerton, NY: Paul Strand
Foundation, 1976)
Portfolio of 11 gelatin silver prints, ed. 3/50
Gift of Michael E. Hoffman '64
80.424

Snow, Backyards, New York City, 1914
Image: 9¹¹⁄₁₆ x 12½
Paper: 10¾ x 13½
80.424.1

Abstraction, Porch Shadows, Connecticut, 1915
Image: 13¼ x 9
Paper: 13¾ x 9½
80.424.2

Jug and Fruit, Connecticut, 1915
Image: 11¼ x 7⅜
Paper: 13½ x 9⅝
80.424.3 §

Rebecca, New York City, 1922
Image: 7¹¹⁄₁₆ x 9⁹⁄₁₆
Paper: 7¹⁵⁄₁₆ x 9⅞
80.424.4 §

Toadstool and Grasses, Georgetown, Maine, 1928
Image: 9⁹⁄₁₆ x 7¹³⁄₁₆
Paper: 11¹⁄₁₆ x 9¼
80.424.5

Torso, Taos, New Mexico, 1930
Image: 9¹⁵⁄₁₆ x 10¹⁄₁₆

· 177 ·

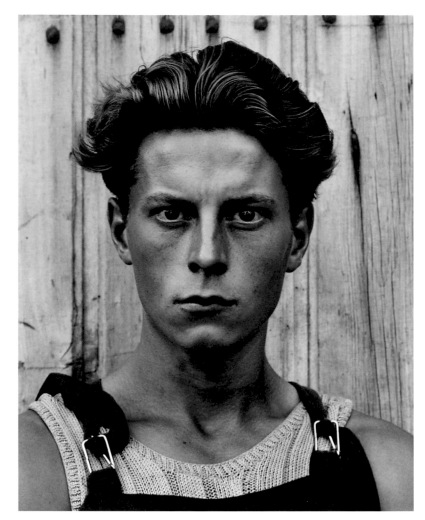

PAUL STRAND, *Young Boy, Gondeville, Charente, France*

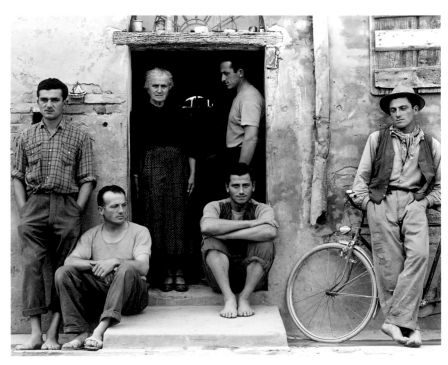

PAUL STRAND, *The Family, Luzzaro, Italy*

Paper: 10¹³⁄₁₆ x 10¹⁵⁄₁₆
80.424.6

*Akeley Motion Picture Camera,
New York City,* 1923
Image: 9½ x 7⅝
Paper: 9¹⁵⁄₁₆ x 8
80.424.7

Side Porch, Vermont, 1947
Image: 9⅝ x 7⅝
Paper: 9¹⁵⁄₁₆ x 8
80.424.8

Susan Thompson, Cape Split, Maine,
1945
Image: 9¹⁵⁄₁₆ x 7⅞
Paper: 11¾ x 9⁹⁄₁₆
80.424.9

*White Horse, Ranchos de Taos,
New Mexico,* 1932
Image: 9¹⁄₁₆ x 11½
Paper: 10¹³⁄₁₆ x 13¼
80.424.10

Iris Facing the Winter, Orgeval, 1972
Image: 12⁷⁄₁₆ x 9⅞
Paper: 14½ x 11⅝
80.424.11

PAUL STRAND
Portfolio II: The Garden (Millerton,
NY: Paul Strand Foundation, 1976)
Portfolio of 6 gelatin silver prints, ed. 11/50
Gift of the Trustees of the Paul Strand
Foundation
80.423

The Garden, Orgeval, 1964
Image: 9⅝ x 7⁹⁄₁₆
Paper: 9¹⁵⁄₁₆ x 8
80.423.1 §

Crocus and Primroses, Orgeval, 1957
Image: 9⁹⁄₁₆ x 7⅝
Paper: 9⅞ x 7¹⁵⁄₁₆
80.423.2

Fungus, Orgeval, 1967
Image: 9⅝ x 7⅝
Paper: 9⅞ x 7¹⁵⁄₁₆
80.423.3

Yellow Vine and Rock Plants, Orgeval,
1960
Image: 9⁹⁄₁₆ x 7⁹⁄₁₆
Paper: 9⅞ x 7¹⁵⁄₁₆
80.423.4 § *(Fig. 11)*

The Happy Family, Orgeval, 1958
Image: 9⅝ x 7⅝
Paper: 9⅞ x 7¹⁵⁄₁₆
80.423.5

Driveway, Orgeval, 1957
Image: 9⅝ x 7⅝
Paper: 9⅞ x 7¹⁵⁄₁₆
80.423.6

PAUL STRAND
Portfolio III
(Millerton, NY: Paul
Strand Foundation, 1980),
printed 1976–77
Portfolio of 10 gelatin silver
prints, ed. 27/100
Gift of Michael E. Hoffman '64
84.1

*The White Fence, Port Kent,
New York*, 1916
Image: 9¹¹⁄₁₆ x 12⅞
Paper: 10¹¹⁄₁₆ x 13¹³⁄₁₆
84.1.1

Blind Woman, New York,
1916
Image: 12⅞ x 9¾
Paper: 13⅝ x 10⅞
84.1.2

Iris, Georgetown, Maine,
1928
Image: 9½ x 7⁹⁄₁₆
Paper: 9⅞ x 7⅞
84.1.3

*Truckman's House, New
York*, 1920
Image: 9½ x 7⁹⁄₁₆
Paper: 9¾ x 7⅞
84.1.4

*Cobweb in Rain,
Georgetown,
Maine*, 1927
Image: 9½ x 7⁹⁄₁₆
Paper: 11⅜ x 9¹⁄₁₆
84.1.5 §

Mr. Bennett, Vermont, 1944
Image: 7¼ x 8¹³⁄₁₆
Paper: 7¹⁵⁄₁₆ x 9¾
84.1.6

Fox River, Gaspé, 1936
Image: 8¾ x 11
Paper: 10⅞ x 13¾
84.1.7

*Young Boy, Gondeville, Charente,
France*, 1951
Image: 10⅞ x 8¾
Paper: 13⁹⁄₁₆ x 10¾
84.1.8 §

The Camargue, France, 1951
Image: 8⅜ x 10¹³⁄₁₆
Paper: 9¼ x 11½
84.1.9

Oil Refinery, Tema, Ghana, 1963
Image: 9¼ x 7⁷⁄₁₆
Paper: 9¾ x 7¹⁵⁄₁₆
84.1.10

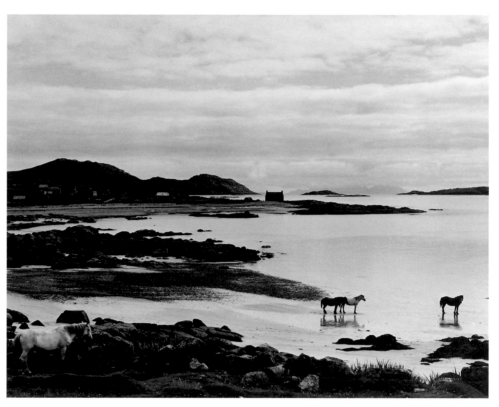

PAUL STRAND, *Tir A'Mhurain, South Uist, Hebrides*

PAUL STRAND
Portfolio IV (Millerton, NY: Paul
Strand Foundation, 1980), printed
1976–77
Portfolio of 10 gelatin silver prints, ed.
27/100
Gift of Michael E. Hoffman '64
84.2

The River Po, Luzzaro, Italy, 1953
Image: 6¹³⁄₁₆ x 8⅝
Paper: 9¹⁄₁₆ x 11⁷⁄₁₆
84.2.1

The Family, Luzzaro, Italy, 1953
Image: 8½ x 10¹³⁄₁₆
Paper: 10¹³⁄₁₆ x 13¾
84.2.2 §

Landscape, Sicily, Italy, 1954
Image: 6¹³⁄₁₆ x 8⁹⁄₁₆
Paper: 7¹³⁄₁₆ x 9¹¹⁄₁₆
84.2.3

*Shop, Le Bacarès, Pyrénées-Orientales,
France*, 1950
Image: 7⅛ x 5¹¹⁄₁₆
Paper: 9¹¹⁄₁₆ x 7⅞
84.2.4

Tir A'Mhurain, South Uist, Hebrides,
1954

Image: 9⁵⁄₁₆ x 11¾
Paper: 10⅞ x 13¾
84.2.5 §

Georges Braque, Varangéville, France,
1957
Image: 9⁹⁄₁₆ x 7⁵⁄₁₆
Paper: 11½ x 9³⁄₁₆
84.2.6

Fall in Movement, Orgeval, France,
1973
Image: 13⅛ x 10⁵⁄₁₆
Paper: 13¾ x 10⅞
84.2.7

Iris and Stump, Orgeval, France, 1973
Image: 10⁹⁄₁₆ x 11¹¹⁄₁₆
Paper: 10¹⁵⁄₁₆ x 13¾
84.2.8

Bani Salah, Fayyum, Egypt, 1959
Image: 12 x 9¾
Paper: 13½ x 10¹¹⁄₁₆
84.2.9

*Sheik Abdel Hadi Misyd, Attar Farm,
Delta, Egypt*, 1959
Image: 9¼ x 7¼
Paper: 11½ x 9⅛
84.2.10

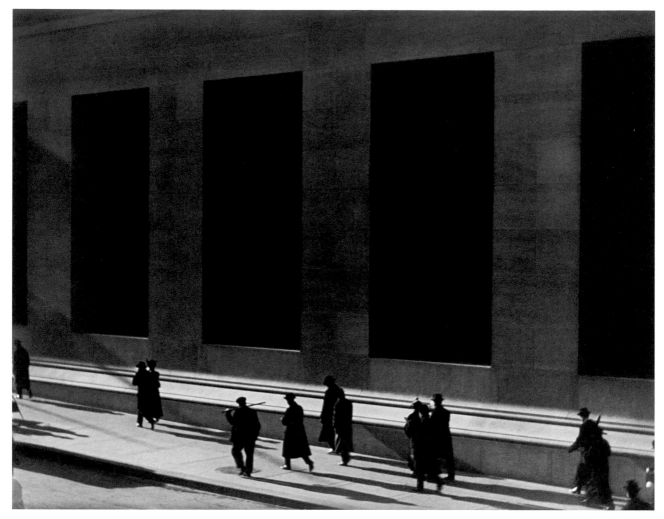

PAUL STRAND, *Wall Street, New York*

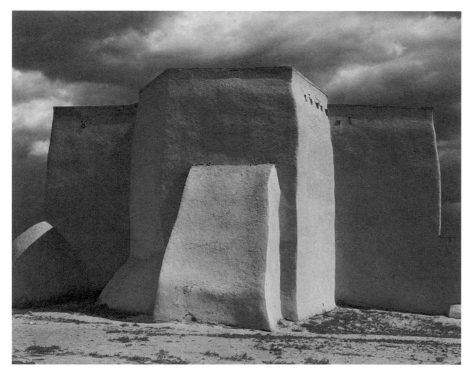

PAUL STRAND, *St. Francis Church, Ranchos de Taos, New Mexico*

PAUL STRAND
Wall Street, New York, 1915, printed 1984
Platinum/palladium print, ed. 3/100
Image: 9⅞ x 12¹¹⁄₁₆
Paper: 11 x 13⅞
Gift of Michael E. Hoffman '64
85.16 §

PAUL STRAND
Wire Wheel, New York, 1917, printed 1984
Platinum/palladium print, ed. 12/100
Image: 12½ x 9¹⁵⁄₁₆
Paper: 13¾ x 11
Gift of Michael E. Hoffman '64
85.18 § *(Plate 25)*

PAUL STRAND
St. Francis Church, Ranchos de Taos, New Mexico, 1931, printed 1984
Palladium print, ed. 15/100
Image: 6¹¹⁄₁₆ x 8⁷⁄₁₆
Paper: 7⁹⁄₁₆ x 9¹⁄₁₆
Gift of Michael E. Hoffman '64
85.17 §

BARRY I. STRUM, *Pleiku*

MORTON STRAUSS
Communion, 1958
Gelatin silver print
Image/Paper: 15¼ x 11⁹⁄₁₆
Gift of the artist through Doris M.
Offermann '34
65.1.42

MORTON STRAUSS
Snow over City Hall, New York City,
1960
Gelatin silver print
Image/Paper: 16¾ x 13¹⁵⁄₁₆
Gift of the artist through Doris M.
Offermann '34
65.1.15

MORTON STRAUSS
Weathered, 1961
Gelatin silver print
Image/Paper: 16¹⁵⁄₁₆ x 14
Gift of the artist through Doris M.
Offermann '34
65.1.24

MORTON STRAUSS
*Acapulco Market, a.k.a. Mexican
Market*, 1965
Gelatin silver print
Image/Paper: 13⅝ x 16⅞
Gift of the artist through Doris M.
Offermann '34
65.1.25

BARRY I. STRUM
Pleiku, 1969

Gelatin silver print
Image: 10³⁄₁₆ x 15¼
Paper: 13¼ x 18¼
Gift of Richard Amerault
92.22.58 §

BARRY I. STRUM
Pleiku, 1969
Gelatin silver print
Image: 9⅜ x 14¹⁄₁₆
Paper: 13 x 17¼
Gift of Richard Amerault
92.22.59

MICHAEL F. SULLIVAN '63
Rock Wall #1, Essex, Massachusetts,
1965, printed 1969
Gelatin silver print
Image/Paper: 6⅛ x 7¾
University purchase
74.4.2

MICHAEL F. SULLIVAN '63
Untitled (Tattered Flag against Old
Grave), c. 1966
Gelatin silver print
Image/Paper: 6⅝ x 5
University purchase
66.35

MICHAEL F. SULLIVAN '63
Alan Teichman, Saranac Lake, 1970
Gelatin silver print
Image/Paper: 5¾ x 7
University purchase
74.4.1

MICHAEL F. SULLIVAN '63
*Bass Rocks at Sunrise, Gloucester,
Massachusetts*, 1971
Gelatin silver print
Image/Paper: 7⁷⁄₁₆ x 9⁷⁄₁₆
University purchase
74.4.4

MICHAEL F. SULLIVAN '63
*Wilton Reservoir, New Canaan,
Connecticut*, 1973
Gelatin silver print
Image/Paper: 7³⁄₁₆ x 9⅜
University purchase
74.4.3

MICHAEL F. SULLIVAN '63
Joel, the Slaughterhouse Executioner,
1981
Gelatin silver print
Image: 8⁵⁄₁₆ x 12⁵⁄₁₆
Paper: 10⅞ x 13⅞
University purchase
82.308

**MICHAEL F. SULLIVAN '63 with
ANDREW SKOLNICK**
Self-Portrait, n.d.
Gelatin silver print
Image/Paper: 4⁹⁄₁₆ x 3⁹⁄₁₆
University purchase
74.4.5

MICHAEL F. SULLIVAN '63
Untitled (Tree in Fog), n.d.
Gelatin silver print
Image/Paper: 9 x 7⁵⁄₁₆
University purchase
74.115a

MICHAEL F. SULLIVAN '63
Untitled (Tree Covered in Ice), n.d.
Gelatin silver print
Image/Paper: 8⅛ x 7½
University purchase
74.115b

STEPHEN SUMNER
A North Country Essay, 1973
Series of 5 chromogenic process color prints
University purchase
74.20

Untitled (Winter Landscape)
Image: 10¾ x 13
Paper: 11⅛ x 13¹⁵⁄₁₆
74.20.1

Untitled (Car in Dust Cloud)
Image: 5⅛ x 7⁵⁄₁₆
Paper: 8 x 9¹⁵⁄₁₆
74.20.2

Untitled (Tires and Tarp)
Image: 5¼ x 7⁷⁄₁₆
Paper: 8 x 9¹⁵⁄₁₆
74.20.3

Untitled (Winter Landscape with
Barn and Blue Sky)
Image: 5½ x 7¹³⁄₁₆
Paper: 8 x 9¹⁵⁄₁₆
74.20.4

Untitled (Spider Web on Barbed
Wire)
Image: 7¹³⁄₁₆ x 5⁷⁄₁₆
Paper: 9¹⁵⁄₁₆ x 8
74.20.5

ALAN J. TEICHMAN '68
Untitled (Rushes in Snow), 1968
Gelatin silver print
Image/Paper: 7½ x 9¼
University purchase
68.2.1

ALAN J. TEICHMAN '68
Untitled (Log in Water), 1968
Gelatin silver print
Image/Paper: 7⁹⁄₁₆ x 9⅜
University purchase
68.2.2

ALAN J. TEICHMAN '68
Untitled (Road and Trees), 1968
Gelatin silver print
Image/Paper: 6⅝ x 9⅜
University purchase
68.2.3

DAVID A. TEWKSBURY '75
Untitled (Plowed Cornfield in
Snow), c. 1975
Gelatin silver print
Image: 4 x 8⅜
Paper: 6¹⁄₁₆ x 10
University purchase
75.23.10

MAX THOREK
Chief White Cloud, n.d.
Gelatin silver print from paper negative
Image/Paper: 16 x 12¾
Gift of Barbara Green through Doris M.
Offermann '34
65.1.1 § (Fig. 9)

MAX THOREK
Corner in Venice, n.d.
Chlorobromide print from paper negative
Image/Paper: 16¹⁵⁄₁₆ x 13
Gift of Barbara Green through Doris M.
Offermann '34
65.1.72

MAX THOREK
Shadows of the Past, n.d.
Chlorobromide print from paper negative
Image: 16¼ x 13
Paper: 16⁹⁄₁₆ x 13
Gift of Barbara Green through Doris M.
Offermann '34
65.1.112

MAX THOREK
Souvenir de Toledo, n.d.
Chlorobromide print from paper negative
Image: 15⁹⁄₁₆ x 11⅝
Paper: 15¾ x 11¾
Gift of Barbara Green through Doris M.
Offermann '34
65.1.114

JERRY UELSMANN
Marilynn in the Sky, 1967
Gelatin silver combination print
Image/Paper: 9⁹⁄₁₆ x 7¹¹⁄₁₆
University purchase
71.116 §

JERRY UELSMANN
Untitled (Tree and Roots), 1968
Gelatin silver combination print
Image: 8⅞ x 7⅛
Paper: 9¹⁄₁₆ x 7⁵⁄₁₆
University purchase
71.118

JERRY UELSMANN, Untitled (Birds and Rock)

JERRY UELSMANN, Marilynn in the Sky

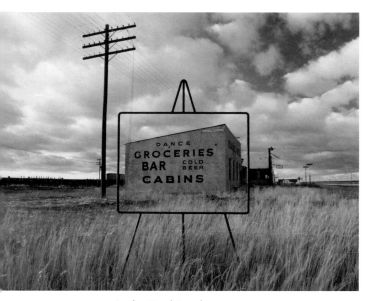

OHN VAN ALSTINE, *Bosler Easel Landscape* JOHN VAN ALSTINE, *Teton Easel Landscape*

JERRY UELSMANN
Untitled (Birds and Rock), 1970
Gelatin silver combination print
Image/Paper: 7 x 6⅝
University purchase
71.115 §

FRED E. UNVERHAU
Fringed Gentian Trio, c. 1962
Chromogenic process color print,
Ektacolor
Image/Paper: 16¾ x 12⅝
Gift of the artist through Doris M.
Offermann '34
65.1.11

TRUDY UNVERHAU
Sanguinaria Canadensis (Bloodroot),
c. 1962
Chromogenic process color print,
Ektacolor
Image/Paper: 16¾ x 13¹⁵⁄₁₆
Gift of the artist through Doris M.
Offermann '34
65.1.9

JOHN VACHON
Road out of Romney, West Virginia,
c. 1940, printed 1985
Dye transfer print
Image: 7 x 10
Paper: 10 x 13½
Gift of Rick Jeffrey (parent of Richard
Jeffrey, Jr. '85)
92.11.17

JOHN VACHON
Country School near Portsmouth,

Ohio, c. 1940, printed 1985
Dye transfer print
Image: 6¹³⁄₁₆ x 10
Paper: 9¹³⁄₁₆ x 13
Gift of Rick Jeffrey (parent of Richard
Jeffrey, Jr. '85)
92.11.18

JOHN VACHON
Lincoln, Nebraska, c. 1940, printed
1985
Dye transfer print
Image: 6¹¹⁄₁₆ x 9¹⁵⁄₁₆
Paper: 10 x 13
Gift of Rick Jeffrey (parent of Richard
Jeffrey, Jr. '85)
92.11.19

JOHN VACHON
Lincoln, Nebraska, c. 1940, printed
1986
Dye transfer print
Image: 6¾ x 10¹⁄₁₆
Paper: 9¹¹⁄₁₆ x 13¼
Gift of Rick Jeffrey (parent of Richard
Jeffrey, Jr. '85)
92.11.20

JOHN VAN ALSTINE, SLU 1970–72
Bosler Easel Landscape, 1979
Chromogenic process color print
Image: 13⅞ x 17⅞
Paper: 15⅞ x 19⅞
University purchase
87.30 §

JOHN VAN ALSTINE, SLU 1970–72
Amish Easel Landscape, 1979
Chromogenic process color print

Image: 13¹⁵⁄₁₆ x 17¹⁵⁄₁₆
Paper: 15¹³⁄₁₆ x 19¹⁵⁄₁₆
University purchase
87.31

JOHN VAN ALSTINE, SLU 1970–72
Easel Landscape after Monet, 1980
Chromogenic process color print
Image: 13⅞ x 17¹⁵⁄₁₆
Paper: 15¹⁵⁄₁₆ x 19¹⁵⁄₁₆
University purchase
87.32

JOHN VAN ALSTINE, SLU 1970–72
Untitled (Easel Landscape), 1981
Chromogenic process color print, ed. 4/10
Image: 13¾ x 17⅞
Paper: 15⅞ x 19⅞
University purchase
87.33

JOHN VAN ALSTINE, SLU 1970–72
Windows, 1980
Chromogenic process color print, ed. 4/10
Image: 13⅞ x 17¹⁵⁄₁₆
Paper: 15¹⁵⁄₁₆ x 19¹⁵⁄₁₆
University purchase
87.34

JOHN VAN ALSTINE, SLU 1970–72
Abstract Easel Landscape, 1980
Chromogenic process color print, ed. 5/10
Image: 13⅞ x 17⅞
Paper: 15¹⁵⁄₁₆ x 19¹⁵⁄₁₆
University purchase
87.35

JOHN VAN ALSTINE, SLU 1970–72
Teton Easel Landscape, 1980

Chromogenic process color print, ed. 3/10
Image: 13⅝ x 17⅞
Paper: 15⅞ x 19⅞
University purchase
87.36 §

JOHN VAN ALSTINE, SLU 1970–72
Wyoming Easel Landscape, 1980
Chromogenic process color print, ed. 7/10
Image: 14 x 17⅞
Paper: 15¹⁵⁄₁₆ x 19¹⁵⁄₁₆
University purchase
87.37

JOHN VAN ALSTINE, SLU 1970–72
Wyoming Easel Landscape, 1980
Chromogenic process color print, ed. 3/10
Image: 14 x 18
Paper: 15¹⁵⁄₁₆ x 19¹⁵⁄₁₆
University purchase
87.38

JOHN VAN ALSTINE, SLU 1970–72
Wyoming Easel Landscape, 1980
Chromogenic process color print, ed. 2/10
Image: 14 x 17⅞
Paper: 15¹⁵⁄₁₆ x 19¹⁵⁄₁₆
University purchase
87.39

FRANK VENTO
Central Park, N.Y., 1968
Gelatin silver print
Image: 6¾ x 10
Paper: 11 x 14
Gift of Richard Amerault
92.22.60

J. R. VILELLA
Grazing Zebras, n.d.
Chlorobromide print
Image/Paper: 16 x 13½
Gift of Arthur S. and Katherine Holt
Mawhinney through Doris M.
Offermann '34
65.1.126

BENJAMIN K. WARNER '88
Untitled (Light through Curtain),
spring 1988
Gelatin silver print
Image/Paper: 6⅛ x 3¾
University purchase
88.10

TED WELLER and CORA WELLER
Untitled (Egyptian Gods), c. 1975
Hand-colored gelatin silver print
Image: 4¾ x 7¹⁵⁄₁₆
Paper: 10 x 8½
University purchase
75.5 §

PAUL WELLS
American Warrior, RVN, 1965
Chromogenic process color print
Image: 9⅜ x 6¾
Paper: 9¹⁵⁄₁₆ x 8
Gift of Richard Amerault
92.22.61

PAUL WELLS
Viet Soldier, 1965
Chromogenic process color print
Image: 9⅜ x 6½
Paper: 9⅞ x 7¹⁵⁄₁₆
Gift of Richard Amerault
92.22.62

STEPHANIE WELSH
A Rite of Passage, 1995
Series of 14 chromogenic process color
prints
Purchased with funds from the Eben
Griffiths '07 Endowment
96.16

Untitled (Body Painting with Red
Ochre)
Image: 9³⁄₁₆ x 13½
Paper: 10¹⁵⁄₁₆ x 13⅞
96.16.1

Untitled (Mother Building House)
Image: 9³⁄₁₆ x 13⁹⁄₁₆
Paper: 10¹⁵⁄₁₆ x 13⅞
96.16.2

Untitled (Father and Friends
Celebrate)
Image: 9¹⁄₁₆ x 13⁹⁄₁₆
Paper: 10¹⁵⁄₁₆ x 13⅞
96.16.3 §

Untitled (Pensive Night Before)
Image: 9³⁄₁₆ x 13½
Paper: 10¹⁵⁄₁₆ x 13⅞
96.16.4 §

Untitled (Head Shaving)
Image: 9¹⁄₁₆ x 13½
Paper: 10¹⁵⁄₁₆ x 13⅞
96.16.5

Untitled (Sunrise, Initiation Day)
Image: 13½ x 9¹⁄₁₆
Paper: 13⅞ x 10¹⁵⁄₁₆
96.16.6

Untitled (Circumcision)
Image: 9¹⁄₁₆ x 13⁹⁄₁₆
Paper: 10¹⁵⁄₁₆ x 13⅞
96.16.7 § (*Fig. 16*)

Untitled (Razor in Hand)
Image: 13½ x 9¹⁄₁₆
Paper: 13⅞ x 10¹⁵⁄₁₆
96.16.8

Untitled (Blood Lost)
Image: 9³⁄₁₆ x 13½
Paper: 10¹⁵⁄₁₆ x 13⅞
96.16.9 §

Untitled (Crying with Friend)
Image: 9³⁄₁₆ x 13½
Paper: 10¹⁵⁄₁₆ x 13⅞
96.16.10

Untitled (Aftermath of Pain)
Image: 9³⁄₁₆ x 13⁹⁄₁₆
Paper: 10¹⁵⁄₁₆ x 13⅞
96.16.11

TED WELLER and CORA WELLER, Untitled (Egyptian Gods)

Untitled (Celebration of Bravery)
Image: 9¹⁄₁₆ x 13⁹⁄₁₆
Paper: 10¹⁵⁄₁₆ x 13⅞
96.16.12

Untitled (Women Blessing House)
Image: 9¹⁄₁₆ x 13½
Paper: 10¹⁵⁄₁₆ x 13⅞
96.16.13

Untitled (Self-Examination)
Image: 13½ x 9¹⁄₁₆
Paper: 13⅞ x 10¹⁵⁄₁₆
96.16.14

TED WHITE
California, 1968
Gelatin silver print
Image: 9⁵⁄₁₆ x 9⁵⁄₁₆
Paper: 13⅞ x 10⅞
Gift of Richard Amerault
92.22.63

ALBERT WIDDER
Town Meeting, n.d.
Chromogenic process color print
Image/Paper: 15⁹⁄₁₆ x 11¹⁵⁄₁₆
Gift of the artist through Doris M.
Offermann '34
65.1.77

EILEEN WIDDER
Candle Glow, c. 1958
Chromogenic process color print
Image/Paper: 17³⁄₁₆ x 7
Gift of the artist through Doris M.
Offermann '34
65.1.122

E. P. WIGHTMAN
Rushes, n.d.
Gelatin silver print
Image: 10³⁄₁₆ x 12¹⁵⁄₁₆
Paper: 10¹⁵⁄₁₆ x 13¹⁄₁₆
Gift of Arthur S. and Katherine Holt
Mawhinney through Doris M.
Offermann '34
65.1.35

GARRY WINOGRAND
Garry Winogrand (New York:
Hyperion Press Limited, 1978)
Portfolio of 15 gelatin silver prints, ed.
63/100
Gift of Donald T. Johnson '61
79.429/80.34/80.35

Cape Kennedy, Florida, 1969
Image: 8⅞ x 13⁵⁄₁₆
Paper: 10¹⁵⁄₁₆ x 13⅞
79.429.1 § *(Fig. 19)*

New York City, 1968
Image: 8⅞ x 13¼

STEPHANIE WELSH, Untitled (Pensive Night Before)

STEPHANIE WELSH, Untitled (Father and Friends Celebrate)

STEPHANIE WELSH, Untitled (Blood Lost)

Paper: 10¹⁵/₁₆ x 13⅞
79.429.2

Utah, 1964
Image: 8¹⁵/₁₆ x 13⁵/₁₆
Paper: 10¹⁵/₁₆ x 13⅞
79.429.3

New York City, 1967
Image: 8¾ x 13⁵/₁₆
Paper: 10¹⁵/₁₆ x 13⅞
79.429.4

New York City, 1969
Image: 8¹³/₁₆ x 13¼
Paper: 10¹⁵/₁₆ x 13⅞
79.429.5

New York City, 1968
Image: 8⅞ x 13¼
Paper: 11 x 13⅞
79.429.6

New York City, 1964
Image: 13³/₁₆ x 8¹³/₁₆
Paper: 13⅞ x 10¹⁵/₁₆
79.429.7 §

New York City, 1971
Image: 8¾ x 13¼
Paper: 10¹⁵/₁₆ x 13⅞
79.429.8

New York City, 1963
Image: 8⅞ x 13¼
Paper: 11 x 13⅞
79.429.9

Toronto, 1969
Image: 8⅞ x 13⁵/₁₆
Paper: 10¹⁵/₁₆ x 13⅞
79.429.10

New York City, 1972
Image: 8¾ x 13³/₁₆
Paper: 11 x 13⅞
79.429.11 § *(Plate 26)*

Austin, Texas, 1974
Image: 8¹³/₁₆ x 13³/₁₆
Paper: 10¹⁵/₁₆ x 13⅞
79.429.12

Fort Worth, Texas, 1974
Image: 8⅞ x 13⁵/₁₆
Paper: 10¹⁵/₁₆ x 13⅞
79.429.13 §

Castle Rock, Colorado, 1960
Image: 8¹¹/₁₆ x 13¼
Paper: 10¹⁵/₁₆ x 13¹⁵/₁₆
80.34

New York City, 1968
Image: 13³/₁₆ x 8⅞
Paper: 13⅞ x 10¹⁵/₁₆
80.35

GARRY WINOGRAND, *New York City*

GARRY WINOGRAND, *Fort Worth, Texas*

GARRY WINOGRAND
Garry Winogrand (New York: The
Double Elephant Press, 1974)
Portfolio of 15 gelatin silver prints, ed. 56/75
Gift of Donald T. Johnson '61
79.442/80.36/80.37

*Coney Island, New York City, New
York*, 1952
Image/Paper: 8½ x 12¹⁵/₁₆
79.442.1

Albuquerque, New Mexico, 1958
Image/Paper: 8⅝ x 12⅞
79.442.2

*Central Park Zoo, New York City,
New York*, 1962
Image/Paper: 8⁹/₁₆ x 12⅞
79.442.3

Texas State Fair, Dallas, Texas, 1964
Image/Paper: 8½ x 12¾
79.442.4

GARRY WINOGRAND, *American Legion Convention, Dallas, Texas*

GARRY WINOGRAND, *Central Park Zoo, New York City, New York*

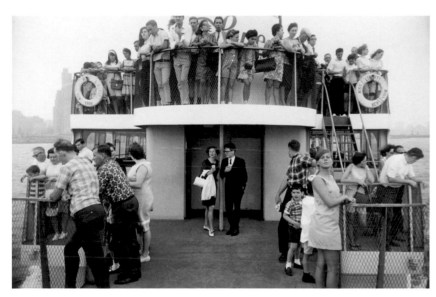

GARRY WINOGRAND, *Staten Island Ferry, New York City, New York*

San Marcos, Texas, 1964
Image/Paper: 8⁹⁄₁₆ x 12¾
79.442.5

Dallas, Texas, 1964
Image/Paper: 8⅝ x 12⅞
79.442.6

World's Fair, New York City, New York, 1964
Image/Paper: 8⅝ x 12⅞
79.442.7

Klamath River, California, 1964
Image/Paper: 8⅝ x 12¹³⁄₁₆
79.442.8

American Legion Convention, Dallas, Texas, 1964

Image/Paper: 8⁹⁄₁₆ x 12⅞
79.442.9 §

Central Park Zoo, New York City, New York, 1967
Image/Paper: 8⅝ x 12¹¹⁄₁₆
79.442.10 §

Los Angeles, California, 1969
Image/Paper: 8⁹⁄₁₆ x 12⅞
79.442.11

Metropolitan Museum of Art Centennial Ball, New York City, New York, 1969
Image/Paper: 8⅝ x 12⅞
79.442.12 § *(Fig. 15)*

New York City, New York, 1970

Image/Paper: 8⁷⁄₁₆ x 12¹¹⁄₁₆
79.442.13

Staten Island Ferry, New York City, New York, 1971
Image/Paper: 8⅝ x 12⅞
80.36 §

Hippy Hollow, Lake Travis, Austin, Texas, 1973
Image/Paper: 8⅝ x 12⅞
80.37

ERNEST C. WITHERS
Little Rock Nine, 1957, printed 1993
Gelatin silver print
Image: 12¹⁄₁₆ x 14¹³⁄₁₆
Paper: 15¾ x 18¼

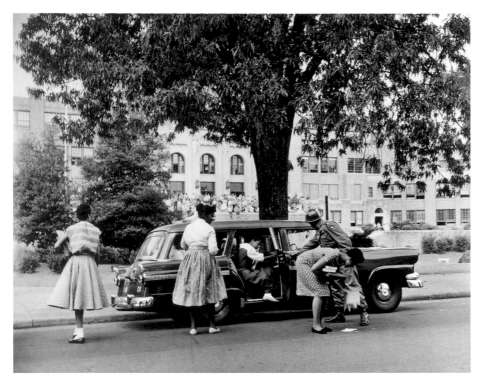

ERNEST C. WITHERS, *Little Rock Nine, 1957*

Purchased with funds from the Helena
Walsh Kane Endowment established by
Richard F. Brush '52
95.25 §

ERNEST C. WITHERS
*I Am a Man (Sanitation Workers
Strike, Memphis, 1968)*, printed
1993
Gelatin silver print
Image: 8½ x 14¾
Paper: 15⅞ x 19¾
Purchased with funds from the Helena
Walsh Kane Endowment established by
Richard F. Brush '52
95.24 § *(Fig. 1)*

EDNA GOOD WOGLOM
Untitled (Snow Scene), 1946
Bromoil process print
Image: 7³⁄₁₆ x 9
Paper: 10¾ x 12½
Gift of Doris M. Offermann '34
65.1.66

DAVID WOJNAROWICZ
Sub-species Helms Senatorius, 1990
Chromogenic process color print,
ed. 8/10
Image: 13¹⁄₁₆ x 19½
Paper: 15¹⁵⁄₁₆ x 19¹⁵⁄₁₆
Purchased with funds from the Eben
Griffiths '07 Endowment
94.3 § *(Plate 27)*

· 188 ·

MARION POST WOLCOTT
*4th of July Celebration, St. Helena's
Island, South Carolina*, June 1939,
printed 1984
Dye transfer print
Image: 6⅞ x 10¼
Paper: 9⅞ x 12¹⁵⁄₁₆
Gift of Rick Jeffrey (parent of Richard
Jeffrey, Jr. '85)
92.11.26

MARION POST WOLCOTT
*Negroes Fishing in Creek near Cotton
Plantations outside Belzoni,
Mississippi Delta*, October 1939,
printed 1986
Dye transfer print
Image: 6⅞ x 9¾
Paper: 9¾ x 12¹⁵⁄₁₆
Gift of Rick Jeffrey (parent of Richard
Jeffrey, Jr. '85)
92.11.33

MARION POST WOLCOTT
*Negroes Fishing in Creek near Cotton
Plantations outside Belzoni,
Mississippi*, October 1939, printed
1986
Dye transfer print
Image: 6⅞ x 9¾
Paper: 9⅞ x 12¾
Gift of Rick Jeffrey (parent of Richard
Jeffrey, Jr. '85)
92.11.34

MARION POST WOLCOTT
*Shacks Condemned by the Board of
Health, Formerly Occupied by
Migrant Workers and Pickers*, January
1940, printed 1985
Dye transfer print
Image: 6⅝ x 9¹¹⁄₁₆
Paper: 9¹⁵⁄₁₆ x 12¹⁵⁄₁₆
Gift of Rick Jeffrey (parent of Richard
Jeffrey, Jr. '85)
92.11.28

MARION POST WOLCOTT
*Clothes of Swimmers Hanging on a
Telegraph Pole . . . , Lake Providence,
Louisiana*, June 1940, printed 1984
Dye transfer print
Image: 9⅞ x 6⅞
Paper: 12⅞ x 9¹³⁄₁₆
Gift of Rick Jeffrey (parent of Richard
Jeffrey, Jr. '85)
92.11.30

MARION POST WOLCOTT
*A Crossroads Store, Bar, "Juke Joint,"
and Gas Station in the Cotton
Plantation Area, Melrose, Louisiana*,
June 1940, printed 1985
Dye transfer print
Image: 7 x 10
Paper: 10 x 13
Gift of Rick Jeffrey (parent of Richard
Jeffrey, Jr. '85)
92.11.31

MARION POST WOLCOTT
*Boys Fishing in a Bayou, Schriever,
Louisiana*, June 1940, printed
c. 1981–1986
Dye transfer print
Image: 10 x 7
Paper: 13¹⁄₁₆ x 10
Gift of Rick Jeffrey (parent of Richard
Jeffrey, Jr. '85)
92.11.32

MARION POST WOLCOTT
*Farmers and Townspeople in Center
of Town on Court Day, Compton
[i.e., Campton], Kentucky*,
September 1940, printed 1981
Dye transfer print
Image: 7¼ x 10¼
Paper: 10¼ x 12⅞
Gift of Rick Jeffrey (parent of Richard
Jeffrey, Jr. '85)
92.11.27 §

MARION POST WOLCOTT
*Living Quarters and Juke Joint for
Migratory Workers, a Slack Season,*

Belle Glade, Florida, February 1941,
printed 1984
Dye transfer print
Image: 6½ x 9¹⁵⁄₁₆
Paper: 9½ x 12¹⁵⁄₁₆
Gift of Rick Jeffrey (parent of Richard
Jeffrey, Jr. '85)
92.11.29 §

ALISON WRIGHT
*Tibetans Spinning Prayer Wheels at
Laugiri Buddhist Temple at the
Lingkhor*, 1998
Chromogenic process color print, ed. 1/75
Image: 9⅜ x 13¹⁵⁄₁₆
Paper: 11 x 13¹⁵⁄₁₆
Purchased with funds from the Helen
Jeanne Gilbert Endowment established by
Richard F. Brush '52
98.56.1

ALISON WRIGHT
Ani Dawa, Tibetan Nun, 1998
Chromogenic process color print, ed. 1/75
Image: 9¼ x 13⅞
Paper: 10¹⁵⁄₁₆ x 13⅞
Purchased with funds from the Helen
Jeanne Gilbert Endowment established by
Richard F. Brush '52
98.56.2

ALISON WRIGHT
*Tibetan Black Hat Dances for Guru
Padmasambava at Tashi Jong Tibetan
Settlement near Dharamsala*, 1998
Chromogenic process color print, ed. 2/75
Image: 13¹⁵⁄₁₆ x 9⅜
Paper: 13¹⁵⁄₁₆ x 10¹⁵⁄₁₆
Purchased with funds from the Helen
Jeanne Gilbert Endowment established by
Richard F. Brush '52
98.56.3

ALISON WRIGHT
*Altar inside the Norbulingka, Tibetan
Buddhist Monastery*, 1998
Chromogenic process color print, ed. 1/75
Image: 9¼ x 13⅞
Paper: 10¹⁵⁄₁₆ x 13⅞
Purchased with funds from the Helen
Jeanne Gilbert Endowment established by
Richard F. Brush '52
98.56.4 §

ALISON WRIGHT
*Palden Galjor, Tortured Monk with
Torture Implements*, 1998
Chromogenic process color print, ed. 2/75
Image: 13¹⁵⁄₁₆ x 9⁹⁄₁₆
Paper: 13¹⁵⁄₁₆ x 10¹⁵⁄₁₆
Purchased with funds from the Helen
Jeanne Gilbert Endowment established by
Richard F. Brush '52
98.56.5

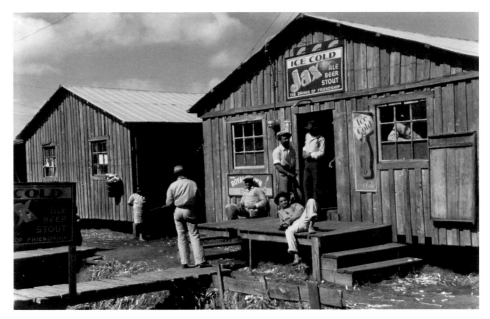

MARION POST WOLCOTT, *Living Quarters and Juke Joint for Migratory Workers, a Slack
Season, Belle Glade, Florida*

MARION POST WOLCOTT, *Farmers and Townspeople in Center of Town on Court Day,
Compton [i.e., Campton], Kentucky*

ALISON WRIGHT
*Dilgo Kyentse, Four-Year-Old
Reincarnate Lama*, 1998
Chromogenic process color print, ed. 1/75
Image: 9⅜ x 13¹⁵⁄₁₆
Paper: 10¹⁵⁄₁₆ x 13¹⁵⁄₁₆
Purchased with funds from the Helen
Jeanne Gilbert Endowment established by
Richard F. Brush '52
98.56.6

ALISON WRIGHT
*The Dalai Lama, Political and
Spiritual Leader of the Tibetan People,
at the Kalachakra Teachings*, 1998
Chromogenic process color print, ed. 4/75
Image: 13¹⁵⁄₁₆ x 8¹¹⁄₁₆
Paper: 13¹⁵⁄₁₆ x 10¹⁵⁄₁₆
Purchased with funds from the Helen
Jeanne Gilbert Endowment established by
Richard F. Brush '52
98.56.7

ALISON WRIGHT, *Altar inside the Norbulingka, Tibetan Buddhist Monastery*

ALISON WRIGHT, *Monks at Namgyal Monastery Sculpting Butter Tormas During Losar, Tibetan New Year*

ALISON WRIGHT, *Tibetan Female Doctor Taking Pulse of Man with White Scarf*

ALISON WRIGHT
*Monks at Namgyal Monastery
Sculpting Butter Tormas During Losar,
Tibetan New Year*, 1998
Chromogenic process color print, ed. 1/75
Image: 9¼ x 13¹⁵⁄₁₆
Paper: 10¹⁵⁄₁₆ x 13¹⁵⁄₁₆
Purchased with funds from the Helen
Jeanne Gilbert Endowment established by
Richard F. Brush '52
98.56.8 §

ALISON WRIGHT
*Thupten's Twin Monks and
Grandfather with Butter Lamps at
Swayambunath Stupa*, 1998
Chromogenic process color print, ed. 1/75
Image: 9⅜ x 13¹⁵⁄₁₆
Paper: 11 x 13¹⁵⁄₁₆
Purchased with funds from the Helen
Jeanne Gilbert Endowment established by
Richard F. Brush '52
98.56.9

ALISON WRIGHT
*Tibetan Female Doctor Taking Pulse of
Man with White Scarf*, 1998
Chromogenic process color print, ed. 1/75
Image: 9⁵⁄₁₆ x 13¹⁵⁄₁₆
Paper: 10¹⁵⁄₁₆ x 13¹⁵⁄₁₆
Purchased with funds from the Helen
Jeanne Gilbert Endowment established by
Richard F. Brush '52
98.56.10 §

FRANCIS WU
Vanity, n.d.
Chlorobromide print
Image/Paper: 18⁹⁄₁₆ x 15
Gift of Barbara Green through Doris M.
Offermann '34
65.1.57 § *(Plate 28)*

FRANCIS WU
Maid of China, n.d.
Chlorobromide print
Image/Paper: 13¹⁵⁄₁₆ x 10¹⁵⁄₁₆
Gift of Barbara Green through Doris M.
Offermann '34
65.1.58

FRANCIS WU
A Maid in the Reading Chamber, n.d.
Chlorobromide print
Image/Paper: 14¼ x 11
Gift of Barbara Green through Doris M.
Offermann '34
65.1.59

FRANCIS WU
Girl with Mirror, n.d.
Chlorobromide print
Image: 14⅜ x 11⁷⁄₁₆
Paper: 14¹⁵⁄₁₆ x 11¹⁵⁄₁₆
Gift of Barbara Green through Doris M.
Offermann '34
65.1.60

FRANCIS WU
Sad Melody, n.d.
Chlorobromide print
Image/Paper: 11⁷⁄₁₆ x 14¹⁵⁄₁₆
Gift of Barbara Green through Doris M.
Offermann '34
65.1.61

FRANCIS WU
Behind the Bamboo Screen, n.d.
Chlorobromide print
Image/Paper: 19 x 14¹⁵⁄₁₆
Gift of Barbara Green through Doris M.
Offermann '34
65.1.62

FRANCIS WU
Modern Girl of China, n.d.
Chlorobromide print
Image/Paper: 18¹⁵⁄₁₆ x 15
Gift of Barbara Green through Doris M.
Offermann '34
65.1.63

KATHERINE L. ZACCARO '91
Untitled (Ribbons), 1991
Gelatin silver print
Image: 4⅛ x 7
Paper: 4⁵⁄₁₆ x 7¼
Purchased with funds from the Jeanne
Scribner Cashin Endowment for Fine Arts
established by Thomas H. Cashin '46
91.13

PHOTOGRAPHER UNKNOWN
General Edwin Atkins Merritt, n.d.
Gelatin silver print
Image: 17⅞ x 12¾
Paper: 17¹⁵⁄₁₆ x 12⅞
Transferred from the University Archives
x.20

PHOTOGRAPHER UNKNOWN
Untitled (Woman), c. 1860
Crayon enlargement print
Image/Paper: 21¾ x 18 (oval)
Transferred from the University Archives
x.28

PHOTOGRAPHER UNKNOWN
Dick, NHA Trang, RVN, 1963
Gelatin silver print
Image: 9¼ x 6⅝
Paper: 9⅞ x 8
Gift of Richard Amerault
92.22.1

PHOTOGRAPHER UNKNOWN
Captured V.C. Photographs, c. 1960s
Gelatin silver print
Image: 16¼ x 13½
Paper: 20 x 16
Gift of Richard Amerault
92.22.2

The Past as Present:
Selected Photographs from the
Libraries' Special Collections and
University Archives

THE ST. LAWRENCE UNIVERSITY LIBRARIES' division of Special Collections is comprised of rare books, manuscripts, printed ephemera, maps, and photographs that require special care and handling to ensure their continued value as educational and historical resources. Housed in the Owen D. Young Library, Special Collections contains the Rare Book and Manuscript Collections and the University Archives. As a part of a library serving primarily the needs of an undergraduate liberal arts college, the division emphasizes the teaching and learning opportunities that the collections provide students and faculty while recognizing that these materials are important to independent researchers. The focus of the Archives pertains to St. Lawrence University's permanently valuable records and selected non-current materials whose value may be historical, legal, cultural, or fiscal, and which include all of the various textual and visual formats mentioned above. Special Collections contains a variety of photographic images created for a variety of purposes. This essay includes brief descriptions of the library's holdings in photography and a representative selection of images.

THE MANUSCRIPT COLLECTIONS

Comprising 1,500 linear feet of material, the Manuscript Collections consist of more than 120 discrete collections including those on the United States Civil War, the St. Lawrence River and Seaway, North Country women's diaries, Adirondack history, and the personal papers of Owen D. Young and David Parish, among others.

Several photographic formats document the Adirondack Mountain region of New York in the Adirondack Collection (Mss. Coll. No. 032). Over three dozen albumen prints and stereoviews by Seneca Ray Stoddard (1844–1917) depict Adirondack great camps, hotels, and hunting and logging scenes. A unique figure in Adirondack history, Stoddard was a dedicated entrepreneur who wrote and published tourist guidebooks, such as *The Adirondacks, Illustrated*. With a genuine gift for visual composition, Stoddard was a master in his ability to capture and manipulate light in his photographs. He is said to have enhanced the fire to achieve the quality of lighting he wanted, for example, in *Adirondack Survey, Camp near Long Lake* (fig. 21). Stoddard was fortunate to have been active during the era when both the Adirondacks and photography came into mass popularity. Thus, his photographs are of interest for their documentary value as well as their visual appeal (plate 29).

The photograph collections of two local commercial photographers, Benjamin M. Kip (1871–1957) and Dwight P. Church (1891–1974), are utilized by historians of the region. The Kip

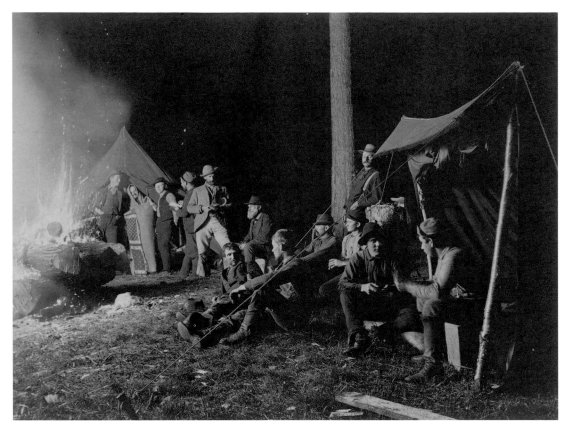

Fig. 21. SENECA RAY STODDARD
Adirondack Survey. Camp near Long Lake, 1888
6½ x 8½ albumen print

Fig. 22. DWIGHT P. CHURCH
Photographic advertising and travel case, ca. 1930s
Gift of Carmelita Church Hood, 1981

Fig. 23. DWIGHT P. CHURCH
Gelatin silver copy prints, ca. 1930s, printed 1990s
Gift of Carmelita Church Hood, 1981

Collection (Mss. Coll. No. 088) consists of rare glass plate negatives, from 2 x 4 to 11 x 14 inches, documenting daily life in the North Country at the turn of the century (plates 30, 31, 32). Before the advent of film, glass was used to hold the photographic emulsion. Although fragile, glass plate negatives produce prints with a unique character. Kip, who worked as a photographer from 1898 to 1948, augmented his portrait business by publishing souvenir books of Potsdam, Canton, and Gouverneur, N.Y. The negatives serve as a historical record of churches, businesses, schools, streets, and residences, many of which no longer exist. There are also many photographic negatives of St. Lawrence University's campus and fraternity and sorority life.

Dwight "Dippy" P. Church, also of Canton, ran the $5 Photo Company, an early mail-order developer, and published photographic postcards of local scenes (figs. 22, 23). After the commercial photo developing market was taken over by larger firms such as Eastman Kodak, Church turned to an old passion, flying, and began an aerial photography business to support his family, producing views of hundreds of farms and towns in the North Country (plate 33). The Church Collection (Mss. Coll. No. 057) contains over 13,000 prints and negatives created from 1912 to the late 1960s (plate 34).

Other manuscript collections with photographic components include the G. Atwood Manley Papers (Mss. Coll. No. 067). Manley (1893–1989) graduated from St. Lawrence in 1916 and is best known as the editor of the *St. Lawrence Plaindealer.* A prolific writer, Manley was the author of numerous articles and books, including *Frederic Remington and the North Country* and *Rushton and His Times in American Canoeing.* His papers contain many photographs of Canton (fig. 24) and the Cranberry Lake area in the northwestern Adirondacks, depicting a variety of North Country people and issues.

Richard C. Ellsworth (1875–1948) grew up in Canton, graduated from St. Lawrence in 1895, and

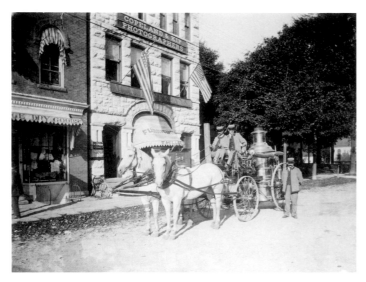

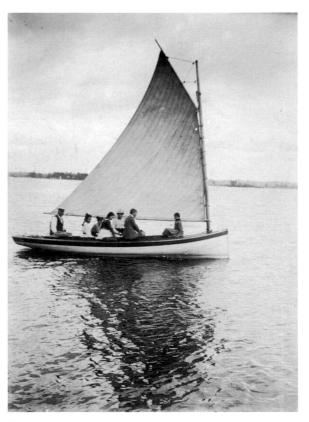

Fig. 24. PHOTOGRAPHER UNKNOWN (COPELAND & KIP?)
Canton Fire Department, Silsbee Steamer, ca. 1900, printed later
Gelatin silver copy print
Gift of Margaret Manley Mangum '45 and Janet Labdon (parent of
Kenneth Labdon '72), 1989

Fig. 25. PHOTOGRAPHER UNKNOWN
Catboat on the St. Lawrence, ca. 1890
6½ x 4¾ gelatin silver print
Sudds Family Photographs

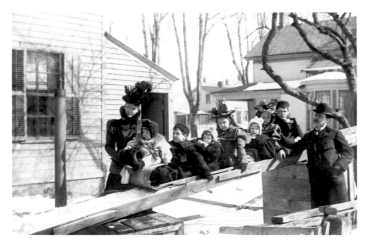

Fig. 26. A. L. JAMESON
Family on Toboggan, 1898
From 5 x 8 glass plate negative
Gift of Tom Jenison, 1983

served as Secretary of the University from 1922–1943. In the late 1920s, he established the first University archive, called the "Museum," in the men's residence hall. The Collection (Mss. Coll. No. 069) provides a wealth of visual history of the village and people of Canton. Ellsworth was instrumental in preserving many of the photographs that are now part of the University Archives.

The Sudds Family Photographs (Mss. Coll. No. 123) include portraits, interiors, and street scenes in Gouverneur, N.Y. English-born composer William F. Sudds (1843–1920) attended the Boston Conservatory and wrote musical scores published by Oliver Ditson & Co., among others. The family had a summer home in Chippewa Bay, N.Y., where some of the photographs were taken (fig. 25, plate 37). In addition, the A. L. Jameson Collection (Mss. Coll. No. 089) consists of 136 glass plate negatives taken between 1895 and 1910 of family and domestic scenes from Ogdensburg, N.Y., and the nearby Black Lake area (fig. 26). Although the Thousand Islands

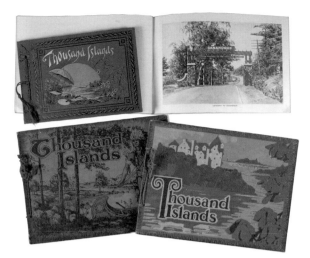

Fig. 27. VARIOUS PUBLISHERS
Viewbooks, 1890s–1920
Thousand Islands Collection

Fig. 28. PHOTOGRAPHERS UNKNOWN
Photographs inserted in Nathaniel Hawthorne's *The Marble Faun*
Gift of Ulysses. S. Milburn, 1949

Collection of ephemera (Mss. Coll. No. 109) does not contain original photographs, several early twentieth-century viewbooks include mechanically reproduced photographic images that illustrate the emerging relationship between tourism and photography in publishing (fig. 27).

THE RARE BOOK COLLECTION

The Rare Book Collection contains over 7,000 titles, including significant collections of the works of Irving Bacheller, Robert Frost, Nathaniel Hawthorne, Marietta Holley, Edwin Arlington Robinson, and Frederic Remington, as well as subject collections on New York's Adirondack Mountains, Arctic exploration, book arts, Universalism, and the War of 1812.

The collection's photographic titles include the quarterly journal *Camera Work*, first published in January 1903 by the renowned photographer Alfred Stieglitz, and devoted to reproducing "the best examples of all 'schools' both American and foreign."[1] Throughout the publication's fourteen-year history, Stieglitz published some of the best work of the photographers of his day. Not only were the photographs of exquisite quality, but the design, typography, and hand-pulled photogravures set new standards for the reproduction of photographs. The Collection includes seven issues of the journal, representing the work of Edward Steichen, Paul Strand (plate 35), Francis Bruguière (plate 36), and others.

Several titles in the Rare Book Collection are extra-illustrated with tipped-in photographs, a practice in which individual plates (prints or photographs) are attached as illustrations to blank pages. One such example is Nathaniel Hawthorne's *The Marble Faun* (fig. 28). While on the Italian leg of their grand tour, English-speaking tourists would purchase the late 19th-century Tauchnitz edition of the book as a guidebook for Rome and subsequently insert original photographs illustrating Hawthorne's story and the city's tourist sites. Each of the collection's four copies is a unique Victorian souvenir.

1. *Camera Work*. New York: Alfred Stieglitz, 1903–1917.

Fig. 29. PHOTOGRAPHERS UNKNOWN
Mr. and Mrs. Barzillai Hodskin, ca. 1865
4 x 3 ambrotypes in case

Fig. 30. A. J. RUNIONS
St. Lawrence University Baseball
Players, ca. 1892
6½ x 4¼ albumen print

THE UNIVERSITY ARCHIVES

The University Archives contains over 1,200 linear feet of material documenting the history of St. Lawrence. Founded in 1856, St. Lawrence is the oldest continuously co-educational college in New York State. Various publications, photographs, scrapbooks, letterbooks, and minutes by students, faculty, and alumni provide information about the undergraduate college and document the history of the Universalist Theological School (1856–1965), Brooklyn Law School (1903–1943), and State Agricultural School (1906–1948), when they were part of the University.

Although frequently unrecognized beyond its primary purpose of documenting St. Lawrence's history, the University Archives contains over 75 linear feet of photographs—some 20,000 images from the 1850s to the present. Most early photographic formats are represented: daguerreotypes, ambrotypes (fig. 29), tintypes, cartes de visite and cabinet albumen prints, cyanotypes, as well as more contemporary slides, Polaroids, and gelatin silver prints. In a broader context, this collection chronicles American social and cultural history through the people, places, and events at St. Lawrence (fig. 30, plates 38, 39, 40, 41).

As part of an undergraduate college, the Library's division of Special Collections emphasizes the ongoing teaching value of historical images and documents. While a number of independent scholars use the collections for research purposes, real success often comes when students use such materials to make that leap of understanding between the object in front of them and the topic they are studying.

MARK C. McMURRAY

Plate 29. SENECA RAY STODDARD
The Way It Looks from the Stern Seat, ca. 1895
4¼ x 7½ albumen print

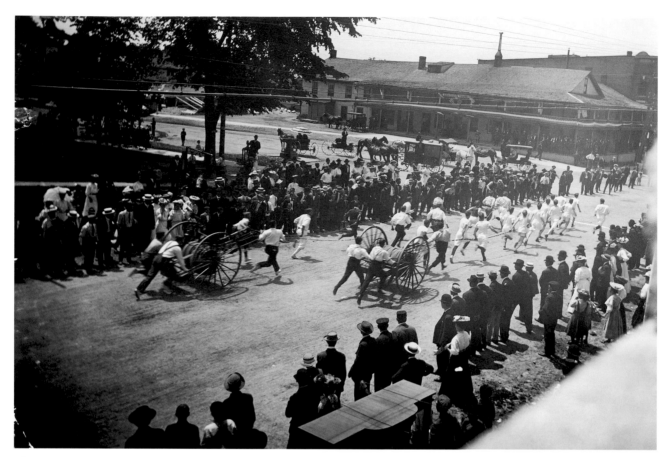

Plate 30. PHOTOGRAPHER UNKNOWN (COPELAND & KIP?)
Races at the St. Lawrence County Fireman's Convention, ca. 1908, printed later
Gelatin silver copy print
Gift of Margaret Manley Mangum '45 and Janet Labdon (parent of Kenneth Labdon '72), 1989

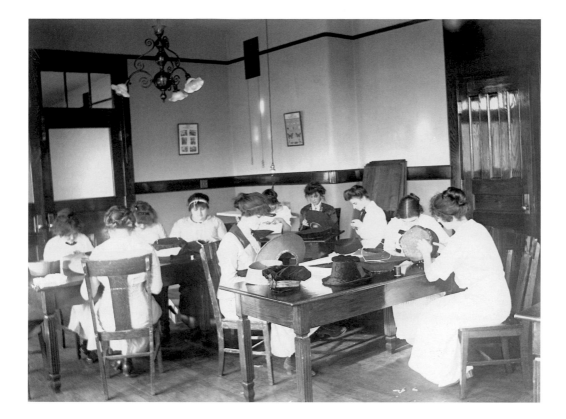

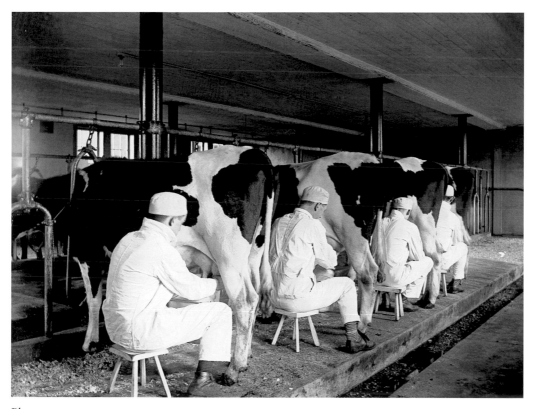

Plate 31, 32. BENJAMIN J. KIP
Making Hats, Milking Cows, ca. 1910
From 3¼ x 4¼ glass plate negatives

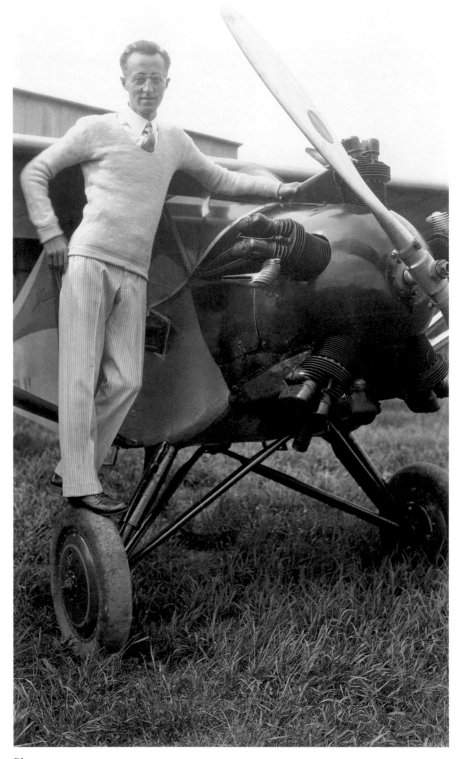

Plate 33. DWIGHT P. CHURCH
Dwight Church and Airplane, ca. 1930s, printed 1990s
Gelatin silver copy print
Gift of Carmelita Church Hood, 1981

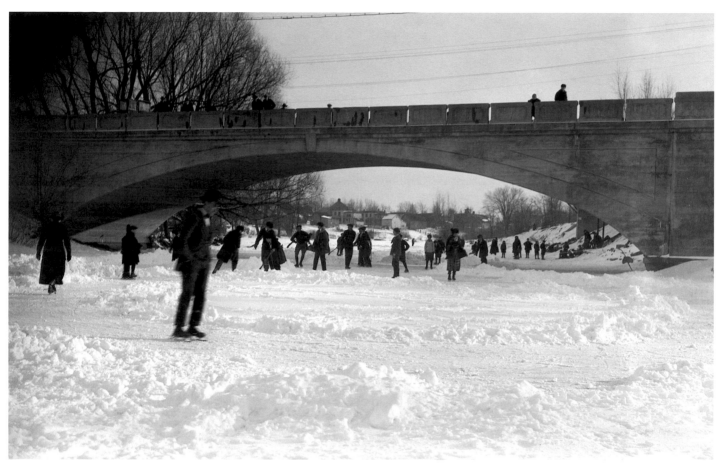

Plate 34. Skating on the Grasse River, Canton, NY, ca. 1930s, printed 1990s
Gelatin silver copy print
Gift of Carmelita Church Hood, 1981

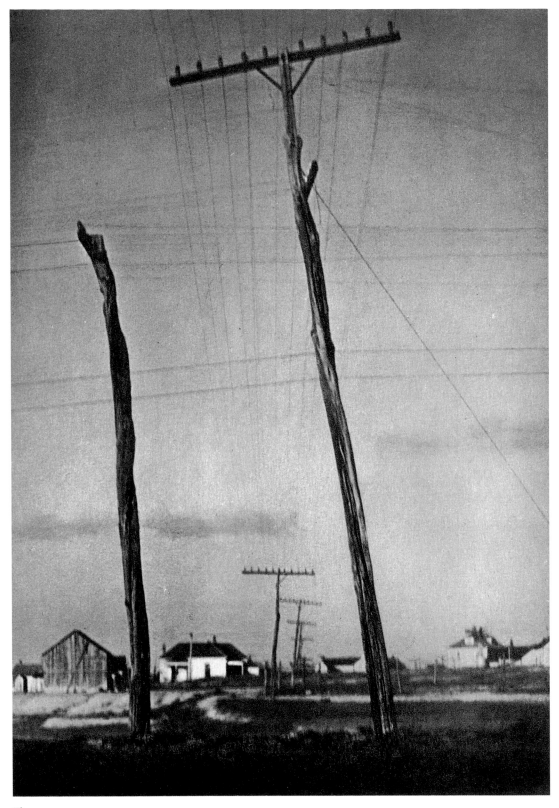

Plate 35. PAUL STRAND
Telegraph Poles, October 1916
8 x 5⅜ photogravure
Camera Work, no. 48:27
Gift of Michael E. Hoffman '64, 1977

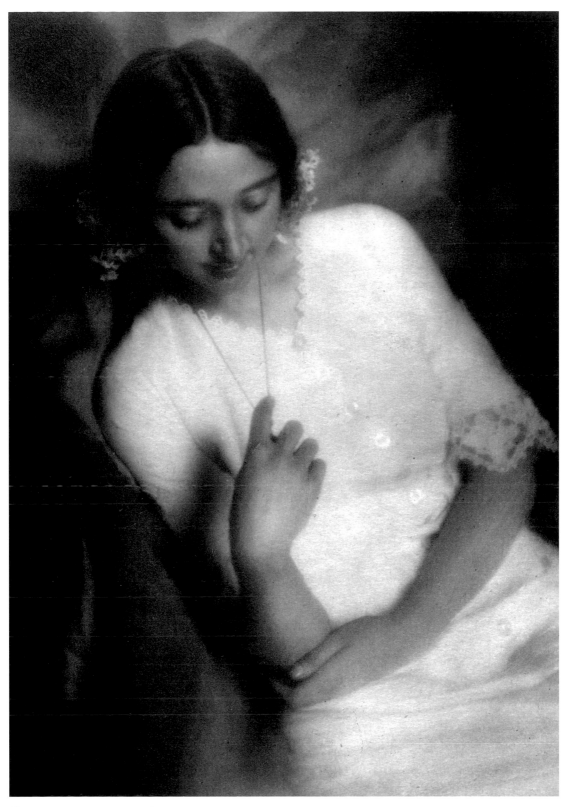

Plate 36. FRANCIS BRUGUIÈRE
A Portrait, October 1916
6½ x 4½ photogravure
Camera Work, no. 48:51
Gift of Michael E. Hoffman '64, 1977

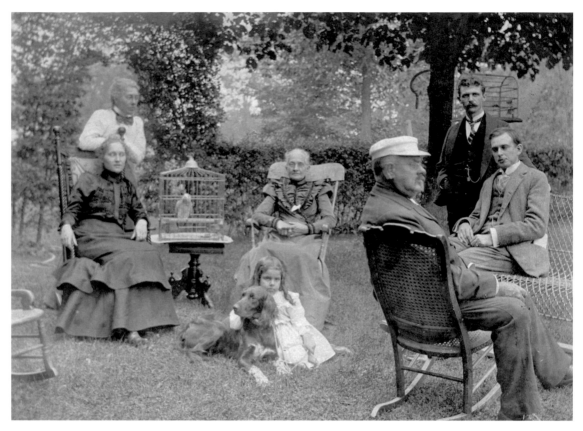

Plate 37. PHOTOGRAPHER UNKNOWN
Family in Garden, ca. 1890
6½ x 4¾ gelatin silver print
Sudds Family Photographs

Plate 38. PHOTOGRAPHER UNKNOWN
St. Lawrence University Women's Basketball Team, 1906
6 x 8¼ albumen print

Plate 39. PHOTOGRAPHER UNKNOWN
St. Lawrence University Football Team, 1892
3¾ x 5½ albumen print

Plate 40. PHOTOGRAPHER UNKNOWN
Skiers in front of St. Lawrence University's Fisher Hall, ca. 1945
8 x 10 gelatin silver print

Plate 41. PHOTOGRAPHER UNKNOWN
Vietnam War Protest at St. Lawrence University, May, 1970
5 x 7 gelatin silver print

Contributors

BILL GASKINS earned a B.F.A. from the Tyler School of Art at Temple University, a M.A. from Ohio State University, and a M.F.A. from the Maryland Institute, College of Art. His photographs have focused on the diversity, complexity, rituals, and gestures of African-American life and have garnered critical attention through fellowships, residencies, grants, and awards, as well as solo and group exhibitions, exhibition catalogues, anthologies, and other publications. *Good and Bad Hair: Photographs by Bill Gaskins*, published by Rutgers University Press in 1997, examines the significance of African-American hairstyling and identity. His writings have appeared in the *New Art Examiner, Afterimage: The Journal of Media Arts and Cultural Criticism, Dialogue*, and other journals. Gaskins has taught at the University of Minnesota, Syracuse University, the American Photography Institute at New York University, and the School of the Art Institute of Chicago. He is currently a lecturer in photography at Parsons School of Design and a fellow in the African-American Studies program at Princeton University.

ELOY J. HERNÁNDEZ graduated from St. Lawrence University in 1993 and now lives in Philadelphia, Pennsylvania, where he is a sexual and reproductive health counselor for CHOICE Health Concerns, Inc. He is currently working to complete his doctoral dissertation on popular culture, critical pedagogy, and the crisis of HIV/AIDS in urban youth communities. His work has appeared in *Afterimage: The Journal of Media Arts and Cultural Criticism*, the *New Art Examiner*, and a number of independent and alternative media outlets.

MICHAEL E. HOFFMAN is a 1964 graduate of St. Lawrence University. Since 1965, he has been the Executive Director of Aperture Foundation, an internationally acclaimed organization dedicated to promoting photography as a unique form of artistic expression by illuminating social, cultural, and environmental issues. Its programs include the publication of *Aperture, The Quarterly*, a well-known periodical of the highest quality, as well as scores of monographs that span the entire history of photography. Aperture oversees the Burden Gallery in New York City and the Paul Strand Archive in Millerton, New York. In addition, Hoffman is the founder and adjunct curator of the Stieglitz Center at the Philadelphia Museum of Art.

MARK C. KLETT graduated from St. Lawrence University in 1974 and received his M.F.A in photography from the Visual Studies Workshop of the State University of New York at Buffalo. He is an associate professor of art at the School of Art at Arizona State University and chief photographer for the Rephotographic Survey Project of the American West. His exhibitions and publications record is extensive, with recent one-person exhibitions at the Huntington, the Cleveland Museum of Art, and the National Museum of American Art at the Smithsonian Institution, among others. In public and private collections around the world, his photographs have been published in *An American Century of Photography: From Dry-Plate to Digital* and *Innovation/Imagination: 50 Years of Polaroid Photography*. In addition, *View Finder: Mark Klett, Photography, and the Reinvention of Landscape* by William L. Fox is forthcoming.

DOROTHY LIMOUZE received her Ph.D. from Princeton University and is an associate professor of art history at St. Lawrence University. In addition to teaching, she has worked as an area editor for Central Europe at the Dictionary of Art in London and as a cataloguer of Dutch and Flemish prints at the Philadelphia Museum of Art. At St. Lawrence, she teaches courses in medieval through baroque art, the decorative arts, and the history of the museum. She has authored articles and collaborated on catalogues in the fields of Renaissance and baroque art in northern and central Europe, including *The Felix M. Warburg Print Collection: A Legacy of Discernment* (1995) and *Rudolf II and Prague: The Court and the City* (1997).

CAROLE MATHEY has been collections manager of the Richard F. Brush Art Gallery since 1993. She received a B.A. from San Diego State University and a M.A. in medieval history from the University of California at Los Angeles. Curator of *Biting Lines: English Caricature Prints from the Permanent Collection* and *The Skin Landscape*, an exhibition that examined tattooing in photographs and other media, she has helped organize several exhibitions at St. Lawrence University. These include *Maureen Connor: Selected Sculptures and Installations 1988–93* and exhibitions from the Permanent Collection of photographs by Manuel Alvarez Bravo and by Farm Security Administration artists, among others. Mathey maintains the Gallery's Web site at www.stlawu.edu/gallery.

MARK C. MCMURRAY received his B.A from Hamilton College and his M.S. in library science from Columbia University. He was a librarian in the Archives, Rare Book, and Rare Book Cataloging departments at the New York Public Library before coming to St. Lawrence University in 1993 as the cataloging librarian. He has been curator of Special Collections and University archivist since 1998. He is also the proprietor of Caliban Press, a private press located in Canton, New York.

ESTHER PARADA is an artist and critic whose work has addressed the relationship between visual representation, memory, and power. She is currently professor of photography at the University of Illinois at Chicago. Parada was a recipient of National Endowment for the Arts Photography Fellowships in 1982 and 1988; and she has exhibited extensively in the United States, as well as in several Latin American and European countries. Her work is represented in permanent collections at the Art Institute of Chicago, the Museum of Modern Art in New York City, and the Museum of Fine Arts in Houston, among others. Her critical essay "C/Overt Ideology: Two Images of Revolution" is anthologized in *The Contest of Meaning* (1989). Since 1986, Parada has used digital technology to create photo/text or photomontage works that offer a revisionist historical perspective. Her work "To Make All Mankind Acquaintances," based on research of historical stereographs of Latin America, was published in 1996 as part of the CD-ROM *Three Works* and was included in the 1999 exhibition *Zonas de contacto: el arte en CD-ROM (Contact Zones: Art on CD-ROM)* at the Centro de la Imagen, Mexico City, Mexico.

GARY D. SAMPSON received his M.A. and Ph.D. in art history from the University of California at Santa Barbara and is currently an associate professor at the Cleveland Institute of Art in Ohio. His teaching background includes a two-year appointment at St. Lawrence University (1988–90),

where he first became acquainted with the Permanent Collection and curated *American Photographs, 1950–1980* for the Richard F. Brush Art Gallery. His essays on the photography of Samuel Bourne and Lala Deen Dayal in India appear in *India through the Lens*, published in conjunction with a fall 2000 exhibition at the Arthur M. Sackler Art Gallery of the Smithsonian Institution. Sampson is co-editor of a forthcoming compilation of essays with Eleanor M. Hight entitled *Imag(in)ing Race and Place in Colonialist Photography*. He has recently published on the topic of new media and photographic theory.

THOMAS W. SOUTHALL, a 1973 graduate of St. Lawrence University, received a M.A. degree from the University of New Mexico and was appointed in 1998 to his current position as curator of photography at the High Museum of Art in Atlanta, Georgia. Southall has taught at the University of Kansas at Lawrence, the University of New Mexico at Albuquerque, and the College of Santa Fe, and he was curator of photography at the Spencer Museum of Art at the University of Kansas and at the Amon Carter Museum in Fort Worth, Texas. In 1996, he was awarded a Joshua C. Taylor Fellowship at the National Museum of American Art, Smithsonian Institution, Washington, D.C. Southall has organized several exhibitions with publications including: *Revealing Territory: Photographs of the Southwest by Mark Klett* (1992); *Walker Evans and William Christenberry: Of Time and Place* (1990); and *Diane Arbus: Magazine Work* (1984). For the High Museum, he organized *Harry Callahan: Photographs 1981–1996*, and he is now working on an exhibition of almost 400 twentieth-century photographs from the extensive collection of Sir Elton John.

CATHERINE TEDFORD received a B.A. from the State University of New York at Potsdam and a M.F.A. from the University of Massachusetts at Amherst. After graduation, she lived and worked in Boston where she was assistant director at Haley & Steele, a historical print gallery; gallery director at the Art Institute of Boston; and director of the Arts at CityPlace, a non-profit gallery, public art, and music performance program. She has been director of the Richard F. Brush Art Gallery at St. Lawrence University since 1989, overseeing an active exhibitions program and Permanent Collection of over 7,000 art objects and artifacts. She teaches on an occasional basis in the First-Year Program, the Cultural Encounters Program, and a non-departmental course in artists' books, and makes sculptures, collages, and artists' books about gender and spirituality; five of her sculptures were included in the 1996 New York State Museum's *Biennial Exhibition*.

Acknowledgements

FIRST, I WOULD LIKE to thank Richard F. Brush '52 for his ongoing support of the Art Gallery and Permanent Collection at St. Lawrence University. An initial gift from Dick Brush made this publication possible and will allow its distribution to universities, art departments, museums, arts organizations, and individuals across the country, as well as to libraries and schools in northern New York. Though Dick's presence on campus is often fleeting, his generous spirit is ever present, and his enthusiasm for the arts will leave an enduring legacy. Cheryl L. Grandfield '73 matched Dick's gift for the project to recognize his service to the University as a trustee and to continue her support of St. Lawrence and the arts.

Gary Sampson, co-editor of the publication and curator of the accompanying exhibition, helped guide and shape the publication by his fine scholarship and thoughtful, careful responses to the contributors' essays. In his feature essay and in the exhibition, Gary's knowledge and expertise will undoubtedly lead to a more meaningful understanding of the University's photography collection and its potential as a teaching resource. Likewise, the contributions of Bill Gaskins and Esther Parada, feature essayists, will have a lasting impact on the Brush Art Gallery and Permanent Collection. We were very honored to include in the publication essays by St. Lawrence alumni active in photography and cultural studies, Eloy J. Hernández '93, Michael E. Hoffman '64, Mark C. Klett '74, and Thomas W. Southall '73, and essays by St. Lawrence faculty, Dorothy Limouze and Mark C. McMurray.

Carole Mathey's work was outstanding regarding the checklist of the catalogue, reproduction rights and digital scanning for over 200 photographs, and her assistance with the final editing of the essays. The generous guidance that Anne Salsich provided throughout the project was invaluable, and I am in her debt. Denise LaVine '00 and Marguerite Torres worked hundreds of hours to ensure that the checklist was complete and accurate.

St. Lawrence University President Daniel F. Sullivan and Vice-President and Dean of Academic Affairs Thomas B. Coburn have been strong advocates for the Gallery's educational mission and the goals of this publication. In University Advancement, Linda Pettit and Pete Beekman, enthusiastic supporters of the Gallery, helped secure full funding for the project.

Paul Hoffmann at The Stinehour Press designed this fine publication, and it was a real pleasure to work with him and Stephen Stinehour. In addition, I am grateful to Nathan Farb who gave permission to use a detail of his photograph *Orebed Brook* for the publication's cover.

So many students over the years make everything we do in the Gallery worthwhile: Martha Watterson, Tori Mills, Laura Desmond, Eloy J. Hernández, Annette Trapini, Bob Richardson, Jodie Phaneuf, Joost de Laat, Jess Land, Sage Litsky, Cristianne McKenna, Denise LaVine, Sarah Lott, Tyler Pecora, Todd Matte, Matt Bogosian, and others. You are all shining stars in this northern constellation.

CATHERINE TEDFORD

Copyright Holders

Design by Paul Hoffmann
Composed in Adobe Garamond types
and printed on Warren Lustro Dull Text
by The Stinehour Press, Lunenburg, Vermont

Binding at Acme Bookbinding
Charlestown, Massachusetts